P9-CDS-290

Faces of Discord

THE CIVIL WAR ERA AT
THE NATIONAL PORTRAIT GALLERY

VESTAL 973.7092 NATI
National Portrait Gallery
(Smithsonian Institution)
Faces of discord :

JAN 1 1 2007			
FEB 0 6 2007			
JUL 0 8 2008			
AUG 0 1 2008			

VESTAL PUBLIC LIBRARY

0 00 10 0300016 1

Vestal
Public Library

DEC 1 5 2006

Vestal, NY
607-754-4243

EDITED BY JAMES G. BARBER

WITH A FOREWORD BY MARC PACHTER
AND A PREFACE BY JAMES M. MCPHERSON

ENTRIES BY JAMES G. BARBER,
MARGARET C. S. CHRISTMAN,
AND FREDERICK S. VOSS

THE NATIONAL PORTRAIT GALLERY SMITHSONIAN INSTITUTION WASHINGTON, D.C.

An Imprint of HarperCollins Publishers

Faces of Discord

THE CIVIL WAR ERA AT
THE NATIONAL PORTRAIT GALLERY

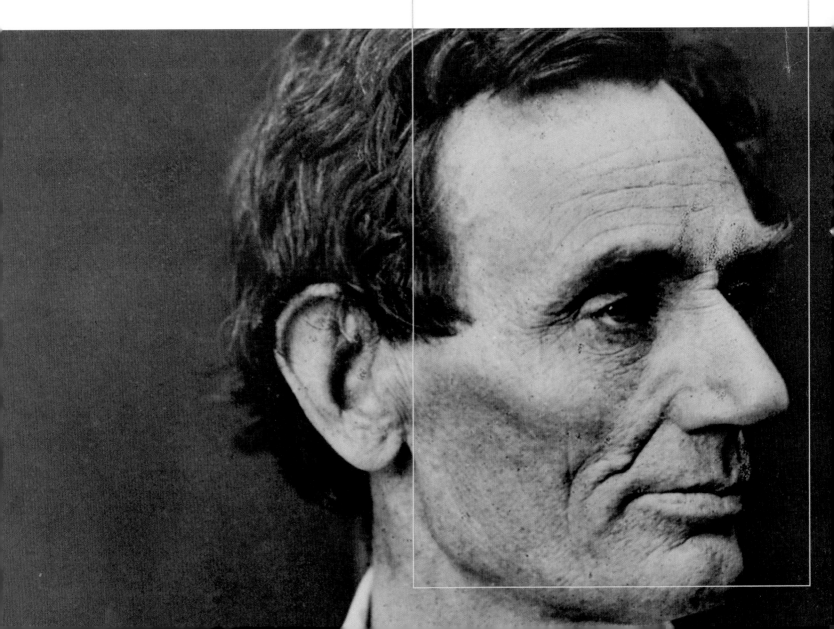

PHOTOGRAPY CREDITS:
Marianne Gurley and Rolland White: All National Portrait Gallery images
Matt Flynn: pages 148 and 149.

FACES OF DISCORD. Copyright © 2006 by the Smithsonian Institution. All rights reserved. Printed in the United States of America. No part of this book may be used or reproduced in any manner whatsoever without written permission except in the case of brief quotations embodied in critical articles and reviews. For information, address HarperCollins Publishers, 10 East 53rd Street, New York, NY 10022.

HarperCollins books may be purchased for educational, business, or sales promotional use. For information please write: Special Markets Department, HarperCollins Publishers, 10 East 53rd Street, New York, NY 10022.

FIRST EDITION

The name of the "Smithsonian," "Smithsonian Institution," and the sunburst logo are registered trademarks of the Smithsonian Institution.

Project coordinator: **Dru Dowdy, Head of Publications, National Portrait Gallery**

BOOK DESIGN BY **SHUBHANI SARKAR**

Library of Congress Cataloging-in-Publication Data has been applied for.

ISBN-10: 0-06-113584-4
ISBN-13: 978-0-06-113584-2

06 07 08 09 10 ❖/QW 10 9 8 7 6 5 4 3 2 1

Contents

Foreword

WHEN AMERICANS SPEAK OF THE DIFFERENCES between our society and most other nations, we usually assume that the past does not control our actions; as a people, we are more present- and future-oriented. And who can deny that we are constantly changing, constantly reinventing ourselves economically, socially, and technologically?

Still, there is one central event that continues to concern us and perhaps to shape us. It is, of course, the Civil War, at once a terrible exception in our history, a time when fierce battles were fought on our own soil and among our own people, and yet a defining event in how we think of our union as a nation, the relationship of our regions, and the legacy of racial injustice. It reminds us of how far we have come in national strength, regional reconciliation, and the expansion of civil rights for all citizens. But it nags at our consciousness and conscience both as a time when violence and hatred overtook us and as a legacy mixed with bitterness and hope.

In the nation's capital, there is perhaps no place better suited to contemplate all that was glorious and terrible in the Civil War experience and legacy than the National Portrait Gallery. Our building, as Frederick Voss, former senior historian, explains here, stood as witness and participant in the war, whether as barracks for General Ambrose Burnside's troops, occasional Federal hospital, site of Lincoln's second inauguration, or workplace for Walt Whitman and Clara Barton. But it is our function as the national place to remember the roles of remarkable Americans that allows us to best tell this fundamental story in human terms rather than through dry abstraction. In our collection of portraits in every medium, you can see the moral intensity of the soon-to-be-hanged abolitionist John Brown, the self-possession of the African American heroine Sojourner Truth, the lasting impact of Stonewall Jackson captured in a tribute portrait after his heroic death, the epic pride of Grant and his generals, and the political mockery made of Lincoln's successor, Andrew Johnson. We wonder what we ourselves would have made of the tasks they confronted, the decisions they were forced to make.

As a museum of the twenty-first century, the National Portrait Gallery must tell this central story of American experience in many different forms. If you are lucky enough to be in Washington, you will have the opportunity to see many of these wonderful paintings, sculptures, prints, photographs, folk art, and political cartoons "in the flesh," so to speak, where our permanent exhibition on the Civil War will have pride of place. You also have this publication to enjoy, whether or not you will be able to make the visit. But happily, there is now yet another way to encounter the men and women of the Civil War, and the artifacts that bear witness to their experience. The electronic National Portrait Gallery has pulled

together from all the collections of the Smithsonian an exhibition in cyberspace (www.civil-war.si.edu) to allow anyone in the world to see this great national drama unfold.

We can do none of this without the expertise and devotion of our remarkable staff of historians and curators. James G. Barber, Margaret C. S. Christman, and Frederick S. Voss have provided text and context worthy of these great images. But we are also dependent on the kindness of friends. Professor James McPherson, whose monumental work on the Civil War informs all our understanding, has provided a brilliant preface to this book. He sees, quite literally, how much we need the visual record of an era, the grim expressions, the heroic postures, to comprehend what it was like to live it. As long as we have guides like these, we will continue to learn a great deal from the Civil War.

MARC PACHTER

Director, National Portrait Gallery

THEY STARE OUT AT US across the decades with unsmiling faces, holding themselves with a stiff intensity that seems almost painful. This posture is mainly the consequence of having to sit or stand perfectly still for several seconds in that era of daguerreotype and glass-plate photography. Conventions of artistic portraiture also seemed to forbid a casual or smiling pose. Thus, despite Abraham Lincoln's famous sense of humor, we have no picture of him smiling. But in his case as well as in those of other men and women portrayed in this volume, this grim alertness suggests the seriousness of the times and of the issues that brought these people to prominence. Questions of slavery and freedom, union and disunion, war and peace, were not matters for levity or relaxed reflection. Nobody was having a good time when these pictures were made. They were dealing, literally, with matters of life and death—of a nation, of a society, and of hundreds of thousands of people.

The most famous American abolitionists greet the viewer here. William Lloyd Garrison inaugurated the militant phase of abolitionism with the first issue of his newspaper *The Liberator* in 1831: "I am in earnest—I will not equivocate—I will not excuse—I will not retreat a single inch—AND I WILL BE HEARD." And he *was* heard, by Northerners like Wendell Phillips, whom Garrison converted to the cause, and escaped slaves like Frederick Douglass, who became the most eloquent black spokesman for freedom. Sojourner Truth, also a former slave, added women's rights to her message of abolition. And it was a woman, Harriet Beecher Stowe, who struck the most powerful blow for the cause of liberty with her novel *Uncle Tom's Cabin*, published in 1852.

Stowe wrote this story in angry response to passage of the Fugitive Slave Act in 1850. Part of the Compromise of 1850, the Fugitive Slave Act stretched the long arm of Federal law into Northern states to recapture black men and women who had escaped from bondage. The Compromise of 1850 also attempted to settle other aspects of the growing sectional controversy over slavery, especially its status in the new territories of the Southwest, which had been seized from Mexico in the war of 1846–48. To the center of the political stage strode the great triumvirate of senators whose careers stretched back to the century's first decade—Henry Clay, Daniel Webster, and John C. Calhoun—whose penetrating eyes lock onto the viewer in the early pages of this volume. Clay had fashioned compromises in 1820 and 1832 to defuse threatened secession by slave states; once again he framed a series of measures to give something to both North and South. Webster supported him; Calhoun opposed, because the provision allowing settlers in territories to decide for themselves whether to have slavery offered insufficient protection to the institution. Calhoun died during the debate; Webster was denounced by antislavery Northerners; Clay gave up in disgust. Into the

vacuum of leadership created by the failure of that generation stepped a new generation, headed by Senator Stephen A. Douglas of Illinois, who put together a congressional coalition to pass the Compromise measures.

The Compromise of 1850 did not settle the slavery controversy; indeed, one of its key features, the Fugitive Slave Act, further polarized the slave and free states. Senator William H. Seward, whose hawklike profile illustrated the sharpness of his intellect, had been a leading opponent of the Compromise because he thought it granted too much to slavery. Seward became a leader in the new antislavery Republican Party, which formed in response to the Kansas-Nebraska Act of 1854. Sponsored by Senator Douglas, this act opened Kansas and Nebraska territories to slavery if the settlers wanted it. On a platform of banning slavery from all territories, Republicans carried most Northern states in the presidential election of 1856 and stood poised to carry them all—and the election—in 1860.

Before then, however, an abolitionist who looked and acted like an Old Testament prophet, John Brown, tried to liberate the slaves by starting an insurrection. Brown's first step was an attack on the Federal arsenal at Harpers Ferry in 1859. Brown and several of his men were captured and hanged. No insurrection occurred. But this affair stretched the bonds of union between North and South to the breaking point. Through a chain of guilt by association, proslavery partisans identified Republicans with abolitionists and abolitionists with John Brown and slave insurrections. If the Republicans won the presidency in 1860, Southerners believed, the South would have to secede to preserve its peculiar institution. The Republicans won, and seven slave states seceded before the new president ever took the oath of office.

The victorious presidential candidate was not Seward, but Abraham Lincoln, who became perhaps the most photographed, painted, and caricatured president in the nineteenth century. The first crucial decision that Lincoln faced as president was whether to pull Federal troops out of Fort Sumter in response to demands by the newly formed Confederate States of America. In April 1861, Confederate artillery bore on Fort Sumter from almost every point of the compass around Charleston Harbor, commanded by General Pierre G. T. Beauregard. Lincoln refused to withdraw the troops; Confederate president Jefferson Davis ordered the guns to open fire; Beauregard carried out the order; and the war came.

The ensuing four years of conflict resulted in the deaths of almost as many American soldiers, North and South, as all the rest of the wars this country had fought *combined*. Most Americans are familiar with the names of the leading generals on both sides: Beauregard, Robert E. Lee, Thomas J. "Stonewall" Jackson, Braxton Bragg, and James E. B. "Jeb" Stuart

for the Confederacy; Winfield Scott, George B. McClellan, Ulysses S. Grant, William Tecumseh Sherman, George Thomas, Philip H. Sheridan, and George Armstrong Custer for the Union. The photographs and portraits of these commanders, and others, that appear herein make it clear that this war was no frolic.

The cabinet officers and naval commanders portrayed in this volume may be less familiar, but perhaps no less important to the war's outcome—especially Union admiral David Glasgow Farragut, whose order in the Battle of Mobile Bay in 1863, "Damn the torpedoes! Full speed ahead!" has become legendary in the annals of the U.S. Navy. The portraits of women who played significant roles in the war effort are of special interest: the spies Rose O'Neal Greenhow (Confederate) and Pauline Cushman (Union); the reformer Dorothea Dix, who was superintendent of female nurses for the Union; Julia Ward Howe, who wrote the words for "The Battle Hymn of the Republic"; and the tragic Mary Todd Lincoln, who lost one of her sons to typhoid fever during the war and lost her husband to assassination by John Wilkes Booth at the end of it. Photographs, illustrations, paintings, sculptures, and drawings of these and other people and events important in the great struggle that preserved the United States as one nation, abolished slavery, and defined the new contours of America offer to the reader of this book a visual feast to broaden and deepen understanding of that war, which was both America's greatest tragedy and greatest triumph.

JAMES M. MCPHERSON

George Henry Davis Professor
of American History Emeritus, Princeton University

Unless otherwise specified, all images are from the collection of the National Portrait Gallery, Smithsonian Institution. "The Personalities of the Civil War Era" are written by James Barber (JB), Margaret Christman (MC), and Frederick Voss (FV); the author's initials appear after the text.

JAMES G. BARBER has been a historian at the Smithsonian's National Portrait Gallery since 1981, and is the author of nearly a dozen historical monographs, including *Theodore Roosevelt: Icon of the American Century* (1998), *George C. Marshall: Soldier of Peace* (1997), *To the President: Folk Portraits by the People* (1993), and *Andrew Jackson: A Portrait Study* (1991).

MARGARET C. S. CHRISTMAN is a historian at the National Portrait Gallery and the author of several books, including *1846: Portrait of the Nation* (1996), *The Spirit of Party: Hamilton and Jefferson at Odds* (1992), and *The First Federal Congress* (1989).

FREDERICK S. VOSS was at his retirement in 2004 the museum's senior historian and curator of its *Time* collection. A staff member of the National Portrait Gallery for thirty-two years, he is the author of numerous books, including *Women of Our Time: An Album of Twentieth-Century Photographs* (2002), *Picturing Hemingway: A Writer in His Time* (1999), and *Reporting the War: The Journalistic Coverage of World War II* (1994).

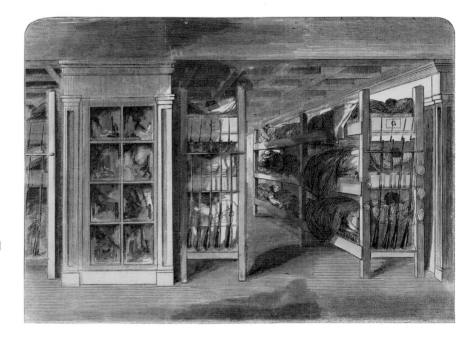

Figure 1. *Sleeping-Bunks of the First Rhode Island Regiment, at the Patent Office, Washington* by an unidentified artist, hand-colored wood engraving, from *Harper's Weekly*, June 1, 1861

Figure 2. Patent Office Building by Bierstadt Brothers, c. 1861

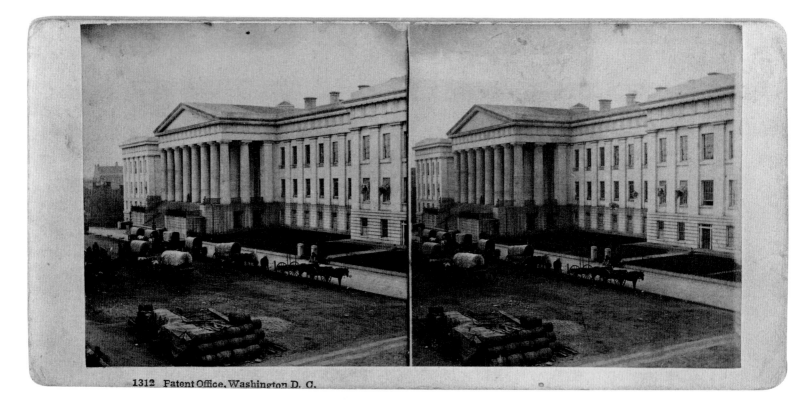

1312 Patent Office. Washington D. C.

Introduction FREDERICK S. VOSS

ONE OF THE GREATEST STRENGTHS IN THE NATIONAL PORTRAIT GALLERY'S collec-
tions is its portraiture relating to the Civil War. That is as it should be because the Civil War
is arguably the most salient event in American history. While so much of this country's early
history can be read as preamble to that traumatic rift in national unity, the memory and
meaning of the war itself has an impact even today. For evidence of that, one need look
only to the South itself, where in recent years controversies have swirled in Columbia, South
Carolina, around the tradition of flying the Confederate battle flag on the grounds of the
state capitol; in Georgia around the adoption of a new state flag that no longer includes the
Confederate battle flag in its design; and in the former Confederate capital at Richmond
around the dedication of an outdoor sculpture of Abraham Lincoln with his
son Tad.

Yet there is a less obvious factor that warrants the Gallery's rich concentration of Civil
War imagery: the museum's physical setting. The National Portrait Gallery is housed in a
building whose rooms and hallways resonate with Civil War history. In the spring of 1861,
when the first shots of the war were fired at Fort Sumter in Charleston harbor, the Gallery
building was home to the U.S. Patent Office, and its exhibit halls, containing case upon case
of patent application models, were a major tourist attraction (fig. 2). But those halls soon
would be commandeered for wartime uses. Within weeks of Fort Sumter, soldiers from
Colonel Ambrose Burnside's First Rhode Island Regiment began settling into makeshift
quarters in the building and sleeping in bunks erected between the model cases (fig. 1).

For two extended periods, portions of the building also served as a hospital for
wounded Union soldiers, and the poet Walt Whitman was one of the civilian volunteers who
went there to minister to their needs (fig. 3). Among the impressions that Whitman carried
away from the experience was how odd it was to see these maimed and battered men—many
in great pain—against a backdrop of Patent Office cases, "crowded with models in miniature
of every kind of utensil, machine, or invention it ever entered into the mind of man to
conceive." He noted, "It was, indeed, a curious scene, especially at night when lit up. The
glass cases, the beds, the forms lying there, the gallery above, and the marble pavement
underfoot."[1] This macabre juxtaposition of human creativity and destructiveness later gave
way to a more positive mood when the building became the site of a successful fair that
raised money for the families of volunteer troops from the District of Columbia. Then, on
the evening of March 6, 1865, President Abraham Lincoln—with the Union victory nearly a
fait accompli—could be seen at the Patent Office moving among guests at his second

Figure 3. Walt Whitman by Mathew Brady (c. 1823–1896), albumen silver print, c. 1867. Gift of Mr. and Mrs. Charles Feinberg

inaugural ball. Remarking on this festive scene, in contrast to what he had witnessed in these same Patent Office halls not long before, Whitman once again could not resist the ironic note, observing: "Tonight, beautiful women, perfumes, the violins' sweetness, the polka and the waltz; then the amputation, the blue face, the groan, the glassy eye of the dying" (fig. 4).[2]

A revealing quality of the Gallery's Civil War collections is how certain portraits can illuminate the lives of their subjects. Among the most engaging images in that regard are the likenesses of three prominent figures in the pre-war abolitionist movement—William Lloyd Garrison, John Brown, and Harriet Beecher Stowe.

Garrison's likeness, painted by Nathaniel Jocelyn, was actually the occasion for a bit of high drama involving lookouts and narrow escapes (see page 36). While Garrison posed for Jocelyn in New Haven, Connecticut, in the spring of 1833, the state of Georgia—outraged by his outspoken attacks on slavery—was offering a $5,000 reward for his capture. At the same time, Garrison's strong support of a new school for African American girls in Connecticut had deeply alienated many local residents. Consequently, as he sat for his portrait, friends stood by, ready to fend off a local conspiracy to claim Georgia's handsome bounty. Suspected conspiracies sometimes are more imagined than real, but in this instance the threat was genuine. No sooner was the painting completed than Garrison narrowly missed being legally detained, with an eye to being shipped off to Georgia.

Another salient likeness is of John Brown, that most radical of abolitionists, who would

ultimately die at the gallows in 1859 for trying to foment a slave rebellion in Virginia (see page 56). In this photographic image taken by the African American daguerreotypist Augustus Washington, Brown's fiery gaze and militantly stiff pose characterizes the extremism that impelled him to that end. Moreover, all evidence suggests that the image documents a pivotal moment in his radicalization, which gave birth in about 1847 to his earliest thoughts of plotting an armed clandestine attack against slavery in the South. In retrospect, Brown seems to be conveying his desperation and commitment to violence.

Brown's daguerreotype dates from a time when he was still an unrecognized factor in the antislavery movement. By contrast, Harriet Beecher Stowe's portrait by Alanson Fisher is celebratory and marks her greatest abolitionist triumph, the publication in 1852 of her best-selling fictional exposé of the evils of slavery, *Uncle Tom's Cabin* (see page 52). Painted early the following year to hang in the New York theater where one of the first dramatized versions of her novel was staged, the likeness is on one level a reminder of Stowe's naïveté about the financial implications of her success. She would graciously acquiesce to the theater owner's request that she sit for this portrait, but it apparently never crossed her

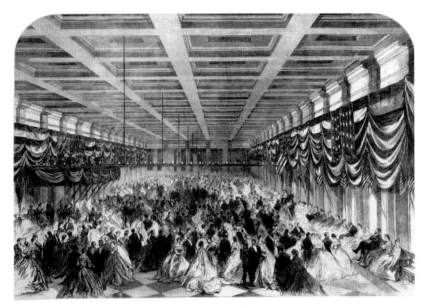

Figure 4. *Ball in Honour of President Lincoln in the Great Hall of the Patent Office at Washington* by an unidentified artist, engraving, 1865

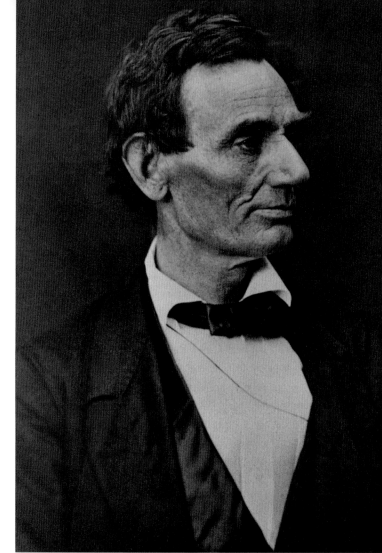

Figure 5. Abraham Lincoln by Alexander Hesler (lifedates unknown), gelatin silver print, 1956 print from 1860 negative

mind to make any effort to reap royalties from the play that she had spawned and that would always be in production somewhere in America until well into the twentieth century. But perhaps the most interesting way to consider this portrait, with its idyllic interpretation of her features, is in relation to Stowe's own inventory of her physical traits in a letter to one of her legions of new admirers. "So you want to know something about what sort of a woman I am!" she wrote in February 1853. "To begin, then, I am a little bit of woman—somewhat more than forty, about as thin and dry as a pinch of snuff; never very much to look at in my best days, and looking like a used-up article now."[3]

Predictably, the single most represented figure in the Gallery's Civil War collections is Abraham Lincoln. Among the roughly one hundred paintings, sculptures, prints, photographs, and drawings of him, one of the most interesting images is found among those produced during his presidential campaign of 1860. An unfortunate circumstance for Lincoln's supporters was that their candidate was not a handsome man by any stretch of the imagination. His rawboned features were coarse, his thick hair was often untidy, and no one would describe his long, lank figure as graceful. Making matters worse, many of the early images of "Honest Abe" circulated to the electorate were based on none-too-flattering photographs (fig. 5). Not surprisingly, his opponents found amusement in the situation, and one song of the campaign ran in part:

> *Tell us of his fight with Douglas—*
> *How his spirit never quails;*
> *Tell us of his manly bearing,*
> *Of his skill in splitting rails.*

Any lie you tell we'll swallow—
Swallow any kind of mixture;
But oh! don't, we beg and pray you—
Don't, for God's sake, show his picture.[4]

Yet a redemptive effort was not long in coming, and when a Pennsylvania judge commissioned artist John Henry Brown to visit Lincoln at his home in Springfield, Illinois, to produce a likeness suitable for engraving, he instructed the artist to come back with a handsome image, "whether the original would justify it or not."[5] Brown followed his instructions, producing a likeness that both looked like Lincoln and made him look good (see page 68). But top prize in candidate-beautification should go to the collaborative efforts of Boston printmaker Joseph Baker and artist Charles Barry, who arrived in Springfield to take Lincoln's likeness in spring of 1860. The Barry-Baker partnership ultimately yielded a lithograph image that, like Brown's likeness, was unmistakably Lincoln. And although all his homely, raw-boned features were very much present (fig. 6), they had been softened in a way that was almost poetic and that transformed Lincoln into a kind of Byronic frontier hero. "Everybody laughs at B's [the Barry-Baker] lith[ograph]," reported another artist who was in Springfield seeking to draw Lincoln.[6] Maybe the comment was the resentment of a would-be rival to Barry and Baker.

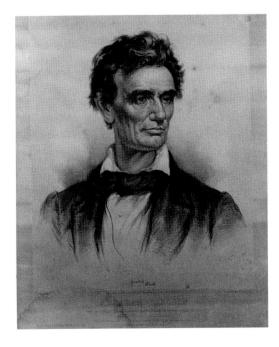

Figure 6. Abraham Lincoln by Joseph Edward Baker (1835–1914), after Charles A. Barry, J. H. Bufford Lithography Company, lithograph on rice paper

But more probably there was truth to the remark, for it is doubtful that any of Lincoln's Springfield neighbors had ever seen him look quite so dashing.

A particularly rich segment of the Civil War's visual record is photography. By any measure, some of the most jolting testaments to the conflict's dreadful human toll are the post-battle pictures by photographers such as Mathew Brady, Timothy O'Sullivan, and Alexander Gardner, showing the mangled corpses of soldiers strewn across the fields at Antietam, Gettysburg, and Spotsylvania. Indeed, when one views some of these pictures, the war takes on a reality that seems almost as grimly palpable today as it was then.

Still, most Civil War photography was focused on the living and consisted of posed portraits—single and grouped—of enlisted men, officers, and civilian leaders. Everybody involved in the Civil War seemed to be drawn to the photographer's lens, and it was all the rage to have small carte-de-visite images of oneself made for loved ones and friends. Nowhere was the market for these pictures better than among the enlisted man. As one observer noted, "The young Volunteer rushes off at once to the studio when he puts on his uniform, and the soldier of a year's campaign sends home his likeness that the absent ones may see what changes have been produced in him by war's alarms." The war, in short, brought boom times to the "mighty tribe of cameraists" who, by one rather macabre estimate of the day, seemed to be doing as well as the makers of coffins.[7]

One remarkable surviving testament to these good times for photographers is the Gallery's Frederick Hill Meserve collection of original collodion glass-plate negatives from Mathew Brady's New York and Washington studios. Included in that trove of more than five thousand images are likenesses of the many Civil War figures who paraded before Brady's cameras between 1861 and 1865—ranging from luminaries such as Lincoln and General Ulysses S. Grant to hosts of other lesser lights whose part in the conflict has long since been forgotten. In terms of backdrop and composition, there is not a great deal of variation in the likenesses, and most of them share a straightforward compositional simplicity. But that simplicity is what gives many of these pictures their individual character, placing the presence of the subject in high relief.

Take, for example, Brady's portrayal of General Philip Sheridan, in his porkpie hat, seated against a stark, light background (see page 292). The impressiveness of this short, solid Union officer is immediately apparent, and it is easy to understand how the sheer force of his determination was capable on occasion of turning chaotic retreat into major victory. Then there is the image of Pauline Cushman, a sometime actress and spy for the Union

cause (see page 192), dressed in an army major's uniform. Although she proved to be a failure as a spy, it was not for want of convention-defying boldness.

In most aspects of the Civil War, the South invariably had fewer resources than the North at its disposal, and that included the art of portraiture, which in every medium was in short supply, and even rare by Yankee standards. The South was predominantly rural, and unlike the North, it did not have enough sufficiently large urban centers whose dense populations fostered the growth of printmaking establishments, illustrated newspapers, photography studios, and the community of artisans and artists needed to work in them. Nor, as the war went on and the South began to feel the effects of the Union blockade, did the Confederacy have ready access to the supplies, skilled workers, and equipment required for carrying on any of these picture-making enterprises. And when it did muster some of these resources, the result was quite often of a poor quality. One of the more amusing manifestations of this shortfall was the Confederacy's paper currency compared with Northern attempts at counterfeiting it. It was said that the more superior the images on a bill, the more likely it was that the bill was a Yankee counterfeit.

To some extent, the scarcity of Confederate-produced portraiture of the South's wartime luminaries was made up for by Yankee enterprise, which might have reinforced the Southern conviction that profit-minded Northerners would do anything for a dollar— including hawking images of their foes. Thanks to that enterprise, many of the Confederate likenesses in the Portrait Gallery's collections originated above the Mason-Dixon line. But crafting likenesses at a distance had its hazards, and sometimes these Confederate images from Yankeedom were not entirely au courant.

Consider, for example, the carte-de-visite photograph of General P. G. T. Beauregard, who orchestrated the Confederate assault on Fort Sumter in April 1861 and then went on to lead Southern forces to victory at the First Battle of Manassas (see page 109). The picture, copyrighted by the New York photographer Charles Fredricks in 1862, was a good likeness, but it had one problem: it was fully a year out of date on Beauregard's loyalties, for it showed him dressed not as a Confederate general, but as a U.S. colonel of engineers, the temporary rank he assumed briefly in January 1861, in his capacity as superintendent of the U.S. Military Academy at West Point.

Still another Northern image that did not get things quite right was a lithograph, *Jefferson Davis and His Generals*, published early in the war by the Goupil Lithography Company in New York (fig. 7). In this scene, the uniforms are not accurate reflections of what

Confederate officers were wearing at the moment, and Robert E. Lee's portrayal in it was based on a photograph that was more than ten years out of date. But Goupil finally got the visual details under control, and when it recycled the compositional elements of *Jefferson Davis and His Generals* to create *Robert E. Lee and His Generals* in about 1865, the authenticity of the faces and the uniforms was noticeably improved (fig. 8).

In its print collections, the National Portrait Gallery preserves two noteworthy examples that could be dubbed the Alpha and Omega of Civil War satire. The first recalls the warning to President-elect Lincoln that he risked assassination if he did not take special precautions in traveling by train through Baltimore in February 1861—a hotbed of pro-Confederate sentiment—on his way to his inauguration in Washington. Taking the warning to heart, Lincoln decided to travel through Baltimore unannounced and under cover of night, and he regretted it ever after. When the story got out, the anti-Lincoln press had a field day, characterizing his caution as cowardice unworthy of a president. The incident was also grist for the mill of Baltimore's ardently pro-South cartoonist, Adalbert J. Volck. Taking his cue from the rumor that Lincoln had gone through the city disguised as a

Figure 7. *Jefferson Davis and His Generals* by Goupil Lithography Company (active in America 1840s–60s), after photographs, lithograph with tintstone, c. 1861

Left to right: Leonidas Polk, John B. Magruder, Thomas J. Simmons, George N. Hollins, Benjamin McCulloch, Jefferson Davis, Robert E. Lee, P. G. T. Beauregard, Sterling Price, Joseph E. Johnston, William J. Hardee

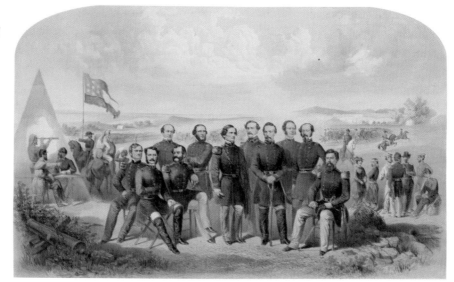

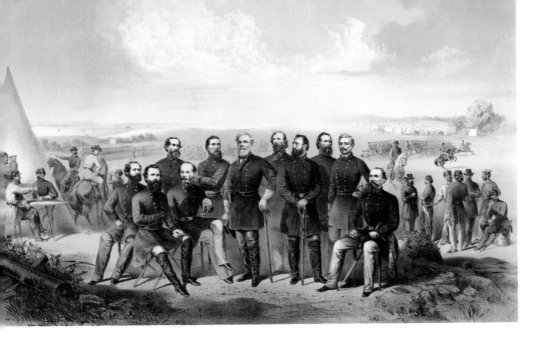

Figure 8. *Robert E. Lee and His Generals* by Goupil Lithography Company (active in America 1840s–1860s), after photographs, lithograph with tintstone, c. 1865

Left to right: Wade Hampton, J. E. B. Stuart, Jubal A. Early, Joseph E. Johnston, John Bell Hood, Robert E. Lee, Ambrose Powell Hill, Thomas J. ("Stonewall") Jackson, James Longstreet, P. G. T. Beauregard, John H. Morgan

Scotsman, Volck depicted Lincoln in a Scottish tam and fearfully peering out from behind a freight car door at nothing more menacing than a stray cat (fig. 9).

If it was hard for Lincoln to live down this incident, it was also hard for Confederate president Jefferson Davis to live down the alleged final scene of his exit from office in the wake of the Confederate surrender at Appomattox in April 1865. Arrested by Union soldiers in Georgia in May, Davis had, in the midst of a futile, last-ditch effort to elude capture, mistakenly donned his wife's raincoat, and she had hastily draped her shawl around his head and shoulders against the morning cold. Not surprisingly, the North regaled at this sartorial turn of events, which predictably grew more exaggerated with the telling. Ultimately, the story reported in the North was that Davis had tried to evade capture by intentionally donning a female disguise. Here was a cartoonist's dream if ever there was one! Soon the printmakers were churning out images showing Davis at the point of capture ignominiously decked out in bonnet and skirts. In the Portrait Gallery's version (fig. 10), while Davis utters protests indicating that he is but a defenseless woman, a pursuing Union soldier shouts, "It's no use trying that shift, Jeff, we see your boots!"

In spite of the emerging technological role the camera played in creating the pictorial record of the Civil War, the most dramatic and event-oriented images found in the Gallery's collections are not photographs but paintings and prints. This is because photography was still greatly in a developmental state of infancy. Hampered by the bulkiness and technical limitations of their equipment, photographers did not have the capacity to record

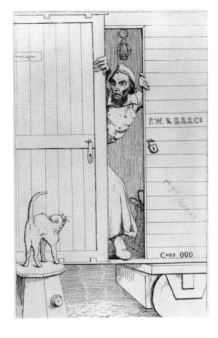

Figure 9. *Passage Through Baltimore* by Adalbert J. Volck (1828–1912), etching from *Sketches from the Civil War in North America*, 1863

Figure 10. *The Last Ditch of the Chivalry, or a President in Petticoats* by Currier and Ives Lithography Company (active 1857–1907), lithograph, 1865

events as they happened—even those of the more static sort. Thus, making a photograph of Lincoln as he blotted his signature on the historic Emancipation Proclamation at the White House on New Year's Day 1863 would have been staged at best, and any attempt to photograph Pickett's famous charge at the Battle of Gettysburg would have been altogether impossible. But what the camera could never hope to do, the more traditional brush and pencil excelled at with all manner and degree of interpretation, imagination, and success. Admittedly these pictures were often completed well after the fact, and fabricated elements inevitably crept into the final product. But they were the closest thing to actual events that nineteenth-century picture-making could provide. For example, the engraving *First Reading of the Emancipation Proclamation* records the moment in July 1862 when Lincoln presented a draft of the proclamation to his cabinet for discussion (see page 136). In creating the original oil painting of this tableau, the artist, Francis B. Carpenter, was permitted to set up his studio in the White House in 1864 and to carefully study the room where the cabinet met. He was also privy to Lincoln's own recollections of this watershed event, and although compositional concerns prompted Carpenter to take liberties in his picture with the actual placement of cabinet members at the meeting, the picture nevertheless offers an instructive measure of palpability to one of the Civil War's historic turning points.

By far, the Portrait Gallery's most impressive piece of Civil War art—at least in terms of size—also falls into the in situ category. But it is by no means the re-creation of a historic event. Measuring twelve by sixteen feet, the picture shows General Ulysses S. Grant riding under the Union banner, flanked by twenty-six generals who served under his command. This was an assemblage that never took place. Even so, *Grant and His Generals* has its own claim to authenticity: its creator, Ole Peter Hansen Balling, spent many weeks in army encampments making preliminary sketches of generals and their horses, and Grant himself created opportunities for the artist to draw him as he rode to and from camp in the company of his staff officers.

The picture's authenticity, however, goes beyond the lifelike representations garnered from all of Balling's splendid sketching opportunities. Above all, the painting is a celebration marking Union victory. As such, it resonates with the momentary ethos of a crucial moment in America's past, and in doing so it exemplifies one of the intangible qualities of the Portrait Gallery's Civil War collections—its ability to stir the historical imagination.

MARCH 6, 1820: President James Monroe signs the Missouri Compromise, which admits Maine as a free state and Missouri as a slave state, and excludes slavery from any future Louisiana Purchase territory north of latitude 36° 30'.

JUNE 1822: Former slave Denmark Vesey's elaborate conspiracy for a slave rebellion is foiled when he is informed upon, yet the specter of Vesey's plot arouses fear in the minds of Southern slave owners.

JANUARY 1, 1831: William Lloyd Garrison begins publication of the small but influential abolitionist newspaper *The Liberator.*

AUGUST 22: Nat Turner begins his slave rebellion in Virginia.

MAY 26, 1836: The House of Representatives passes a resolution to prevent all petitions regarding slavery from being debated; this gag rule continues through 1844.

JUNE 1845: Frederick Douglass's *Narrative of the Life of Frederick Douglass, an American Slave,* is published.

JANUARY 29, 1850: Henry Clay of Kentucky offers a series of resolutions, collectively known as the Compromise of 1850, to the Senate in an attempt to preserve a Union increasingly divided by slavery.

SEPTEMBER: The Compromise of 1850 passes into law, including the Fugitive Slave Act, which makes the Federal government responsible for the apprehension of runaway slaves.

MARCH 20, 1852: Harriet Beecher Stowe's *Uncle Tom's Cabin* is published as a book and sells 300,000 copies within the first year.

MAY 1854: The Kansas-Nebraska Act is signed into law by President Franklin Pierce, opening the territory north of the Missouri line to slavery.

1854–58: In the wake of the Kansas-Nebraska Act, the Kansas frontier witnesses a series of bloody and murderous encounters between antislavery migrants and pro-slavery border ruffians from Missouri for control of the future state.

MARCH 6, 1857: Chief Justice Roger B. Taney issues his polemical ruling in the *Dred Scott* case, in which he declares that slaves are property, not people, and that antislavery laws are thus unconstitutional, as they deprive people of property.

AUGUST 21–OCTOBER 15, 1858: In his campaign to unseat Senator Stephen A. Douglas of Illinois, Abraham Lincoln challenges Douglas to a series of debates; Lincoln will lose the election, but will gain national attention for his arguments against the expansion of slavery.

OCTOBER 16–18, 1859: John Brown, in an attempt to amass arms for a slave insurrection, attacks the federal arsenal at Harpers Ferry, [West] Virginia.

DECEMBER 2: Brown is hanged for murder and treason at Charles Town, [West] Virginia.

NOVEMBER 6, 1860: Abraham Lincoln is elected president, with Hannibal Hamlin as his vice president.

DECEMBER 20: As a consequence of Lincoln's election, a special convention of the South Carolina legislature votes to secede from the Union.

JANUARY 9, 1861: *Star of the West*, an unarmed merchant vessel secretly carrying Federal troops and supplies to Fort Sumter, is fired upon by South Carolina artillery at the entrance to Charleston harbor.

JANUARY 9–MARCH 2: Mississippi, Florida, Alabama, Georgia, Louisiana, and Texas follow South Carolina's lead and secede from the Union.

JANUARY 29: Kansas is admitted as a state with a constitution prohibiting slavery.

FEBRUARY: Delegates from six seceded states meet in Montgomery, Alabama, to form a government and elect Jefferson Davis president of the Confederate States of America.

MARCH 4: Abraham Lincoln is inaugurated as the sixteenth president of the United States.

APRIL 12–13: Fort Sumter is bombarded and surrenders to South Carolina troops under P. G. T. Beauregard.

APRIL 15: Lincoln declares a state of insurrection and calls for 75,000 volunteers to enlist for three months of service.

APRIL 17–MAY 23: Virginia, Arkansas, Tennessee, and North Carolina secede from the Union.

APRIL 19: Lincoln orders a blockade of all Confederate ports.

MAY 24: Union troops cross the Potomac River from Washington and capture Alexandria, Virginia, and vicinity. Colonel Elmer E. Ellsworth is killed by a local innkeeper and is the first officer to die in the war. He becomes a martyr for the North.

MAY 29: Richmond becomes the capital of the Confederacy.

JULY 21: Confederate forces win a victory at the First Battle of Manassas.

NOVEMBER 1: George B. McClellan, thirty-four, replaces the aging Winfield Scott as general-in-chief of the Union armies.

NOVEMBER 8: The Union navy seizes Confederate commissioners to Great Britain and France—James A. Mason and John Slidell—from the British steamer *Trent*, inflaming tensions between the United States and Great Britain.

NOVEMBER: Julia Ward Howe, inspired after seeing a review of General McClellan's army in the Virginia countryside near Washington, composes the lyrics to "The Battle Hymn of the Republic." They are published in the *Atlantic Monthly* in February 1862.

MARCH 9, 1862: The ironclads *Monitor* and *Merrimack* (renamed CSS *Virginia* after the Confederates raised it from the Norfolk Navy Yard) battle to a draw at Hampton Roads, Virginia, demonstrating the superior potential of vessels made of steel.

APRIL 4: On the peninsula southeast of Richmond, McClellan leads the Army of the Potomac toward Yorktown, Virginia, beginning the Peninsular Campaign.

APRIL 6–7: Union General Ulysses S. Grant prevails at the Battle of Shiloh in Tennessee, but not without enormous losses.

APRIL 16: Conscription is adopted in the Confederacy.

APRIL 25: Federal fleet commander David G. Farragut captures New Orleans.

MAY 8: Stonewall Jackson's Shenandoah Valley campaign begins successfully with a victory at the Battle of McDowell in Virginia.

MAY 31–JUNE 1: During the Battle of Seven Pines in Virginia, Robert E. Lee takes over command of the Confederate army from the wounded Joseph E. Johnston.

JUNE 25–JULY 1: Lee forces McClellan's army to retreat, ending the threat to Richmond in the Seven Days' campaign.

AUGUST 20: Horace Greeley of the *New York Tribune* publishes "The Prayer of Twenty Millions," a plea for Lincoln to liberate slaves in the Union.

AUGUST 29–30: The South is again victorious at the Second Battle of Manassas.

SEPTEMBER 17: The Battle of Antietam, Maryland, exacts heavy losses on both sides.

DECEMBER 13: Lee wins the Battle of Fredericksburg, Virginia, decisively.

JANUARY 1, 1863: Lincoln issues the Emancipation Proclamation, which declares that slaves in the seceded states are now free.

MARCH 3: President Lincoln signs a federal draft act.

APRIL 7: In a test of ironclad vessels against land fortifications, Union admiral Samuel F. Du Pont's fleet fails to penetrate the harbor defenses of Charleston.

MAY 1–4: Lee hands the Army of the Potomac another defeat at the Battle of Chancellorsville.

JULY 1–3: The Battle of Gettysburg is fought in Pennsylvania. General George G. Meade compromises his victory by allowing Lee to retreat South and recross the Potomac.

JULY 4: After a long siege, Confederates surrender Vicksburg to Ulysses S. Grant, thus securing the Mississippi River for the Union.

JULY 13–15: Violent riots erupt in New York City in protest against the draft.

SEPTEMBER 19–20: The Battle of Chickamauga in Georgia, where General George H. Thomas earned the title of "The Rock," ends in a tactical victory for the Confederates.

NOVEMBER 19: Lincoln delivers his Gettysburg Address, in which he reiterates the nation's fundamental principle that all men are created equal.

NOVEMBER 23–25: After three days of battle, the Union victory at Chattanooga, Tennessee, opens the way for Union advancement into the heart of the Confederacy.

MARCH 9–10, 1864: Ulysses S. Grant is commissioned a lieutenant general and is given command of the Armies of the United States.

MAY 5–6: The Battle of the Wilderness in Virginia is the first of a bloody series of month-long engagements between Grant and Lee.

MAY 10–12: Battles at Spotsylvania Court House and Yellow Tavern impede Grant's drive for Richmond.

JUNE 1–3: The Battle of Cold Harbor results in heavy Union casualties.

JUNE 19: The USS *Kearsarge* sinks the CSS *Alabama* off Cherbourg, France, where the Confederate raider was bound for refitting.

JUNE 28: Lincoln signs a bill repealing the Fugitive Slave Laws.

AUGUST 5: Union admiral David G. Farragut wins the Battle of Mobile Bay.

SEPTEMBER 2: William T. Sherman captures Atlanta.

OCTOBER 19: A Union victory at Cedar Creek ends the Confederate threat in the Shenandoah Valley.

NOVEMBER 8: Lincoln is reelected president, with Andrew Johnson as vice president.

NOVEMBER 16: Sherman leaves Atlanta and begins his "march to the sea," in an attempt to demoralize the South and hasten surrender.

DECEMBER 21: Savannah falls to Sherman's army without resistance.

JANUARY 31, 1865: Congress passes the Thirteenth Amendment, which abolishes slavery throughout the United States.

FEBRUARY 17: Columbia, South Carolina, is destroyed by fire, presumably set by Sherman's troops.

MARCH 4: Lincoln is inaugurated as president for a second term.

MARCH 29: The Appomattox campaign begins, with Grant's move against Lee's defenses at Petersburg, Virginia.

APRIL 2: Petersburg falls, and the Confederate government evacuates its capital, Richmond.

APRIL 3: Union troops occupy Richmond.

APRIL 9: Robert E. Lee surrenders the Army of Northern Virginia to Grant at Appomattox.

APRIL 14: John Wilkes Booth shoots President Lincoln at Ford's Theatre; Secretary of State William H. Seward is stabbed and wounded in an assassination attempt inside his Washington home.

APRIL 15: Lincoln dies, and Andrew Johnson is inaugurated as president.

APRIL 26: Joseph E. Johnston surrenders to William T. Sherman in North Carolina; John Wilkes Booth is captured in a barn in Virginia and is mortally wounded.

MAY 10: Jefferson Davis is captured and taken prisoner near Irwinville, Georgia.

MAY 26: In New Orleans, terms of surrender are offered to General E. Kirby Smith, commander of the Trans-Mississippi Department. His acceptance on June 2 formally ends Confederate resistance.

JUNE 30: All eight conspirators are convicted of the assassination of President Lincoln; four are sentenced to death.

1865–77: The South undergoes a period of reconstruction to assure its compliance with federal laws, largely in the realm of civil rights for blacks.

FEBRUARY 22, 1868: President Andrew Johnson is impeached by the House of Representatives for allegedly violating the Tenure of Office Act in removing Secretary of War Edwin M. Stanton from office. On May 16, the Senate acquits Johnson by one vote.

JULY 28: The Fourteenth Amendment, guaranteeing citizenship to all persons born in the United States, is ratified.

MARCH 30, 1870: The Fifteenth Amendment, guaranteeing the right to vote to all male citizens, regardless of race or color, is ratified.

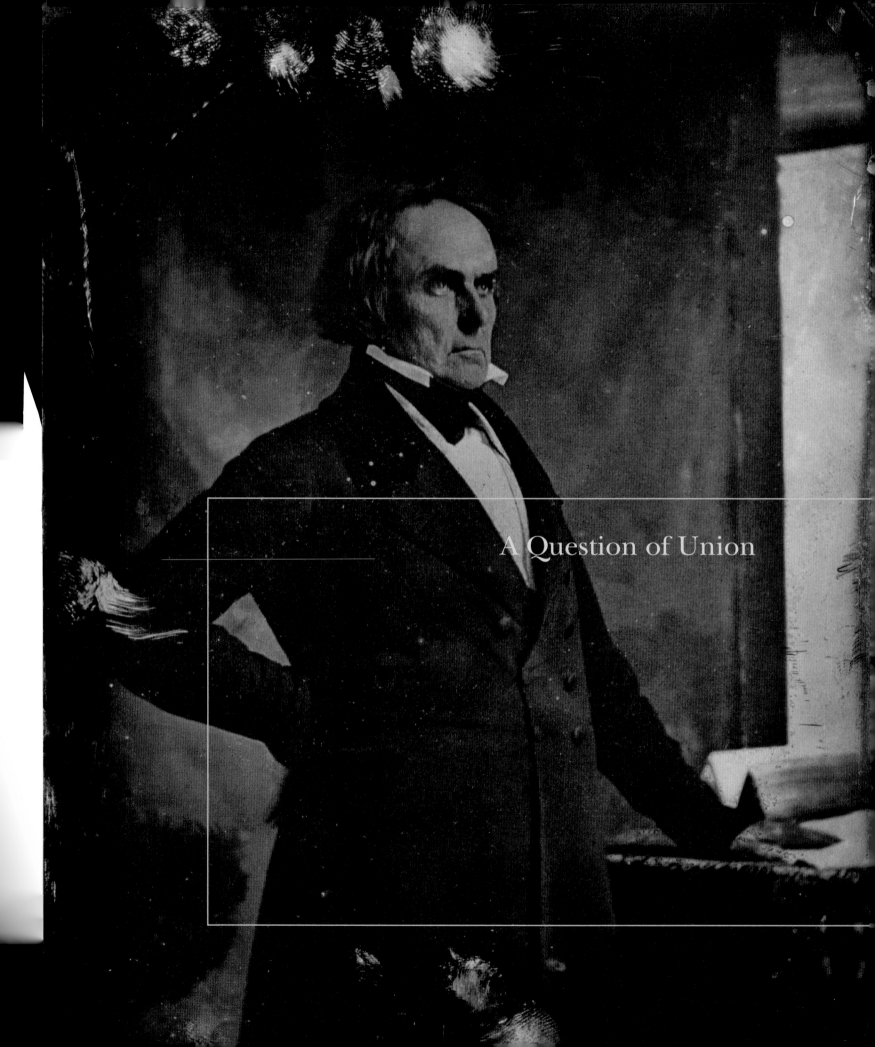

A Question of Union

BEFORE THE CIVIL WAR, and decades before the United States became one nation irrevocably united by technology, commercialism, and national entitlements, there existed a burgeoning new America in which the concept of oneness, or union, was mostly an ideal, as opposed to an established way of living. Throughout the first half of the nineteenth century, there emerged a developing industrial North, which had no commercial need for the institution of slavery. There was also an agricultural South, which balanced a large segment of its economy on the backs of enslaved men, women, and children. Moreover, there was a seemingly boundless West, which promised apparently infinite opportunities to any free American who would take the risks that went with inhabiting the ever-retreating frontier.

For better or worse, two of the threads running through antebellum America were the notion of union and the reality of slavery. In the North, Americans insisted on union above all else; in the South, Americans insisted on slavery above all else; and in the great American West, pioneers and settlers were left to choose between the two.

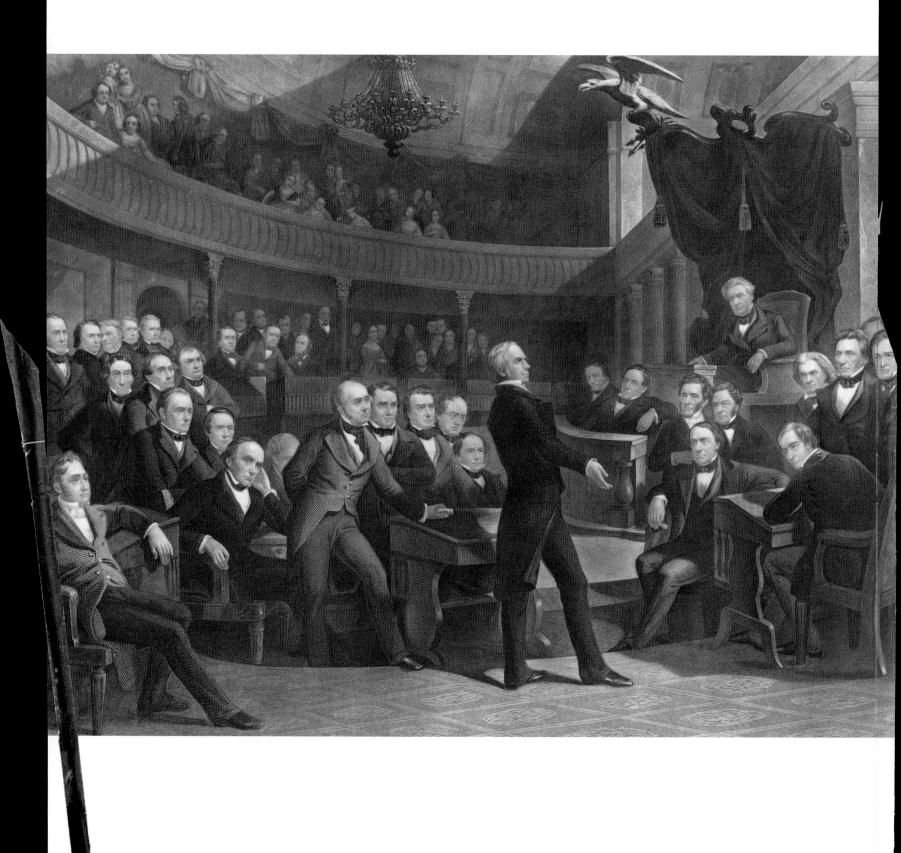

THE ENGRAVING THE UNITED STATES SENATE, A.D. 1850, advertised its Philadelphia publisher, "far transcends anything hitherto produced in this country, as the period chosen for illustration surpasses, in interest, any since the memorable July of 1776."[8] Under way in Congress was the eight-month battle over whether the vast territory acquired in the wake of the Mexican War should be open to slavery. Senator Henry Clay of Kentucky, who thirty years earlier had fathered the compromise that confined slavery below Missouri's southern border, once more stepped to center stage (as the artist here depicts him) to declare, "I have witnessed many periods of great anxiety, of peril, and of danger even to the country; but I have never before arisen to address an assembly so oppressed, so appalled, so anxious."[9] Clay put forth a series of proposals providing for the admission of California as a free state, the organization of territorial governments for New Mexico and Utah without restrictions on slavery, the abolition of the slave trade in the District of Columbia, and, to appease the South, a stringent Fugitive Slave Act.

Senator Daniel Webster of Massachusetts (seated, with his hand to his head) took the floor on March 7. In the speech that would damn him forever in abolitionist circles, Webster supported the compromise with its fugitive slave provision, "I speak to-day for the preservation of the Union," said Webster.[10]

The third of the Senate's great triumvirate, John C. Calhoun of South Carolina (seen standing third from right), was in fact on the point of death, so another read his speech. Calhoun insisted that any restrictions on the spread of slavery in the territories would result in "destroying irretrievably the equilibrium between the two sections." He pronounced that if the Union could not be saved, he would cast his lot with the South, which "I sincerely believe has justice and the Constitution on its side."[11]

Senator Stephen A. Douglas of Illinois (the middle head in the group immediately behind Clay), who steered the package of five separate bills (collectively called the Compromise of 1850) through the Senate, was confident that the crisis had been averted. "The Union will not be put in peril; California will be admitted; governments for the territories must be established; and thus the controversy will end, and I trust forever."[12]

By the time the engraving was finished in 1855, Clay, Calhoun, and Webster were all dead; the North was in an uproar over the Fugitive Slave Act; and Douglas's plan to let popular sovereignty decide the question of slavery in the territories had once again unleashed sectional furies.

MC

THE UNITED STATES SENATE
By Robert Whitechurch
(1814–c. 1880), engraving,
1855

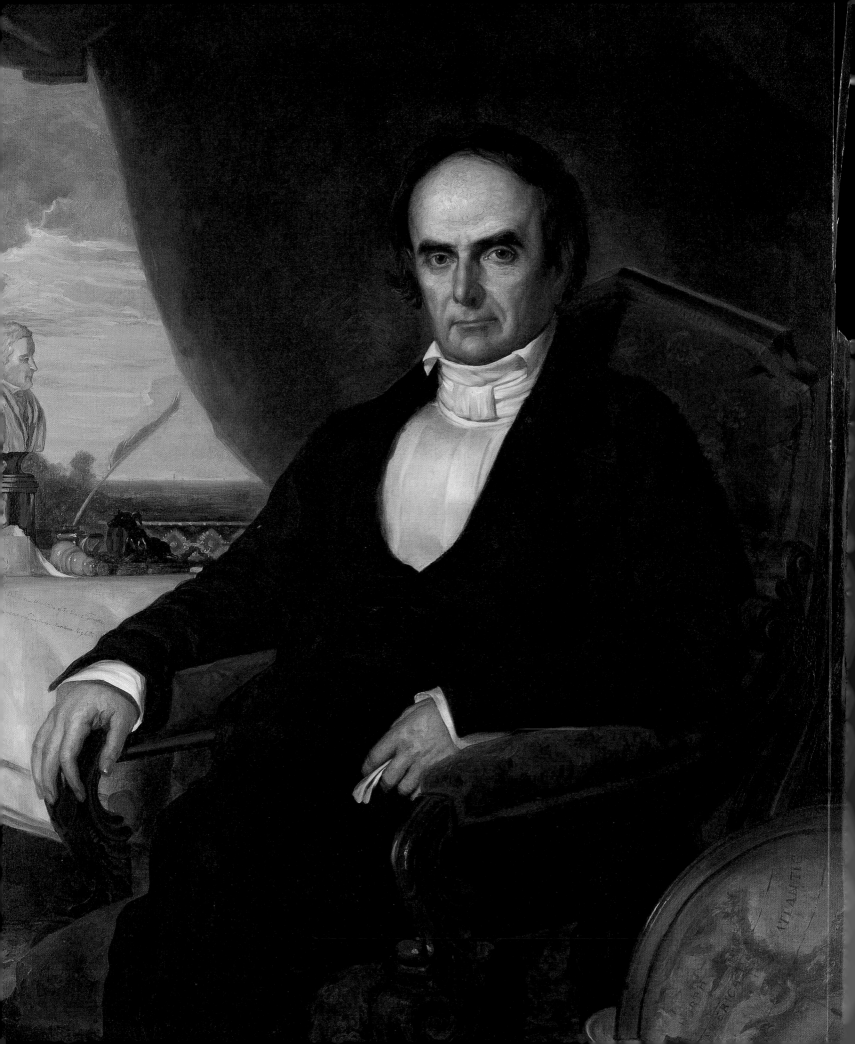

THE SOURCES OF NEW ENGLANDER DANIEL WEBSTER'S FAME WERE MANY. A secretary of state under two presidents and for years a power in the Senate, he was an immensely able courtroom lawyer who figured in many of the most important Supreme Court cases of his day. He was also widely considered to be the greatest orator of his time; to have heard the "Godlike" Webster speak at a patriotic commemoration was a memory that hundreds of his contemporaries never forgot. Finally, in the mounting sectional crisis leading to the Civil War, he was easily among the most compelling defenders of the inviolability of the Union against John C. Calhoun's theories of states' rights and nullification.

Webster entered into the debate over states' rights in January 1830, when he shifted a Senate exchange over public land policy with Calhoun's ideological soul mate, South Carolina Senator Robert Hayne, into a full-blown discourse on the constitutional nature of the Union. Through much of the proceedings, Hayne more than held his own in defending the states'-rights position. In fact, as the time neared for Webster to make his final rejoinder, his friends worried that great as his powers of persuasion were, he could not defeat Hayne's arguments. Their concerns proved groundless. Speaking out "like Vulcan . . . forging thoughts for the Gods" in a Senate chamber filled to overflowing, Webster held his listeners enraptured with his impassioned arguments on behalf of national unity. By the time he uttered his final words, "Liberty *and* Union, now and for ever, one and inseparable!" the entire chamber seemed mesmerized, and it was several moments before anyone dared to break the spell by speaking.[13] From that moment on, Webster was for many contemporaries an emblem of fixed national unity. As the Civil War approached, the South invoked Calhoun's states'-rights theories to justify secession, and Webster's assertions regarding the Union's inviolability formed much of the rationale for opposing it.

Webster's immense popularity, especially in his native New England, and his impressive Jovian bearing contributed to a steady demand through much of his career for his portrait. The likeness here was painted early in 1846 by George P. A. Healy, who was working on yet another portrait of him for the gallery of American statesmen being assembled for Versailles by France's King Louis-Philippe. The commission came from New York City's Hone Club, a group of prosperous gentlemen who shared Webster's allegiance to the Whig Party and at whose gatherings he was a frequently honored guest. Healy filled the picture with objects offering a shorthand summary of his subject's tastes and accomplishments. While, for example, the statuette of a whippet—a dog well suited for rabbit-chasing—denoted Webster's love of hunting, the barely visible phrases inscribed on the

DANIEL WEBSTER
By George P. A. Healy
(1813–1894), oil on
canvas, 1846

sheaf of papers beside him recalled his recent tenure as secretary of state under President John Tyler.

At about the time of the sittings for the Hone Club likeness, Healy began contemplating a far grander picture of Webster, a huge tableau depicting him in a packed Senate delivering his celebrated reply to Hayne. That picture was completed in 1851, and in the following year, the city of Boston, where Webster kept a residence for most of his adult life, purchased it for Faneuil Hall, where it hangs today.

FV

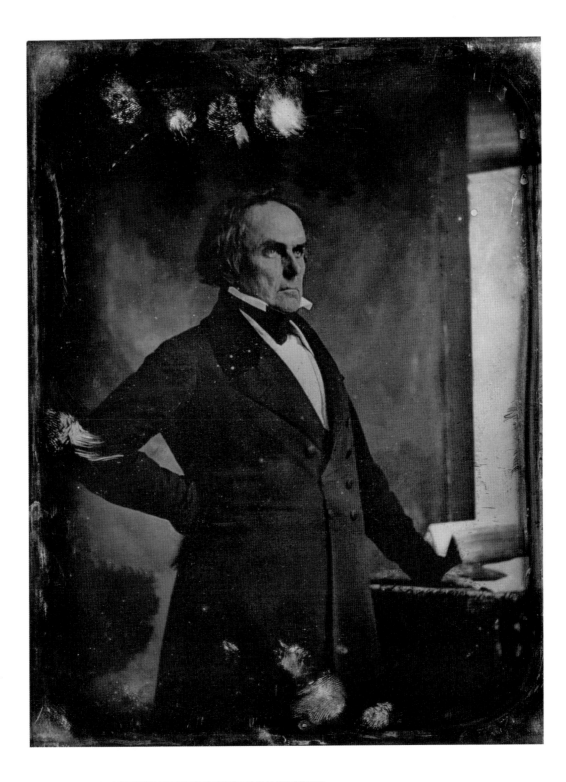

Daniel Webster by Southworth & Hawes (active 1844–61),
daguerreotype, c. 1846

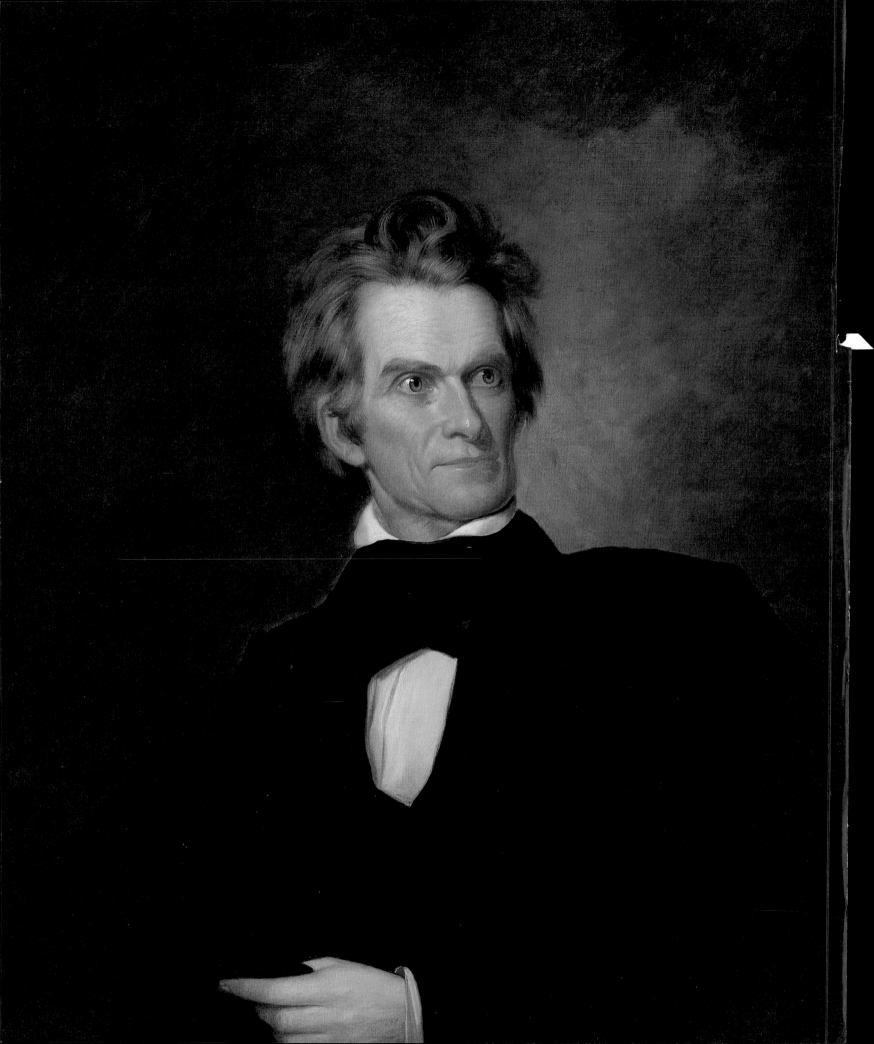

HIS CONTEMPORARIES NUMBERED JOHN C. CALHOUN among America's great triumvirate of statesmen, along with Henry Clay and Daniel Webster. But membership in this elite trio did not mean harmony in points of view, and although Calhoun began his political career sharing many of the same nationalistic convictions as Clay and Webster, his outlook ultimately had little in common with their steadfastly unionist views. A secretary of war, a vice president under two presidents, and a leading figure in the Senate, Calhoun was above all a defender of his native South Carolina and, by extension, the slaveholding agricultural interests of the South. As Northern manufacturing interests increasingly collided with those interests in matters such as the tariff, and as slavery came under attack from the growing abolitionist movement in the 1830s and 1840s, he thus became the South's—and slavery's—most forceful and visible champion. By the late 1840s, he was characterizing slavery as "the most . . . stable basis for free institutions in the world."[14] Perhaps more significant, however, was Calhoun's emergence in the late 1820s as his region's chief propounder of the constitutional theory of nullification and states' rights. Responding initially to tariff measures that promised to undermine the South's agrarian prosperity, he held that the people of the separate states had the right to nullify federal policies inimical to their interests. Later, in his *Disquisition on Government*—regarded as one of America's best-argued exercises in political thinking—he undertook to expand on that idea. In so doing, he articulated the pseudo-constitutional line of reasoning that the South—with Calhoun's native South Carolina in the lead—would invoke to justify secession from the Union and form the Confederacy in late 1860 and early 1861.

The Boston-born portraitist George P. A. Healy was living in Paris in the 1840s. There, he had won the favor of King Louis-Philippe, and in 1845 he returned to the United States to paint a series of portraits of leading American statesmen that the French monarch had requested for Versailles. Among the individuals painted for this commission was Calhoun. Healy eventually produced several variants of his Calhoun portrait, including a full-length portrait that the city of Charleston ordered shortly after Calhoun's death in 1850. The National Portrait Gallery's version resided for many years with the family of Henry Gourdin, a South Carolina businessman who had helped raise a subscription fund to relieve Calhoun of his burdensome debts just before his death.

The English commentator on American manners and mores Harriet Martineau described Calhoun as "the cast-iron man, who looks as if he had never been born and never could be extinguished."[15]

FV

JOHN C. CALHOUN
By George P. A. Healy
(1813–1894), oil on
canvas, c. 1845

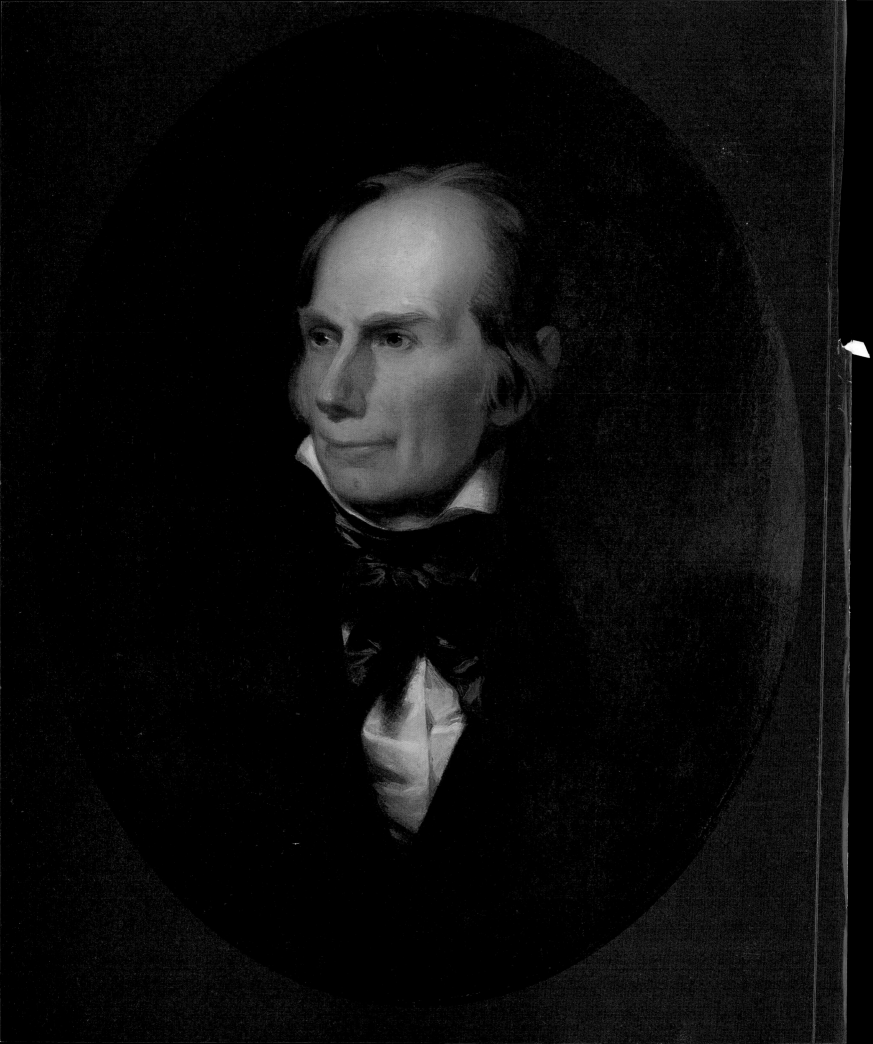

HENRY CLAY'S LEGIONS OF ADMIRERS called him Gallant Harry and the Western Star. Noted for his impetuous charm, he was doubtless one of the most beloved politicians of his generation. He was also one of the most ambitious, and although he once said, "I had rather be right than be president," only his own death finally put an end to his incessant pining for the presidency.[16] But often outweighing his White House ambitions was an unwavering devotion to ensuring a strong and peaceful American Union. During his many years of representing Kentucky in Congress, first in the House and then in the Senate, no one was more instrumental than he in keeping the specter of disunion and civil war at bay in the face of ever-mounting disputes between North and South. As Speaker of the House during the protracted and bitter debates of 1820 and 1821 over the admission of Missouri as a slave state, Clay engineered intercessions and parliamentary ploys that proved crucial in assuring that the agreed-upon compromise would stick. In the early 1830s, with South Carolina claiming the right to nullify congressionally enacted tariffs, rather than risk armed Federal-state confrontation on this issue, he set aside his own ardent support for the tariffs to engineer a compromise.

His greatest moment as a conciliator, however, came early in 1850. With the North and South verging on armed conflict over the extension of slavery into new western territories, a frail Clay walked haltingly into the Senate chamber, where for the better part of two days he defended a set of compromise proposals that he hoped would restore sectional peace. Although it would be many months before those proposals would become law, his persuasive eloquence marked the beginning of the end of the crisis, and Clay's reputation as the Great Pacificator was forever set. Unfortunately, the sectional peace that he sought to achieve turned out to be woefully short-lived, for built into the Compromise of 1850 were new sources of divisiveness between North and South.

Clay was temporarily retired from the Senate when the Philadelphia painter John Neagle traveled to his home near Lexington, Kentucky, to paint a portrait of him in 1842. It was already clear that Clay would be the Whigs' presidential choice in 1844, and a group of his Philadelphia supporters had commissioned Neagle to produce a portrait that would eventually be translated into a print for promoting their candidate's election. The image here is the original likeness, completed in November 1842. It was, however, only a preamble to the much more ambitious likeness destined for Neagle's Philadelphia patrons—a life-sized full-length portrait showing Clay standing amid an array of objects linking him to national peace and prosperity. Following that picture's completion, Clay wrote to inform Neagle

HENRY CLAY
By John Neagle
(1796–1865),
oil on canvas, 1842

that "it is the judgment of my family and friends that you have sketched the most perfect likeness of me that has been hitherto made. My opinion coincides with theirs. I think you have happily delineated the character, as well as the physical appearance, of your subject."[17]

FV

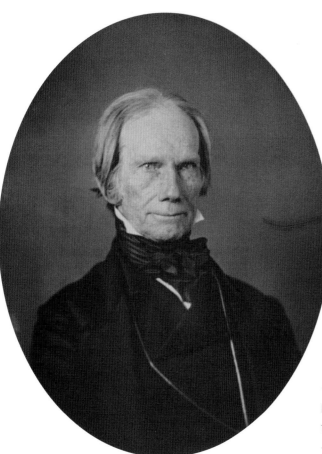

Henry Clay by Frederick De Bourg Richards (1822–1903), daguerreotype, c. 1850

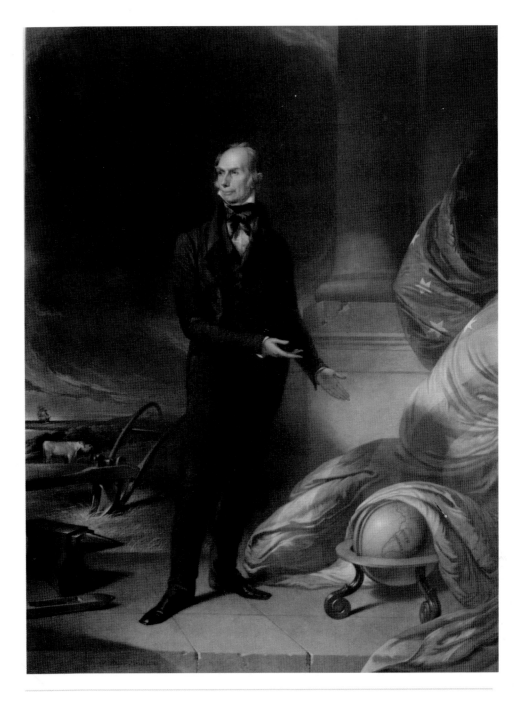

John Sartain's mezzotint of Henry Clay, commissioned by the Philadelphia Whigs, is a superbly executed and faithful copy of John Neagle's large full-length painting, which the artist painted during his visit to Lexington, Kentucky, and Ashland, Clay's home nearby. Amidst Clay's tall, statuesque figure can be seen such implements as a ship, cows, plow, anvil, and shuttle, symbolic of the nation's commerce, agriculture, and industry. In his role as the Great Pacificator, Clay tried to promote a judicious balance between these endeavors, which affected both Northerners and Southerners. The flag-draped globe at Clay's feet refers to his former diplomatic accomplishments as Speaker of the House and as secretary of state, especially for his support of Pan-American independence, mostly from Spain.

Henry Clay by John Sartain
(1808–1897), mezzotint,
1843

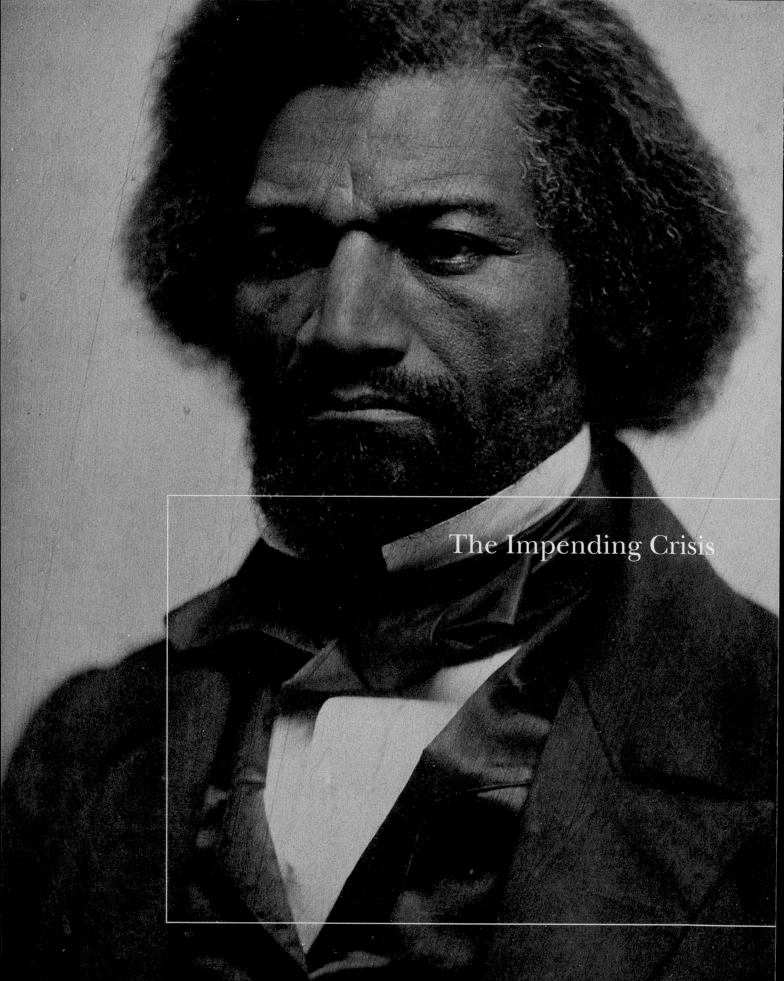

The Impending Crisis

TRUST AND UNDERSTANDING were never so severely strained in the United States as in the decades before the Civil War. Radical views about slavery echoed from both sides of the Mason-Dixon line and clashed with an ominous resonance, instilling fear and confusion in all but the most steadfast of patriots. Throughout the heartland, suppression of dissident voices became the first line of defense, and tar and feathers all too often became the preferred remedy. Not even the venerable halls of Congress were safe, where an injudicious insult could provoke a savage caning. In this climate of national incivility, a civil war was brewing.

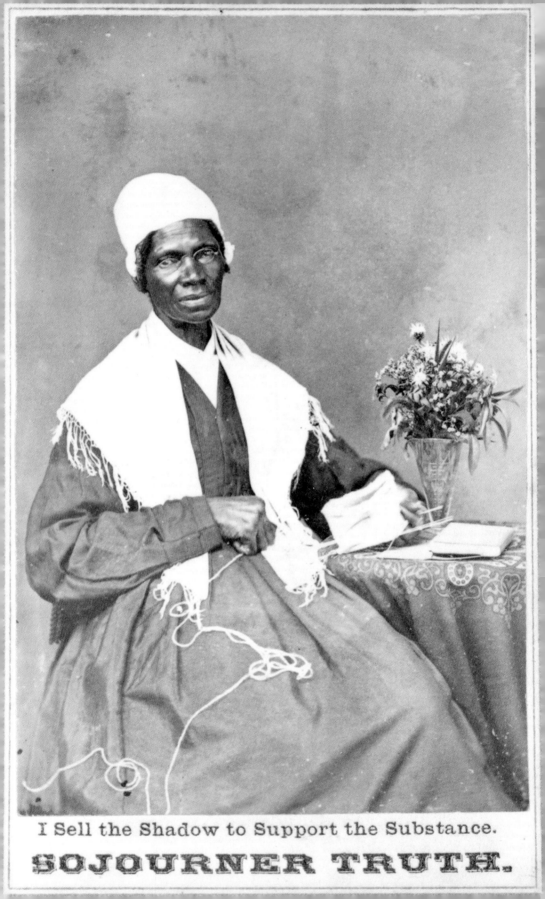

I Sell the Shadow to Support the Substance.

SOJOURNER TRUTH.

SOJOURNER TRUTH SPENT THE FIRST THREE DECADES OF HER LIFE AS A SLAVE named Isabella in rural Ulster County, New York. In 1826, some months before the state's gradual emancipation act was scheduled to set her free, she walked away from her master, and in 1843, hearing the voice of the Lord (who gave her the name Sojourner Truth), became an itinerant preacher.

During her stay at a communal settlement outside of Northampton, Massachusetts, Sojourner Truth first came into contact with the abolitionist movement. Subsequently, Truth (who never learned to read or write) dictated the story of her slave life to abolitionist Olive Gilbert, and in 1850 she paid for the publication of the *Narrative of Sojourner Truth*. At William Lloyd Garrison's suggestion, Truth accompanied the English abolitionist George Thompson on a lecture tour through western New York and Ohio so that she might have the opportunity to sell her book at twenty-five cents a copy. Truth, a six-foot-tall woman of powerful voice, customarily began with a hymn or a song with words of her own composition and went on to discourse about religion and slavery. "She seemed to please herself and others best when she put her ideas in the oddest forms," remembered Frederick Douglass.[18]

Truth became a fixture at antislavery and woman's-rights conventions, where her colorful personality and witty sallies made her a favorite among the reformers. But it was Harriet Beecher Stowe's "Sojourner Truth, the Libyan Sibyl," published in the April 1863 issue of the *Atlantic Monthly*, that brought her to national attention. A month later Truth seized her moment of fame to have her first carte-de-visite photograph taken at Battle Creek.

In February 1864 Truth asked the editor of the *National Anti-Slavery Standard* to inform the public that "I am about to have a new, and, I hope, much better photograph taken of me, which a friend is going to have copy-righted for my benefit."[19] Truth looked to the carte-de-visite likenesses ("shadows," as they were called)—which could be sold for twenty-five to thirty-three cents—for her livelihood, and she had printed on the cards, "I sell the shadow to support the substance." Truth posed as a dignified lady with books and flowers (supplied by the photographer) and her knitting—rather than her pipe—in hand. There is no hint here of one who, as Frederick Douglass put it, "cared very little for elegance of speech or refinement of manners."[20] Rather, this is the woman Harriet Beecher Stowe described as "perfectly self-possessed and at her ease." Wrote Stowe, "I do not recollect ever to have been conversant with any one who had more of that silent and subtle power which we call personal presence than this woman."[21]

MC

SOJOURNER TRUTH
By an unidentified
photographer, albumen
silver print, 1864

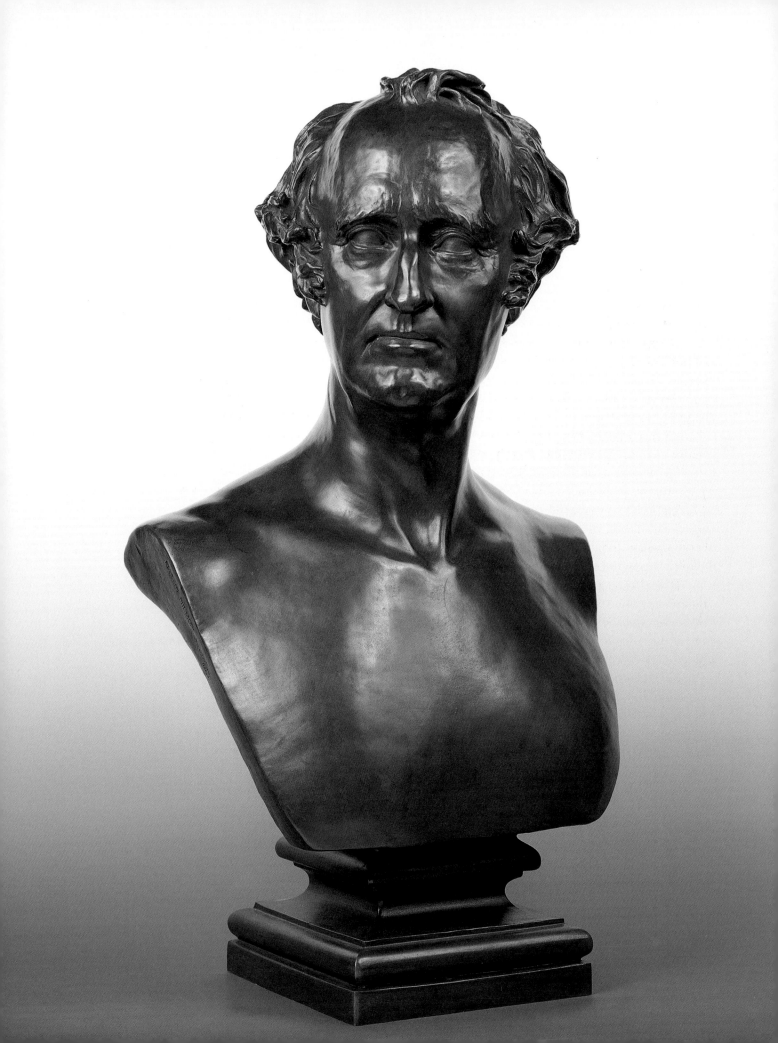

BOSTON BRAHMIN WENDELL PHILLIPS was said to have been converted to abolitionism in 1836 by the sight of the mob parading William Lloyd Garrison through the streets bound up in a rope. But the influence of Phillips's wife, Anne Terry Greene, a member of the Boston Female Anti-Slavery Society, was a primary motivation. Setting out to awaken the moral indignation of the American people, Phillips looked on the speaker's platform, wrote one observer, "like a marble statue, cool and white, while a stream of lava issued red hot from his lips."[22] Espousing the Garrisonian doctrine of "No Union with Slaveholders," Phillips pronounced that it was "impossible to make a nation with one half steamboats, sewing machines, and Bibles and the other half slaves."[23]

Phillips, one of the most powerful orators in an age of oratory, was known as "abolitionism's golden trumpet." As the abolitionists agitated for President Abraham Lincoln to free the slaves, it was recognized that "Phillips manufactures a vast amount of popular opinion. No man will speak oftener or to larger audiences in America. . . . The masses in New England or New York and Ohio are reached by Phillips, who has the public ear in the Lyceum Halls."[24] Disagreeing with William Lloyd Garrison's decision to terminate the American Anti-Slavery Society once the Thirteenth Amendment brought slavery to an end, Phillips took over as president and pressed the fight for black equality until former slaves were given the right to vote by the passage of the Fifteenth Amendment in 1870. It was to "Wendell Phillips, more than to any other, more than to all others," wrote Radical Republican Henry Wilson, that credit must be given for the fact that "colored people were not cheated out of their citizenship after Emancipation."[25]

In 1869, an "association of gentlemen" commissioned young Boston sculptor Martin Milmore to model busts of three Massachusetts men who had fought for the rights and welfare of the freedmen—Senator Henry Wilson, Representative George Sewall Boutwell, and Wendell Phillips. "In all the busts which Mr. Milmore has undertaken," a Boston newspaper reported in August, "he has succeeded not only in a faithful representation of the features and carriage of the head, but also in giving the expression and character that mark the face of his subjects."[26]

Twenty years later, it was not lost on a local art critic that Phillips, in what was described as a "tirade" against Boston's statues and monuments, spoke "only in praise" of Martin Milmore's Soldiers' and Sailors' Monument, erected on Boston Common in 1877. "He was Milmore's friend and was indebted to that artist for an admirable portrait bust."[27]

MC

WENDELL PHILLIPS
By Martin Milmore
(1844–1883), bronze,
1869

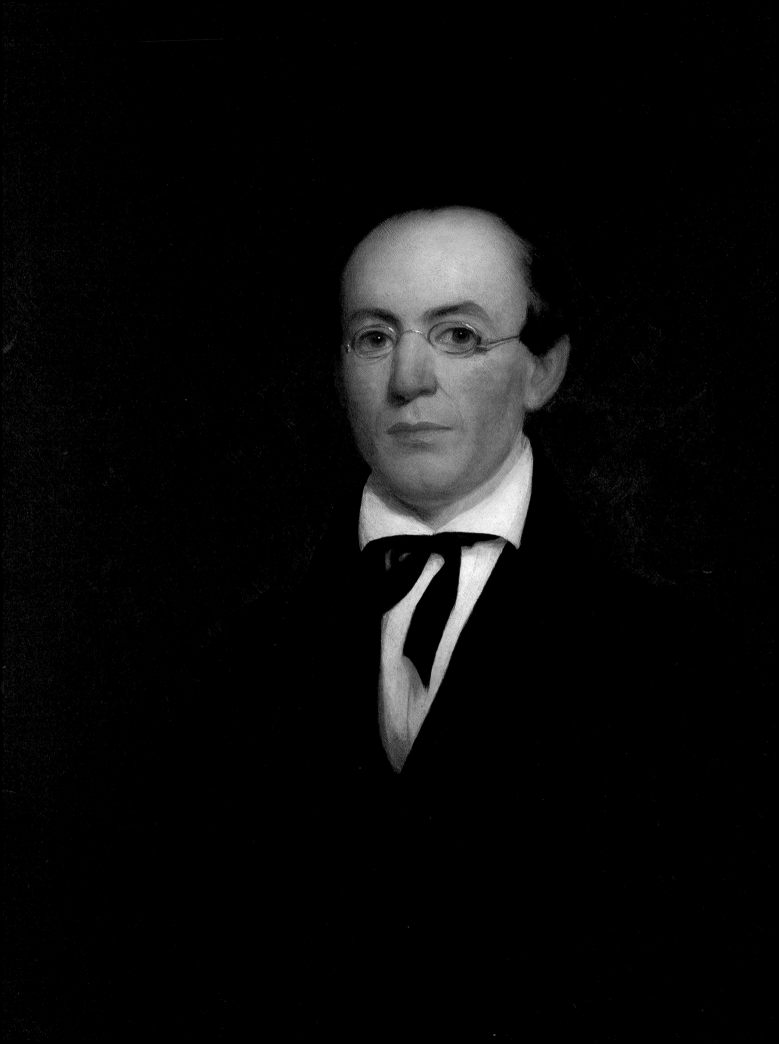

THERE WERE MANY IN AMERICA of the 1830s who deplored slavery and called for gradual emancipation, but William Lloyd Garrison's castigation of slavery as a sin, and his demand for the immediate liberation of those in bondage, brought new energy and direction to the antislavery cause. In January 1831, Garrison, a twenty-five-year-old printer, began publishing *The Liberator*, a weekly of small circulation but widespread notoriety, thanks to the newspaper exchange that enabled other editors to reprint his columns. Garrison, a pacifist, led a crusade against slavery based on moral persuasion, but his uncompromising and harsh language caused him to be viewed as the devil incarnate in the North as well as in the South. One of the reasons he was willing to go out on the antislavery lecture circuit, Garrison jested, was to show that he was "decently made, *without a single horn*."[28]

In April 1833, Garrison, about to go to England on a public relations and fund-raising mission on behalf of the New England Anti-Slavery Society, traveled to New Haven to pose for his portrait. He did so at the behest of his abolitionist friend Simeon S. Jocelyn, who planned to use the painting—executed by his brother Nathaniel—as the basis for an engraving. "I have long thought that your friends and foes would view your portrait with interest," Simeon Jocelyn told Garrison, "and as the Lord has been pleased to give you a head bearing none of the *destructive disposition* which your opposers ascribe to you, it may not be amiss to lead them by a view of the outward man to a more favorable examination of your principles."[29]

More than forty years later, Garrison related to his son that during the three days of the sitting he was kept shut up in a room adjoining the artist's studio to avoid being discovered by the process server. A writ for libel had been sworn out against him, and his friends feared a plot to send him off to Georgia, where the legislature had offered $500 for his arrest and conviction.

The Simeon Jocelyn engraving, Garrison was "sorry to say," proved to be a "total failure," but the oil painting, which came into the possession of Edward M. Davis, a leader in the Pennsylvania abolitionist movement and the son-in-law of reformer Lucretia Mott, Garrison declared to be a "very tolerable likeness."[30]

For thirty-five years William Lloyd Garrison continued the fight against slavery, ceasing publication of *The Liberator* only after ratification of the Thirteenth Amendment to the Constitution abolished slavery in December 1865.

A year before his death, Garrison was enticed to the Boston studio of Anne Whitney—who came from an abolitionist family—to critique her posthumous bust of John Brown.

WILLIAM LLOYD GARRISON
By Nathaniel Jocelyn
(1796–1881), oil on panel,
1833

After several visits in which he enjoyed "much earnest talk," Garrison was persuaded to sit for his own bust. When it was finished, Garrison wrote to his daughter, "I do not think a more accurate 'counterfeit presentment' of your father's features could possibly be made; and I am particularly pleased that it has been achieved by a woman."[31]

MC

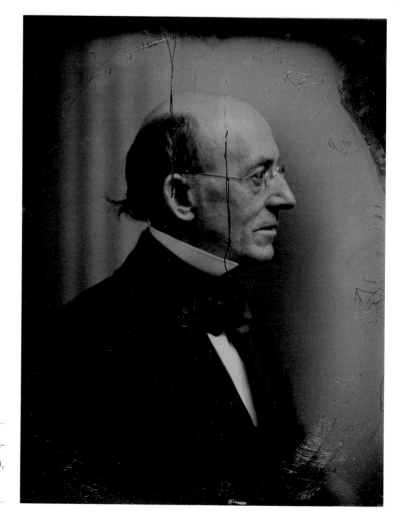

William Lloyd Garrison by Southworth & Hawes (active 1844–61), daguerreotype, c. 1851

William Lloyd Garrison by Anne Whitney (1821–1915), plaster, 1878

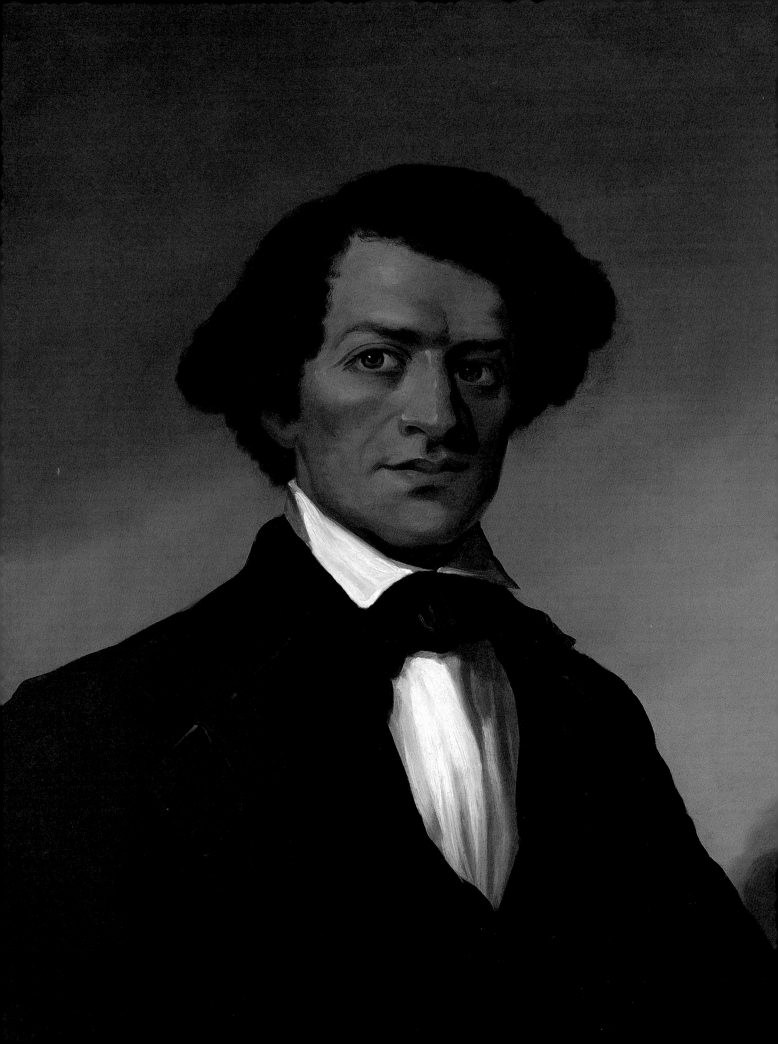

BORN INTO SLAVERY ON MARYLAND'S EASTERN SHORE, Frederick Douglass both observed and experienced the deprivations and cruelties that were so often part of the daily pattern of the South's slave system. But to an extent, he escaped some of slavery's harsher realities, and in addition to having the opportunity to teach himself to read and write, he was allowed in his late teens to hire himself out for wages, part of which he was permitted to keep for himself. His somewhat advantaged circumstances, however, only deepened his resolve to escape, and in September 1838, armed with forged documents identifying him as a free man, he fled and settled in New Bedford, Massachusetts.

Douglass began his new life of freedom as an unskilled worker. His life took a sharp turn, however, in August 1841, when he consented to a spur-of-the-moment request to speak about his slave experience at an abolitionist gathering in Nantucket. Douglass was petrified, he recalled later, but pulling himself together "with the utmost difficulty," he stammered through his remarks.[32] His nervousness could not conceal his gifts for public persuasion, and it was soon clear that a new spokesman for the antislavery movement had been born. Within a few years, his rich, full voice, majestic delivery, and blend of humor and moral urgency had made him one of the most compelling speakers on the abolitionist circuit. "He is a swarthy Ajax," declared a journalist who heard him in 1849, "and with ponderous mace, he springs into the midst of his white oppressors and crushes them at every blow. With an air of scorn he hurls his bolts on every hand. . . . [He] is the master of every weapon. . . . Woe to the man . . . whose hypocrisy passes in review."[33]

While many Americans lamented the coming of the Civil War, Douglass unashamedly welcomed it. Although President Abraham Lincoln's only stated objective at the outset was to bring the seceding states back into the Union, Douglass knew that a Northern triumph almost assuredly meant the demise of slavery. As a result, he eventually became a major recruiter of black enlistments in the Union army. More important, even before emancipation became an actual fact, he stood in the vanguard of those agitating for national policies designed to ensure that newly freed slaves should enjoy a full measure of opportunity and rights.

This portrait by an unidentified artist is thought to have been based on the frontispiece likeness that appeared in Douglass's memoir of his years in slavery, *Narrative of the Life of Frederick Douglass, an American Slave*, originally published in 1845. Douglass wrote the book to counter the charge that no one who spoke as eloquently as he did could have grown up in the harsh slave system described in his abolitionist speeches. The memoir, with all its

FREDERICK DOUGLASS
By an unidentified artist, oil on canvas, c. 1844

specifics about his origin, achieved that aim, but such frankness also increased his chances of being forcibly returned to slavery. Therefore, shortly after his *Narrative* made its appearance, Douglass went to England, where his antislavery speeches won him many admirers—one of whom raised the money to purchase his freedom from his owner.

FV

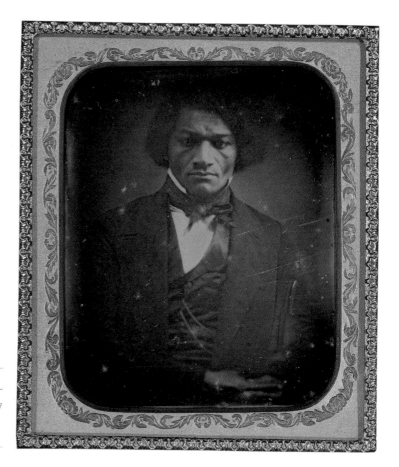

Frederick Douglass by an unidentified artist, daguerreotype, c. 1850 after a c. 1847 daguerreotype

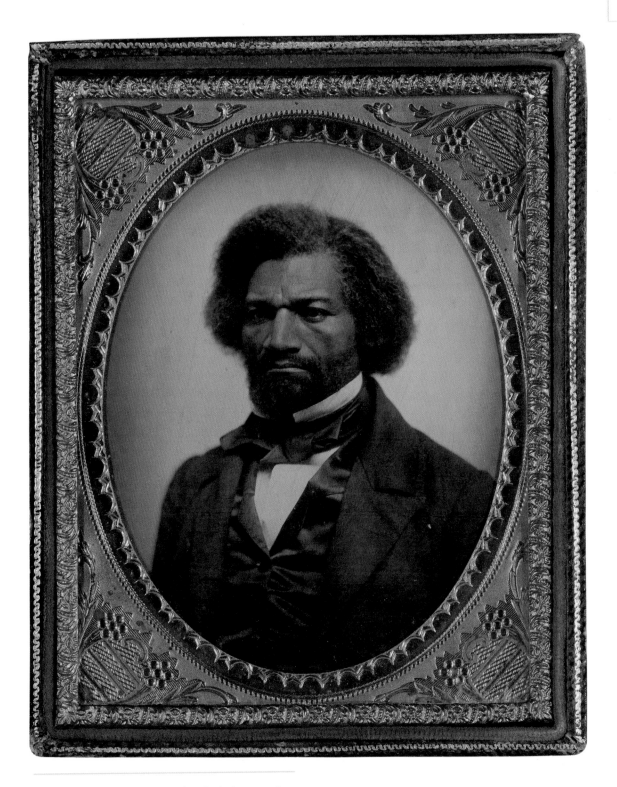

Frederick Douglass by an unidentified photographer,
ambrotype, 1856

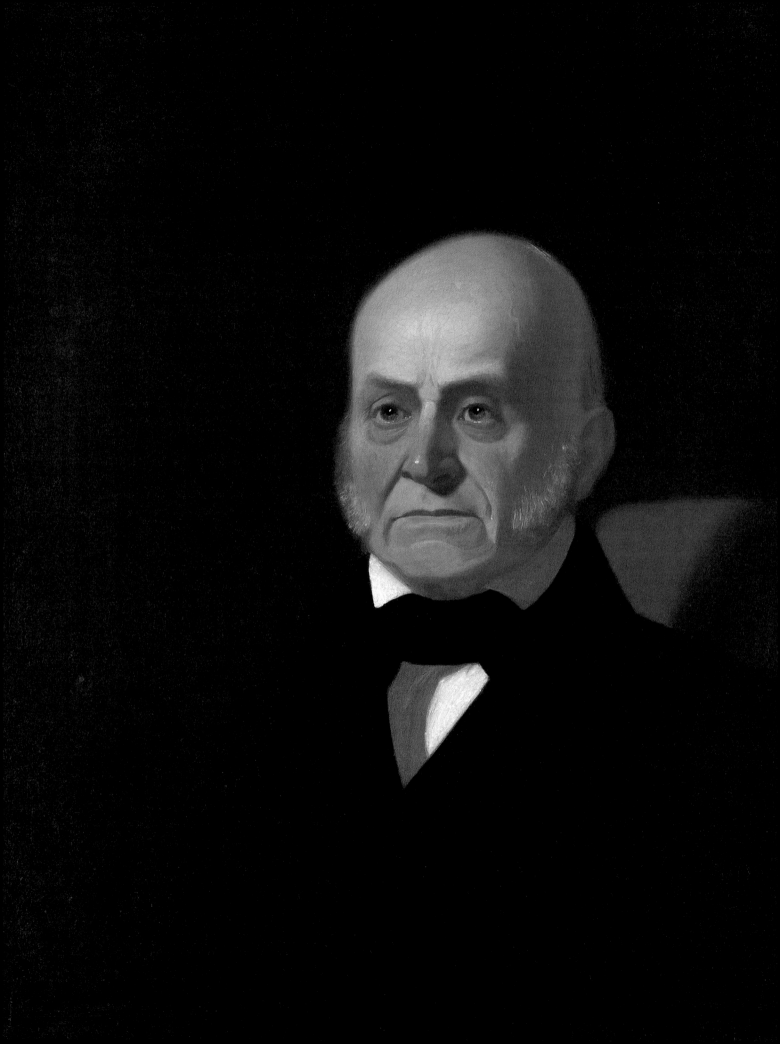

AS A MEMBER OF THE UNITED STATES House of Representatives in the 1830s, former president John Quincy Adams performed some of his noblest service to his country as a staunch and oftentimes courageous spokesman for the abolition of slavery. Yet Adams was not an abolitionist and consequently had to use extreme discretion in whatever support he could lend to the cause of emancipation. The topic was so heated and controversial that a gag rule was adopted in the House on May 26, 1836, by Southerners aided by Northern Democrats. The gag rule was intended to prohibit the discussion of antislavery petitions that began to pour into the Congress in the wake of the growing antislavery crusade and the formation of the American Anti-Slavery Society in 1833. Wisely, Adams knew and accepted the limitations placed upon him. In October 1837, he addressed his situation in his diary: "I have gone as far upon this article, the abolition of slavery, as the public opinion of the free portion of the Union will bear, and so far that scarcely a slave-holding member of the House dares to vote with me upon any question."[34]

At this same time, Adams became personally involved in buying the freedom of a slave woman and her two children, whose fates were in the hands of a notorious Alexandria, Virginia, slave trader named James H. Birch. Toward a subscription to purchase their freedom, Adams generously contributed fifty dollars.

In April 1844, Adams received an ivory cane from Julius Pratt & Company of Meriden, Connecticut, for his efforts to end the gag rule. Adams noted in his diary: "There is in the top of the cane a golden eagle inlaid, bearing a scroll, with the motto 'Right of Petition Triumphant' engraved upon it. The donors requested of me that when the gag-rule should be rescinded I would cause the date to be added to the motto."[35] On December 3, 1844, the gag rule was repealed, and Adams had that date engraved on the top of the cane. He deposited the ivory cane "made from a single tooth" with the commissioner of patents at the Patent Office, and left it in his will to the American people. Later the cane was transferred from the Patent Office to the Smithsonian Institution.

JB

Cane presented to John Quincy Adams in recognition of his efforts to repeal the gag rule

National Museum of American History, Smithsonian Institution, Behring Center

JOHN QUINCY ADAMS
By George Caleb Bingham (1811–1879), oil on canvas, c. 1850 from an 1844 original

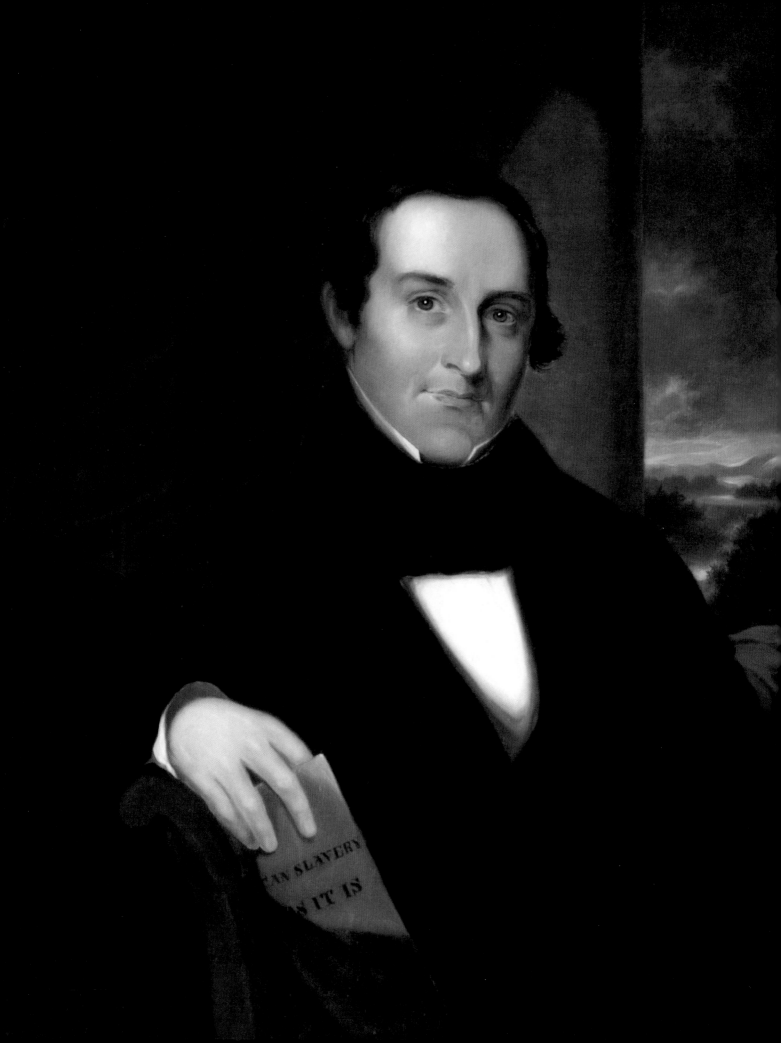

JAMES A. THOME WAS A STUDENT at Lane Theological Seminary in Cincinnati when, in February 1834, Theodore Weld organized nineteen evenings of debate on the subject of slavery. Thome, the son of an Augusta, Kentucky, slaveholder, became an enthusiastic convert to the cause of immediate abolition, and he soon persuaded his father to liberate his slaves.

Partly because Thome had worn himself out as a traveling agent for the American Anti-Slavery Society, Weld persuaded the executive committee to send him, together with his colleague, Horace Kimball, to the West Indies to study the results of emancipation, which had been proclaimed there, under varying conditions, in 1833. The pair returned with voluminous material collected by observation and hundreds of interviews, which Thome (after the sudden death of Kimball and with drastic editing by Weld) turned into *Emancipation in the West Indies: A Six Months' Tour in Antigua, Barbadoes, and Jamaica, in the Year 1837.* The work was presented "to our countrymen who yet hold slaves," Thome said in the introduction, "with the utmost confidence that its perusal will not leave in their minds a doubt, either of the duty or perfect safety of *immediate emancipation,* however it may fail to persuade their hearts—which God grant it may not!"[36]

Abolitionists were satisfied with the evidence that Thome presented—"truth enough to convert the nation," declared fellow antislavery agent Henry B. Stanton—and the executive committee of the American Anti-Slavery Society ordered a second printing of one hundred thousand copies. "Emancipation," pronounced Weld, "more than any other published [cause] in the Country, has advanced the Anti-Slavery Cause."[37]

In the fall of 1839, Thome left Oberlin College (where he had been appointed professor of rhetoric and belles lettres) because he feared that he might be seized in Ohio and dragged into Kentucky, where he might be imprisoned or lynched for assisting an escaped slave. He spent the winter in the safety of Fairfield, Connecticut, occupied with answering questions on slavery raised by the British and Foreign Anti-Slavery Society. Utilizing Theodore Weld's *American Slavery as It Is; Testimony of a Thousand Witnesses* as his major resource, Thome wrote to Weld in November, "I have waded through the blood and gore of 'Slavery as it is' and have just come out on the other side, all dripping, *dripping.* I have more than once asked myself whether the book itself is not the very best answer that can be given to the English Queries."[38]

In the midst of his labors, Thome sat for his portrait. The artist very likely was abolitionist Nathaniel Jocelyn, who had previously executed a portrait of William Lloyd

JAMES A. THOME
Attributed to Nathaniel Jocelyn (1796–1881), oil on canvas, c. 1840

Garrison and who was in Fairfield early in 1840 painting the portrait of a local judge and his wife. Out of admiration and friendship for Weld, Thome chose to be portrayed holding *American Slavery as It Is* rather than his own tract.

MC

Slave collars made of iron were used to discipline and identify slaves who were considered risks of becoming runaways. This broken collar once had three prongs. Abolitionist Theodore Weld, in his provocative treatise *American Slavery as It Is*, described the use of a similar collar on a spirited slave near Charleston, South Carolina, who served her mistress as a seamstress: "A handsome mulatto woman, about eighteen or twenty years of age, whose independent spirit could not brook the degradation of slavery, was in the habit of running away." For this offense, she was repeatedly and severely whipped, and a "heavy iron collar, with three long prongs projecting from it, was placed round her neck, and a strong and sound front tooth was extracted, to serve as a mark to describe her, in case of escape."

National Museum of
American History,
Smithsonian Institution,
Behring Center

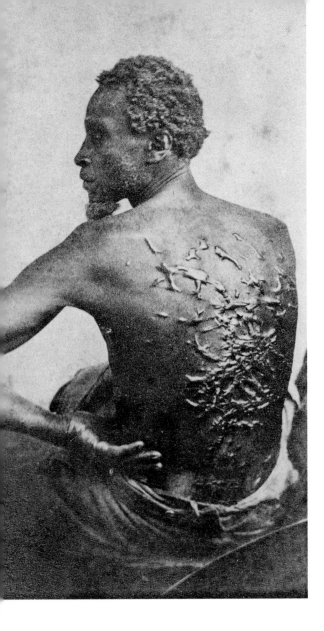

On July 4, 1863, six months after President Lincoln signed his Emancipation Proclamation, a wood engraving made after this image of a runaway slave, bearing scars on his back from a severe scourging, appeared in *Harper's Weekly*. An accompanying article titled, "A Typical Negro," reported that the slave, named Gordon, had escaped from his master in Mississippi in a race for freedom through swamps and bayous, staying just ahead of a search party and a pack of bloodhounds. In March, muddy and exhausted, he came into Union lines at Baton Rouge, Louisiana. *Harper's* ran two additional images, one of Gordon in his bedraggled state, and another of him wearing the uniform of a U.S. soldier. Based on its own merits, Gordon's story was naturally a newsworthy feature for an illustrated weekly such as *Harper's*. Yet by its very content, the story also underscored how the Emancipation Proclamation was giving new meaning to the war to preserve the Union.

The images of Gordon were taken by William D. McPherson and his partner Mr. Oliver at the time Gordon was undergoing a medical inspection by Union authorities. The arresting photograph, showing the massive scarring on Gordon's back, was visual proof of all that the abolitionists had been proclaiming, especially Harriet Beecher Stowe, the author of *Uncle Tom's Cabin* and the "little woman" whom Lincoln jested "wrote the book that made this great war."[39]

This image was widely copied and circulated as a carte de visite by photography houses throughout the North, and in England. The copy in the Portrait Gallery's collection is the only extant version known to have been produced by Mathew Brady's studio.

By the Mathew Brady Studio
(active 1844–94), after
William D. McPherson and
Mr. Oliver, albumen silver
print, 1863

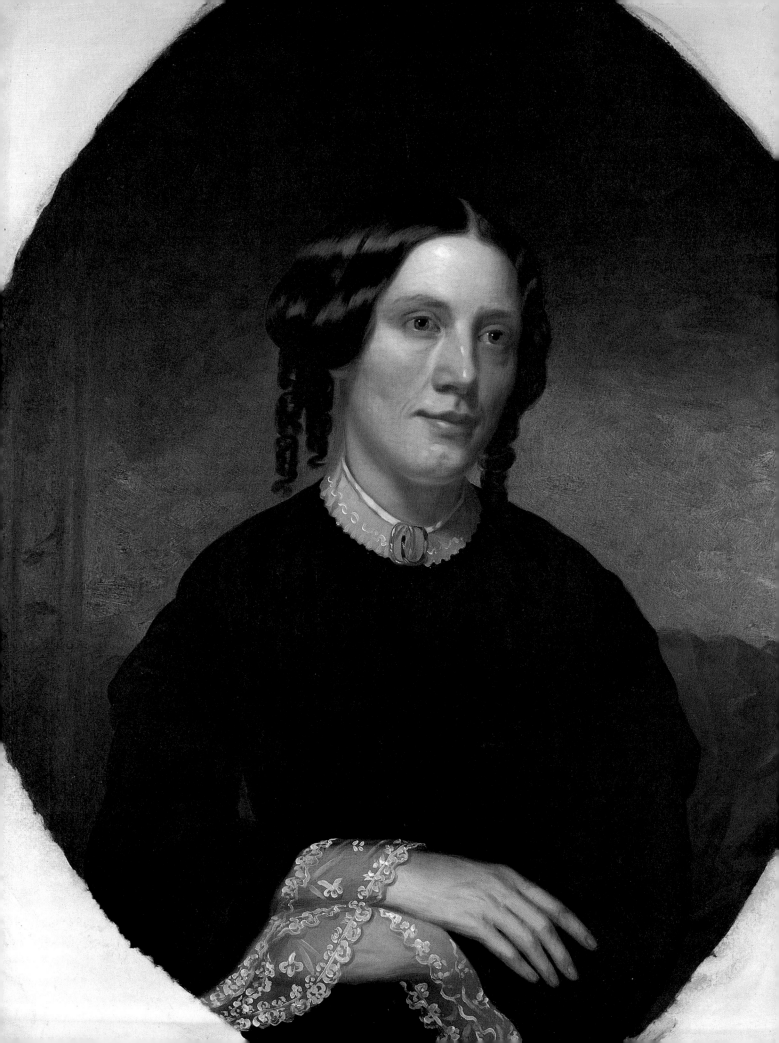

"I HAVE BEGUN A STORY, trying to set forth the sufferings and wrongs of the slaves," Harriet Beecher Stowe informed her brother Henry Ward Beecher as indignation at the strictures of the Fugitive Slave Act swept the North.[40] "Up to this year I have always felt that I had no particular call to meddle with this subject," Stowe wrote to Gamaliel Bailey, editor of the antislavery newspaper *The National Era* in March 1851. "But I feel now that the time is come when even a woman or a child who can speak a word for freedom and humanity is bound to speak."[41] Her proposal for a tale (initially intended as a series of no more than three or four parts) entitled "Uncle Tom's Cabin, or Life among the Lowly" was accepted, and it appeared in forty installments extending from June 5, 1851, to April 1, 1852, captivating a public that could hardly wait for each succeeding episode. Published as a book in March 1852, *Uncle Tom's Cabin* sold 300,000 copies within the first year and, as Stowe observed without too much exaggeration, "powerfully . . . affected every mind that read it."[42]

Exulted poet John Greenleaf Whittier to William Lloyd Garrison, "What a glorious work Harriet Beecher Stowe has wrought. Thanks for the Fugitive Slave Law! Better would it be for slavery if that law had never been enacted; for it gave occasion for 'Uncle Tom's Cabin.' "[43] One of the effects of the book, Stowe herself noted, was "to convert to abolitionist views" many who had been repelled by the "bitterness of feeling in *extreme abolitionists*."[44]

Stowe's vivid sketches lent themselves to dramatization, and *Uncle Tom's Cabin* was adapted to the stage—completely independent of Stowe—where it met with great popular success. Alexander Purdy, manager of the National Theatre in New York, opened a production on July 18, 1853, and solicited Stowe to sit for a portrait to be displayed in the lobby during the run of the play. Upon Stowe's return from a triumphal tour of the British Isles, New York artist Alanson Fisher traveled to Andover, Massachusetts (where Stowe's husband, Calvin was professor of sacred literature at Andover Theological Seminary), to execute the commission.

In January 1854 the *New York Evening Post* announced that the portrait, "enclosed in a splendid gilt frame and another of polished mahogany," had been placed on exhibition. "According to the picture the distinguished writer is quite a good-looking woman, apparently about forty-five years of age." The public was told that "the cost of the portrait and frames was five hundred and sixty dollars, and the manager of the National incurred the expense in consequence of the great success of *Uncle Tom's Cabin* at his place of amusement." A letter from Calvin Stowe testifying "that he is better satisfied with Mr. Fisher's portrait of Mrs. Stowe than with any other attempt of the kind which he has seen" accompanied the

HARRIET BEECHER STOWE
By Alanson Fisher
(1807–1884), oil on
canvas, 1853

Uncle Tom and Little Eva by an unidentified Staffordshire potter, porcelain, c. 1852

picture. "Every feature is exactly copied, and the general expression is pleasant, life-like and natural. On the whole, to his eye, it is a handsome picture and a good likeness."[45]

Popular though *Uncle Tom's Cabin* was in America, it was even more popular in England, where the potters of the Staffordshire district turned out Stowe's much-loved characters to be marketed at home and abroad. The angelic Little Eva, whose death brought tears even to Southern eyes, and the self-sacrificing Uncle Tom were particular favorites.

MC

Harriet Beecher Stowe's Christian reservations about the theater prevented her from ever sharing in the profits garnered from the dramatization of her best-selling novel. Companies throughout the North staged what each billed as the authentic version of *Uncle Tom's Cabin*. Stage managers collectively made millions of dollars, and productions reached a peak in the 1890s, when this poster was printed in Erie, Pennsylvania.

Theatrical poster for *Uncle Tom's Cabin* by Erie Lithography Company (active 1890s), color lithographic poster, c. 1890

In this photograph, Harriet Beecher Stowe sits with her father, Lyman Beecher (1775–1863), and her brother Henry Ward Beecher (1813–1887). Lyman, a Presbyterian clergyman, had three sons follow him in his calling, including Henry Ward Beecher, the most famous Beecher after Harriet. In 1856, from his pulpit in Plymouth (Congregationalist) Church in Brooklyn, New York, Henry Ward Beecher enthusiastically preached against the expansion of slavery into Kansas. He supported equipping free-state emigrants to Kansas with Sharps carbine rifles, stating that they would be of greater moral persuasion than the Bible in dealing with shareholders. In Kansas, Sharps rifles became known as Beecher's Bibles.

By the Mathew Brady Studio
(active 1844–94), albumen
silver print, c. 1861

This .52 caliber Sharps carbine "Beecher's Bible" was confiscated following John Brown's raid at Harpers Ferry.

National Museum of American History, Smithsonian Institution, Behring Center

HARRIET BEECHER STOWE

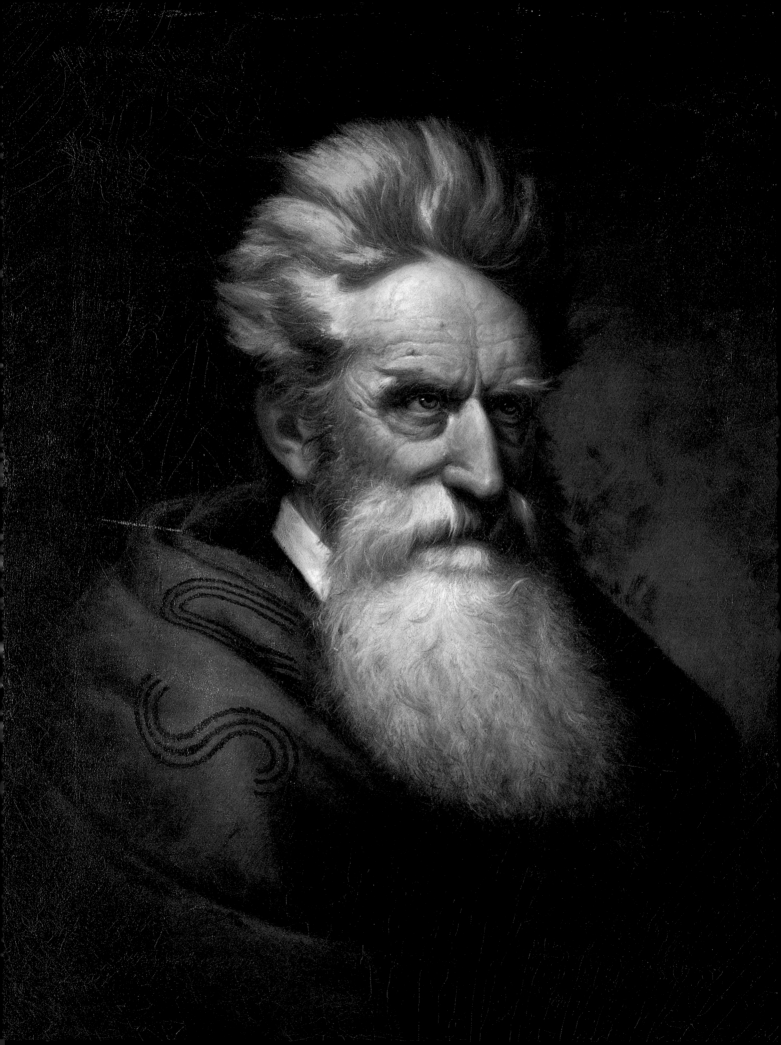

WHEN JOHN BROWN POSED for the African American photographer Augustus Washington, he raised his hand reminiscent of the oath he had taken in 1837 at a memorial service for Elijah Lovejoy, the abolitionist editor murdered by a pro-slavery mob in Alton, Illinois. "Here before God," Brown stood up to declare, "I consecrate my life to the destruction of slavery."[46] Since the daguerreotype is a mirror image, it is obvious (made so by the left-sided buttoning of the coat) that the pose was deliberate, and to achieve the desired effect Brown in fact raised his left hand aloft.

Augustus Washington, the son of a slave, had left Dartmouth College to open a studio in Hartford, Connecticut, just down the river from Springfield, Massachusetts, where Brown, plagued all his life by financial failure, was trying his hand at the wool business. In Springfield, in defiance of the Fugitive Slave Act of 1850, Brown organized local blacks into the biblically named United States League of Gileadites, pledged to prevent, by force of arms if necessary, the return of any fugitives to bondage. "Be firm, determined, and cool; but let it be understood that you are not to be driven to desperation without making it an awful job to others as well as you," Brown charged the forty-four black men and women who signed the agreement he had drawn up.[47]

On the night of October 16, 1859, Brown, with an army of seventeen white and five black men, attacked the Federal armory at Harpers Ferry in an ill-fated attempt to rid the land of the curse of slavery. He was captured two days later, and the Commonwealth of Virginia lost no time in bringing him to trial for murder, treason, and conspiring with slaves to commit treason. "The events that have occurred during the past week at Harpers Ferry, Virginia, have startled the whole country with a force not equalled by any other occurrence for many years," reported *Frank Leslie's Illustrated Newspaper*, one of the many periodicals that sent correspondents to cover the trial and in the process make "Old Brown" a celebrity.[48] Sustained by the certainty that he was the instrument of the Lord, Brown rebuffed friends who sought to prove him insane or effect a rescue, saying, "I am worth now infinitely more to die than to live."[49] On December 2, he was hanged in Charles Town. The abolitionists had their martyr; the South had cause for alarm.

Glorified or vilified, John Brown was not a man to be forgotten. Ole Peter Hansen Balling, who came to America from Norway in 1856 and made his reputation painting Civil War figures, recognized Brown as a compelling figure more than a decade after his death. Using the photograph of Brown that appeared in the November 19, 1859, issue of *Frank Leslie's Illustrated Newspaper*, the artist draped the figure in a United States Army blanket and finished what the *New-York Daily Tribune* of March 19, 1873, pronounced "not only a good portrait but a strong and fine picture, painted with skill and genuine feeling."[50]

MC

JOHN BROWN
By Ole Peter Hansen
Balling (1823–1906),
oil on canvas, c. 1873

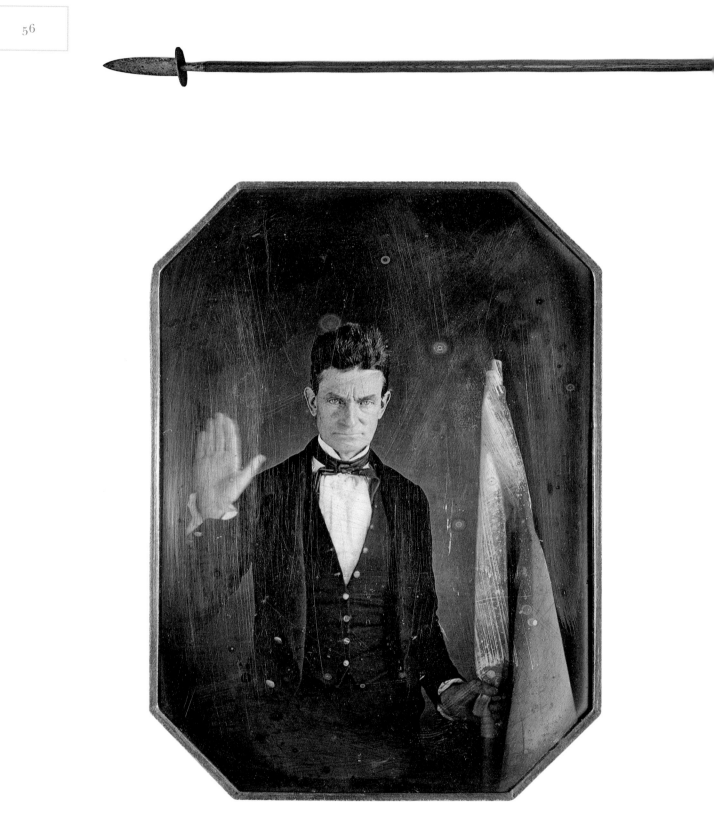

John Brown by Augustus
Washington (1820/21–1875),
daguerreotype, c. 1846–47

This pike was confiscated in connection with John Brown's raid at Harpers Ferry, Virginia, in October 1859. Two and a half years before, Brown had contracted with Charles Blair, a forgemaster in Collinsville, Connecticut, to make 950 pikes for a dollar a piece. Brown intended to issue these inexpensive weapons to his army of slave insurgents. He had the pikes designed in the fashion of a Bowie knife he had taken from a captured Missourian in the border war against the pro-slavery forces in Kansas.

National Museum of American History, Smithsonian Institution, Behring Center

Albert Berghaus was a sketch artist for *Frank Leslie's Illustrated Newspaper* when he made this pencil drawing of the moment John Brown was brought out of the jail in Charles Town, Virginia, on December 2, 1859, to be conveyed in a furniture wagon to the place of execution. The sketch appeared as a woodblock engraving in Leslie's newspaper on December 17.

John Brown Brought Out for Execution by Albert Berghaus (lifedates unknown), pencil on paper, 1859

IN THE FALL OF 1859, Edmund Ruffin of Virginia, the South's foremost agriculturalist, was feeling pangs of uselessness, a new sensation for him and one that he sorely disliked. "I fear that I am now about to enter that condition of idleness & wearisomeness which I always dreaded," he wrote in his diary on October 18, "which I have until now kept off by keeping my mind occupied with some study or pursuit."[51] Ruffin, sixty-five, was well known for his long career of experiments, writings, and lectures in the field of agricultural science. Since his mid-twenties, he had studied the use of calcareous manures, and especially the application of marl to enrich the exhausted soil of his native Tidewater region of Virginia. The abundant harvests on his own plantation, Marlbourne, were testaments to the success of his methods. In 1833, he established the *Farmers' Register*, a monthly publication that quickly proved to be a popular reference for Southern farmers. Largely because of Ruffin's preachings, marl and manure became as important to the South's economy as axle grease in the North, which kept the cogs of industry turning.

In spite of Ruffin's productivity, there was an element of defiance in the basic nature of this shaggy, white-haired planter and father of eleven children, which could on occasion lead to self-destructiveness. Politics characteristically brought Ruffin's ire to the fore. When banking reforms became a national issue following the depression of 1837, he began viciously attacking the banking class and the paper money system in a separate new journal, the *Bank Reformer*. This triggered cancellations by enough wealthy magazine subscribers to make him cease publishing both of his journals. Yet no single issue, political or otherwise, so stirred Ruffin in the late 1850s as the topic of secession. A fanatical believer in states' rights, Ruffin became a firebrand and an "itinerant missionary of disunion."[52] In December 1859, he journeyed to Charles Town, Virginia, where John Brown was tried for murder and insurrection, to witness his execution. And to secure a privileged view, he borrowed a Virginia Military Institute uniform overcoat and stood shoulder to shoulder with the institute's cadets. Ruffin received a similar honor in April 1861, when, as a temporary member of the Palmetto Guards, he was invited to fire one of the first hostile shots at Fort Sumter in Charleston harbor. His participation in the bombardment made him a celebrity of the Confederacy. That July, he rejoined the guards on the battlefield at Manassas. Allegedly he fired a cannon shot, this time from Kemper's Battery, which exploded on the bridge over Cub Run, blocking and causing mayhem in the Federal retreat. This, however, would prove to be the highlight of the struggle for Ruffin; four years of war would ravage Virginia and ultimately claim him as a victim. His plantation would be despoiled and his slaves set free. On June 17, 1865, only weeks after the collapse of the Confederacy, Ruffin would revile Yankeedom in his diary one last time before shooting himself to death.

JB

EDMUND RUFFIN
By an unidentified photographer, salted-paper print with watercolor wash, c. 1861

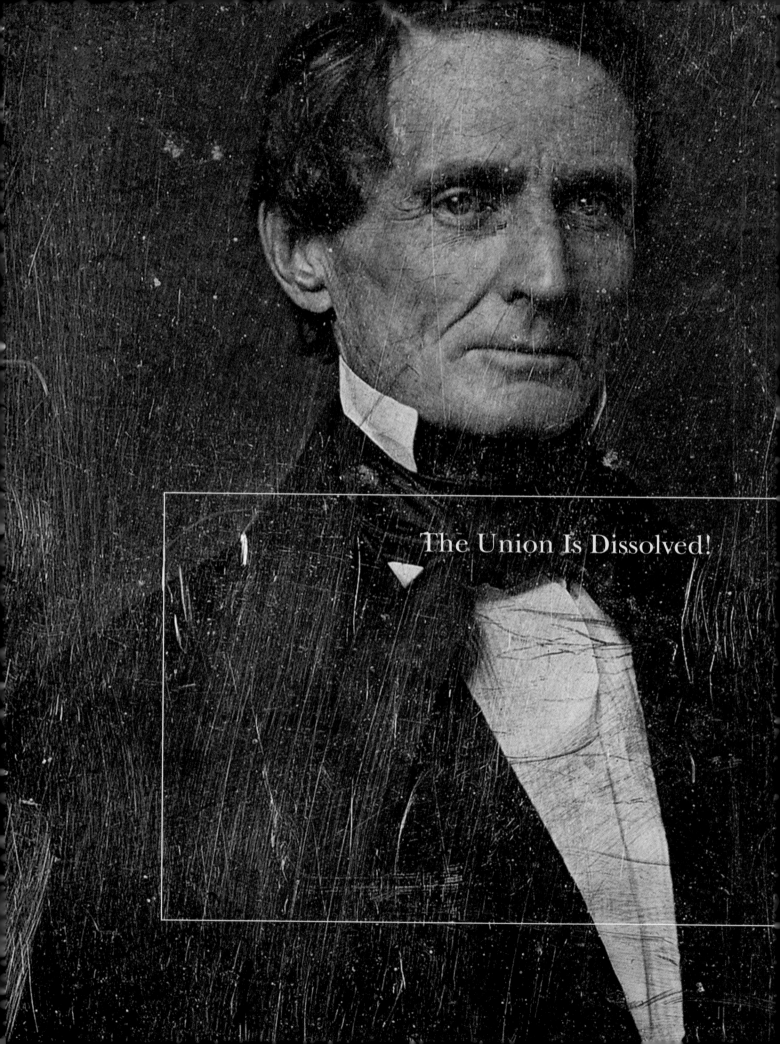

The Union Is Dissolved!

THE ELECTION OF ABRAHAM LINCOLN to the presidency in November 1860 exacerbated the fears of radical leaders in the South, who vehemently defended the institution of slavery. Lincoln, the Republican Party candidate, wholly endorsed his party's platform to ban the extension of slavery into the western territories. Although Lincoln emphatically made clear his intention not to interfere with slavery where it legally existed, Southern extremists did not trust the new president-elect. In response, Southerners enacted their own sacred doctrine of states' rights. "The Union Is Dissolved!" proclaimed the *Charleston Mercury* on December 20, 1860, when South Carolina became the first of eleven states to secede. On the heels of secession followed a sectional call to arms. "Both parties deprecated war," Lincoln reflected four years later in his second inaugural address, "but one of them would make war rather than let the nation survive; and the other would accept war rather than let it perish. And the war came."

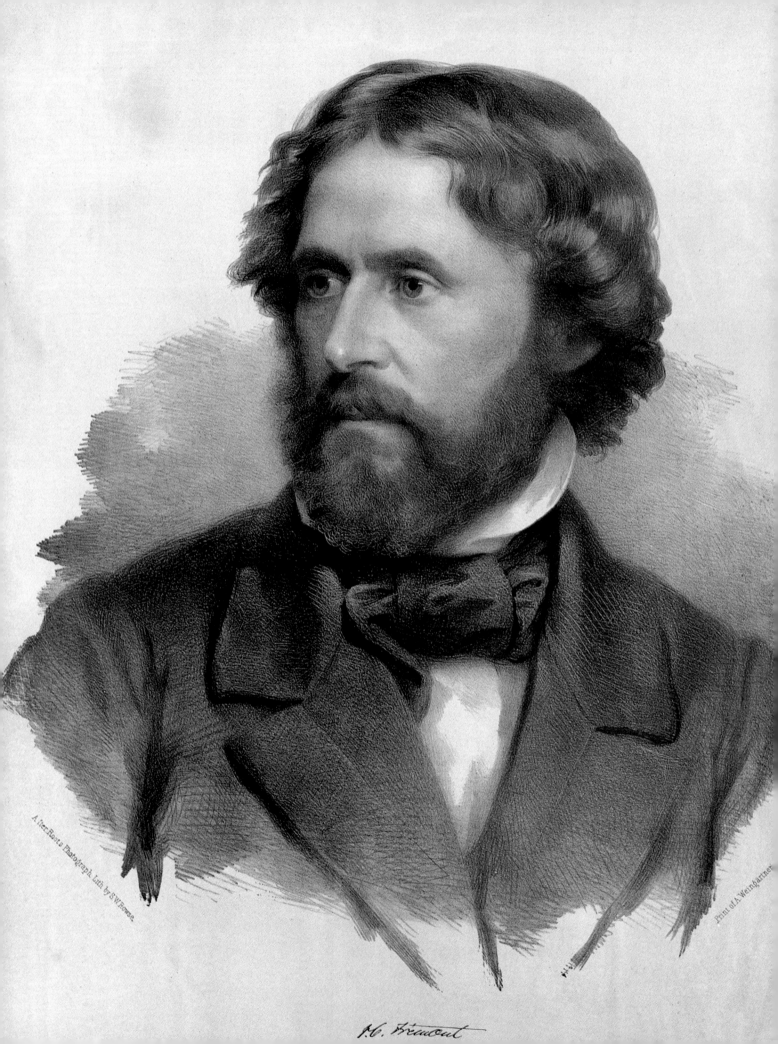

J.C. Frémont

IN 1856, JOHN C. FRÉMONT, the celebrated leader of four exploring expeditions across the Rocky Mountains who had also played a dramatic role in the conquest of California, was chosen as the first presidential candidate of the barely two-year-old Republican Party. Frémont's political experience had been limited to a six-month stint as one of California's first senators, but his youth and vigor made him a fitting standard-bearer for a crusading movement determined to resist the spread of slavery. "The times require a man who has something heroic in his character," editorialized William Cullen Bryant in the *New York Evening Post*.[53]

Frémont was no radical abolitionist. "I am hostile to slavery upon principle and feeling," he declared in June 1856. "While I feel myself inflexible in the belief that it ought not to be interfered with where it exists under the shield of state sovereignty, I am as inflexibly opposed to its extension on this continent beyond its present limits."[54]

In accord with the custom of the day, Frémont took no active part in the campaign and did little more than greet people at his New York City home. But the emigrant aid societies, which had been set up to help keep Kansas free, provided an active political organization in almost every county in the North and West. Frémont's supporters went forth to organize rallies and torchlight parades; campaign biographies were issued; songs were composed; lithographs of the dashing forty-six-year-old candidate were proliferated. The cry of "Free Speech, Free Press, Free-Soil, Free Men, Frémont and Victory" rang out with gusto.

False accusations that Frémont was a secret Catholic sent a good number of potential Republican voters into the ranks of the Native American (Know-Nothing) Party, whose candidate was ex-President Millard Fillmore. But far more daunting to Frémont's success was the fear that a triumph of the first sectional party in American history would precipitate a dissolution of the Union. Frémont's father-in-law, Thomas Hart Benton—himself voted out as senator from Missouri because of his free-soil views—publicly said as much as he stuck with his Democratic Party's nominee, James Buchanan. "We are treading upon a volcano," Benton warned, "that is liable at any moment to burst forth and overwhelm the nation."[55]

Frémont carried all save five of the Northern states, but Buchanan, who captured the slaveholding states except for Maryland, which was Fillmore's sole win, prevailed. "In those States of the Union which have now given such large majorities for Frémont, public opinion, which till lately has been shuffling and undecided in regard to the slavery question, is now clear, fixed, and resolute," William Cullen Bryant summed up. "The cause is not going back—it is going rapidly forward."[56]

MC

JOHN C. FRÉMONT
By Samuel Worcester
Rowse (1822–1901),
after a photograph by
Samuel Root, lithograph,
c. 1856

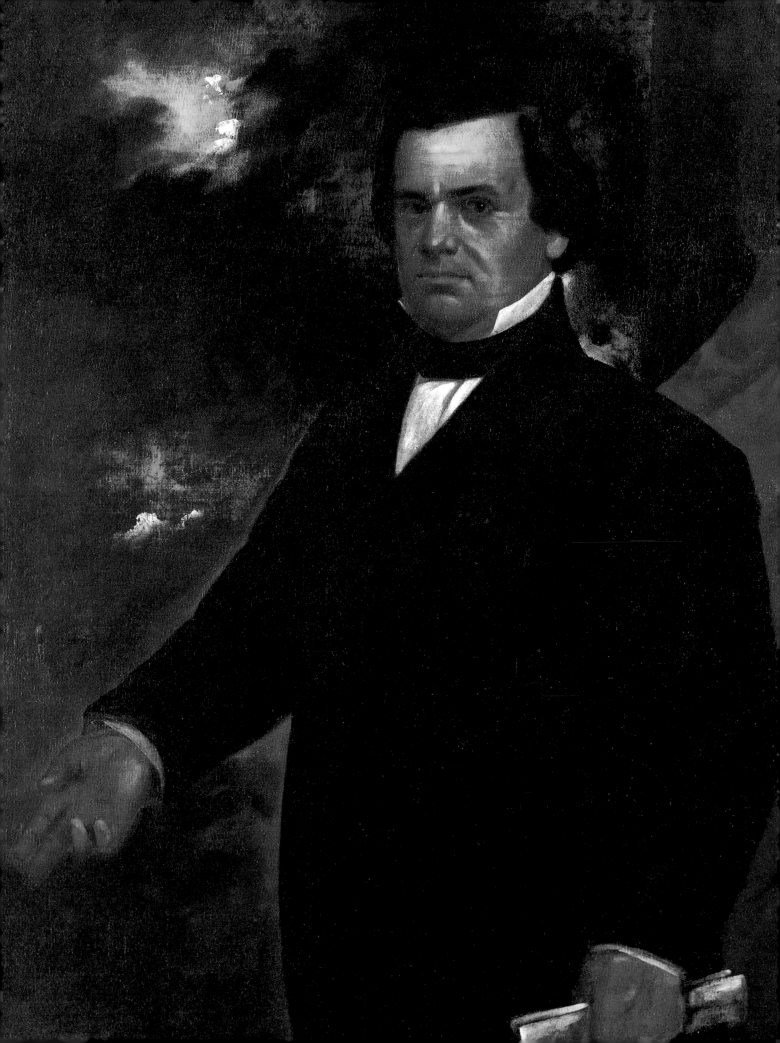

DURING HIS REELECTION CAMPAIGN IN 1858, Democratic senator Stephen A. Douglas of Illinois, one of the best-known politicians in the country, was maneuvered into seven debates with the little-known challenger from the Republican Party, Abraham Lincoln. An unidentified folk artist, inspired by the popular entertainment, carved a figure of Douglas, capturing the Little Giant to the life (page 67). "Douglas stood almost like a dwarf, very short of stature, but square-shouldered and broad-chested, a massive head upon a strong neck, the very embodiment of force, combativeness, and staying power," wrote Carl Schurz, who observed Douglas at the fifth debate in Quincy, Massachusetts. "The deep, horizontal wrinkle between his keen eyes was unusually dark and scowling."[57] Proclaimed Douglas, the proponent of popular sovereignty, "It is no answer . . . to say that slavery is an evil and hence should not be tolerated. You must allow the people to decide for themselves whether it is a good or an evil."[58]

Douglas won reelection, but the campaign elevated Lincoln to national attention. Two years later Douglas, now the candidate of the Northern wing of the split Democratic Party, contested Lincoln again in the four-way race for the presidency. "We must make the war boldly against the *Northern abolitionists* and the Southern *Disunionists*, and give no quarter to either," Douglas wrote to a supporter.[59] Partly at the urging of his wife and partly out of the need to raise campaign contributions, Douglas determined an unprecedented course of campaigning personally throughout the country. In an exhausting three-and-a-half months, from mid-July until early November, he visited twenty-three states, including those in the Deep South. One newspaper correspondent groaned that Douglas talked so much about popular sovereignty "that he seems to be falling into a monomania about it, and drags it about the country with him with as much assiduity as if it were a change of linen or a toothbrush."[60] Told that the "extreme men of the South" considered popular sovereignty to be as bad as abolition, Douglas replied, "Oh! little do they know of my heart. I am no advocate of slavery; but viewing it as a matter belonging to the people and protected by the Constitution, I would never consent for Congress to touch it in any way for any purpose."[61]

After Lincoln won the presidency, Douglas expended all his efforts toward preventing secession. Shattered in health, he succumbed to a fever at the age of forty-seven on June 3, 1861, not quite two months after the first shots of the Civil War were fired on Fort Sumter.

STEPHEN A. DOUGLAS
By Duncan Styles
(lifedates unknown),
oil on canvas, 1860

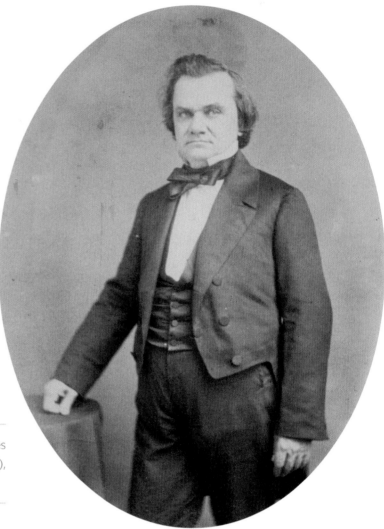

Stephen A. Douglas by James Earl McClees
(1821–1887) and Julian Vannerson (c. 1827–?),
c. 1859

Douglas's portrait by Duncan Styles (page 64), which gives evidence of having been done in haste on the back of a piece of patterned floor covering, was part of the trappings of the presidential race, and it ended up in the hands of an active member of the New York campaign.

MC

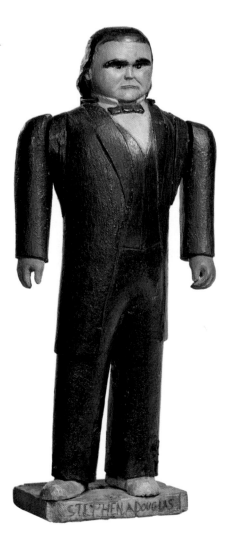

Stephen A. Douglas by an unidentified artist, polychromed
wood, c. 1858

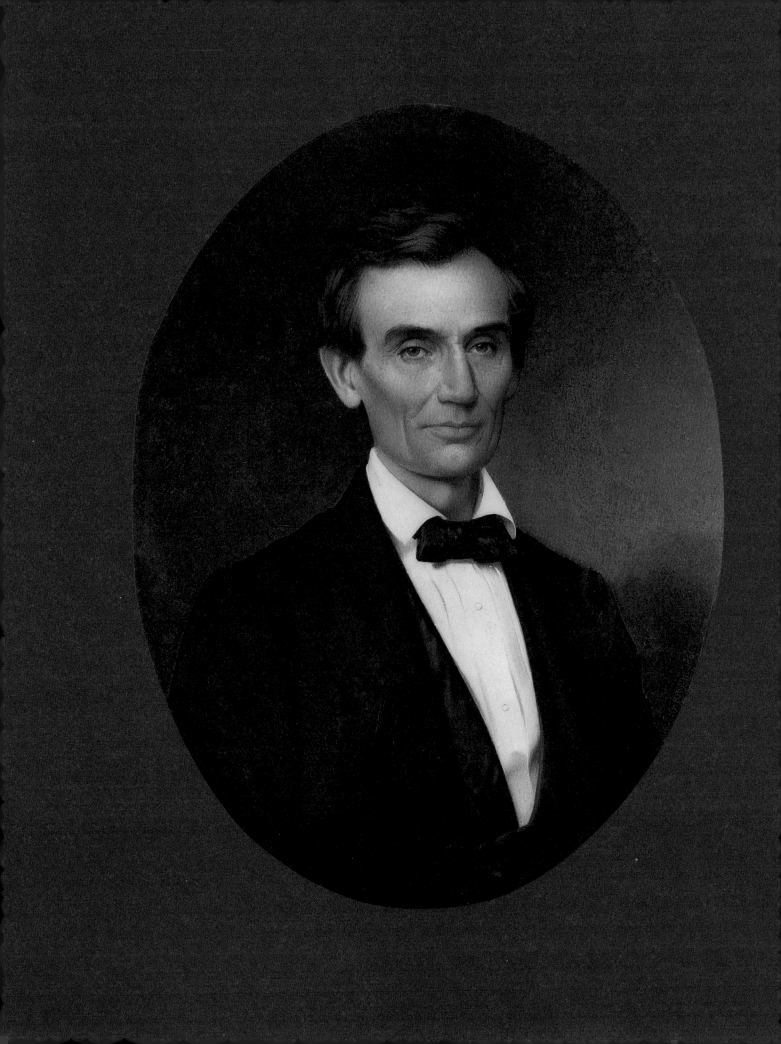

WELL BEFORE ABRAHAM LINCOLN BECAME PRESIDENT, he had a vision for the nation, which was stated in the Declaration of Independence and would extend far into the future. Its fundamental idea was liberty, which Lincoln expressed in a personal way, as he was fond of doing: "As I would not be *a slave*, so I would not be *a master*. This expresses my idea of democracy. Whatever differs from this, to the extent of the difference, is no democracy."[62] In spite of his abhorrence of slavery, Lincoln was a realist. Slavery was protected under the Constitution, and no political or social movement was going to eradicate it instantly. Yet Lincoln drew the line when it came to the expansion of slavery into the western territories. In his debates with Illinois senator Stephen Douglas and in his speeches, Lincoln could never compromise on this issue. He once compared slavery and its expansion to finding a rattlesnake. He explained that if he encountered the snake in a field he would strike and kill it. Yet if he encountered the snake in a bed where children were sleeping, he would not kill it for fear of doing greater harm. "The question that we now have to deal with," he argued in 1860, is " 'Shall we be acting right to take this snake and carry it to a bed where there are children?' The Republican party insists upon keeping it out of the bed."[63]

By the summer of 1860, having won the party's nomination at the Chicago convention in May, Lincoln was quickly becoming a national celebrity, and he was obliged to respond to scores of requests for his signature, his biography, and his picture. One special request produced an appealing miniature portrait by a Pennsylvania artist named John Henry Brown. The portrait was commissioned by Judge John M. Read of Philadelphia, a member of the Supreme Court of Pennsylvania. Read had become annoyed with the unflattering caricatures of Lincoln that the presidential contest was inevitably inspiring. With a view to publishing a respectable lithograph of Lincoln for the campaign, Read instructed the artist to execute an attractive picture of the "railsplitter," regardless of whether it was a credible likeness.

In August 1860, Brown traveled to Lincoln's hometown of Springfield, Illinois, and sought out the gangling candidate. After Lincoln consented to have his portrait painted, Brown suggested that he should be photographed as a first step. Lincoln sat for half a dozen pictures by Preston Brooks before Brown saw one to his liking. "There are so many hard lines in his face that it becomes a mask to the inner man," Brown recorded in his diary. "His true character only shines out when in an animated conversation, or when telling an amusing tale, of which he is very fond." Brown was taken immediately with Lincoln's person- ality: "I like him much, and agree with him in all things but his politics."[64] Moreover, Brown was pleased with Lincoln's appearance: he would not have to create a flattering picture after all; he could paint a lifelike portrait instead.

ABRAHAM LINCOLN
By John Henry Brown
(1818–1891), watercolor
on ivory, 1860

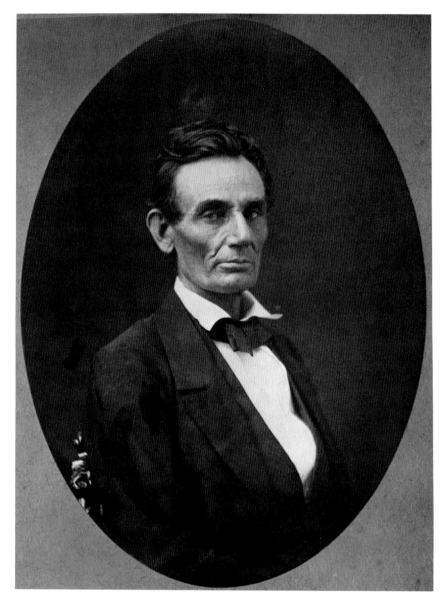

Abraham Lincoln by Samuel M. Fassett (active 1855–75?), salted-paper print, 1859

Lincoln sat to Brown on five occasions inside the state capitol, where he had been given use of the governor's office that summer to escape the throngs of visitors who descended on his house. Brown's results of capturing Lincoln on a piece of ivory with watercolors were roundly praised. Lincoln's secretary, John G. Nicolay, declared it to be "decidedly the best picture of him that I have seen." He described the miniature in a letter to his fiancée as being "about twice as large as a common quarter-size daguerreotype or ambrotype, that when magnified to life size one cannot discover any defects or brush marks on it at all."[65] The miniature was on view at the state house, and apparently a magnifying glass was made available to viewers. The local paper called it a "splendid picture" and noted that under magnification, "instead of presenting a more rugged appearance as it grows larger, the naturalness of its expression is increased."[66] In a broader historic sense, this was the estimate of the man himself as the nation became better acquainted with him as president.

JB

During the campaign of 1860, cartoonists played up Abraham Lincoln's frontier image as a rail splitter. In this cartoon, he rides the rail of the Republican Party's antislavery platform. Unlike the abolitionists, Lincoln was personally resigned to respecting the institution of slavery where it existed under the Constitution. Yet he was firmly committed to stopping its expansion by keeping it out of the western states and territories.

The Rail Candidate by Louis Maurer (1832–1932) for Currier and Ives Lithography Company, lithograph, 1860

The presidential campaign of 1860 was the occasion for massive, emotionally charged political parades. An observer noted that a torchlight procession in Chicago for Abraham Lincoln was bigger and more imposing than any previous political parade in that city. Estimates placed the number of participants at ten thousand. Throughout the entire procession, marchers carried torches similar to this one, as well as banners and transparencies bearing portraits of Lincoln and Republican Party mottoes.

National Museum of American History, Smithsonian Institution, Behring Center

A day or two after President-elect Abraham Lincoln arrived in Washington for his inauguration on March 4, 1861, he visited the photographic studio of Mathew Brady. This image was one of several taken by Brady's cameraman Alexander Gardner. Lincoln, in the midst of the secession crises, appears deep in thought and is wearing the new beard he had begun growing after receiving a letter from a young lady suggesting that he do so. This photographic session was apparently for the benefit of *Harper's Weekly*, which published an engraved version of this image several weeks later.

By the Mathew Brady Studio
(active 1844–94), collodion
glass-plate negative, 1861

Several weeks before Lincoln secured the presidential nomination of the Republican Party on May 18, 1860, the sculptor Leonard Wells Volk asked to do his portrait. Realizing that Lincoln was unable to come often to his Chicago studio for sittings, Volk decided to make a life mask, upon which he based his bust. "There is the animal himself," Lincoln remarked when the mask was shown to him.[67]

By Leonard Wells Volk
(1828–1895), plaster, cast
after 1860 bronze original

The Southern caricaturist Adalbert J. Volck of Baltimore included in a series of etchings titled *Great American Tragedians, Comedians, Clowns and Rope Dancers in Their Favorite Characters* this image of Lincoln as Don Quixote (right), the errant knight in Cervantes's popular novel of the same name. Satiric symbolism infuses every aspect of this potent yet subtle drawing. The image of the president is reminiscent of the contemplative Lincoln photographed by Mathew Brady's Washington studio in late February 1861 (top of page). Lincoln, holding a quill pen, has made a list of Union defeats; his inkwell is in the shape of an artillery mortar. His foot rests irreverently on a stack of books labeled "Constitution," "Law," and "Habeas Corpus." Beside the legs of Lincoln's chair lie a rail and an ax, allusions to his humble beginnings, and resting against the seat back is a John Brown pike, a symbol associating Lincoln with abolition and anarchy. The picture on the wall is of Lincoln's first commander of the army, General Winfield Scott. Nicknamed Old Fuss and Feathers, Scott is bedecked in feathers.

By Adalbert J. Volck
(1829–1912), etching, 1861

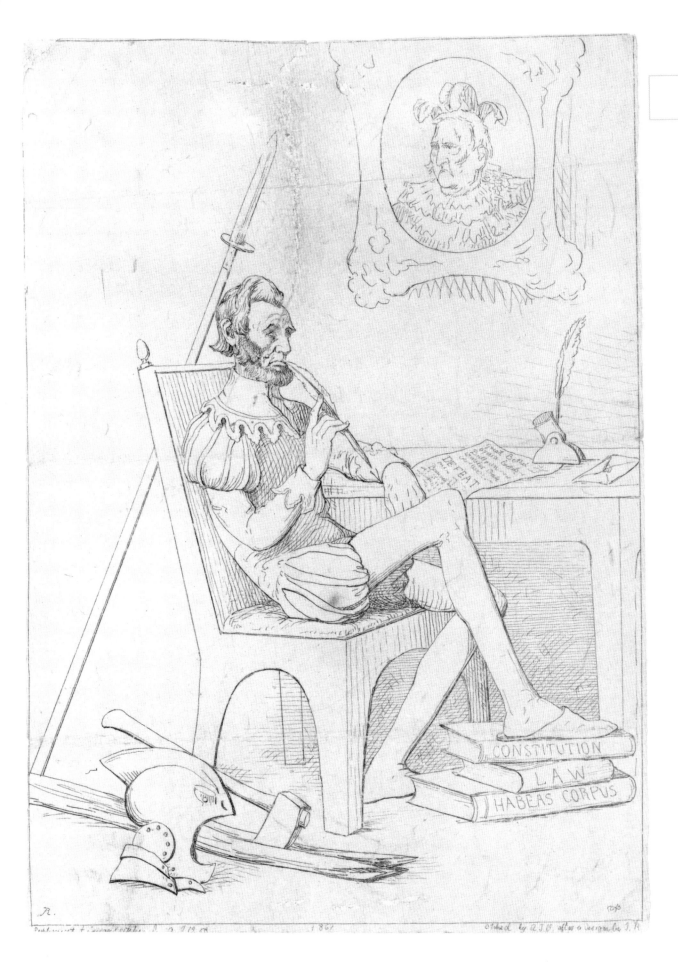

ABRAHAM LINCOLN

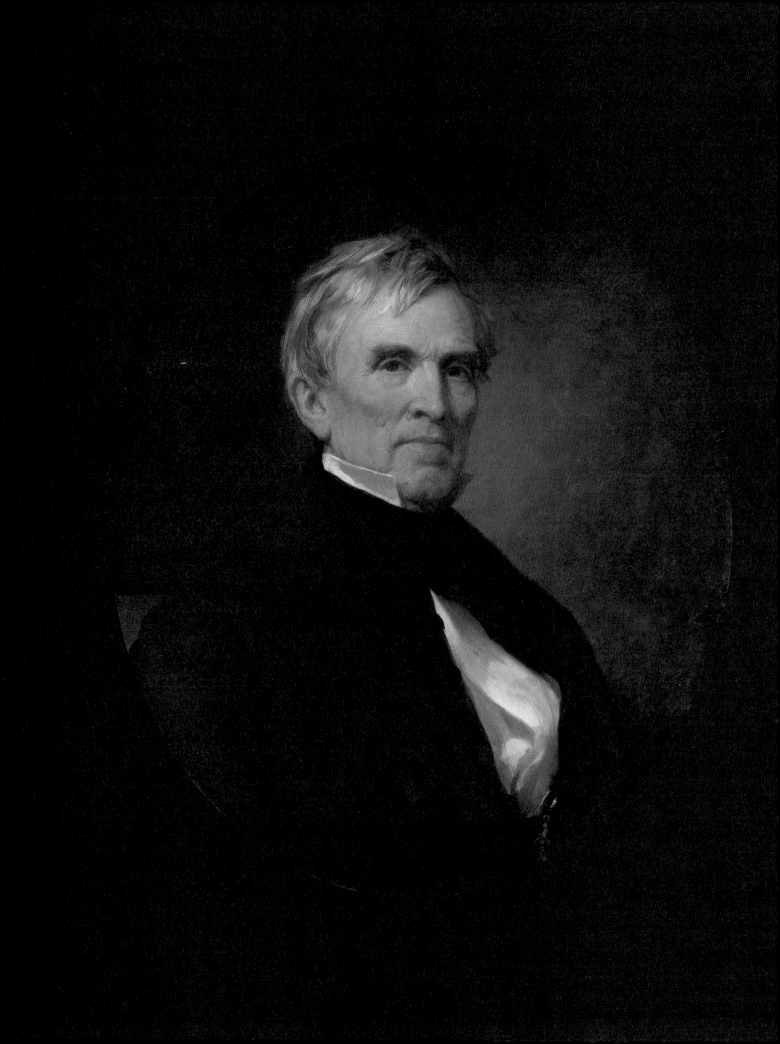

JOHN CRITTENDEN'S MOST INGRAINED INSTINCT was a respect for order and tradition, and in the escalating battle over slavery in the 1840s and 1850s, he naturally gravitated to the conciliatory strategies of his fellow Kentuckian Henry Clay, who had repeatedly sought to hold America's political order intact through peaceable compromise. To those who would risk a breakup of the Union rather than seek a middle ground, Crittenden once warned, "The dissolution of the Union can never be regarded . . . as a *remedy*, but as the *consummation of the greatest evil that can befall us.*"[68] A onetime governor of Kentucky and a member of two presidential cabinets, Crittenden faced his first test as a practitioner in the politics of conciliation shortly after winning election to the Senate in 1854. Entering into that body's burning debates over whether to permit the possible extension of slavery into the Kansas-Nebraska Territory on the principle of popular sovereignty, he argued strenuously against such a measure on the grounds that it could only heighten sectional rancor and further divide the country.

Yet the battle against popular sovereignty proved to be in vain, and as Crittenden had feared, the implementation of that policy in Kansas and Nebraska did indeed fuel the fires of sectional dissension. But that did not keep him from hoping that somehow an enduring, Union-preserving compromise on slavery could be found. When, in November 1860, Lincoln's presidential election on an antislavery platform sparked the move toward secession in the Southern states, Crittenden tried to find a way to reverse that turn of events. The result was the Crittenden Compromise, which, among other things, would restore the stipulation of the Missouri Compromise of 1820, stating that slavery could be extended only to territories south of the 36°30' latitude. Crittenden worked long and hard for his plan, and he was much admired for his dedication. One newspaper doubted that "even in the . . . Revolution" had there been "a grander . . . spectacle of true heroism" than this eleventh-hour struggle to prevent rupture of the Union.[69] But in the end, the momentum toward disunion and civil war was too great, and his effort failed. In one matter, he did succeed, however. Thanks largely to Crittenden's influence, his own slaveholding state of Kentucky did not succumb to secession.

This is George P. A. Healy's second portrait of Crittenden. He painted the first likeness in the summer of 1845 in Kentucky, where he had come to take a portrait of Henry Clay for a series of American statesmen that French king Louis-Philippe had commissioned. The later portrait was completed in 1857, and Healy most likely did it while he was in

JOHN CRITTENDEN
By George P. A. Healy
(1813–1894), oil on
canvas, 1857

Washington, lobbying Congress to authorize him to paint a series of presidential portraits for the Executive Mansion. In fact, the painting of this portrait, along with those of several other members of Congress done that year, may have been part of the artist's ultimately successful lobbying effort.

FV

Despite Crittenden's efforts to prevent disunion, in the end, eleven states seceded. South Carolina stood at the forefront, after Lincoln's election, in calling for Southern separation from the Union. A week after the presidential polls closed, one of the state's residents likened its fevered political climate to that of the French Revolution. As the days passed, this spirit of rebellion only escalated. On December 20, 1860, South Carolina declared its independence from the North and urged its more hesitant southern sisters to do likewise.

"The Union Is Dissolved!"
broadside from the *Charleston Mercury*, 1860

CHARLESTON
MERCURY

EXTRA:

Passed unanimously at 1.15 o'clock, P. M. December 20th, 1860.

AN ORDINANCE

To dissolve the Union between the State of South Carolina and other States united with her under the compact entitled "The Constitution of the United States of America."

We, the People of the State of South Carolina, in Convention assembled, do declare and ordain, and it is hereby declared and ordained,

That the Ordinance adopted by us in Convention, on the twenty-third day of May, in the year of our Lord one thousand seven hundred and eighty-eight, whereby the Constitution of the United States of America was ratified, and also, all Acts and parts of Acts of the General Assembly of this State, ratifying amendments of the said Constitution, are hereby repealed; and that the union now subsisting between South Carolina and other States, under the name of "The United States of America," is hereby dissolved.

THE

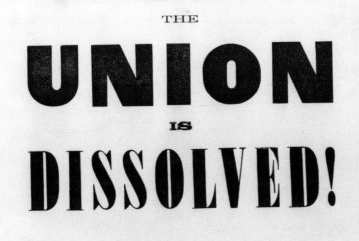

UNION
IS
DISSOLVED!

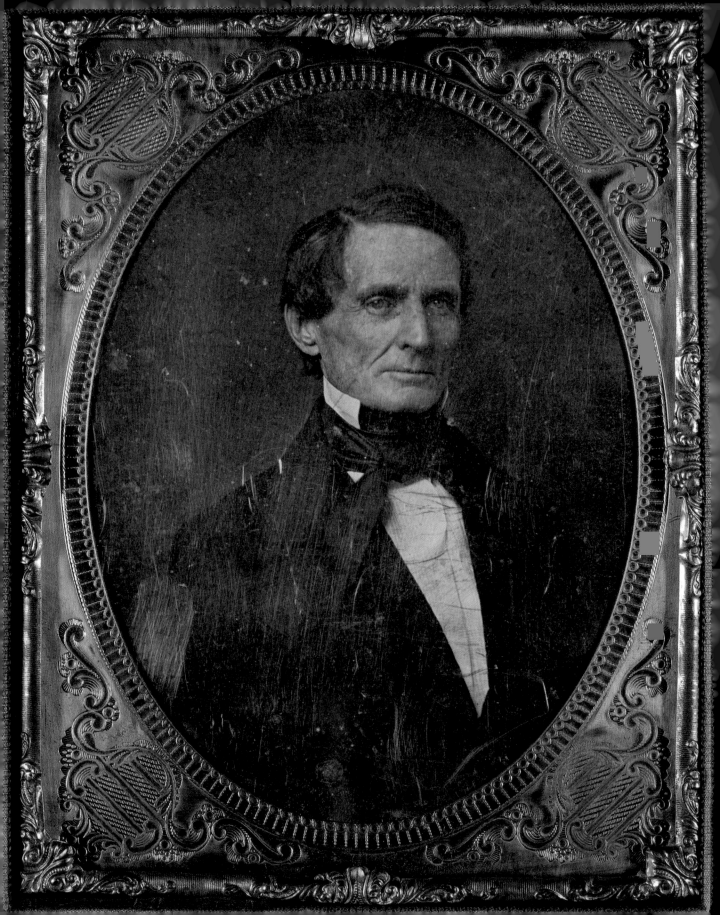

AFTER 113 YEARS, and by a special act of Congress, Jefferson Davis, former president of the Confederacy, received his citizenship back again in 1978. In observance of this occasion, Kentucky-born writer Robert Penn Warren reflected on the meaning of Davis and his times. In an article for *The New Yorker*, he noted that Davis and Abraham Lincoln were both Kentuckians, born within a year of each other and some one hundred miles apart. At an early age, both future presidents left the state, Davis for Mississippi and Lincoln for Indiana. It might be said that their political destinies were first formed when each youngster crossed the state line. In this context, Warren asked how might history have been altered if Davis had been taken north instead, and Lincoln had ventured south. "How much is a man the product of his society?" posed Warren.[70]

Jefferson Davis, a slaveholding plantation owner, was representative of the planter class in the Deep South. He aligned himself with the Democratic Party and was an advocate of states' rights from the beginning of his public career as a congressman from Mississippi. Later he served in the Senate and was an effective secretary of war under Franklin Pierce. A graduate of West Point and a veteran of the Black Hawk and Mexican wars, Davis had a predilection for military matters. On the eve of the Civil War, he was a reluctant secessionist, but with the exhaustion of a peaceful solution to the crisis, he became a confirmed rebel; he would have welcomed the command of the Confederate army, had such an offer been made. Yet the South had generals enough. Among its immediate needs were statesmen to run the fledgling government, and in this capacity Davis was eminently available. He brought more administrative experience to his presidency than Abraham Lincoln did to his.

Yet unlike Lincoln, Davis never learned to manage men, "and he was too great a character to let men manage him," observed the Southern writer and poet Allen Tate.[71] He lacked Lincoln's patience, tact, flexibility of command, and most of all his infectious sense of humor to help sway minds and ride out difficulties. In times of duress, Davis by nature became introspective. One historian has aptly called him the Sphinx of the Confederacy. Ironically, states' rights, the doctrine that had given birth to secession, severely undermined Davis's attempts to fashion a viable national government. That it was able to function for four years in the face of unremitting and adverse circumstances was, in the opinion of one Northern writer, a testament to "the sagacity, energy and indomitable will of Jefferson Davis."[72]

The daguerreotype of Davis by an unidentified photographer depicts him in his prime, near the time when he was secretary of war. This was the man who left a vivid

JEFFERSON DAVIS
By an unidentified photographer, daguerreotype, c. 1858

Jefferson Davis as he appeared four years after his marriage

By George Lethbridge Saunders (1807–1863), watercolor on ivory, 1849

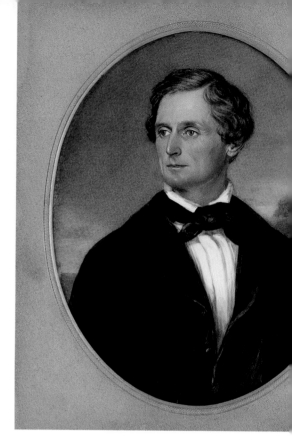

impression on Carl Schurz, an outspoken proponent of the Republican Party:

> His slender, tall and erect figure, his spare face, keen eyes and fine forehead, not broad but high and well shaped, presented the well-known strong American type. There was in his bearing a dignity which seemed entirely natural and unaffected, that kind of dignity which does not invite familiar approach but will not render one uneasy by lofty assumptions.[73]
> JB

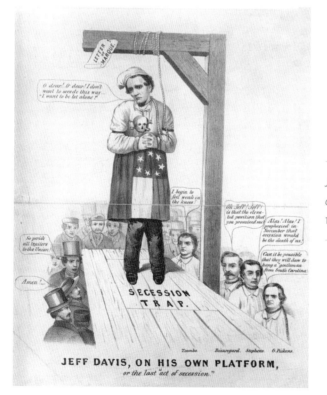

Jeff Davis, on His Own Platform, or the Last "Act of Secession" by Currier and Ives Lithography Company (active 1857–1907), lithograph, c. 1861

Howell Davis (1826–1906) was born near Natchez, ippi. At eighteen, when she married Jefferson Da-o was twice her age, she had developed a lively in-and polished social graces. In Richmond during the ar, as the wife of the president of the Confederacy, Davis admirably fulfilled her three primary roles: as ctionate spouse to a proud and sensitive husband, ttentive mother to five young children (two of whom orn during the war), and as a socially engaging first his miniature portrait of Davis was painted by John Dodge in 1849, four years after her marriage.

n Wood Dodge
893), watercolor on
349

This emerald and diamond engagement ring belonged to Varina Howell Davis.

National Museum of Ameri-can History, Smithsonian Institution, Behring Center

The expression of Jefferson Davis can be changed in this paper caricature from an open-mouthed grin to a pop-eyed scowl by pulling the tab at the bottom. Inside the cutout window the words "Fort Sumter" appear with the dates 1861 or 1863, which refer respectively to the Confed-erate and Union victories at this venerable and symbolic bastion in Charleston harbor.

By David Claypoole Johnston
(1799–1865), lithograph,
c. 1863

JEFF DAVIS,
AFTER THE FALL OF
FORT SUMTER
1861.

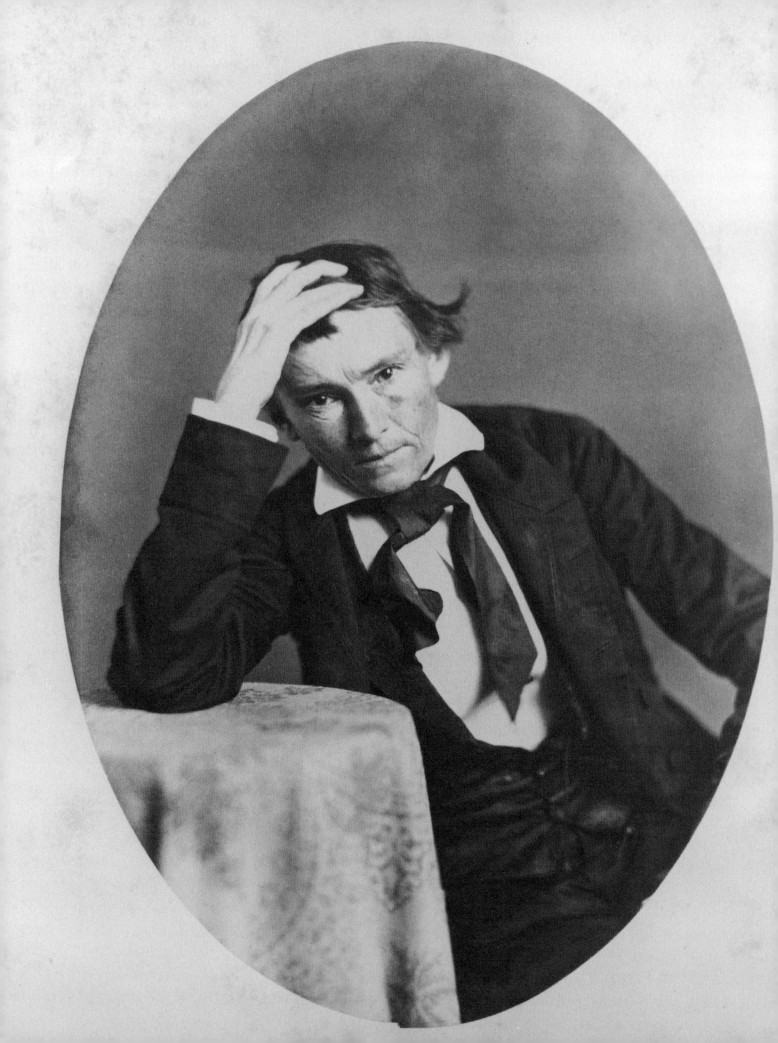

ONE OF THE MOST SUPPLE MINDS of the Confederacy was encased in the gaunt and consumptive frame of Alexander H. Stephens. No other Southern statesman better embodied the paradoxical elements inherent in the new nation itself. During his long tenure in Congress, this sallow wisp of a man had been a staunch Unionist, a devotee of Webster over Calhoun, and a friend and supporter of his Whig colleague Abraham Lincoln. Only when secession became an insolvable crisis did he cast his destiny with his native Georgia, accept the Confederate vice presidency, and proclaim, in one of the most notable speeches of the hour, that slave ownership together with its underlying assumption of racial inferiority was the "corner-stone" on which the new republic rested.

Stephens played his most important role in framing the constitution for the provisional Confederate government. During the subsequent four years, however, his penchant for constitutional restraints and his doctrinaire scruples turned him into the South's leading obstructionist. Having early lost the ear of President Jefferson Davis, he withdrew into melancholy isolation and generally displayed less leadership ability than at any previous time in his career.

This candid salted-paper print photograph of Stephens was part of a rare, calligraphically produced album titled *Portraits (and Autographs) of the President of the United States, Vice President, Cabinet and Eminent Senators and Representatives. Taken from Life, Washington, D.C. 1859*. Although no photographer was mentioned, the images are identical to extant photographs credited to the studio of James E. McClees, in which Julian Vannerson and Samuel Cohner were operators. The image of Stephens is believed to have been taken in early 1858, apparently at the request of George P. A. Healy, who wished to use it for the basis of a portrait. Healy had seen Stephens assume this same pose in the House of Representatives, and he wanted to replicate it in an oil painting, which he signed and dated 1858. Healy most likely selected McClees's newly opened Washington studio—a branch of his Philadelphia establishment—to do the photography because Julian Vannerson was the most experienced photographer of politicians in town.

Stephens was then a Georgia congressman on the verge of retirement. Although exhausted by work, he was still proving to be an effective parliamentarian. In 1854 he had been instrumental in steering the controversial Kansas-Nebraska Bill successfully through the House. Now he was entrenched in the confusing muddle of securing passage of the Lecompton Constitution, which, if passed, would have provided for a pro-slavery state of Kansas. As a compromise, Stephens helped to engineer the English Bill, which effectively

ALEXANDER H. STEPHENS
Attributed to James Earl
McClees (1821–1887)
and Julian Vannerson
(c. 1827–?), salted-paper
print, c. 1858

shifted the acrimonious debate away from slavery to the question of land—the future size of the state.

The unusual composition of this photograph suggests Stephens's true mental and physical state at the time. The image is that of an anguished and diminished-looking man. At maturity, Stephens stood five feet seven inches and weighed less than a hundred pounds. Ill health plagued him all of his life. Neuralgia, rheumatoid arthritis, and recurring headaches were among his debilitating ailments. Little wonder that his agile mind often succumbed to moods of despair. "Thus life passes away," he wrote in 1858, at the age of forty-six. "Wrinkles in the face, gray hairs on the head, and dimmed vision in the eyes. In a few more years, loss of teeth, bending shoulders, and trembling limbs will close the scene."[74] Surprisingly, he lived to be seventy-one. Unlike Jefferson Davis, Stephens welcomed back his citizenship and served again in Congress from 1873 to 1882.

JB

Frederich Graetz's caricature of Alexander H. Stephens, *The Nestor of the Confederacy*, appeared as a supplement to *Puck* magazine (No. 269) in 1882. In spite of Stephens's precarious health, his mind and zest for public service remained strong until the end of his life. He served in the U.S. House of Representatives from 1873 until 1882, when he resigned to enter the Georgia gubernatorial race. He was elected and died a few months later in the governor's mansion in Atlanta.

By Frederich Graetz
(c. 1840–c. 1913),
chromolithograph, 1882

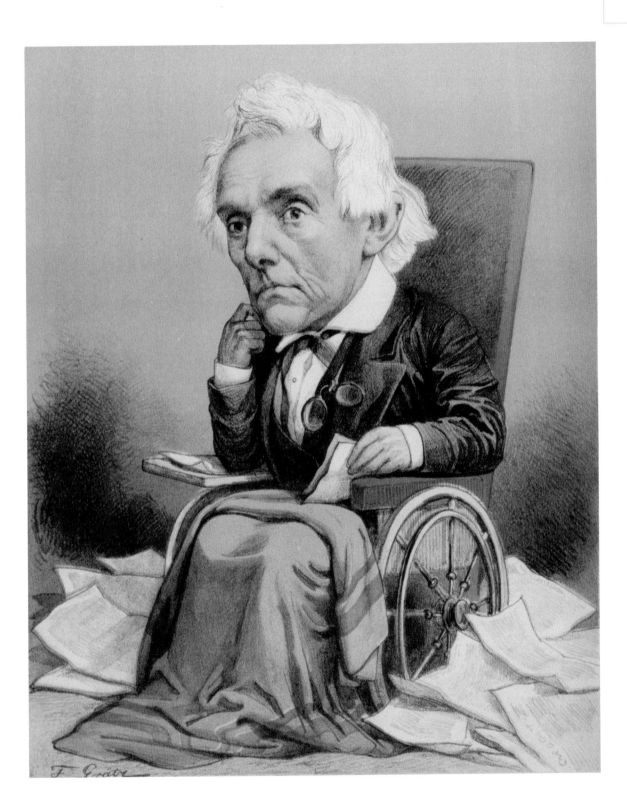

ALEXANDER H. STEPHENS

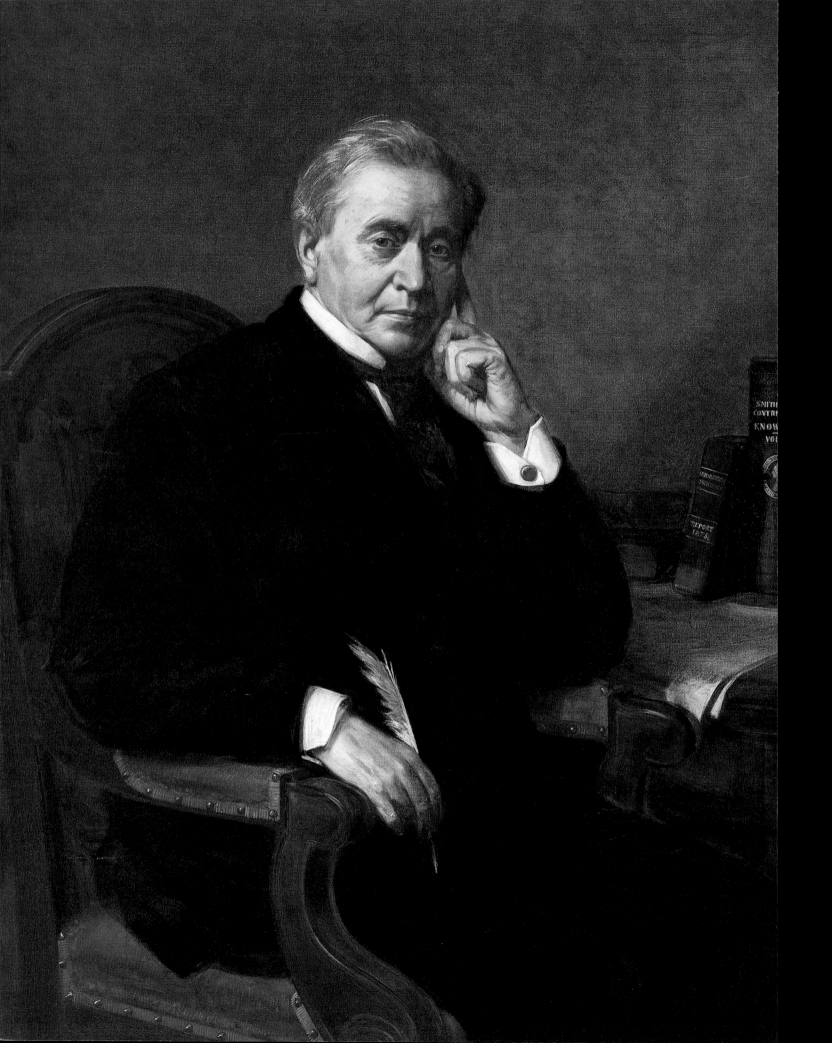

JOSEPH HENRY WAS an eminent American scientist and educator at the College of New Jersey (Princeton) before being selected to head the newly established Smithsonian Institution in 1846. He was a pioneer in the field of electromagnetism and the telegraph, and he invented the electric motor. He was also thoroughly committed to making the Smithsonian worthy of its mandate to increase and diffuse knowledge throughout the world. Curiously, Henry's vision for the Smithsonian was not the modern complex of extensive buildings and multiple museums that America knows today. He thought the Smithsonian endowment of roughly half a million dollars could not support the cost of building museums, which he believed would be impractical for most nineteenth-century Americans to visit. Henry had not even been in favor of the building of the structure now known as the Castle. Rather, he envisioned an institution whose core mission was intellectual and whose realm of inquiry was international. He favored the dissemination of knowledge in a wide range of fields, including physics, astronomy, chemistry, natural history, and archaeology, through an annual publication called *Smithsonian Contributions to Knowledge*. Before the Civil War, publications of this kind were expensive to produce, especially if they contained lithographic illustrations. Henry believed the institution could financially assist scientists in the publication of their findings and also encourage the foreign exchange of scientific papers and journals.

The Smithsonian Institution was not yet fifteen years old when the secession crises teetered on erupting into an all-out civil war in the spring of 1861. The institution's physical structure consisted of a single red sandstone building, designed by James Renwick Jr. and completed in 1855. The building, designed like a castle, and grounds occupied an expanse of grassy meadow. To the east lay the unfinished Capitol, and to the west rose a stub of stone masonry that, when completed, would be a 555-foot obelisk to the memory of George Washington. The Castle's towers overlooked the Patent Office Building to the north and the Potomac River to the south. On the opposite bank lay Virginia. Just up the river on a majestic hill, the columned front of Arlington, the home of Robert E. Lee, overlooked the city. Downriver, the rooftops of Alexandria, the hometown of both Washington and Lee, could be seen distinctly with a pair of binoculars.

The Confederate bombardment of Fort Sumter on April 12–13 had practical implications for Joseph Henry and the Smithsonian, as it did for all of Washington. On April 15, President Lincoln issued a proclamation declaring that an insurrection had commenced. He called on the states to send 75,000 volunteer militia to the unprotected capital. Two days later, a secession flag—visible from the Castle towers and the White House—was hoisted

JOSEPH HENRY
By Henry Ulke
(1821–1910), oil on
canvas, 1875

atop Alexandria's Marshall House Hotel in celebration of the Virginia state convention's recent vote for a referendum for secession. On April 19, Southern firebrands in Baltimore rioted when the Sixth Massachusetts Volunteers, in answer to Lincoln's call, passed through the city. Rebels cut telegraph lines, isolating Washington from the North. For several anxious days, residents and city authorities alike feared that the capital would be attacked, "if not by the Southern Confederacy," wrote Joseph Henry, "by reckless filibusters, who, taking advantage of a state of war, will endeavor to surprise the city."[75] His opinion was reinforced by Secretary of War Simon Cameron in a memo of April 20, informing Henry that the colonel of ordnance would be issuing the Smithsonian twelve muskets and 240 rounds of ammunition "for the protection of the Institute against lawless attacks."

From the beginning, Henry had emphasized the need for the institution to be apolitical and autonomous of government interference. To demonstrate the institution's neutrality,

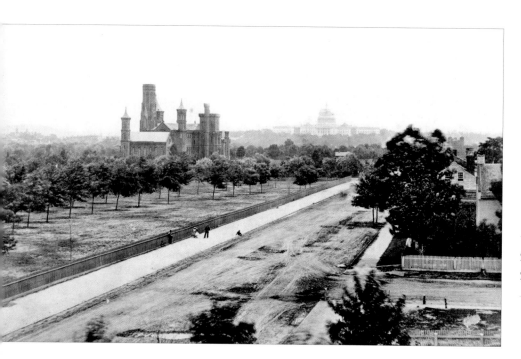

Smithsonian Castle with the Capitol in the distance
Smithsonian Institution Archives

Henry did not fly the American flag over the Castle during the conflict. He was criticized for this, and his patriotism was questioned by some, but never by President Lincoln or his administration. Henry believed that in the event of a hostile attack, the institution might fare better if it flew no colors at all, especially during that precarious spring of 1861. Ironically, Henry's immediate concern was not fending off attacking Southerners, but coping with the influx of Yankees seeking quarters in such public buildings as the Capitol and the Patent Office. When authorities suggested the Smithsonian as a temporary barracks, Henry argued instead that its use as an infirmary would be "more in accordance with the spirit of the Institution."[76] The War Department respected his wishes and did not impose upon the institution. Still, Henry proved to be a valuable asset to the administration. He and President Lincoln liked and admired each other's talents, although their political philosophies differed significantly. Henry believed that war was a mistake and that it would not necessarily lead to reconciliation between North and South. Nevertheless, he placed himself and the institution at the service of Federal authorities whenever science could lend a hand to the war effort.

In June 1861, aeronaut Thaddeus S. C. Lowe brought his balloon to the Smithsonian for Henry's inspection and to make an ascent to test the use of telegraphing from the air to the ground. Henry supported Lowe's efforts to provide the Union army with aerial reconnaissance. Likewise, he cooperated with Albert J. Myer, the army's first chief of the signal corps, in testing a system of lantern signals at night from the Castle's highest tower. In February 1862, Henry was named to a three-member navy advisory commission to assist the government in assessing such scientific innovations as the design of ironclad ships and new weapons. The board's formal evaluations on hundreds of proposals, many of them impractical, saved the government from spending money on bad inventions.

Throughout the conflict, the Smithsonian experienced what Henry called "interruptions" of its own programs. One of Henry's first scientific endeavors as secretary was to establish a national network of volunteer weather observers, who would send monthly reports to the Smithsonian by mail or telegraph. The war largely interfered with these means of communication, especially hindering news from the South and West. There would be other interruptions for sure, but no event was as devastating as the Castle fire on January 24, 1865. An improperly installed stovepipe caused the fire, which did extensive damage to the building and collections. Worse still, most of the Smithsonian's early records were reduced to ashes. Within days the military had constructed a temporary roof, and the

building was eventually restored. Yet the bulk of Henry's letters, some 85,000 pages, were mostly irretrievable. "In the space of an hour was thus destroyed the labor of years," wrote Mary Henry in her diary of her father's loss. Mary went on to record how the letters had been "written with great care & were in answer to questions upon almost every subject. . . . It is next to losing Father to have them go."[77]

JB

In a memo of April 20, 1861, Secretary of War Simon Cameron wrote Joseph Henry that the colonel of ordnance would be issuing the Smithsonian twelve muskets and 240 rounds of ammunition "for the protection of the Institute against lawless attacks."

Smithsonian Institution
Archives

Mary Henry (1834–1903) was the second child and eldest daughter of Joseph Henry. She was twenty-seven when the war began, unmarried, and living in the Castle with her family. A photograph of her reveals a comely young lady, who, given her father's prominence, would seemingly have had many opportunities to meet prospective suitors. Yet she never married. Between 1858 and 1868, Mary kept a diary, and her entries offer glimpses of how the Smithsonian functioned during the war years. She recounts the ongoing scientific activities of her father and the changes the city of Washington experienced as it coped with an escalating Union army in its midst. She wrote about the grandeur of the camps—the colorfully uniformed soldiers and the splendor of the officers—and about death and disease and the mud and squalor that invariably followed an army. Her descriptions of her brother's fatal illness and last hours are especially poignant against the backdrop of war and underscore the frailties of the human condition in every time and age.

Undated photograph,
Smithsonian Institution
Archives

Faces of War

EFFORTS TO RECORD THE Civil War have traditionally taken a variety of familiar medi-
ums, including letters, diaries, books, recordings, and more recently a plethora of Web
sites pertaining to almost every military and social aspect imaginable. But paintings,
drawings, and photographs—especially those executed during the conflict—provide
some of the most realistic commentary of all. The portraits of soldiers, martyrs, and
spies illustrated here are no exception, and they represent the best Civil War like-
nesses at the Smithsonian. More than just pictures in a book, they are historical artifacts
whose provenances trace back to that era of great national discord.

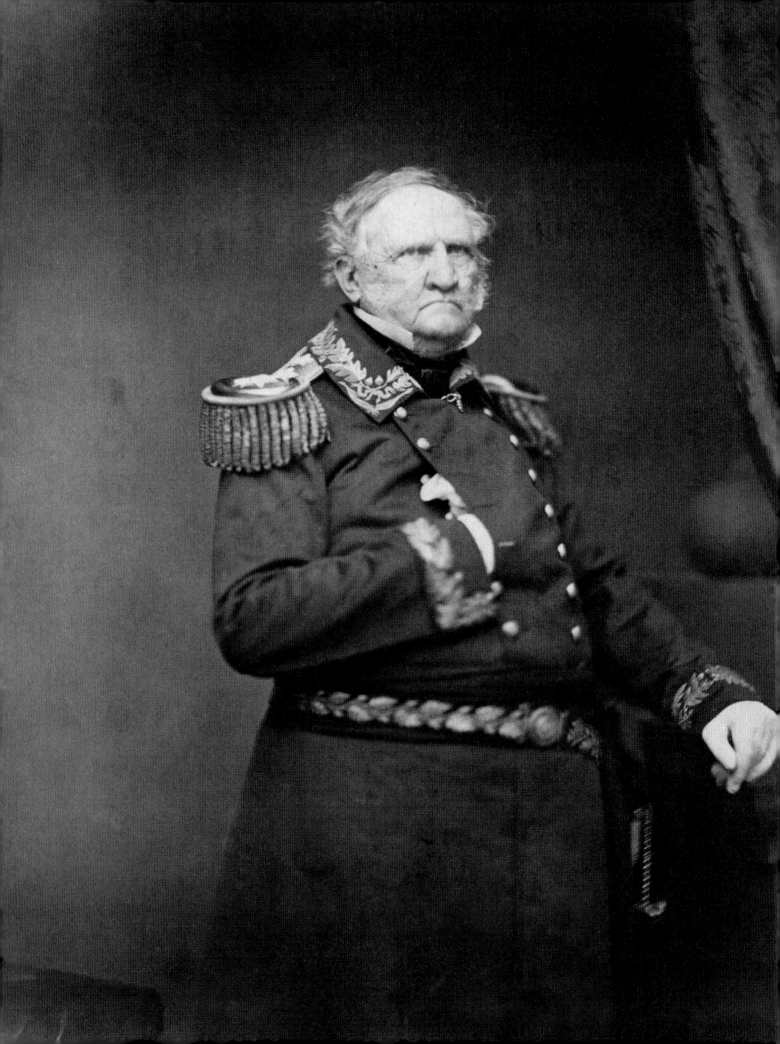

AT THE AGE OF SEVENTY-FOUR, Lieutenant General Winfield Scott, the army's senior commander, was still the picture of intense pride and fusty grandeur. His expansive uniform coat, no longer as trim fitting as it had been five decades before, at the start of his illustrious military career, was ample background for the gold stars, gilded buttons, and clusters of silk braid to which he was privileged by rank and partial to wearing. A veteran of the War of 1812 and a hero of the Mexican War, Scott had served under fourteen presidents, beginning with Thomas Jefferson. To the nation at large, he was known as the "old soldier." As he demonstrated in the studio of Mathew Brady, he could still carry himself erect, all six feet, five inches of bulky frame, but only with increasing difficulty. Standing motionless for even a few seconds of exposure time was harder than it had ever been to stand at attention, as evinced by the blur of his right coat cuff and prodigious belt and buckle. Scott had always been a stickler for military regulations, codes of dress, and conduct, earning himself the sobriquet Old Fuss and Feathers. Age and declining health had naturally diminished the general's renowned panache. Gout and dropsy were two of his greatest complaints; the former made walking painful, and the latter, coupled with his corpulence, made riding a horse impossible. If the general was reduced to commanding from a carriage, he was still perfectly at ease seated at a dinner table.

At the time this photograph was taken, on the eve of the Civil War, Scott's mind was as focused on military affairs as ever, which is what mattered most in the days following Lincoln's election. With secession brewing in South Carolina, Scott moved his headquarters from New York to Washington to better monitor the defense of Forts Moultrie and Sumter, which were guarding Charleston harbor. In the nation's capital, Scott organized the local defenses in preparation for Lincoln's inauguration. Afterward, the president's immediate concern was whether to provision Fort Sumter, which Scott argued could not be done without the risk of provoking war. He recommended that the fort be evacuated, but Lincoln was unwilling to make a concession to the Confederacy. For the principle of nationhood, he was willing to take the risk, especially if the Confederates fired first—as he suspected they would do—so he ordered Scott to send supplies to the fort.

If the war was beginning more or less as Lincoln had foreseen, the ultimate path to victory would be closer to what the wizened old general had predicted: that the war could last three years and some three hundred thousand soldiers would be needed to win it. These predictions seemed dire at the time but in the end proved to be grossly underestimated. Moreover, Scott discussed a plan to blockade the Confederacy's eastern seaboard

WINFIELD SCOTT
By the Mathew Brady
Studio (active 1844–94),
salted-paper print, c. 1861

and the Gulf of Mexico, and to seize control of the Mississippi and Ohio rivers. This Anaconda Plan was designed to sever the South's two most western states, Texas and Arkansas, and to squeeze the Confederacy into submission. Although never officially endorsed, the plan was implemented in phases throughout the war. In the beginning, however, it was seen as impractical and not politically expedient enough to quell the cries of "on to Richmond," by those who thought the logical step was to take the Confederate capital. By the fall of 1861, Scott found himself only nominally in command of the army, after having been gently pushed aside by Lincoln's new commander, General George B. McClellan, who was physically able to take the field. His effectiveness at an end, Scott retired at the beginning of November and returned to his home in New York.

JB

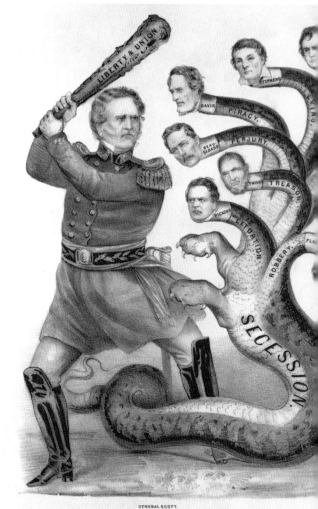

THE HERCULES OF THE UNION,
SLAYING THE GREAT DRAGON OF SECESSION.

General Scott, the Hercules of the Union, Slaying the Great Dragon of Secession by an unidentified artist, lithograph, 1861

This paper silhouette depicts Winfield Scott as he looked—fit and trim—twenty-one years before the start of the Civil War.

By Auguste Edouart (1789–1861), positive cut and lithograph, 1840

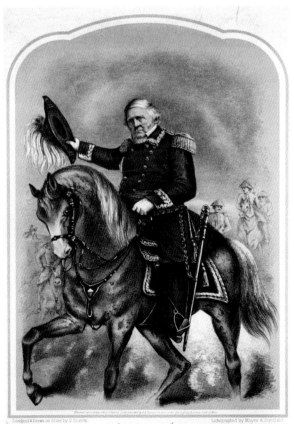

This print of General Scott riding a horse was perhaps indicative of the North's optimistic view for a quick and short war. Scott was not of this mind, however, and sensed that his usefulness as a military leader was at an end. He retired as general in chief in the fall of 1861, and in his letter of resignation he cited the poor state of his health; he said that he had not been able to mount a horse in more than three years, and that it pained him to walk even a few paces at a time.

By Otto Starck (lifedates unknown), lithograph with tintstone, 1861

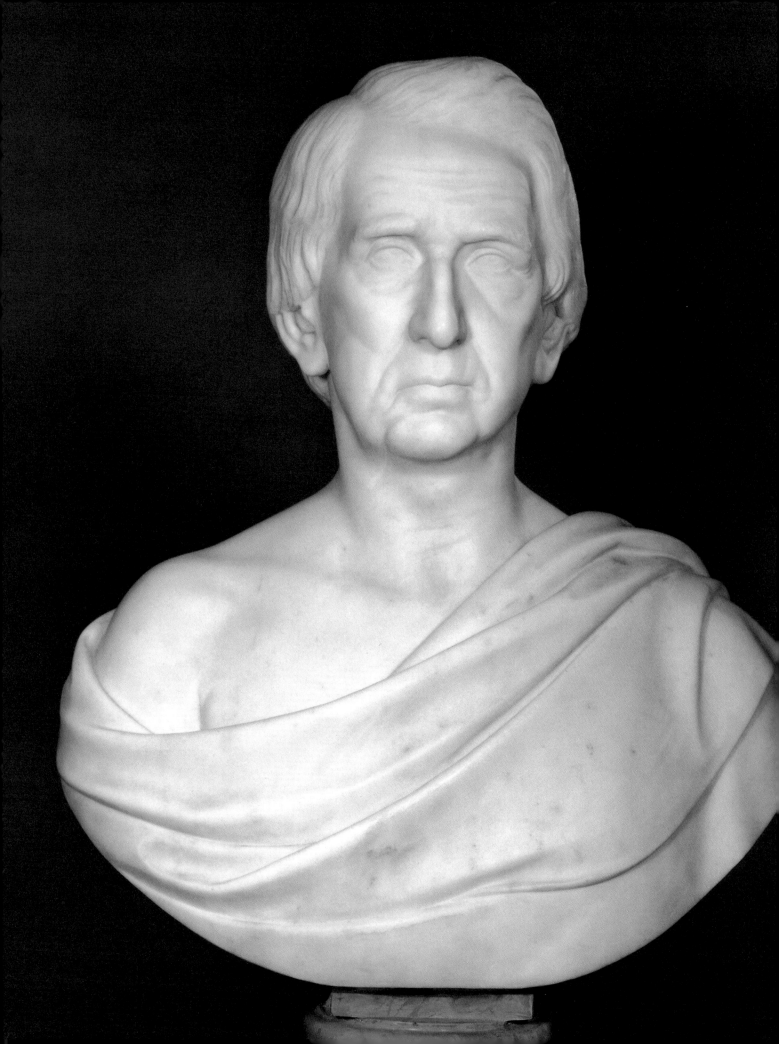

SEASONED POLITICIANS WERE surprised when William H. Seward was passed over for the Republican presidential nomination in 1860 in favor of Abraham Lincoln. Seward was by far the better-known and more experienced candidate. His two terms as governor of New York, combined with his long career in the U.S. Senate, had given him a national reputation. In the opinion of one journalist, he was the "central figure of the whole [antislavery] movement, its prophet, priest, and oracle." When his credentials for the nomination were questioned, he let it be known that he considered himself the "chief teacher of the principles of the Republican party before Lincoln was known other than as a country lawyer of Illinois."[78] In his hometown of Auburn, New York, Seward's rhetoric inspired confidence; in anticipation of his nomination, supporters trundled the town cannon from the community park and positioned it on the lawn of his brick house, making ready for a celebration.

Yet Abraham Lincoln, a "prairie politician" in Seward's opinion, proved a formidable candidate, underestimated by all but his own ardent supporters. Although bitter over his defeat, Seward forsook thoughts of ending his public career and accepted Lincoln's offer to become secretary of state rather than "leave the country to chance."[79] Events soon proved Seward wrong about Lincoln's qualifications. At the height of the secession crises, Lincoln refused Seward's conciliatory advice to evacuate the Federal garrison at Fort Sumter. Lincoln's decision to reinforce it was the wiser one, because the new Confederate nation had no intention of being wooed back into the Union as Seward had hoped. Seward's brazen memorandum of April 1, 1861, titled "Some Thoughts for the President's Consideration," in which he in essence volunteered to become the administration's foreign policy czar, was an earnest and misguided attempt to probe Lincoln on his grasp of statesmanship. Lincoln politely and firmly declined his suggestions. Thereafter, Seward acknowledged Lincoln's authority and came to admire his extraordinary sense of justice and compassion. He quickly showed himself to be an outstanding cabinet member and became a friend and confidant of the president throughout the war. He was especially effective in urging Lincoln to suspend the writ of habeas corpus—denying persons arrested by the government the right to a court hearing to determine whether they are lawfully detained—and in maintaining neutral relations with Great Britain. It was a measure of his fidelity to Lincoln's policies that he was targeted by the conspirators against the president on the night of April 14, 1865. Seward was at home recuperating in bed from injuries sustained in a carriage accident a few days before, when he was attacked by a knife-wielding intruder, Lewis Paine. Seward, who barely

WILLIAM H. SEWARD
By Giovanni Maria
Benzoni (1809–1873),
marble, 1872

escaped death, bore the scars from Paine's knife on his neck and right cheek for the rest of his life.

Italian sculptor Giovanni Maria Benzoni could scarcely ignore Seward's facial defect in the early 1870s, when he carved a marble bust of the retired statesman as he passed through Rome during his world tour.[80] Post–Civil War photographs of Seward always showed him in profile, as does his image by Mathew Brady's studio taken before the war.

JB

William H. Seward by the Mathew Brady Studio (active 1844–94), albumen silver print, c. 1860

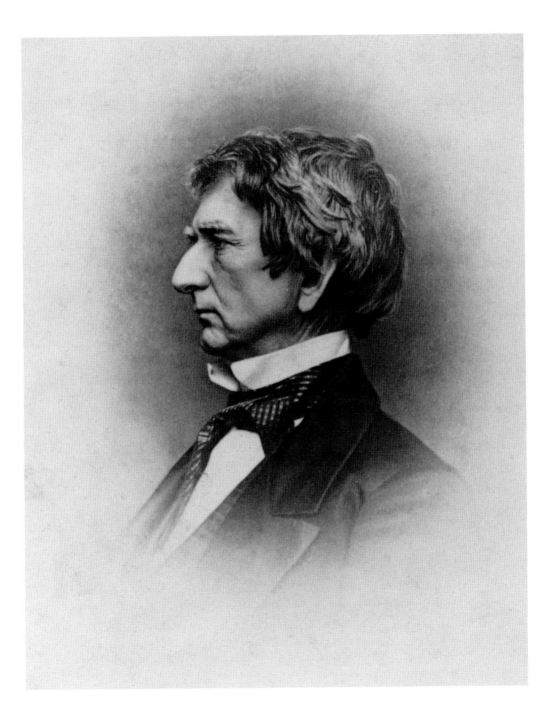

WILLIAM H. SEWARD

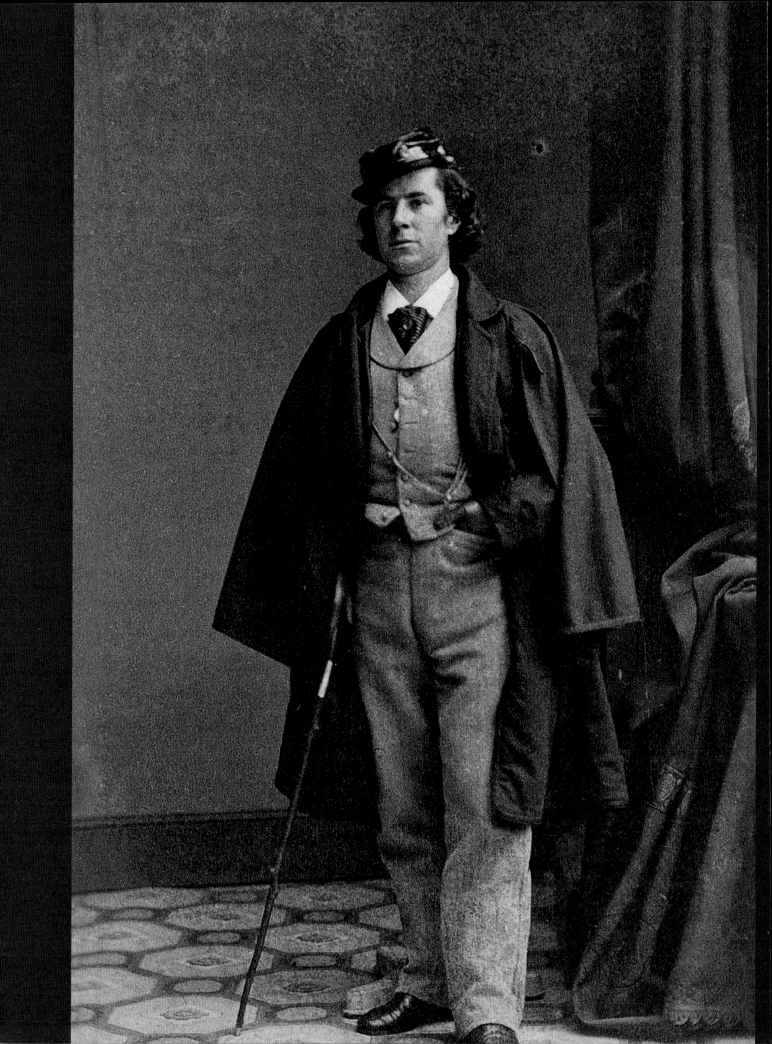

A NATIVE OF MALTA, NEW YORK, Elmer E. Ellsworth had aspirations of becoming a professional soldier from his youth. Although his early education was meager and disqualified him from attending West Point, Ellsworth moved to Chicago and organized what became the U.S. Zouave Cadets. This volunteer militia unit went on tour in 1860 and won admiration for the precision of its close order drill and for its brightly colored, Algerian-inspired uniforms of short jackets, baggy pants, and gaiters.

Ellsworth became a friend of Abraham Lincoln during the fall campaign of 1860 and accompanied him to Washington for his inauguration. With the outbreak of hostilities, Ellsworth hurried to New York City and organized the First New York Fire Zouaves, which became the Eleventh New York Volunteer Infantry. This regiment, composed of city firemen, was one of the first to arrive in Washington. The Zouaves proved to be expert at putting out city fires—they saved Willard's Hotel from burning—but they were rowdy soldiers and sorely tested Ellsworth's efforts to instill in them a sense of military discipline. Immediately after their commander's death in Alexandria, the Zouaves threatened to burn the city in retaliation. Union authorities quickly removed them from town and set them to work digging earthworks for the new Fort Ellsworth, which overlooked the city.

JB

ELMER E. ELLSWORTH
By the Mathew Brady
Studio (active 1844–94),
albumen silver print,
c. 1861

This cover of *A Requiem*, composed in memory of Colonel Elmer Ellsworth, is decorated with scenes recalling his brief and tragic Civil War service as the commander of the Eleventh New York Volunteer Infantry. At dawn on May 24, 1861, Ellsworth's command participated in the first Union invasion of Northern Virginia. The Eleventh was ordered to help capture the city of Alexandria, where above the roof of the Marshall House Hotel on King Street flew a large Confederate flag, which was allegedly visible from the White House, some eight miles away. The exuberant young Ellsworth, age twenty-four, could not resist the chance to seize the flag. With a small detail of men, he hastened to the hotel and made his way to the rooftop flagpole, where he lowered the flag. While Ellsworth was rolling it up, the soldiers were descending the staircase when from out of the shadows they were surprised by the innkeeper, James W. Jackson. Jackson leveled a double-barreled shotgun at Ellsworth and killed him instantly with a shot to the chest. Jackson, whose second shot missed, was himself shot and bayoneted to death by Private Francis E. Brownell.

Ellsworth's funeral services were held in the White House, where thousands of mourners viewed his corpse lying in state in the East Room. Throughout the conflict, his name, face, and heroism would be recalled on stationery, in sheet music, and in memorial lithographs. One New York regiment, the Forty-Fourth Volunteer Infantry, would dub themselves the "Ellsworth Avengers." Francis E. Brownell, the soldier who killed Ellsworth's assailant, bequeathed several artifacts to the Smithsonian Institution, including the weapons used in the incident and his congressional Medal of Honor.

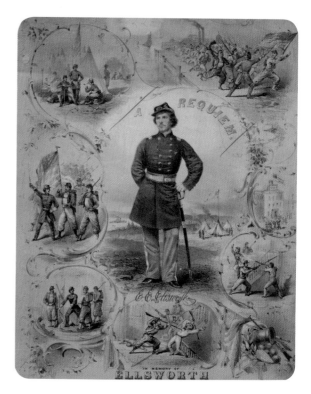

National Museum of
American History,
Smithsonian Institution,
Behring Center

The innkeeper of the Marshall House, James W. Jackson, used this English-made double-barreled shotgun to kill Colonel Elmer Ellsworth as he descended the stairs of the hotel with the Confederate flag he had just removed from the flagpole over the roof.

National Museum of
American History,
Smithsonian Institution,
Behring Center

These envelopes commemorate Elmer Ellsworth and his death inside of the Marshall House in Alexandria.

National Postal Museum, Smithsonian Institution

The Medal of Honor, the highest award for valor that combat veterans can attain, was inaugurated during the Civil War. After the war, Francis E. Brownell twice put his name forward to receive the medal and succeeded a third time with the help of his congressman. Brownell received his decoration in 1877, inscribed with his name and organization. He returned the medal to the War Department, with the request to describe the action. He was given a new medal, inscribed: "The Congress to Sergt Frank E. Brownell, 11th N.Y. Vol Inf'y for gallantry in shooting the murderer of Col. Ellsworth at Alexandria, VA, May 24, 1861." Although Brownell received his medal long after the event, his medal marked the first action in the Civil War to merit the award.

National Museum of American History, Smithsonian Institution, Behring Center

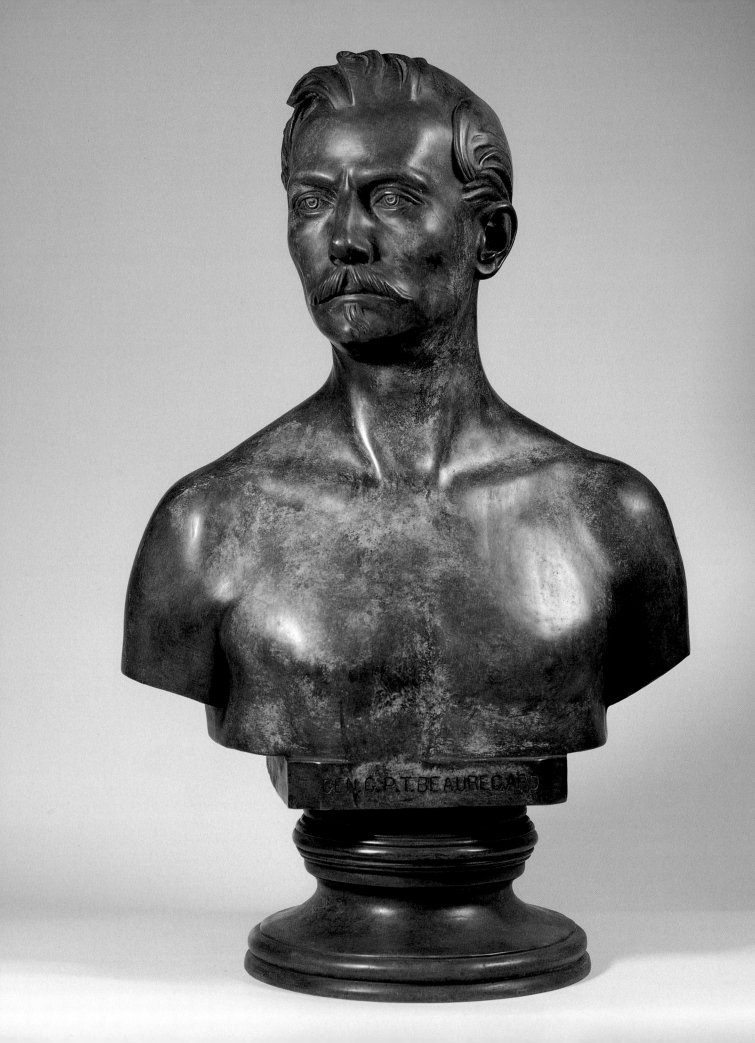

GEN. G. P. T. BEAUREGARD

FEW MILITARY FIGURES of either side were more steeped in the romance of the Civil War than General Pierre Gustave Toutant Beauregard. The ring of his name even evoked an exotic aspect about this Louisiana Creole. Physically, he was not out of the ordinary. He stood five feet seven inches and weighed about one hundred and fifty pounds. He had an olive complexion, dark eyes, and a crop of jet-black hair that would begin to turn white during the first months of the war. A foreign dignitary, seeing him in camp after the First Battle of Manassas in 1861, observed:

> Face, physiognomy, language and accent, everything about him denotes his French origin. . . . He is quick and cutting. Though well brought up, he often hurts others, less by the things he says than by the way he says them. He does not attempt to restrain his ardent personality, and he is well aware of his reputation, to which a brilliant military success has added a legitimate amount of self-confidence.[81]

Admirers thought of him as a "Napoleon in gray." If the comparison was premature and overly flattering, one could not deny this professional soldier's flair for the military life. His biographer wrote that his staff "glittered with former governors and senators serving as voluntary aides."[82] His headquarters was routinely bedecked with gifts of flowers and keepsakes from Southern belles.

In the beginning, the adulation for Beauregard was understandable. No other Confederate officer or official enjoyed his ready success. Early in 1861, Beauregard, newly appointed superintendent of West Point, had resigned his army commission to don a Confederate general's uniform. Assigned command of the forces in Charleston, Beauregard carried out the orders for the bombardment of Fort Sumter. That success earned him a field command of one of the two armies that would later form the redoubtable Army of Northern Virginia. Together with his senior officer, General Joseph E. Johnston, Beauregard would win the First Battle of Manassas, and because of his reputation, he would garner the most recognition. It was during a tense moment of that battle that Beauregard identified a serious design flaw in the Confederate flag; when unfurled and at a distance, it could not be distinguished from the American flag. Afterward, Beauregard designed a new battle flag, the one traditionally recognized today as the flag of the Confederacy, although it was never officially approved by the Confederate Congress.

The Manassas campaign was a testing ground of men, too, and ironically the victor

P. G. T. BEAUREGARD
By Edward Virginius
Valentine (1838–1930),
bronze, 1978 cast after
1867 plaster

himself evinced some serious flaws as a commander. Douglas Southall Freeman summed them up in his authoritative study, *Lee's Lieutenants*: "Beauregard never could be rid of his Napoleonic complex or be induced to shape his strategical plans in terms of available force and practicable logistics."[83] Moreover, his indiscretion in his correspondence to authorities in Richmond, particularly President Jefferson Davis, prevented him from winning any major permanent command during the war.

JB

P. G. T. Beauregard by Charles DeForest Fredricks (1823–1894), albumen silver print, 1861

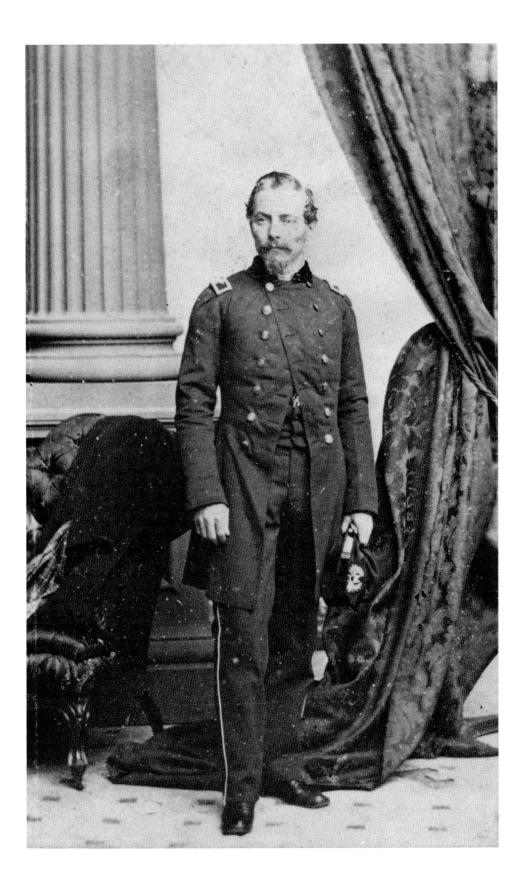

P. G. T. BEAUREGARD

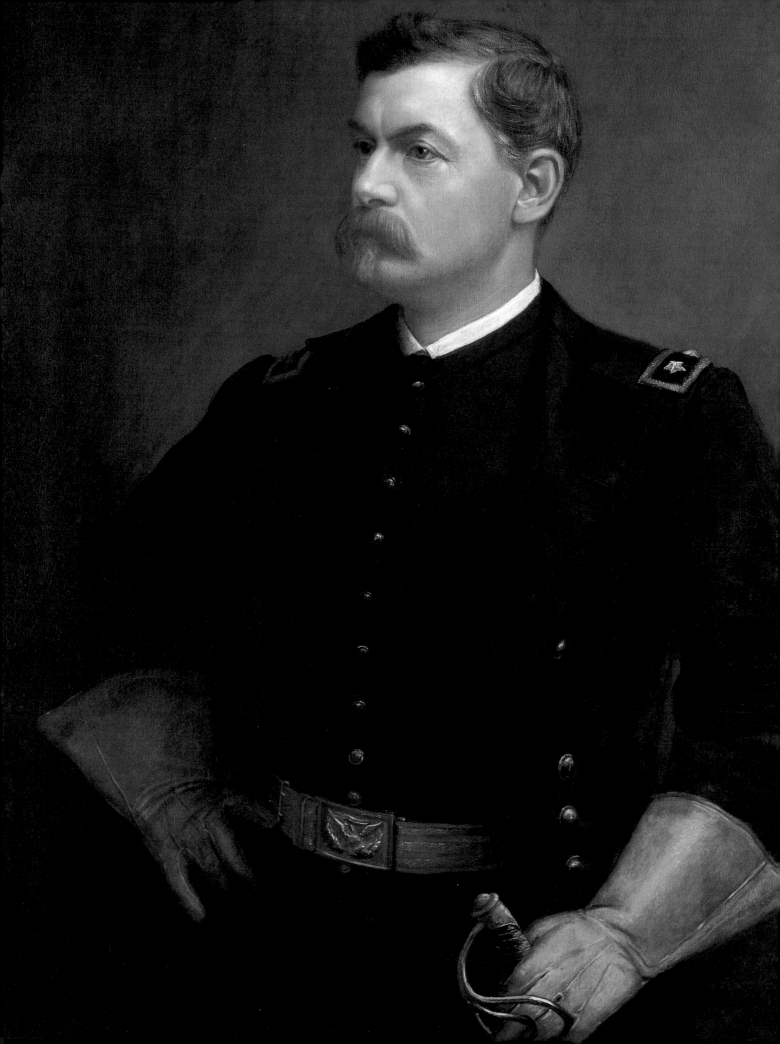

George B. McClellan 1826–1885

AFTER THE UNION ARMY'S ROUT AT THE FIRST BATTLE OF MANASSAS IN JULY 1861, Abraham Lincoln sought a promising commander to direct Federal operations in Virginia. His choice was General George B. McClellan. Just thirty-four years of age, McClellan had already garnered military laurels: at West Point he had graduated second in his class, and more recently he had sent Confederates scurrying at Rich Mountain, Virginia. Within weeks of taking command in Washington, "Little Mac" had transformed the remnant of a demoralized armed mob into a trained and disciplined army. He named his creation the Army of the Potomac, a name that has become legendary in the annals of war.

Yet achieving victory required more than spit-and-polish discipline. McClellan had to engage the enemy, and in this he procrastinated repeatedly, much to Lincoln's exasperation. When he did engage the enemy, he was slow to advance and quick to retreat. Finally, after McClellan failed to pursue Robert E. Lee's army following the Battle of Antietam in September 1862, Lincoln relieved him from command. McClellan reemerged briefly in national politics in 1864 as the Democratic Party's unsuccessful presidential peace candidate.

Julian Scott, the artist who painted this portrait of McClellan, was no stranger to the general. Scott had once been a volunteer in the Army of the Potomac. Only fifteen, he had enlisted in the Third Vermont Volunteer Infantry in June 1861, giving his age as sixteen to avoid having to seek his father's permission. Still too young for infantry duty, Scott signed on as a fife player and listed his occupation as painter.[84] His tour of duty in Virginia lasted until June 1862, when he was wounded at the Battle of White Oak Swamp. During his convalescence, Scott continued to draw sketches of life in the army. His art won the admiration of a soon-to-be patron, who helped secure Scott's early release from the army and afterward provided the financial means for his education in the arts abroad. Meanwhile, Scott was recommended for and awarded the congressional Medal of Honor for bravery in action at Lee's Mill, Virginia, in April 1862.

In the 1870s Scott enjoyed a successful career as a painter of Civil War topics. His prize commission was a large canvas, *The Battle of Cedar Creek*, painted for the Vermont State Capitol in Montpelier. Scott was living in Plainfield, New Jersey, in the late 1870s, at the time General McClellan became the state's governor. Scott's portrait of McClellan dates from this time, and is believed to have been commissioned by the family, in whose possession the portrait remained until 1953, when Mrs. George B. McClellan Jr. bequeathed it to the Smithsonian Institution.

JB

GEORGE B. MCCLELLAN
By Julian Scott (1846–1901),
oil on canvas, not dated

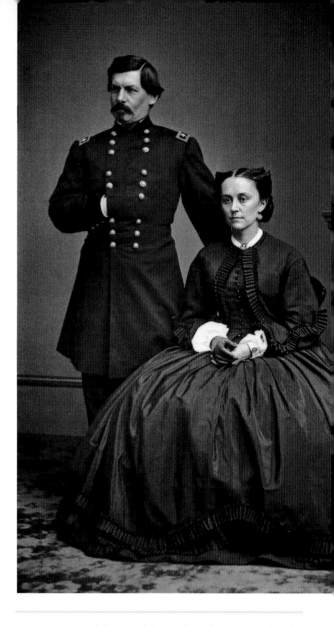

George B. McClellan and his wife, Ellen Marcy, by the Mathew Brady Studio (active 1844–94), collodion glass-plate negative, not dated

This wood carving of George B. McClellan was reputedly removed from the stern of a ship built in Thomaston, Maine.

By an unidentified artist,
c. 1862

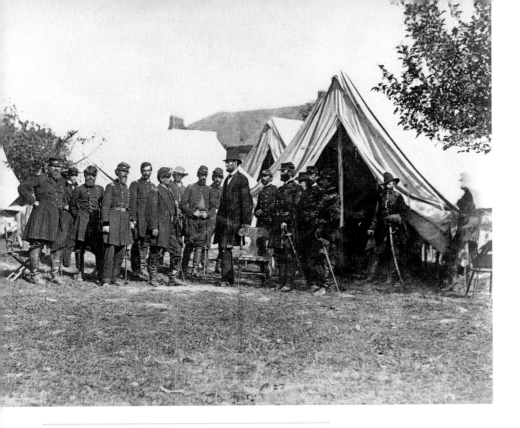

President Lincoln with General McClellan and his generals at Antietam, October 1862

By Alexander Gardner
(1821–1882), albumen silver
print, 1862

This printed poem commemorating General McClellan's farewell to the Army of the Potomac on November 10, 1862, reflects the high regard in which he was held by his troops.

By Charles Magnus (active
c. 1854–79), chromolithograph,
c. 1862

GEORGE B. MCCLELLAN

DURING HER NEARLY TWO DECADES of marriage to Samuel Gridley Howe—one of the secret six who aided John Brown—Julia Ward Howe had been surrounded by the reform culture of New England. A "literary lady" in her own right, she had written several volumes of poetry, travel essays, and a play.

In November 1861, Howe accompanied her husband, a member of the Sanitary Commission, to Washington, where he had the responsibility of investigating the health conditions of the troops. "The journey was one of vivid, even romantic interest," Howe remembered. "We were about to see the grim Demon of War, face to face."[85] On November 18, the Howes, spectators at a grand review of Union soldiers in Northern Virginia, were caught up in the crush of carriages headed back to Washington after Confederate skirmishers disrupted the ceremony. To enliven the tedious journey, the Howe party began to sing, "John Brown's body lies a-mouldering in the grave," the new verses adapted to the Methodist camp-meeting hymn "Say, Brothers, Will We Meet You Over on the Other Shore?" As the retreating soldiers joined in the song, Howe was told that she ought to write "some good words for that stirring tune." She replied that she had often wished to do so, "but had not as yet found in my mind any leading toward it."[86]

Back at Willard's Hotel in the District of Columbia, Mrs. Howe awoke "in the gray of morning twilight," she many times recounted, "and as I lay waiting for the dawn, the long lines of the desired poem began to twine themselves in my mind."[87] She sprang from her bed and with a stub of a pencil "began to scrawl the lines almost without looking, as I had learned to do by often scratching down verses in the darkened room where my little children were sleeping."[88]

The poem that she called "The Battle Hymn of the Republic" was published in the February 1862 issue of the *Atlantic Monthly*. Soon the new words were taken up by Union soldiers and became what William Cullen Bryant aptly called "the most stirring lyric of the war."[89]

Many years later, Howe's artist son-in-law John Elliott sought to portray her as she looked at the moment that had brought her her greatest fame. Howe selected a photograph taken in Boston by H. H. Hawes around 1862 as the basis for a painting, which Elliott never finished. After his death Mrs. Elliott brought in Rhode Island artist William Henry Cotton to complete the canvas. Maud Howe Elliott, in presenting the portrait to the Smithsonian in 1933, explained, "We call this the Battle Hymn portrait as it represented her as she was at the time the Hymn was written in Washington—on Sanitary Commission paper!"[90] Mrs. Howe is shown holding a lily and several buds, a reference to the fifth verse of the "Battle Hymn"—"In the beauty of the lilies Christ was born across the sea."

MC

JULIA WARD HOWE
Begun by John Elliott
(1858–1925) and finished
by William H. Cotton
(1880–1958), oil on
canvas, c. 1925

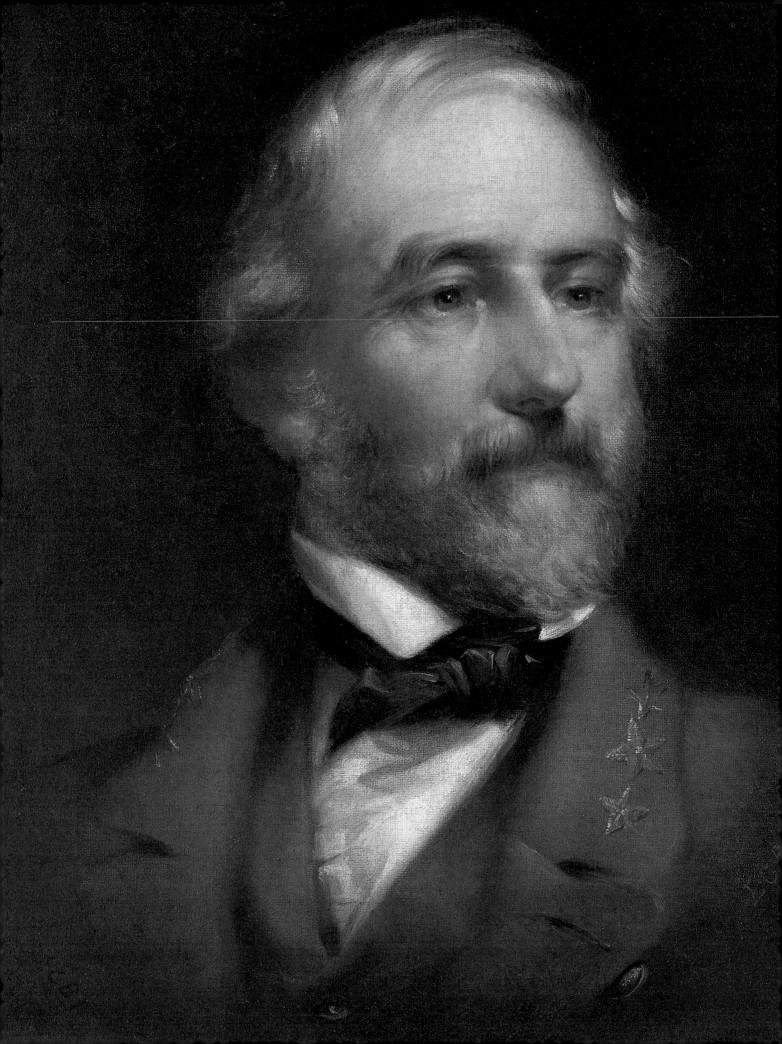

ON APRIL 19, 1861, Robert E. Lee left his Arlington, Virginia, estate and rode a short distance to Alexandria, the town of his boyhood, to attend to some personal business. It was while he was in town that he read the news that the state convention meeting in Richmond had passed an ordinance of secession. That morning, Lee went to an apothecary shop on Fairfax Street to pay a bill. The druggist, unbeknownst to this longtime customer, carefully recorded in the register opposite the entry of payment a lamentation Lee had just made: "I am one of those dull creatures that cannot see the good of secession."[91]

In those heady days of April 1861, Lee was on the minds of many people, both above and below the Potomac River, along whose southern banks so much of his life had been lived and his heritage lay. Only the day before, Lee had been summoned into Washington and told that President Lincoln was offering him the command of a large volunteer army—some seventy-five thousand strong—then being assembled in the capital. Lee, however, respectfully declined the honor. When Lee went to inform General Winfield Scott, a Virginian himself, Scott somberly told his gifted protégé that he was making the greatest mistake of his life. If Scott could not agree with Lee's decision, he at least had an inkling of how deep the loyalties of family and home ran in this scion of old Virginia. After hours of painful contemplation and prayer, Lee submitted his resignation as a colonel in the U.S. Army, ending a career of nearly thirty-two years. In a letter to his sister, Lee explained: "I have not been able to make up my mind to raise my hand against my relatives, my children, my home."[92]

No sooner had Lee become a private citizen again than Virginia authorities turned to him to organize the state's defenses. When he left for Richmond that April, he would never set foot in his house again. "The road from Arlington," wrote Lee's biographer, Douglas Southall Freeman, "though lit with glory, led straight to Appomattox."[93] At fifty-four, Lee was entering the final phase of his military career. Put in command of the Army of Northern Virginia in June 1862, Lee gave the Confederacy snatches of hope with a succession of early victories. His soldiers were always outnumbered, at times by as much as three to one, so it was a triumph that he kept them in the fight for the duration of the war. Yet given the attrition of his army, the Confederacy's lack of resources, and the determination of a cagey opponent in Ulysses S. Grant, Lee's surrender on April 9, 1865, was inevitable.

The Richmond painter Edward Caledon Bruce claimed to have painted Lee from life during the last months of the war. This head-and-shoulders study canvas is believed to have been based on Bruce's now unlocated full-length painting of Lee.

JB

ROBERT E. LEE
By Edward Caledon
Bruce (1825–1901),
oil on canvas,
c. 1864–65

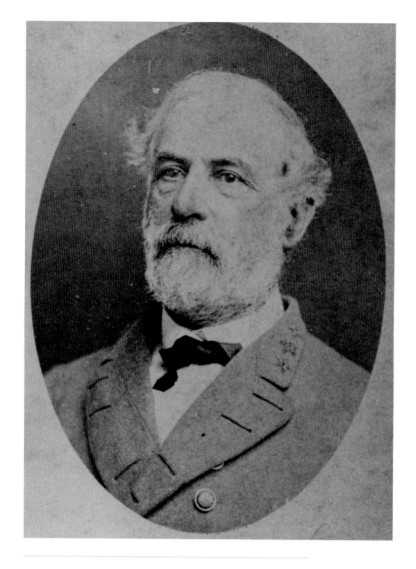

Robert E. Lee by John W. Davies (lifedates unknown),
albumen silver print, 1864

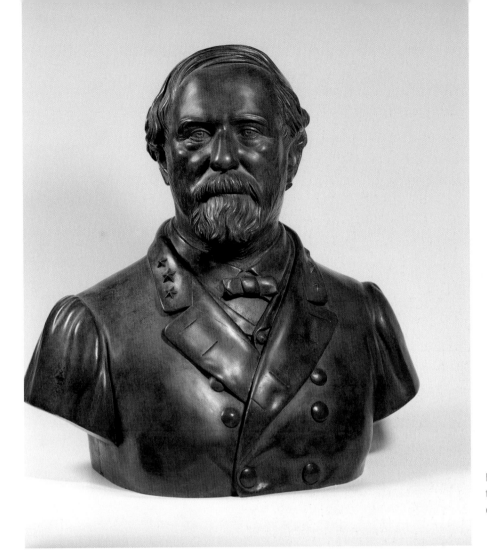

By Edward Virginius Valentine (1838–1930), bronze, cast after 1870 plaster

At the end of May 1870, Robert E. Lee was in Richmond for a few days, checking in with his doctors, who were monitoring his progressively deteriorating condition. Bound for home in Lexington, Virginia, where he was president of Washington College, Lee was completing the last leg of a two-month tour of the South. This visit would prove to be his last in the former Confederate capital. Although Lee never complained to virtual strangers about the precarious state of his health, he was forced into alluding to it in a conversation with Richmond sculptor Edward V. Valentine. Valentine was taking some measurements of Lee for the bust illustrated here and asked if he could visit Lee in Lexington to do the modeling; Valentine suggested either in June or later that fall. Lee said that he would have more time in the fall, but that Valentine should not delay his trip.

Valentine understood Lee's personal anxiety over his health and arrived in town not many days after Lee himself had returned home. Lee offered the young sculptor a first floor of the Lee's residence as a temporary studio, but Valentine, not wanting to disturb the family, opted instead to set up his studio in a vacant store. As expeditiously as possible, Valentine made a rough study bust of Lee, which he took back to Richmond. By early fall, he was ready to ship a finished bust to Lexington for the family's inspection when he learned of Lee's death on October 12.

Valentine's bust met with the approval of Mary Custis Lee, the general's widow. Moreover, with Mrs. Lee's endorsement, the trustees of Washington College commissioned Valentine to create a memorial sculpture for Lee's sarcophagus, to rest in a planned Lee Chapel. For this, Valentine sculpted the *Recumbent Lee*, for which he is best remembered.

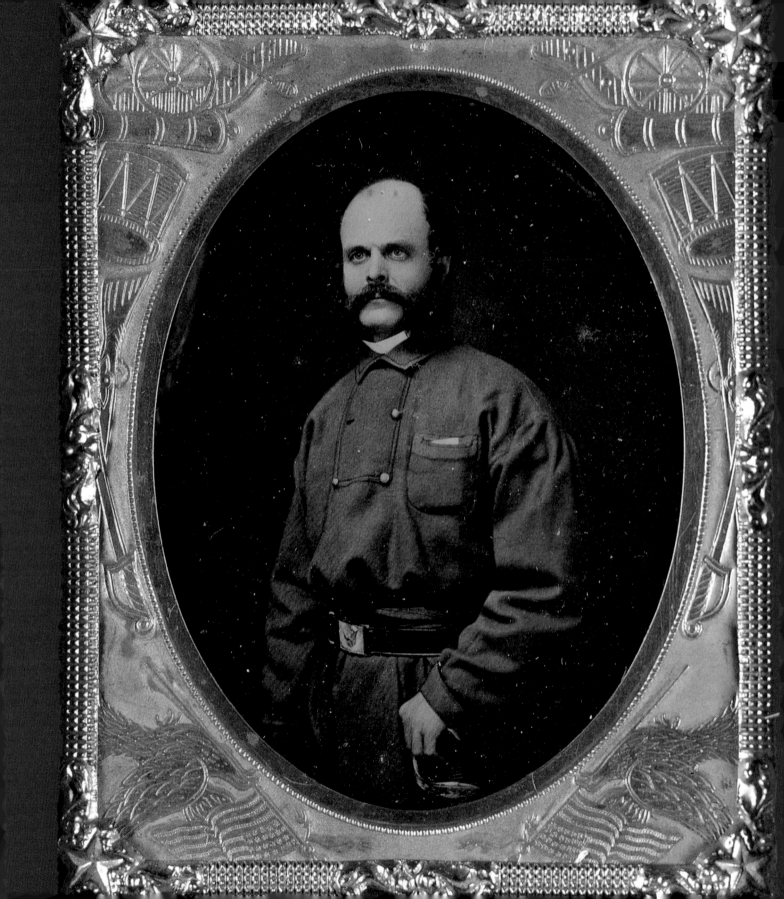

Ambrose E. Burnside 1824–1881

THE NAME OF AMBROSE E. BURNSIDE has several Civil War–era associations, including a rifle, a style of side-whiskers, a stone bridge in Maryland, and two marches—one musical and the other strategical. These associations—some positive, some negative, and one merely distinctive—underscore Burnside's checkered service as a Union commander. A graduate of West Point, Burnside began his military career as a lieutenant of artillery. In 1847, his first assignment was to join the American army fighting in Mexico, but he arrived too late to see much action in the war. In 1853, he resigned his commission to manufacture a breech-loading rifle that he had invented while in the army. His last post was in Rhode Island, where the native Indianian would marry a woman from Bristol, and where he would claim residence for much of his life.

Upon President Lincoln's call for seventy-five thousand troops in April 1861, Burnside was the governor's choice to command the First Rhode Island Volunteer Infantry. Burnside's rapid and enthusiastic organization made it possible for his regiment to be one of the first to arrive in Washington. The Rhode Islanders found temporary quarters inside the Patent Office Building (now the home of the National Portrait Gallery) and stacked their bunks between display cases of invention models. The fitness of the regiment and Burnside's gregarious temperament made an immediate good impression on the president, and he became a favorite of Lincoln's.

Burnside commanded a brigade at the First Battle of Manassas, after which he was commissioned a brigadier general of volunteers. In January 1862, he was assigned duty on the North Carolina coast, where a string of small victories made him one of the North's most promising commanders, earning him a second star and a victory march. In the fall of 1862, after the Battle of Antietam, where a hotly contested stone bridge became a Burnside landmark, Lincoln put Burnside in command of the Army of the Potomac, against the general's wishes. His colossal defeat at Fredericksburg in December and his ill-advised attempt to move the army in bad weather a month later—dubbed Burnside's Mud March—helped to convince the president that he had the wrong man. He was replaced by General Joseph Hooker. The following year Burnside was given charge of the Department of the Ohio, where he aptly defended Knoxville. Brought back east in 1864, he headed the Ninth Corps, which was entrenched before Petersburg. He endorsed the stupendous idea to mine the Confederate earthworks by digging an underground tunnel nearly six hundred feet long, and his corps made the first charge on the exploded earthworks and crater. The fiasco that followed, resulting in 3,798 Union casualties, was largely attributed to inept leadership.

AMBROSE E. BURNSIDE
By Manchester and
Brother Studio (active
c. 1848–80), ambrotype,
c. 1861

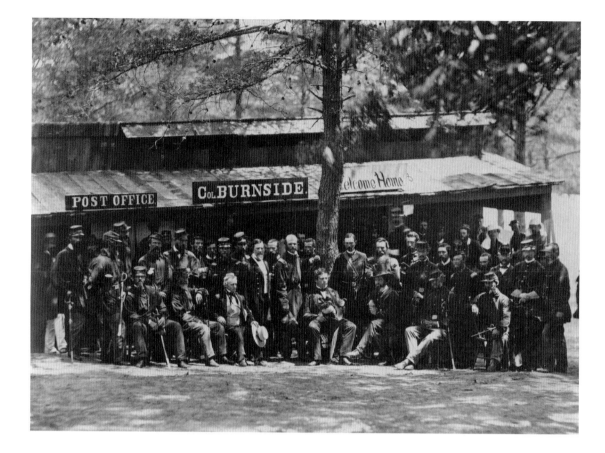

Colonel Burnside and the First Rhode Island Volunteers at
Camp Sprague, near Washington, D.C., 1861, by an uniden-
tified photographer, albumen silver print, 1861

Burnside took much of the blame and left the army. After the war, Ulysses S. Grant de-
scribed Burnside as "an officer who was generally liked and respected. He was not, however,
fitted to command an army. No one knew this better than himself."[94]

 This ambrotype (page 120) shows Burnside wearing his trademark whiskers and
dressed in the loose pullover blue blouse with which he outfitted his First Rhode Island
Volunteers at the start of the war.

 JB

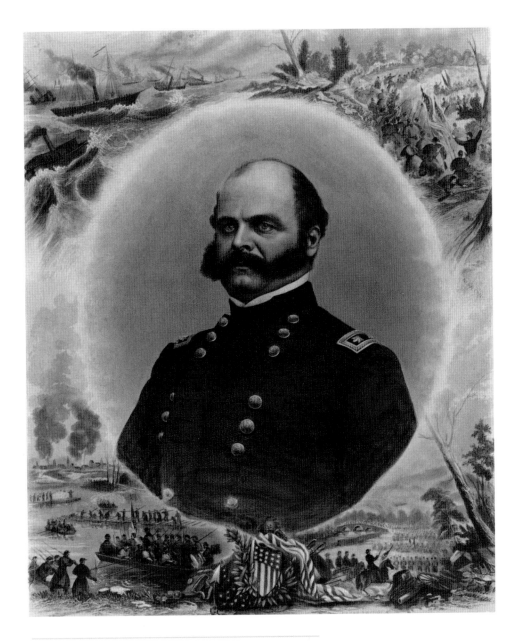

In this steel engraving, General Burnside is depicted surrounded by vignettes of his early war service, including the battles of Antietam and Fredericksburg, in 1862.

By an unidentified artist,
hand-colored steel engraving, not dated

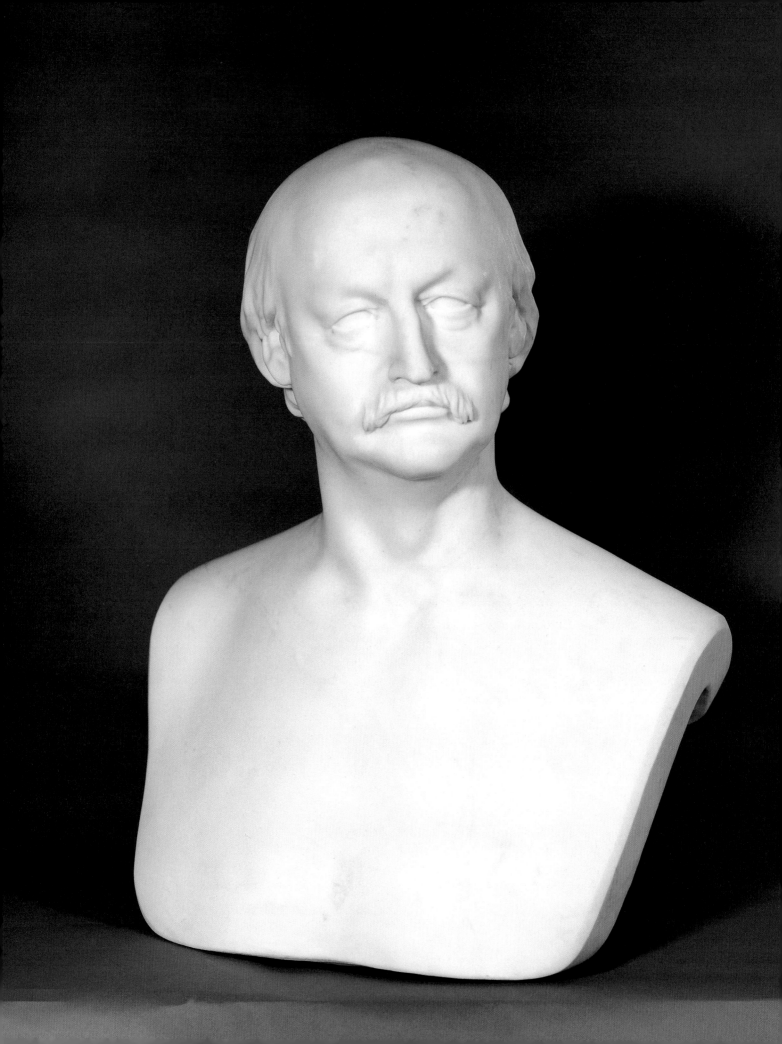

UNION GENERAL BENJAMIN F. BUTLER WAS SOMETHING OF A NOVELTY. An arch-Democrat fighting a war for a Republican administration, he was a wily lawyer and politician in military garb. At the start of the conflict, he raised a regiment of Massachusetts militia out of patriotism, but soon thereafter he looked on the conflict as a way to advance his presidential ambitions and the financial fortunes of his family and friends. Almost every phase of his wartime career proved controversial, especially his heavy-handed administration of the military district of New Orleans in 1862. During his stay in that city, he was accused of everything from issuing orders designed to harass female secessionists to personally pilfering the spoons from the house he occupied. As military governor, Butler was effective in bringing order to the city, but at a scandalous cost to his already dubious reputation and to that of the administration in Washington. Late in 1862, Lincoln prudently removed him.

For most of 1863, Butler was without another military assignment, while President Lincoln decided how best to use this controversial soldier-politician. Politically, Butler had been shedding his allegiance to the Democratic Party and was now philosophically more in league with the Radical Republicans of Congress. The uncompromising zeal of these extremists for the abolition of slavery, control of military management, and retribution for Southern leaders all created undue burdens for the evenhanded president. Butler, elected to Congress after the war, would join the Radicals and play a prominent role in the impeachment of President Andrew Johnson in 1868. Meanwhile, he waited at home in Lowell, Massachusetts. It was during this interlude that Boston sculptor Edward Augustus Brackett began work on a marble bust of him. Butler, tired of all the critical caricatures of himself that recently had been printed in such illustrated weeklies as *Vanity Fair*, was understandably flattered by Brackett's lifelike bust, especially because it did not accentuate his crossed eyes. That same year, James Parton, the popular biographer and one of Butler's supporters for president, wrote a defense of him titled *General Butler in New Orleans*. Following Butler's suggestion, Parton illustrated the second printing of the book with an engraving of the bust in profile, the view that Butler always preferred of himself.

In November 1863, Lincoln, anxious to keep Butler preoccupied and out of the political arena, put him in charge of the Department of Virginia and North Carolina, with headquarters at Fort Monroe, Virginia. By the end of summer the pigeonholed general was beginning to feel underutilized and "almost homesick." In a letter to his wife, he wrote, "Do you want to see me? Do the next best thing—send down to Brackett and get the marble bust which he has done. Get up a handsome pedestal for it—he has been paid for it."[95]

JB

BENJAMIN F. BUTLER
By Edward Augustus
Brackett (1818–1908),
marble, 1863

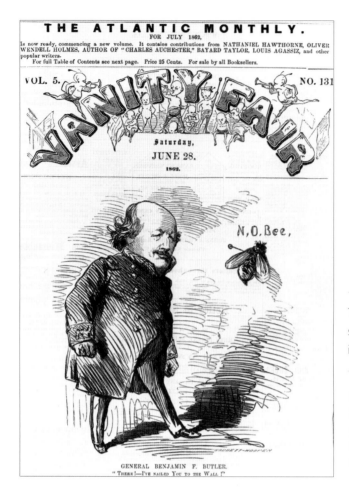

THE ATLANTIC MONTHLY.

FOR JULY 1862.

Is now ready, commencing a new volume. It contains contributions from NATHANIEL HAWTHORNE, OLIVER WENDELL HOLMES, AUTHOR OF "CHARLES AUCHESTER," BAYARD TAYLOR, LOUIS AGASSIZ, and other popular writers.

For full Table of Contents see next page. Price 25 Cents. For sale by all Booksellers.

VOL. 5. NO. 131

VANITY FAIR

Saturday,
JUNE 28.
1862.

N. O. Bee,

GENERAL BENJAMIN F. BUTLER.
"There!—I've nailed You to the Wall!"

This 1862 cover for *Vanity Fair* makes reference to Butler's severe rule as military governor of New Orleans; the victim in this instance was the local newspaper, the *Bee*.

By Bobbett and Hooper Wood Engraving Company (active 1855–70?), after Henry Louis Stephens, wood engraving, 1862

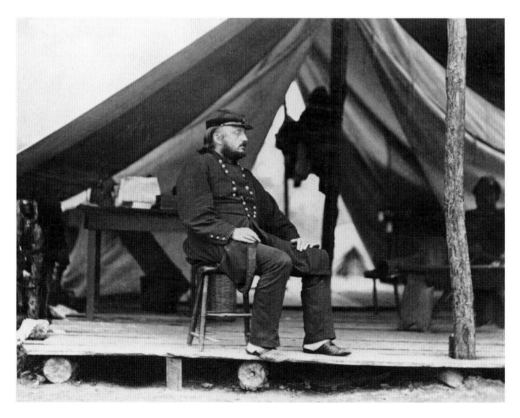

Benjamin F. Butler by an unidentified photographer, albumen silver print, c.

As military governor of New Orleans, General Butler issued an order on May 15, 1862, that decreed that local females who showed contempt for Union officers and soldiers would be treated as prostitutes. This infamous "Woman's Order" earned Butler the nickname "Beast Butler," as illustrated in this Currier and Ives lithograph depicting him as the "great Massachusetts Hyena," violating the graves of Confederate officers.

Grand Federal Menagerie!! Now on Exhibition!! by Currier and Ives Lithography Company (active 1857–1907), lithograph, c. 1862

GRAND FEDERAL MENAGERIE!! NOW ON EXHIBITION!!

The great Massachusetts Hyena, an extraordinary animal newly discovered, true to his traditional instincts, he violates the grave!

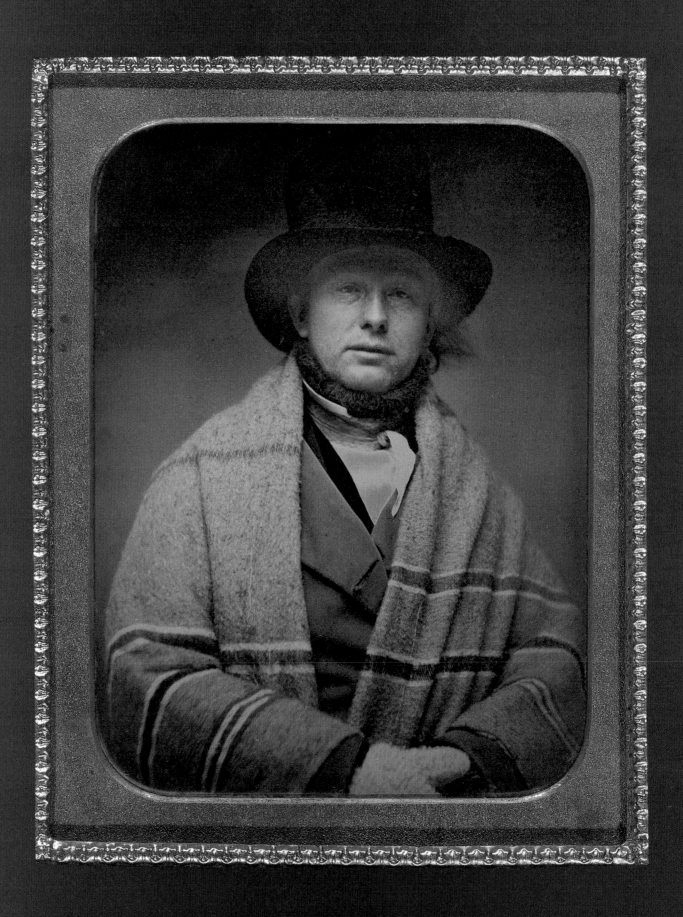

HORACE GREELEY'S ECCENTRIC APPEARANCE belied his influence as the editor of the *New York Tribune*, a newspaper read everywhere in the country outside of the South by 287,750 subscribers and many more besides. "No single force in educating the nation for the terrible struggle with slavery was so powerful as the *Tribune*," noted *Harper's Weekly* upon Greeley's death in 1872.[96]

Every winter Greeley donned his Quaker hat (described as "double the size of his head"), stuffed his pockets with papers and magazines, wrapped himself in a red and blue striped blanket for warmth, and headed west on a lecture tour.[97] On one such trip he presented the daguerreotype shown here to the farm family in Belvidere, Illinois, with whom "he staid all night" and, according to a note attached to the lining of the case, "had long talk with my Grand Mother—said she was the best Posted Woman that he ever met in Bible & Politics."

A man of great moral earnestness, Greeley espoused many causes, but in the 1850s his greatest crusade was waged in support of the free-soil movement. Orchestrating the protest against Stephen A. Douglas's proposition that voters in the territories should decide whether new states should be slave or free, Greeley asked, "What kind of 'popular sovereignty' is it that allows one class of people to vote slavery for another?"[98]

Horace Greeley was at the national organizational meeting of the Republican Party in Pittsburgh on February 22, 1856, and in the fall he editorialized in favor of the presidential candidacy of John C. Frémont. Four years later, Greeley campaigned hard for Abraham Lincoln and, after his election, bombarded the president with political and military advice. He grew frantic over the inability of the North to win victories, and General George B. McClellan's inaction—as the cartoon on the March 29, 1862, cover of the humor magazine *Vanity Fair* indicates—was more than he could bear. Clad in his famous flapping white coat, a furious Greeley protests, "Gineral McClellan don't go strong 'nuff for 'Bobolition [abolition]—Dat what's de matter!"

Greeley, aggravated that Lincoln, intent on keeping the border states in the Union, held back from liberating the slaves within Union lines, tried to force the issue in "The Prayer of Twenty Millions," published on August 20, 1862. "We must have scouts, guides, spies, cooks, teamsters, diggers and choppers from the blacks of the South, whether we allow them to fight for us or not, or we shall be baffled and repelled," the editor exhorted.[99]

Abraham Lincoln, who anxiously awaited only a Union victory to issue his Emancipation Proclamation just recently drafted, replied to Greeley, "If I could save the

HORACE GREELEY
By an unidentified photographer, daguerreotype, c. 1850

Union without freeing *any* slave I would do it; and if I could save it by freeing *all* the slaves, I would do it; and if I could do it by freeing some and leaving others alone, I would also do that."[100]

On September 22, 1862, just after the Battle of Antietam, Lincoln issued what was called the preliminary Emancipation Proclamation, which promised freedom to slaves still in rebellion on January 1. Greeley exulted in the next day's *Tribune*, "It is the beginning of the new life of the nation. God bless Abraham Lincoln!"[101]

MC

Horace Greeley by Bobbett and Hooper Wood Engraving Company (active 1855–70?), after Henry Louis Stephens, wood engraving, 1862

THE POLITICAL GYMNASIUM.

The Political Gymnasium makes light of the historic 1860 presidential contest, in which four candidates vied for the White House. Horace Greeley has been included in this mix; in the pages of his newspaper, the *New York Tribune*, he vigorously supported Lincoln's nomination and campaign. Greeley's own political ambitions are mocked here, showing him attempting to climb a bar labeled "Nom. [Nomination] for Governor." He complains, "I've been practising at it a long time, but can never get up muscle enough to get astride of this bar." Atop the bar in the center, labeled "For President," Lincoln replies, "You must do as I did Greely [*sic*], get somebody to give you a boost, I'm sure I never could have got up here by my own efforts."

In 1872, Greeley, exasperated by the corruption of Ulysses S. Grant's administration, tried to split the Republican Party ticket by running for president. A social reformer at heart and never a viable politician, Greeley won the Democratic Party's nomination. Grant trounced him in the election, however. Exhausted by the campaign and distraught from his wife's recent death, Greeley died a few weeks after the election.

The Political Gymnasium by Louis Maurer (1832–1932) for Currier and Ives Lithography Company, lithograph, 1860

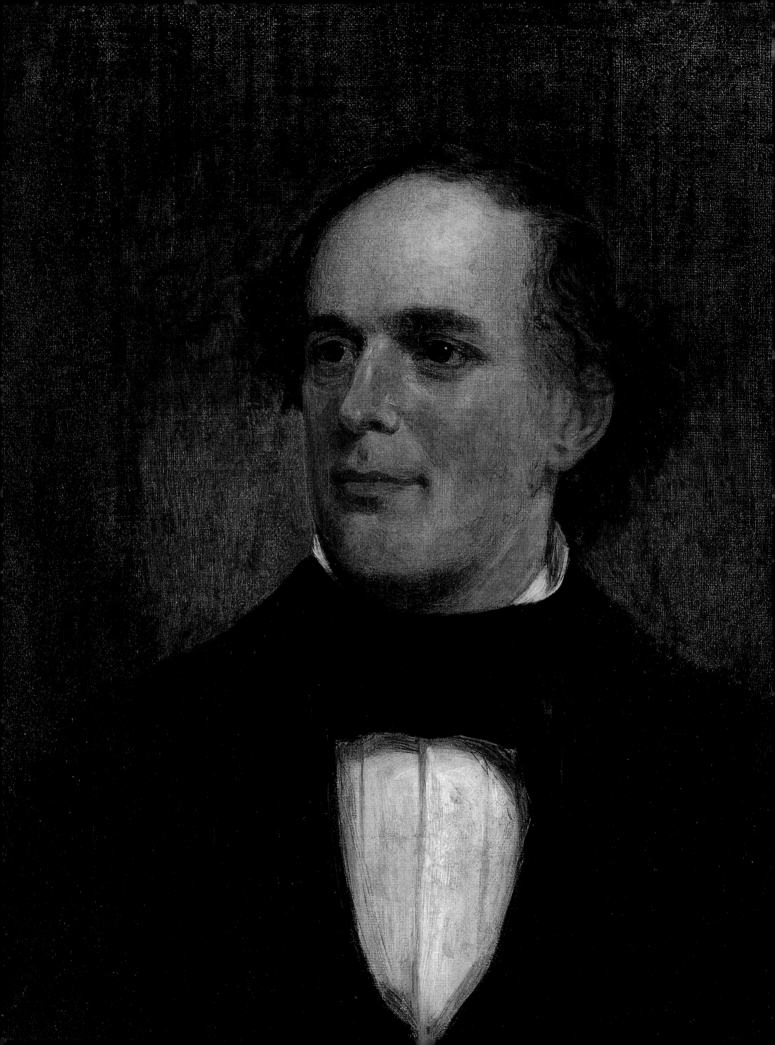

IT WAS A MEASURE OF President Lincoln's trust in men and his confidence in his own ability to lead that he appointed members of his cabinet who were potential political rivals. Secretary of the Treasury Salmon P. Chase proved foremost in that category. As a lawyer and an antislavery leader in Ohio, Chase had built a constituency in his state. He had served in the U.S. Senate between 1849 and 1855, before becoming a two-term governor and prior to his unsuccessful bid for the Republican presidential nomination in 1860. Chase accepted Lincoln's offer to become secretary of the treasury, despite his lack of experience in financial matters, and proved to be highly competent in managing the nation's wartime budget, which was beset with high inflation and mounting debt. His efforts in passing the Legal Tender Act and the National Banking Act laid the foundations for the country's modern monetary system. Chase and the president, however, never established a rapport. Personality had much to do with each man's ill-ease with the other. Chase was accomplished in many aspects, except for politics and humor, the two things Lincoln understood thoroughly and had mastered. On more than one occasion, Chase offered his resignation, only to have it refused. Yet when his intrigues to become a presidential candidate in 1864 were leaked to the press, they embarrassed the administration and finally prompted his departure from the cabinet. Eager to appease Chase's ambition and render him mute politically, especially with the Radical wing of the party, Lincoln appointed him chief justice of the Supreme Court later that year, following the death of Roger B. Taney. Chase's Republicanism differed markedly from Taney's Southern biases, making the transition of head of the court, in one historian's words, "the most sweeping judicial metamorphosis in American history."[102]

JB

SALMON P. CHASE
By Francis B. Carpenter
(1830–1900), oil on
canvas, 1861

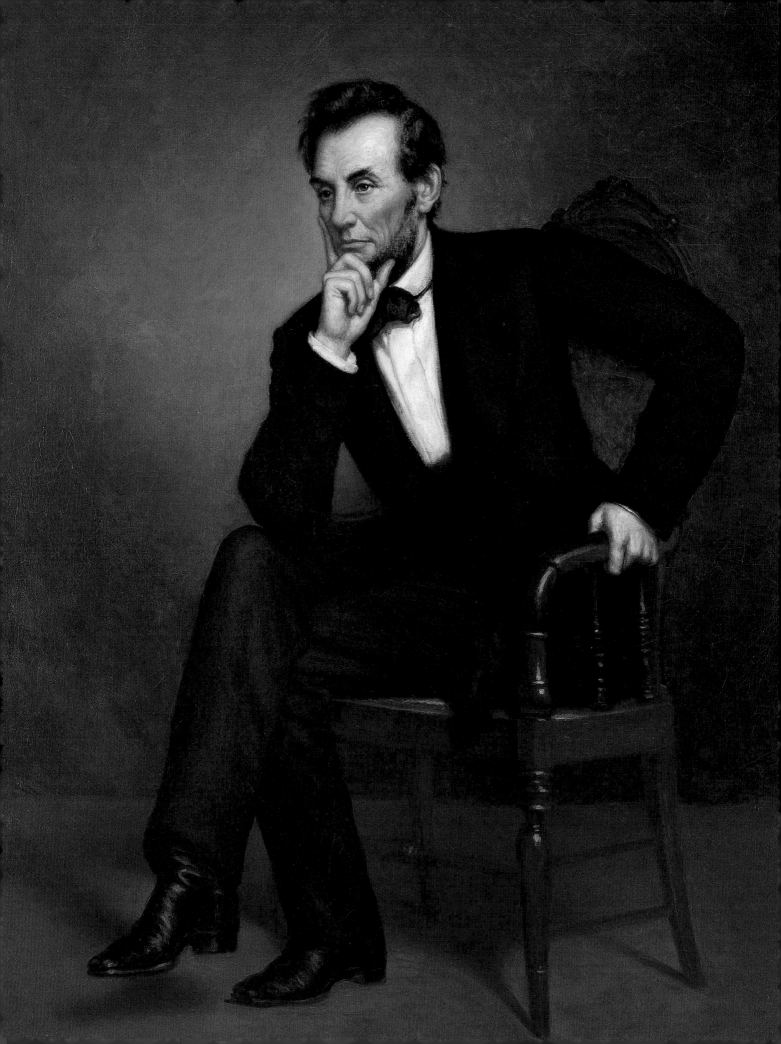

THERE IS PROBABLY NO FIGURE in American history who today commands greater unreserved admiration than Abraham Lincoln. During his presidency, however, that was hardly the case. From the moment he took office, Lincoln was beset with criticism from friend and foe alike, and it sometimes seemed that he could satisfy no one. While abolitionists railed at his refusal to make the end to slavery an openly stated goal at the Civil War's outset, others bitterly attacked him when he finally did move toward that aim with the Emancipation Proclamation. His wartime curtailment of civil rights in the name of shutting off pro-South agitation in the North drew charges that he was a Constitution-trampling despot. On the other hand, some complained bitterly of his indecisiveness, and when the Union forces suffered defeat or their victories exacted high casualties, much of the blame fell to him. But as the North moved toward triumph and as Lincoln himself gave eloquent and compassionate voice to the democratic ideals that defined American union, all these premature notions began to fade away, and his leadership came to be recognized as the ingenious blend of caution and firmness that it was. By war's end he had assumed, in the eyes of many, a heroic stature that became virtually unassailable in the days following his assassination in April 1865.

In its quiet, contemplative pose, George P. A. Healy's portrait seems to bespeak the reverence that engulfed Lincoln's reputation after his death. Healy had painted his first likeness of Lincoln in November 1860, days after his election to the presidency. On that occasion Lincoln had posed for him in the Illinois capitol in Springfield. But when Healy came to do the original version of this full-length likeness in about 1868, Lincoln was, of course, dead, and for the seated figure, the artist took as a model Leonard Swett, a Chicago lawyer and friend of Lincoln's whose own lanky build much resembled the former president's. For the face, Healy probably worked from sculptor Leonard Volk's bust or life mask of Lincoln, which could be set at whatever angle and in whatever light the artist wanted. The first version of the likeness was intended mainly to serve as a study for Healy's large projected composition *The Peacemakers*, which depicted a conference in March 1865 at which Lincoln had discussed with Generals Ulysses S. Grant and William T. Sherman and Admiral David D. Porter the terms of surrender to be accorded to Confederate forces. But the study stood up well in its own right, and Healy eventually painted three replicas of it, the last of which was the one here, done in 1887 for Lincoln's friend and admirer Elihu Washburne. Healy hoped that one of his replicas would become Lincoln's official White House portrait, but the picture lost to one by William F. Cogswell. Still, eventually it won. Lincoln's son Robert acquired the portrait, and one of his heirs gave it to the White House, where it holds pride of place today in the great East Room.

FV

ABRAHAM LINCOLN
By George P. A. Healy
(1813–1894), oil on
canvas, 1887

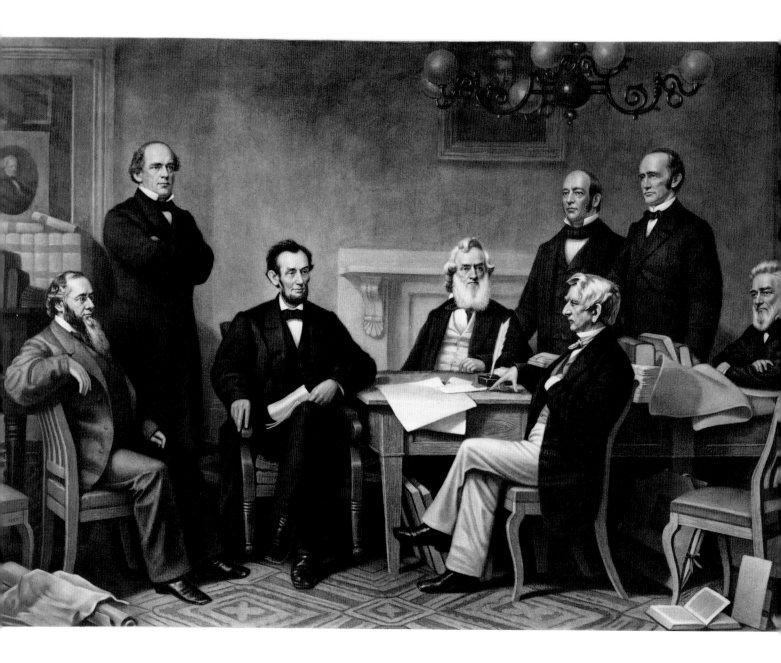

FEARFUL OF ALIENATING the Union's precariously loyal slaveholding states, President Abraham Lincoln had, at the outset of the Civil War, cautiously disavowed any intentions of putting an end to slavery. The North, he insisted, was fighting not for the liberation of black bondage but for the preservation of the Union. In the spring of 1862, however, as Northern resolve waned in the wake of battlefield failures, Lincoln quietly weighed the tactical advantages of striking a blow at slavery in the seceded states. By early summer, with painstaking deliberation, he was drawing up the Emancipation Proclamation, granting freedom to all slaves in Confederate-held territory.

Made public in September and officially signed on January 1, 1863, the proclamation marked the philosophical turning point in the Union's war efforts. Because it applied only to slaves residing behind enemy lines, the South was partly correct when it declared the president's "heinous" decree little more than a hollow gesture. But in a larger sense, Lincoln's measure underscored his heartfelt faith in and vision for the future of the reunited country. For the time being, the proclamation clothed the Northern cause in a new moral imperative and made the eradication of slavery at war's end a certainty.

For portraitist Francis B. Carpenter, Lincoln's issuance of the Emancipation Proclamation represented the consummation of the nation's founding ideals. It was therefore with a special sense of patriotic mission that he arrived at the White House in 1864 to execute his monumental painting commemorating the first cabinet reading of the historic decree. In devising the composition for his nine-by-fourteen-foot canvas, Carpenter took great care to make the background details of the event as accurate as possible. As for the actual moment depicted, Carpenter derived his inspiration from the president's own narrative of the proceedings. In the final rendering, Lincoln listens attentively as Secretary of State William Seward—his hand poised as if to stress his point—urges delaying announcement of the proclamation until after a battlefield victory. On its completion, Carpenter's painting was exhibited in several major cities, and at Lincoln's second inaugural in 1865, it was placed on view in the Capitol, where it has hung permanently since 1878. Prints of Carpenter's work proved immensely popular. For years they could be found in schoolrooms and other public places across the country.[103]

JB

THE FIRST READING
OF THE EMANCIPATION
PROCLAMATION
BEFORE THE CABINET
by Alexander Hay Ritchie
(1822–1895), after
Francis B. Carpenter,
stipple engraving, 1866

Carpenter's picture was originally sold by subscription. On this first page of the subscription list, Abraham Lincoln signed on as the first subscriber, followed by members of his cabinet.

Yankee printmakers capitalized on the positive reception given the Emancipation Proclamation by issuing scores of commemorative prints. In this lithograph, Abraham Lincoln's portrait is formed from the text of the proclamation.

By William H. Pratt (1858–c. 1888), lithograph, 1865

President Lincoln's Proclamation of Emancipation is celebrated in this wood engraving, one of several decorative prints produced in the North memorializing the signing of this historic edict on January 1, 1863.

By William Roberts (1846–c. 1876), after Mathew Brady, wood engraving with one tint, 1864

This satirical sketch by secessionist Adalbert J. Volck, a Baltimore dentist and artist, casts President Lincoln in league with the devil as he drafts the Emancipation Proclamation. The pictures on the wall purport to show Lincoln in sympathy with radical abolitionist John Brown and with the bloody slave revolt in Santo Domingo at the turn of the nineteenth century.

The Emancipation Proclamation by Adalbert J. Volck (1828–1912), transfer lithograph, 1864

Notwithstanding the biblical quote from Leviticus cited in the caption of this lithograph—"Proclaim liberty throughout All the land unto All the inhabitants thereof"—Lincoln's Emancipation Proclamation declared freedom only to those slaves in the eleven Confederate states that had seceded. Ratification of the Thirteenth Amendment—which occurred in 1865—was required to liberate slaves elsewhere throughout the Union, particularly in the border states of Missouri, Kentucky, Maryland, and Delaware.

Freedom to the Slaves by Currier and Ives Lithography Company (active 1857–1907), after Anthony Berger, lithograph, c. 1864–65

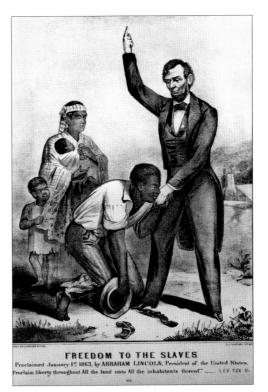

FREEDOM TO THE SLAVES
Proclaimed January 1st 1863, by ABRAHAM LINCOLN, President of the United States.
"Proclaim liberty throughout All the land unto All the inhabitants thereof." ___ LEV XXV. 10.

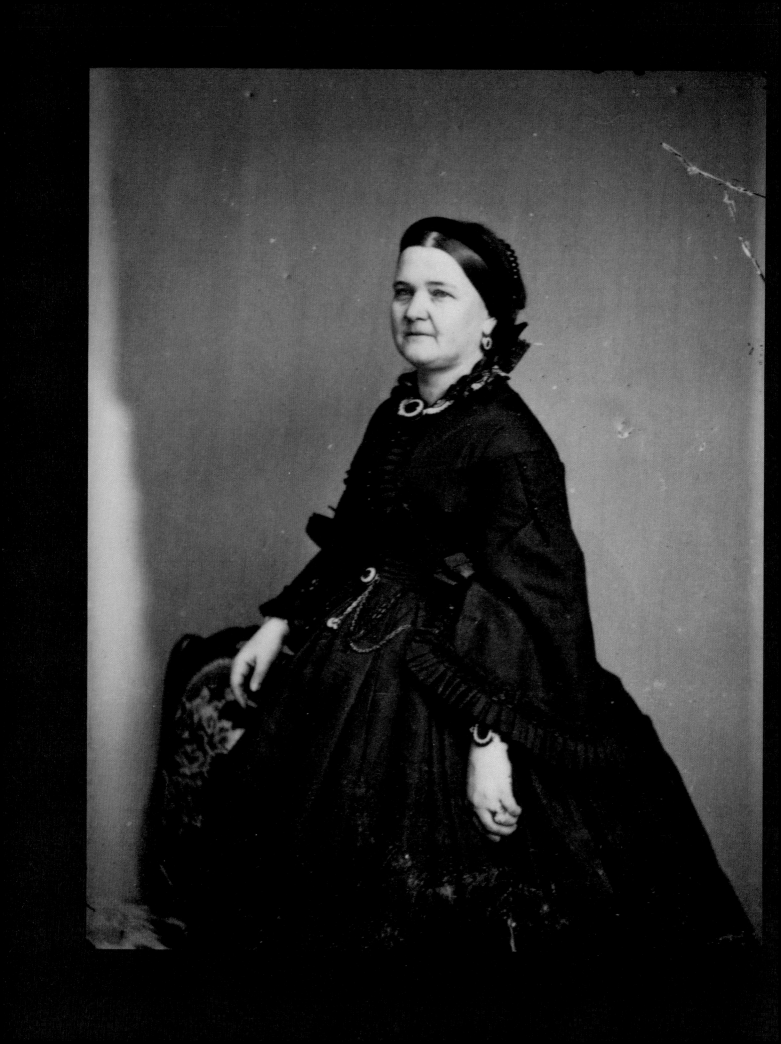

NO ONE CAN TRULY FATHOM the depths of Abraham Lincoln's equanimity and goodwill until one has encountered his beloved spouse, Mary Todd Lincoln, through her correspondence. To say that she was difficult to the point of being despicable, excitable to the point of being deranged, would be to overstate her temperament, as many of her severest detractors were wont to do, especially after the president's death. To say that she was everything her husband was not would be a fairer approximation of the truth. Still, Mrs. Lincoln had much to recommend her. She was intelligent, witty, keenly supportive of her husband's political career, a devoted wife, and an attentive mother. Early in their lives she was the first to realize Lincoln's potential for national leadership and the presidency. She alone had wooed a most remarkable human being to be her life's companion, and this was done contrary to the wishes of the socially prominent relatives with whom she was living at the time of her engagement. They considered Lincoln to be inferior.

Yet a vein of antagonism ran deeply through Mary Todd Lincoln, and it surfaced inexplicably at times. Often her wrath was excited by little more than her own imaginings and self-delusions. Just as her husband took pains never to give offense, Mrs. Lincoln seemingly never let opportunities to do so escape her. A letter she sent to Secretary of War Simon Cameron gives a glimpse of her state of mind during her first weeks in the White House. In a single succinct line, she dispensed her venom: "I understand that you *forgive me*, for all *past offences*, yet I am not Christian enough, to feel the same towards *you* as you pass me so 'lightly by' when you visit the White House."[104] Cameron, like other members of the cabinet, learned to give the president's wife a wide berth.

If not always gracious, Mrs. Lincoln could always be counted on to give the administration a sense of style and fashion. A compulsive shopper, the first lady delighted in refurnishing the presidential mansion, overspending the twenty thousand dollars Congress had allotted. She was just as lavish on herself, especially in her wardrobe and jewelry. Her dresses were designed and made to her specifications, regardless of cost. On one gown alone she spent two thousand dollars. As her personal debts grew and grew, they added to her husband's many war-related vexations.

According to one source, this photograph of Mrs. Lincoln wearing a meticulously fashioned black dress with coordinated black jewelry is believed to have been taken in the autumn of 1863.[105] She was still in mourning for her eleven-year-old son Willie, who died of a fever, probably malarial, in February 1862. Willie's death precipitated his mother's rapid psychological decline, which would become almost clinical after the president's assassination in April 1865.

JB

MARY TODD LINCOLN
By the Mathew Brady Studio
(active 1844–94), collodion
glass-plate negative, c. 1863

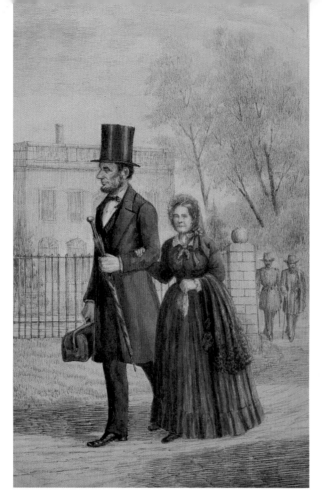

Little is known about this ink drawing of President and Mrs. Lincoln taking a walk just outside the grounds of the White House, which is visible in the background. The scene must have been a familiar one to many who observed the couple on periodic outings. The last such outing together was a carriage ride the Lincolns took in the afternoon on Good Friday, April 14, 1865, only hours before the president's assassination at Ford's Theatre.

By Pierre Morand (active 1839–91), ink and opaque white gouache on paper, c. 1864

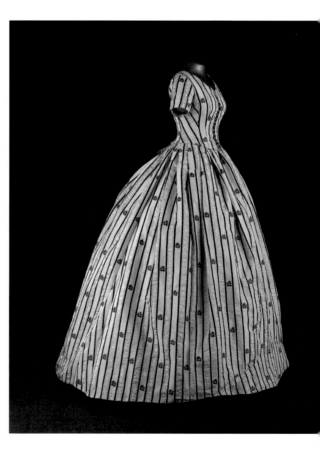

This gown worn by Mary Todd Lincoln was given to Elizabeth Grimsley, a cousin of the first lady, and came to the Smithsonian in 1964 from the Grimsley descendants. Conservation treatment partially restored the nineteenth-century construction of the bodice, but the original neckline and long sleeves could not be restored.

National Museum of American History, Smithsonian Institution, Behring Center

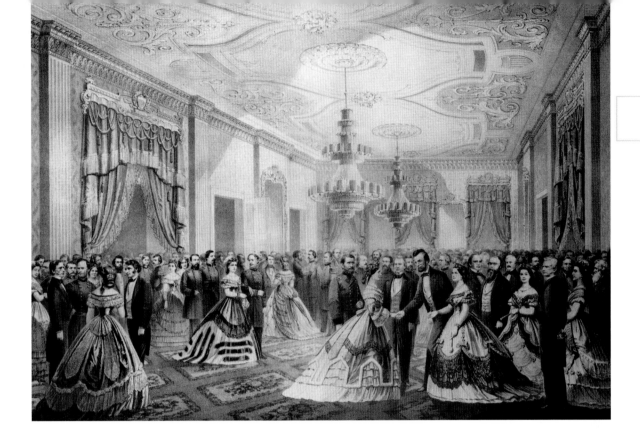

The publisher of this large lithograph caught the essence of a grand reception in the Lincoln White House, if not an actual event. In spite of the first lady's unpredictable mood swings, Mary Todd Lincoln was naturally gregarious and enjoyed hosting formal social gatherings. She was well educated and reared in matters of social etiquette. In this depiction there are at least thirty recognizable faces representing a republican mix of social strata, including army and navy officers, members of Congress, cabinet officers, socialites, and journalists.

Grand Reception of the Notabilities of the Nation by Major and Knapp Lithography Company (active 1864–c. 1881), lithograph, 1865

This silver service is believed to have been given to Mary Todd Lincoln when she was first lady by the citizens of New York. It is Gorham coin silver and is engraved with her monogram.

National Museum of American History, Smithsonian Institution, Behring Center

MARY TODD LINCOLN

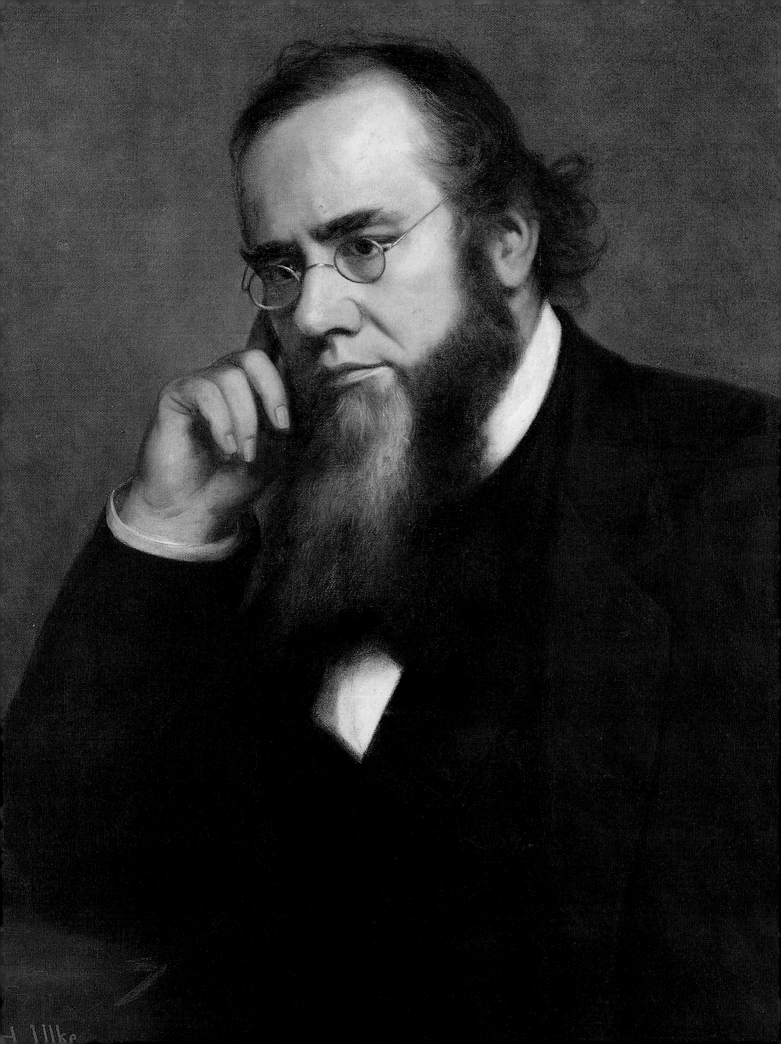

WITH THE WAR COSTING the Federal government a million dollars a day, Edwin M. Stanton proved ideal for the vital cabinet post of secretary of war. In January 1862, he replaced the inefficient and politically motivated Simon Cameron, who left the department mired in waste and scandal. Immediately, Stanton brought about an effective reorganization, establishing strict procedures for negotiating war contracts and vigorously investigating fraudulent ones. Although many officials in Washington found Stanton irascible and arrogant, he maintained good channels of communication with generals in the field. Impervious to criticism or the feelings of others, Stanton was in many respects the perfect foil for Lincoln in administering the dire but necessary duties of fighting a war.

Stanton's surly disposition proved more fitting in times of war than of peace. After Lincoln's assassination, Stanton held on to his powers in the War Department until President Andrew Johnson could no longer tolerate his alliance with the Radical Republicans in Congress, who were supporting punitive Reconstruction policies for the South. Johnson demanded his resignation. Stanton, believing his position to be protected under the newly passed Tenure of Office Act, refused to resign, or even physically vacate his office. (This act, later repealed, required the assent of the Senate in the removal of cabinet officers.) Radicals in Congress, eager to bring down the president, brought impeachment charges against him. Ultimately, in this contest of wills between two stubborn men, the Constitution weighed in favor of Andrew Johnson.

Stanton's portrait by Henry Ulke was painted early in 1872, two years after his death. Family members considered it to be the best portrait ever painted of Stanton, and his son presented a replica to the City Hall of Washington, D.C., later that year. Ulke painted yet a third portrait, ordered by the War Department for its collection of former secretaries.[106]

JB

This caricature for *Vanity Fair* labels Stanton "The Great (In)Censor of the Public Press."

By Bobbett and Hooper Wood Engraving Company (active 1855–70?), after Henry Louis Stephens, wood engraving, 1862

EDWIN M. STANTON
By Henry Ulke (1821–1910), oil on canvas, 1872

WINSLOW HOMER WAS TWENTY-FIVE when the Civil War began in the spring of 1861. Although his native state of Massachusetts was recruiting thousands of men his age to serve in the Union army, Homer, as a special artist for *Harper's Weekly*, was fortunate to have been able to pursue his chosen profession while satisfying his wanderlust for adventure much like a soldier. He was just beginning a lifelong career that would earn him fame and affluence for his paintings of American life and nature, especially of the sea. Already he was winning admirers through the pages of *Harper's* with his sensitive wood engravings that portrayed the life of soldiers in camp and conveyed the longing of loved ones left behind.

Homer was mostly a self-taught artist whose talent was readily apparent from the start of his career. It was matched by his determination to develop his skills independently and to his own liking. As evidence of this, Homer declined to join the staff of *Harper's*, preferring instead to contribute to the paper as a freelance artist. For Homer, the Civil War provided an unusual opportunity to explore and practice the nuances of his profession, while rendering a service to those who valued his art as a documentary of the war.

Between 1861 and 1865, Homer made several trips to the war front in Virginia. Armed with a letter from Fletcher Harper, the editor of *Harper's Weekly*, identifying him as a "special artist," Homer was able to move through the lines and gain access to the Army of the Potomac. Early in April 1861, he was in Alexandria and witnessed the embarkation of the army aboard steamers that would ferry it to the peninsula near Richmond in preparation for General George B. McClellan's long-awaited spring offensive. A drawing he made of the Sixth Pennsylvania Cavalry—the only Union regiment to carry lances—gave witness to Homer's eye for the unusual and the dramatic.

Homer sailed with the army down the Potomac toward Fort Monroe and Yorktown in the Tidewater region. With his drawing supplies of pen and pencil, gray wash, and white paper, Homer stayed with the army for about two months, during which time the siege of Yorktown took place and the Battle of Fair Oaks was fought. Except for what can be delineated in his drawings, Homer never kept records of his movements. Yet the correspondence of an acquaintance, Lieutenant Colonel Francis Channing Barlow of the Sixty-first New York Infantry, indicated that the artist camped, at least temporarily, with them. Homer subtly made this association himself in at least two of his works, in which the number "61" appears on a knapsack. Based on evidence in two other works—the paintings *The Briarwood Pipe* (1864) and *Pitching Horseshoes* (1865)—Homer at some point also came in contact with the Fifth New York Infantry, also known as Duryee's Zouaves. Labeled "the best disciplined and

WINSLOW HOMER
By Thomas A. Gray
(active 1863) and
Thomas Faris (1814–?),
albumen silver print, 1863

soldierly regiment in the Army" by General McClellan, they wore distinctive Zouave uniforms of bright red pantaloons, red fezzes, and dark blue collarless jackets.[107] Homer made sketches of these colorfully clad soldiers, fully realizing that this work had a potential for "future greatness."

"Future greatness." That was how Homer's mother described her son and his activities in the fall of 1861. Mrs. Homer's confidence evokes the self-assuredness of the artist himself. While lasting fame still awaited him, Homer studiously used the backdrop of the Civil War as a practice canvas upon which to record a series of his impressions, a few of which have become iconic images of the common soldier. Many of his sketches would, of course, appear as wood engravings in the pages of *Harper's*. Still dozens more would become study vignettes for future paintings, some of which he put on exhibition and offered for sale.

Zouave by Winslow Homer, black and white chalk on blue-green paper, 1864. Cooper-Hewitt, National Design Museum, Smithsonian Institution

The Smithsonian's Cooper-Hewitt, National Design Museum, in New York City owns more than three dozen of Homer's original Civil War sketches. These form part of a larger collection of 287 drawings donated by Homer's brother, Charles Savage Homer Jr., in 1912, two years after Winslow's death. The drawings, many of them rough sketches, are indicative of how Homer worked to compile a portfolio of images for future use. While his artistic skill is clearly evident, these drawings reveal the early work of a man with great ambitions who would become one of America's most acclaimed artists.

JB

General McClellan's Sixth Pennsylvania Cavalry Regiment Ready to Embark at Alexandria for Old Point Comfort by Winslow Homer, graphite, brush, and gray wash on cream-colored paper, 1862. Cooper-Hewitt, National Design Museum, Smithsonian Institution

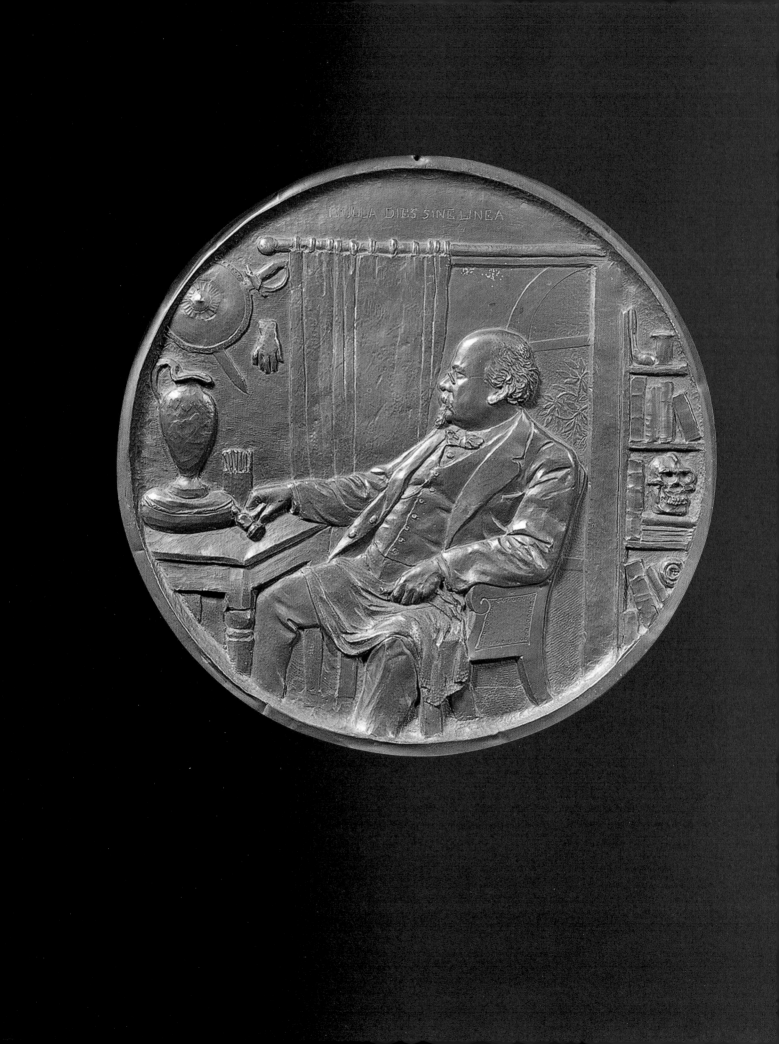

UNLIKE THE MORE URBAN NORTH, the overwhelmingly rural Confederacy did not have an extensive network of printmakers, magazines, and newspapers to propagandize its cause. Nor did it have nearly as easy access to the array of supplies needed to support such enterprises. It did, however, have Adalbert J. Volck on its side.

Born in Germany, where he had been involved in the revolution of 1848, Volck was forced to flee to America when the revolution failed. There, he eventually settled in Baltimore. The liberal idealism of most of the German political émigrés of 1848 inevitably drew them to the Northern cause at the outbreak of the Civil War. But not Volck. Instead, while his adopted Maryland became one of the border slave states to remain in the Union, he sided squarely with the South and was soon engaged in a myriad of subversive activities to promote the Confederate cause. His Baltimore house served as a refuge for Southern agents, and Volck himself went into the smuggling business, crossing the Potomac into Virginia in boats loaded with such contraband items as medical supplies for the Confederate armies.

But Volck's greatest effort on behalf of the Southern cause was in the field of pictorial propaganda. A dentist by profession, he was an artist by avocation, and not long after the firing on Fort Sumter in April 1861, he was trying his hand at editorial illustration for the Confederacy. His maiden efforts were crude. But his work gradually became more polished, and he hit his artistic stride with *Sketches from the Civil War in North America*, the first segment of which appeared in the summer of 1863. Published under the pseudonym "V. Blada"—a combination of his last initial and the reversed first five letters of his Christian name—many of the thirty pictures that ultimately comprised this series were meant to blacken the Union cause beyond redemption. And blacken it they did. In Volck's hands, Lincoln, the Great Emancipator, became the devil incarnate; his abolitionist allies became self-righteous hypocrites; and Union soldiers were transformed into cowardly bullies specializing in the brutalization of Southern civilians. Making this impression of barbarous cruelty all the more appalling were his depictions of the Confederacy as a bastion of high-minded Christian chivalry.

Published in editions of only two hundred, Volck's *Sketches* did not have wide circulation and probably did not sway many minds. Yet their value in understanding the Civil War today is considerable, for in these emotionally charged vignettes can be seen the beliefs and fears that were the Confederacy's psychological underpinnings and that kept it intact even after defeat was inevitable.

Volck concentrated primarily on dentistry after the Civil War. But he still retained an interest in art, and by the 1890s he was working in metal relief. Among his efforts in that medium was an intricate shield memorializing the brave women of the Confederacy. Another was this self-portrait dating from about 1900.

FV

ADALBERT J. VOLCK
Self-portrait, tin relief,
c. 1900

ADALBERT J. VOLCK BEGAN his *Sketches from the Civil War* with this comprehensive indictment of the Union cause, titled *Worship of the North*. Gathered around an altar built of bricks labeled "Puritanism," "Witchburning," "Negro Worship," and "Free Love" are a host of villains responsible for the unholy crusade against the South. As a devil-like Lincoln presides to the right of the altar, abolitionist clergyman Henry Ward Beecher directs his knife toward the white victim being sacrificed to a black idol. While *New York Tribune* editor Horace Greeley swings incense in the left corner and, behind him, Republican senator Charles Sumner holds a torch to guide Beecher's knife, a crowd of Northern luminaries looks solemnly and prayerfully on. Underscoring the Confederacy's commonly held conviction that the North was making war on the South as much for profit as for slave liberation, overfed representatives of "The Holy Cause of the Contractors" stand barely visible in the far right background.

In many respects this was a visual summary of the web of biases that drove the Confederacy, and it is instructive to contemplate this ghoulish scene in juxtaposition to an analysis of the Southern climate of opinion penned in 1861 by the English journalist William Russell. "Believe a Southern man as he believes himself," Russell observed,

> and you must regard New England and the kindred states as the birthplace of impurity of mind among men and of unchastity in women—the home of Free Love, of Fourierism, of Infidelity, of Abolitionism, of false teachings in political economy and in social life; a land saturated with the drippings of rotten philosophy, with the poisonous infections of a fanatic press; without honor or modesty, whose wisdom is paltry cunning, whose valor and manhood have been swallowed up in a corrupt howling demagogy and in the marts of dishonest commerce.[108]

To that, the creator of *Worship of the North* would have uttered a heartfelt "Amen!"

FV

WORSHIP OF THE NORTH
By Adalbert J. Volck
(1828–1912), etching,
1863

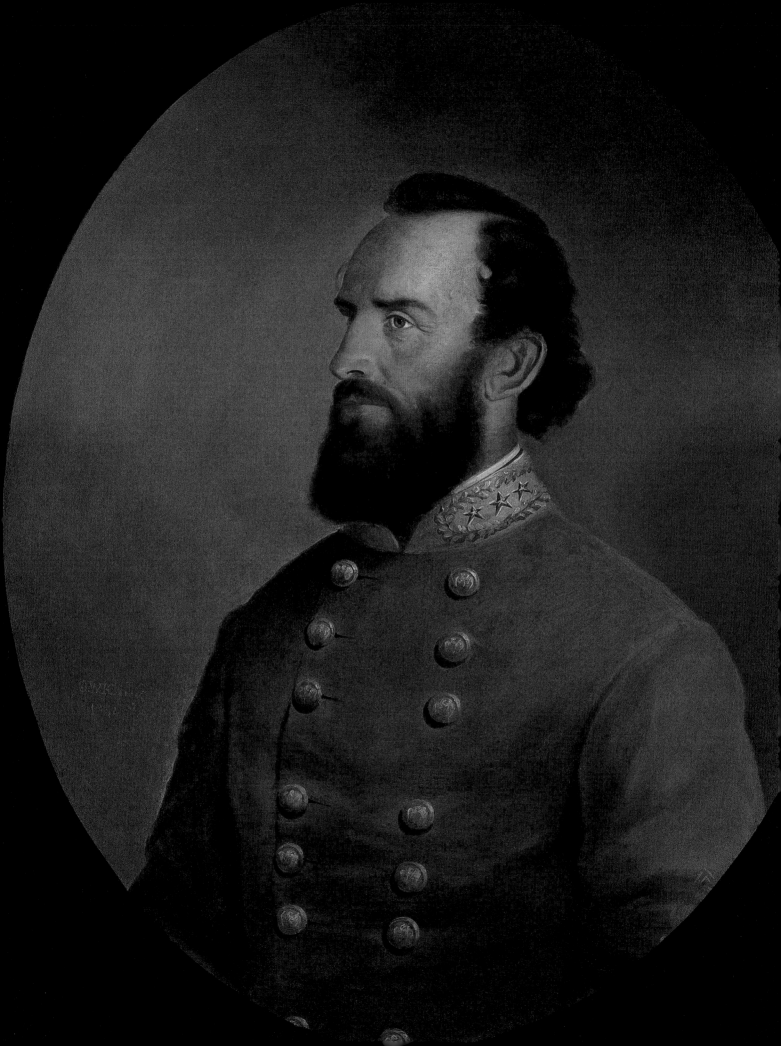

SOLDIERLY DISCIPLINE AND AN ALMOST FANATICAL devotion to his Presbyterian faith were two legendary aspects of Thomas J. Jackson's Civil War career. In April 1863, he demonstrated these qualities in a familial way, only days before his accidental death. Just prior to the start of the spring offensive, while encamped near Fredericksburg, Virginia, Jackson was visited by his wife and the five-month-old daughter he had never seen. Jackson the military taskmaster became again the affectionate husband and gentle parent. Yet an instance arose when Jackson could not help being himself. One day while he was with the baby, she began crying and wanted to be held. He obliged, and once the baby was contented, he promptly laid her back down upon the bed. The baby commenced crying even louder. Mrs. Jackson recalled the ensuing contest of wills years later: "So there she lay, kicking and screaming, while he stood over her with as much coolness and determination as if he were directing a battle; and he was true to the name of Stonewall, even in disciplining a baby!" When the infant stopped crying, he would pick her up and if she started crying again, he would lay her down, "until finally she was completely conquered, and became perfectly quiet in his hands."[109]

Jackson took the opportunity of this visit to have his new daughter baptized by his military chaplain. It was also at this time that the second and last wartime photograph of Jackson was taken. Jackson at first declined to pose before the camera of Daniel T. Cowell from the Richmond photographic studio of Minnis and Cowell. Mrs. Jackson, however, struck by her husband's superior health and fine appearance in a uniform coat given to him by cavalry officer General Jeb Stuart, persuaded him to sit for his picture. "After arranging his hair myself," she wrote, "which was unusually long for him, and curled in large ringlets, he sat in the hall of the house, where a strong wind blew in his face, causing him to frown, and giving a sternness to his countenance that was not natural."[110] In the next two weeks, Jackson would win laurels at the Battle of Chancellorsville, where he would be mortally wounded in the twilight while riding within his own lines.

The last photograph of Jackson became a favorite with his soldiers, and it was reproduced in popular memorial prints and paintings, including this one by J. W. King.[111] King had briefly been an illustrator for the *Southern Illustrated News* and had access to the Minnis Studio's photographs. In addition to his portrait of Jackson, King is known to have painted portraits of Confederate generals William E. Starke and Robert E. Lee, the last allegedly made in Richmond from life during the war.

JB

THOMAS J.
"STONEWALL" JACKSON
By J. W. King (lifedates
unknown), oil on
canvas, 1864

When Jackson sat for this daguerreotype in the summer of 1855, he was a professor of artillery tactics and natural philosophy at the Virginia Military Institute in Lexington. Jackson was known among the students as a competent but not an exciting teacher. His rise as one of the Confederacy's most celebrated and inspiring generals lay six years away. This image was made in Parkersburg, Virginia (now West Virginia), during Jackson's visit with his aunt and uncle, Clementine and Alfred Neale. He was still coping stoically with the death of his first wife, from childbirth, the previous fall. The daguerreotype originally belonged to the Neales and was passed down in their family over several generations.

Attributed to H. B. Hull
(lifedates unknown),
daguerreotype, 1855

The bowed heads and pious demeanor of the soldiers in this etching titled *Scene in Stonewall Jackson's Camp* are suggestive of the religious services and prayer meetings that were held daily within General Jackson's Second Corps, especially during the early months of 1863. No commander in the field did more to invoke the need for Divine Providence in military operations than Jackson. In Jackson's ranks there were never enough chaplains to attend to the troops, in spite of his efforts to recruit them.

By Adalbert J. Volck
(1828–1912), etching, 1863

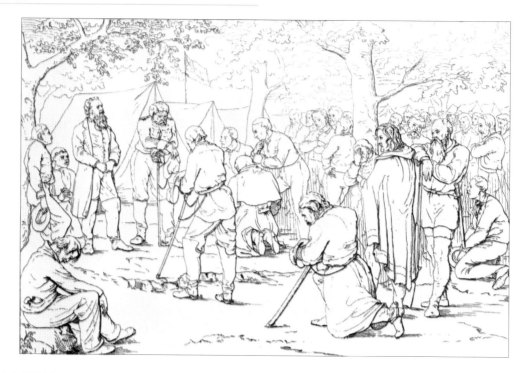

Southern nationalism is symbolically infused in this engraving of Jackson seated with his wife, Anna, and his daughter, Julia. Prominently displayed on the back wall are the portraits of Lee, Calhoun, and Washington. Washington was held in the highest esteem by both sides as a revolutionary patriot and defender of the Constitution.

By William Sartain (1843–1924), engraving, 1866

The image on this cover of sheet music is based on the last photograph of Jackson taken shortly before his death by Daniel T. Cowell. Even in death, Jackson would become, along with Lincoln, Grant, and Lee, one of the most portrayed figures of the Civil War.

By Endicott Lithography Company (active 1828–86), lithograph, 1865

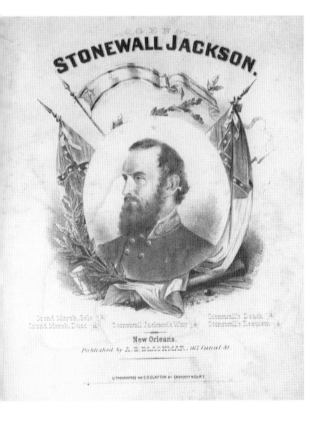

Stonewall Jackson was severely wounded by friendly fire at Chancellorsville in the dark of evening on May 2, 1863. He was hit simultaneously by three bullets, one to his right hand and two more that fractured his left arm. Doctors determined that his arm would have to amputated just below the shoulder. Moved to a house near Guinea Station, south of Fredericksburg, he developed pneumonia and died on May 10. Jackson lay in state in Richmond before he was carried home to Lexington and buried in his family's plot.

The day after Jackson died, while his body was being embalmed and prepared for viewing in Richmond, Frederick Volck made a plaster death mask, which is now in the city's Valentine Museum. His brother, Adalbert J. Volck of Baltimore, made this profile etching of the mask.

By Adalbert J. Volck (1828–1912), etching, c. 1863

THOMAS J. "STONEWALL" JACKSON

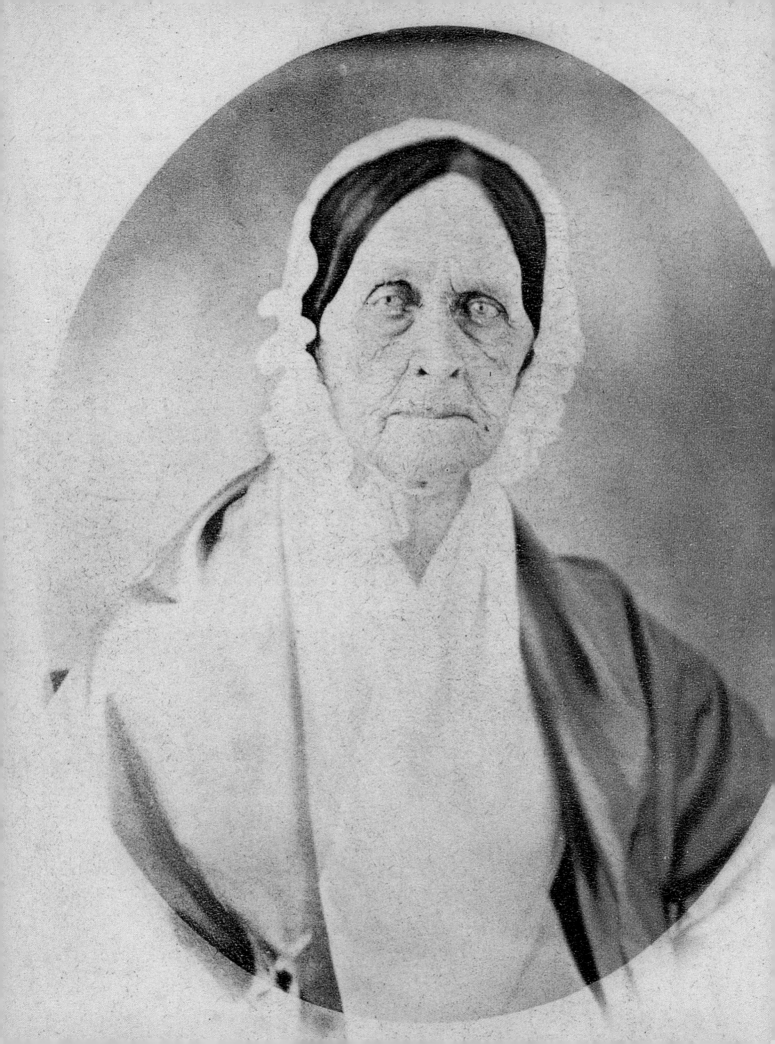

A GOOD LEGEND often evolves seamlessly, presents its characters in a heroic light, and when, told by an accomplished storyteller, can become part of the national lore. The legend of Barbara Fritchie is such a legend, which became one of the most popular to emerge from the Civil War. New England poet John Greenleaf Whittier is credited with giving this legend immortality, if not authenticity, in the sixty-line poem, "Barbara Frietchie [*sic*]," first published in the *Atlantic Monthly* in October 1863. Whittier based his account on information sent to him by Emma D.E.N. Southworth, a popular novelist living in Washington, D.C. According to what she had gleaned from newspapers and other sources, the story of Barbara Fritchie centered on a ninety-five-year old-widow who had demonstrated unusual pluck and patriotism in defying Stonewall Jackson's Confederate soldiers as they marched through Frederick, Maryland, in early September 1862.

Legend has it that when all in the town had boarded up their houses and hauled down the American flag upon the approach of the rebel army, Barbara Fritchie took up the flag and waved it out of her attic window over the heads of Jackson's troops marching past in the street below. The soldiers were ordered to halt, and a shot was fired that cracked the flagstaff. Fritchie retrieved the flag and continued defiantly waving it out the window. In what has since become the poem's most poignant line, Whittier wrote: " 'Shoot, if you must, this old gray head, but spare your country's flag,' she said." Impressed by her courage, Jackson, in the poem, gave the memorable order: " 'Who touches a hair of yon gray head dies like a dog! March on!' he said."

In spite of the popularity of the legend, doubts were cast upon the story almost from the beginning, and time and history have not substantiated it. Whittier always claimed that his poetic rendition was faithful to the sources he had been given. Still, he may have used a measure of poetic license in placing Stonewall Jackson squarely under Barbara Fritchie's window. It is well documented that Jackson himself did not ride past Fritchie's home.

Born in Lancaster, Pennsylvania, in 1766, Barbara Fritchie moved to Frederick as a child and married a glovemaker. By the time of the Civil War, she was in her mid-nineties and was known for her ardent support of the Union, which went back to the founding of the republic. Reputedly, Fritchie had once served dinner to George Washington in a local hotel. She died three months after the rebels had passed through town. Neither Fritchie nor Stonewall Jackson, who died five months later, lived long enough to respond to the claims made by Whittier in his poem.

JB

BARBARA FRITCHIE
Jacob Byerly and Son
(active 1807–83),
albumen silver print,
c. 1862 (printed
c. 1863–64)

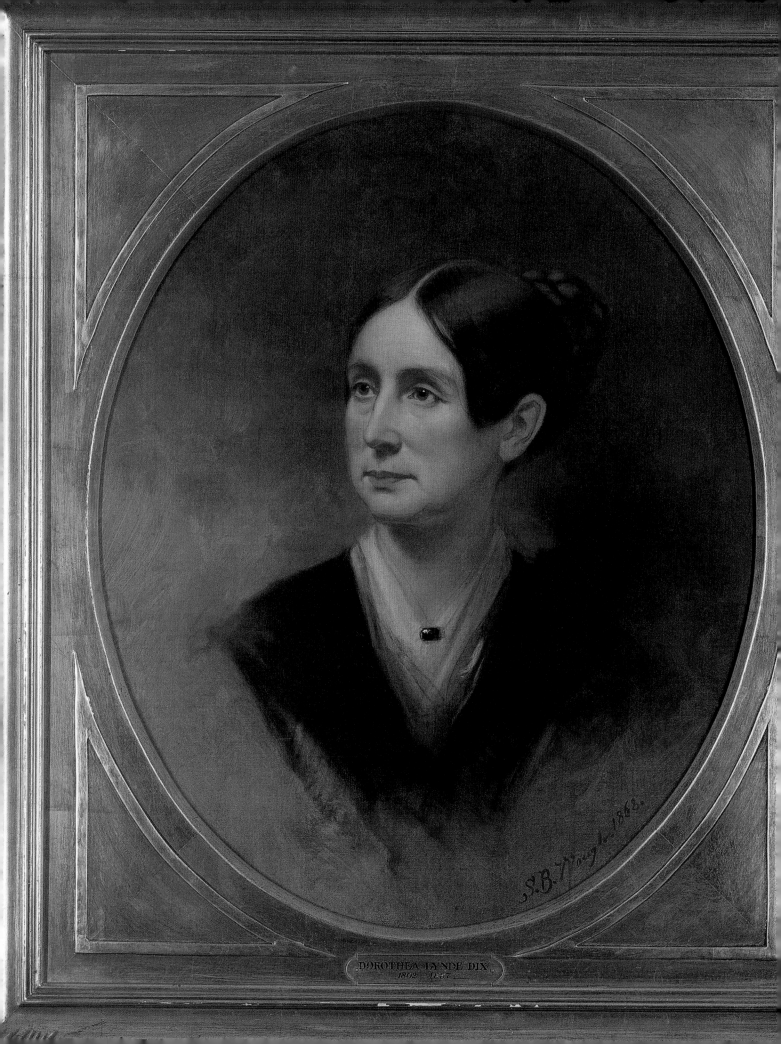

DOROTHEA LYNDE DIX
1802 – 1887

IN MARCH 1841, Dorothea Dix's life changed forever when she went to a Massachusetts jail to teach a Sunday-school class. There, she bore witness to the standard American practice of caging the mentally ill in prisons and poorhouses, in unsanitary and heatless rooms. In that moment Dix found her cause. Before long she dedicated herself exclusively to exposing the inhumane ways in which the country treated its mentally ill and lobbied for the establishment of hospitals to care for them. Although plagued with personal illness, she remained intrepid. By 1853 she had succeeded in convincing twelve state legislatures to fund asylums.

With the start of the Civil War and Lincoln's call for 75,000 volunteer militia, Dix traveled to Washington in the spring of 1861 to offer her services to the surgeon general. She modeled herself on Florence Nightingale, the young British nurse whose humanitarian ministrations in the Crimean War had won her international acclaim. One of the first things Dix did after her arrival in the capital was to have a black dress made for her, imitative of her heroine's trademark. Armed with good credentials and a national reputation, Dix won an appointment as superintendent of women nurses, a title she would hold, without salary, for the next five years.

Dix was dour in temperament, disciplined in her work, and totally dedicated to the task at hand—the management and placement of all women nurses who volunteered their services in the government hospitals. The qualifications she set for admission into her ranks were harsh, even by the standards of her day. "All nurses are required to be plain looking women. Their dresses must be brown or black, with no bows, no curls, no jewelry, and no hoop-skirts."[112] And she would consider no woman under thirty. Predictably, Dix made herself unpopular with many of her nurses. Yet their complaints were a mere whisper compared with the roar of many doctors in the medical corps, who resented the intrusions of women in what was then an exclusively male field. A reorganization of the medical department in 1862 put in place a new surgeon general, who would ultimately curtail Dix's authority and the autonomy she demanded. Her resistance in working with the U.S. Sanitary Commission, a government-sanctioned organization created to aid and assist in the care of sick and wounded soldiers, was recorded by its treasurer, the noted diarist George Templeton Strong: "She is energetic, benevolent, unselfish, and a mild case of monomania. Working on her own hook, she does good, but no one can cooperate with her."[113]

In memory of Dix's pioneering efforts to improve conditions for the mentally ill, this portrait, based on a photograph, was commissioned by St. Elizabeth's Hospital in Washington, D.C., an institution she founded. The portrait hung at the hospital for years and was transferred to the National Portrait Gallery in 1997, in the hopes that it might receive greater visibility.

JB

DOROTHEA DIX
By Samuel Bell
Waugh (1814–1885),
oil on canvas, 1868

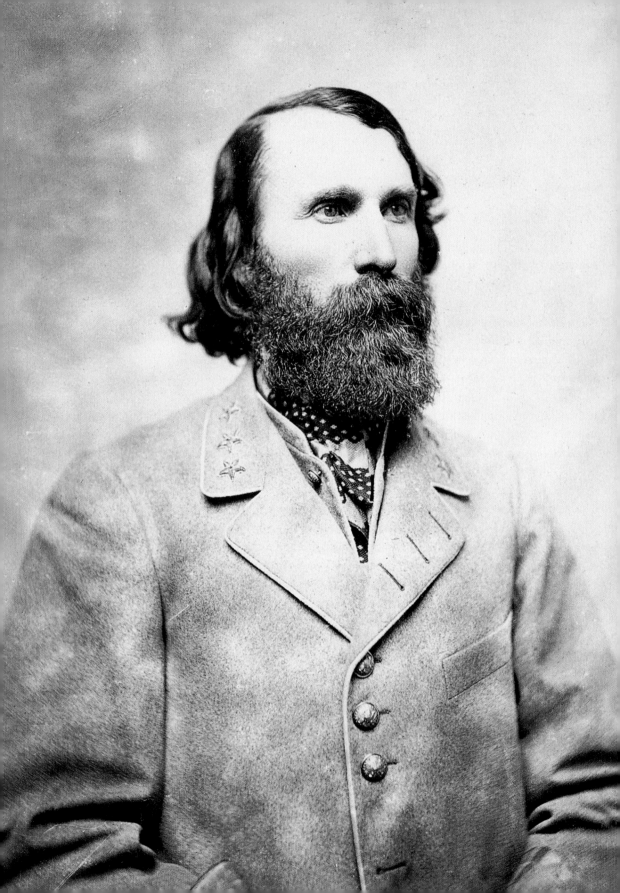

ONE OF THE SMALL MYSTERIES OF THE CIVIL WAR, but a central puzzle for any biographer of this gallant rebel warrior, is what recurring physical ailment so afflicted Ambrose Powell Hill? General A. P. Hill was perhaps the most enigmatic member of that historic cadre of senior officers known as Lee's lieutenants. Principally as a division commander, and later as the commander of the Third Corps of the Army of Northern Virginia, Hill was in a position to play a major role in military operations in Virginia, Maryland, and Pennsylvania between 1862 and 1865. His fleet, hard-hitting attacks during the Peninsular Campaign, Cedar Mountain, Second Manassas, and especially his counterattack at Antietam, all in 1862, earned his command the proud sobriquet of the Light Division. At Chancellorsville in May 1863, Hill aptly stepped in for his chief, Stonewall Jackson, after Jackson suffered the fatal wound that would induce Lee to reorganize his army. Hill was promoted to lieutenant general and given command of the newly created Third Corps.

Yet Hill's performance for the remainder of the war was almost lackluster in comparison to his earlier brilliance. Hill was not the same man. In large part, this could be attributed to his health, which was increasingly failing him, and at inopportune times. Hill was ill at Gettysburg and again at the critical battles of the Wilderness and Spotsylvania Court House in May 1864. The next year he was again incapacitated and took a brief leave of absence just prior to the final Confederate stand at Petersburg before the fall of Richmond.

Sickness had been a debilitating aspect of Hill's military career from the beginning. In 1847, as a new lieutenant in the Mexican War, Hill contracted typhoid fever. In 1850, while on garrison duty in Florida, he came down with yellow fever. It might even be said that his West Point years were a harbinger of things to come. In 1844, Hill contracted a case of venereal disease, probably in New York City during his return to school after a furlough. Unfortunately for him, he was not one of the lucky ones who rode out the infection with no lasting effects. Hill developed more serious complications that lingered into his third year and forced him to recuperate at his home in Culpeper, Virginia. Consequently, he lost a year of school and graduated a year behind his famous class of 1846, from which twenty graduates would become Civil War generals, including Stonewall Jackson and George B. McClellan. McClellan graduated first in his class and had been Hill's roommate and close friend. Jackson and Hill, however, disliked each other from the start—it was a personality clash that they never outgrew. Jackson's strict sense of self-discipline could not tolerate Hill's natural levity. As fate would play out during the Civil War, Hill would fight under Jackson's command against McClellan. A

A. P. HILL
By George S. Cook
(1819–1902), after
Julian Vannerson,
glossy collodion print,
copied c. 1867

prolonged squabble ensued between the two Confederates, which led Jackson in September 1862 to place Hill under temporary arrest for insubordination.

With Jackson's death in May 1863, Hill's promotion to corps commander placed additional burdens on his weakening constitution. Not enough is known about the precise nature of his symptoms, but recurring abdominal pains seemed to have been one of them. Over the years, historians have tried to diagnose his chief ailment and have suggested such maladies as chronic malaria, prostatitis (in Hill's case a lingering symptom from his venereal disease), hepatitis, and even a psychosomatic disorder brought on by the increased rigors of command.

On the morning of April 2, 1865, A. P. Hill was killed by Yankee stragglers as he tried to reach his troops during the evacuation of Petersburg. This popular image may have been the last one taken of Hill, based on the photographic images that are known to be extant. The original photograph was taken by Julian Vannerson around 1864. The National Portrait Gallery's image illustrated here is a copy made by George S. Cook after the war.

JB

Published in Louisville after the war, *In Memory of the Confederate Dead* underscores the strong Southern sentiment that prevailed throughout the border state of Kentucky. Represented on the cover for this musical score are, clockwise from top, Albert Sidney Johnston, Leonidas Polk, James E. Rains, A. P. Hill, J. E. B. Stuart, John Hunt Morgan, and (center) Stonewall Jackson.

By Bennett, Donaldson & Elmes Lithography Company (active c. 1866), lithograph with tintstone, c. 1866

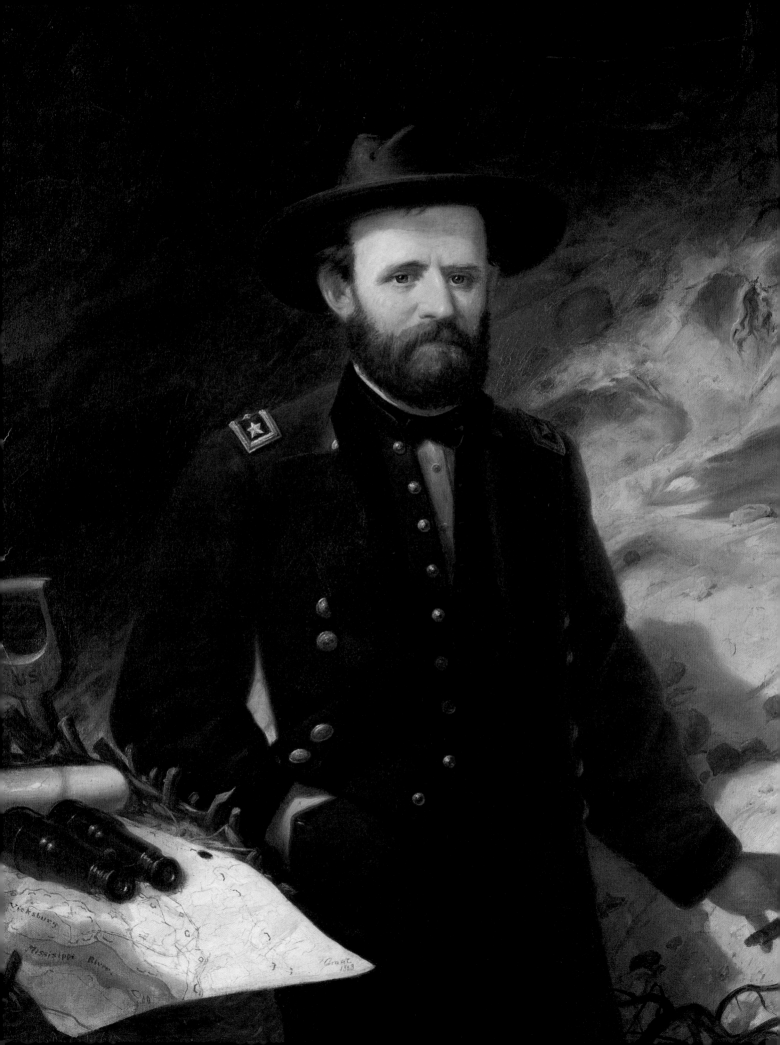

THE CIVIL WAR changed few men's lives as much as that of Ulysses S. Grant. Grant was a West Point graduate, a veteran of the Mexican War, and a member of the class of officers who found life in the regular army, separated from family for extended periods of time, to be lonely and tedious. In 1854, he resigned his commission, only to offer his services again at the start of the war. Meanwhile, he had tried several different occupations and had not prospered at any of them. In 1861, Grant was made a brigadier general and given command in Cairo, Illinois. Nothing extraordinary was expected of him until he began winning battles, first at Fort Donelson, Tennessee, where his terms were "unconditional surrender," and later at Vicksburg, Mississippi, and Chattanooga, Tennessee. Although some said he drank and was not fit for high command, Grant demonstrated conclusively that he was a fighter, and that was enough for the commander in chief: President Lincoln promoted him to lieutenant general in 1864 and gave him command of all of the Union armies.

This portrait of Grant by the Norwegian-born Ole Peter Hansen Balling shows the Union's most celebrated general in the trenches at Vicksburg, the site of his great victory in the summer of 1863. In truth, Balling had his first sittings with Grant more than a year later, while the Army of the Potomac was encamped at City Point, Virginia, during the fall of 1864. Balling visited Grant's headquarters to make life sketches for a commissioned group portrait of Grant and his generals. Inspired afterward by Grant's own campfire reflections on the Battle of Vicksburg, Balling chose this setting for his portrait. From the beginning of the twentieth century until it came to the National Portrait Gallery in 1967, Balling's likeness, and its ornate frame recalling Grant's Civil War triumphs, hung in the lobby of a hotel in Saratoga Springs, New York. Carrying a pass that he had personally obtained from President Lincoln, Balling went to City Point primarily to make sketches for a monumental painting of Grant and twenty-six of his generals. A New York merchant had commissioned the canvas, which he planned to have tour the country to raise money for the U.S. Sanitary Commission.

Balling spent five weeks in camp and left with a portfolio of images, including sketches of many of the officers' steeds. For likenesses of Philip Sheridan and William Sherman, among others, Balling traveled throughout the Old Dominion and later back to Washington, where Sherman had to be cornered by his family before he agreed to give a sitting. Balling's passion for detail took him to Wilmington, Delaware, the temporary home of Mrs. Grant, so that he could sketch an ornately engraved presentation sword voted to Grant

ULYSSES S. GRANT
By Ole Peter Hansen
Balling (1823–1906),
oil on canvas, 1865

at New York City's great Metropolitan Fair in April 1864, in aid of the U.S. Sanitary Commission.

Balling spent a year painting what he considered his masterpiece. The merchant who commissioned it, however, died before it was finished. Except for a brief showing in New York in 1866, the canvas never toured. By then the war was over. The painting spent much of its existence in storage until it came into the collection of the Smithsonian Institution.

JB

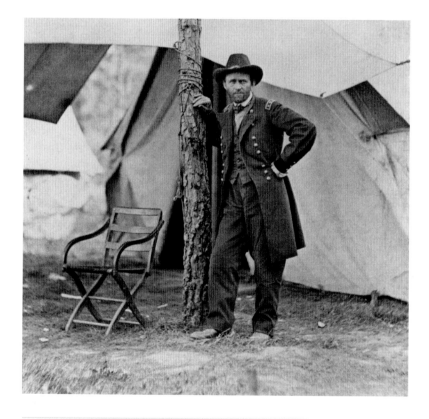

Ulysses S. Grant at headquarters, Cold Harbor, Virginia, by Mathew Brady (c. 1823–1896), albumen silver print, 1864

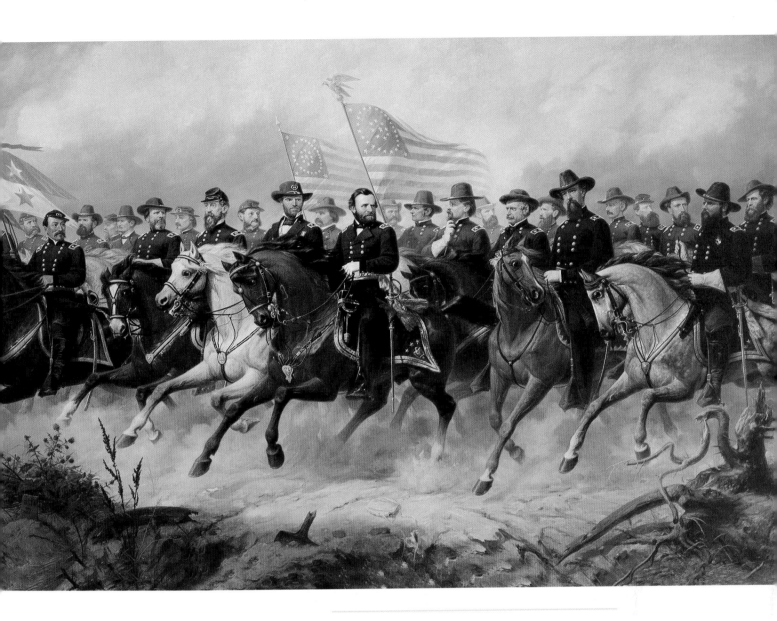

Grant and His Generals by Ole Peter Hansen Balling (1823–1906), oil on canvas, 1865

Left to right: Thomas C. Devin, George Armstrong Custer, Hugh Judson Kilpatrick, William H. Emory, Philip H. Sheridan, James B. McPherson, George Crook, Wesley Merritt, George H. Thomas, Gouverneur K. Warren, George G. Meade, John G. Parke, William T. Sherman, John A. Logan, Ulysses S. Grant, Ambrose E. Burnside, Joseph Hooker, Winfield S. Hancock, John A. Rawlins, Edward O. C. Ord, Francis P. Blair, Alfred H. Terry, Henry W. Slocum, Jefferson C. Davis, Oliver O. Howard, John M. Schofield, Joseph A. Mower

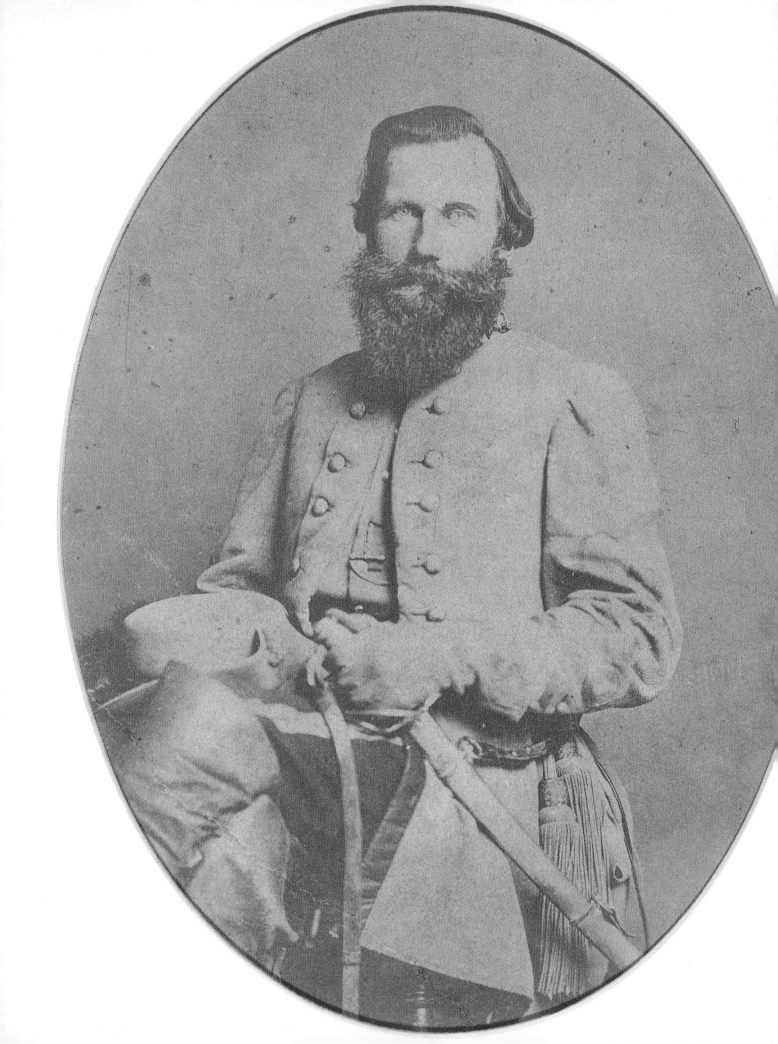

IF THE CIVIL WAR produced but one genuine cavalier, it would be difficult to argue a more qualified candidate than James Ewell Brown Stuart. In both deeds and appearances, he filled the role. There was even something jaunty about his nickname, Jeb. His view of life in the army was always from the saddle, as it had been from the start of his career as a cavalry-man. Family tradition held that in his last year at West Point, Stuart purposely did not live up to his academic potential so that he would not be appointed to the elite corps of engineers upon graduation. Still, he ranked thirteenth in a class of forty-six. Commissioned a second lieutenant in the Mounted Rifles in 1854, the handsome young Virginian had a daguerreotype taken of himself in civilian clothes in Washington before reporting for duty in Texas. This was several months before he began growing the luxuriant cinnamon-colored beard by which he was recognized for the rest of his life. An associate commented that Stuart was the only person he had ever known whose appearance was improved by whiskers, an observation that might substantiate the claim made by others that Stuart had a weak chin.

Yet there was no disputing the magnificence of the beard or the clarity of the light blue eyes, as seen in this photograph of Stuart taken in 1863. At the time the image was taken, Stuart was in command of the cavalry in Lee's Army of Northern Virginia. Lee relied heavily on Stuart's ability to gather intelligence about the enemy's strengths and whereabouts, and to screen his own army's movements. Stuart's ride around McClellan's army during the Peninsular Campaign in June 1862 became legendary in its day. Stuart personally relished the attention and laurels his cavalry garnered, and success became one of the spurs that drove him to new and daring feats. Yet an ambitious reconnaissance that he made during the Gettysburg campaign put him out of communication with the main army at what proved to be a critical moment. The consequences of his failure to keep Lee informed, and his tardy arrival upon the battlefield, have been studied by military historians ever since. Stuart never again let down his vigilance or gave his chief anxious moments of silence about the enemy.

Few officers enjoyed the war more than Stuart. His days in camp were often filled with singing and dancing and bevies of admiring women. It was well known that "he was in the habit of kissing girls," wrote Confederate diarist Mary Chesnut, and because some complained, he "was forbidden to kiss one unless he could kiss *all*."[14] In May 1864, Stuart died from wounds suffered in a clash with Sheridan's cavalry at Yellow Tavern near Richmond.

JB

J. E. B. STUART
By George S. Cook
(1819–1902), salted-
paper print, 1863

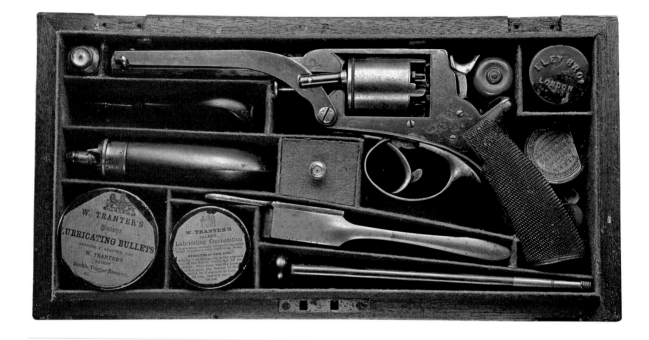

This English-made cased Tranter revolver was given to Confederate major general Stuart by Heros von Borcke, a Prussian officer who took leave from his country's services to serve in the American Civil War. He served as Stuart's chief of staff, with the rank of major, until he was seriously wounded at Middleburg, Virginia, in June 1863. That same month, von Borcke gave this revolver to Stuart, in the expectation that Stuart would have attained the rank of lieutenant general. Stuart had hopes of receiving this rank after commanding Stonewall Jackson's corps when that officer was mortally wounded during the battle of Chancellorsville. Unfortunately, he never obtained that rank, but the inscription on the cover of the cased revolver states: "LT. GEN J.E.B. STUART C.S.A. CULPEPER, VA JUNE 1863/ FROM HEROS VON BORCKE."

National Museum of American History, Smithsonian Institution, Behring Center

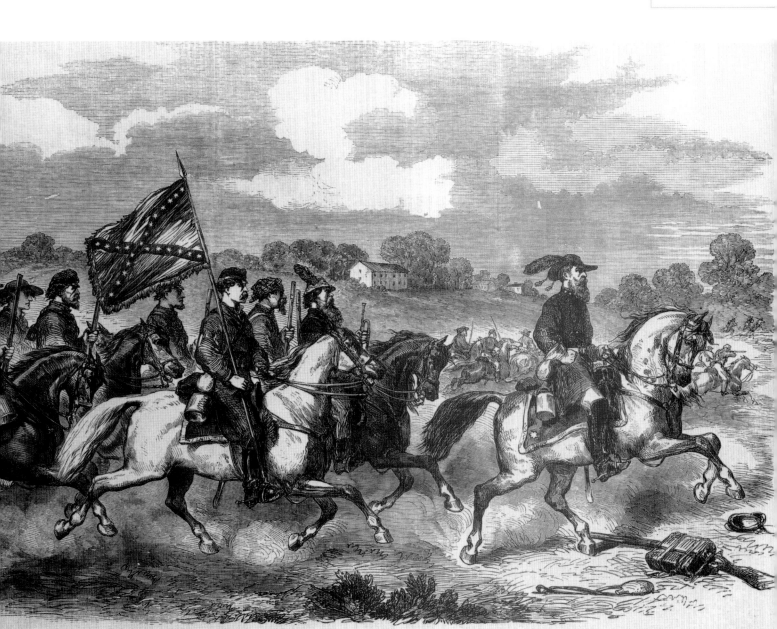

THE CIVIL WAR IN AMERICA : GENERAL STUART (CONFEDERATE) WITH HIS CAVALRY SCOUTING IN THE NEIGHBOURHOOD OF CULPEPPER COURTHOUSE.—FROM A SKETCH BY OUR SPECIAL ARTIST.—SEE NEXT PAGE.

This wood engraving of General Stuart with his cavalry scouting in the neighborhood of Culpeper Court House appeared in the *Illustrated London News*, October 4, 1862.

By Frank Vizetelly (1830–1883?), wood engraving, 1862

A CHANCE MEETING of three Confederate officers in Richmond in 1870 revealed the tensions and bitterness that tormented some men's minds years after the end of the war. The three veterans were legendary in their own way. George Pickett, John Mosby, and Robert E. Lee happened to all be in the former capital of the Confederacy in late March, unbeknownst to one another until Mosby made the chance acquaintance first of Lee and then of Pickett. Lee was nearing the end of his life. He was passing through the city on a quiet tour of the South, in part to try to find relief for his broken health and in part to say farewell to friends and well-wishers. Mosby thought that Lee looked "pale and haggard." Pickett, when apprised by Mosby that Lee was in town, said that he would pay his respects but did not want to visit Lee by himself.

The meeting at Lee's room confirmed Pickett's reluctance to visit his former commander. Although Lee exhibited the perfect manners he had shown all his life, his demeanor was cold and formal. Mosby, sensing the awkwardness of the gathering, got up to leave after a few minutes, and Pickett followed him. Once outside the room, Pickett bitterly denounced Lee as "that old man" who, he said, "had my division massacred at Gettysburg."[115]

In a historical sense, Pickett's entire military career can be summed up in his spearheading of the hour-long frontal assault upon the center of the Union lines at Gettysburg on July 3, 1863. Pickett's charge was the climax of the three-day battle. More than twelve thousand Confederates advanced, and almost half of them were left on the field, either dead or wounded. Lee accepted the blame for the costly rout, and Pickett did not argue. Neither soldier was ever as sure of himself after that battle.

Yet the encounter between Lee and Pickett must have been unpleasant because of still another incident, which occurred at the very end of the war. At the Battle of Five Forks, Virginia, Pickett would fail Lee, and this time the fault lay entirely with Pickett. His lack of diligence at the start of the battle (he had left his command briefly to attend a shad bake) no doubt contributed to the defeat and capture of most of his troops. With Pickett's command decimated, and Lee on the verge of surrendering his entire army, Lee had no further need for Pickett and dismissed him from service.

After the war, Richmond sculptor Edward V. Valentine made portrait busts of many Southern military figures, including Pickett, Mosby, and Lee. He modeled the bust of Pickett in 1875, at the time of Pickett's death. The National Portrait Gallery's bust is a modern cast.

JB

GEORGE E. PICKETT
By Edward Virginius
Valentine (1838–1930),
bronze, 1978 cast after
1875 plaster

VIRGINIA-BORN GEORGE H. THOMAS was a professional soldier who chose to remain with the U.S. Army at the start of the Civil War. Thomas's steadfast allegiance went back to 1840, when he graduated twelfth in a West Point class of forty-two members, including William T. Sherman and Richard S. Ewell. Commissioned a second lieutenant in the Third Artillery, Thomas reported to Florida to join his unit and was promoted for gallantry in action against the Seminole Indians. During the Mexican War he was with Zachary Taylor's army and was breveted twice more for bravery at Monterrey and Buena Vista. In 1861, following the firing on Fort Sumter, when Thomas sided with his country, it was said that his secession-minded sisters in Virginia turned his picture to the wall.

Because of his Southern roots, Thomas came under suspicion in the early months of the war, and his name was passed over for command, with some assignments going to officers who were his junior. In August 1861, he was made a brigadier general of volunteers and ordered to Kentucky. Thomas would spend the entire war proving himself in the western theater. His rise was slow and progressive, just as his method of giving battle was cautious and deliberate. At the Battle of Chickamauga he earned the title of The Rock for the stubborn defense of his position against Confederates of Braxton Bragg's army. Later, during the Chattanooga campaign, Grant placed Thomas in command of the Army of the Cumberland and ordered him to hold the city at all costs. Thomas complied and played a key role during the subsequent battle against Bragg in seizing Lookout Mountain.

In 1864, during the successful Atlanta campaign, Thomas's army comprised more than half of William T. Sherman's force and was constantly engaged. After the surrender of Atlanta, Thomas was assigned to stop John Bell Hood's Confederates in Tennessee. Ordered by Grant to stage an offensive from Nashville, Thomas was deliberate in his preparations but hindered by icy December weather. Grant lost patience and relieved Thomas of command. Yet before the order had reached him, Thomas had engaged Hood in what became a two-day battle. Thomas smashed Hood's army decisively, thereby destroying its usefulness for the rest of the war.

Vindicated, Thomas was made a major general in the regular army and received the thanks of Congress. On the occasion of his death in 1870, hundreds of veterans—but none of Thomas's Virginia relatives—attended his funeral, including President Ulysses S. Grant.

JB

GEORGE H. THOMAS
By the Mathew Brady
Studio (active 1844–1894),
daguerreotype, 1853

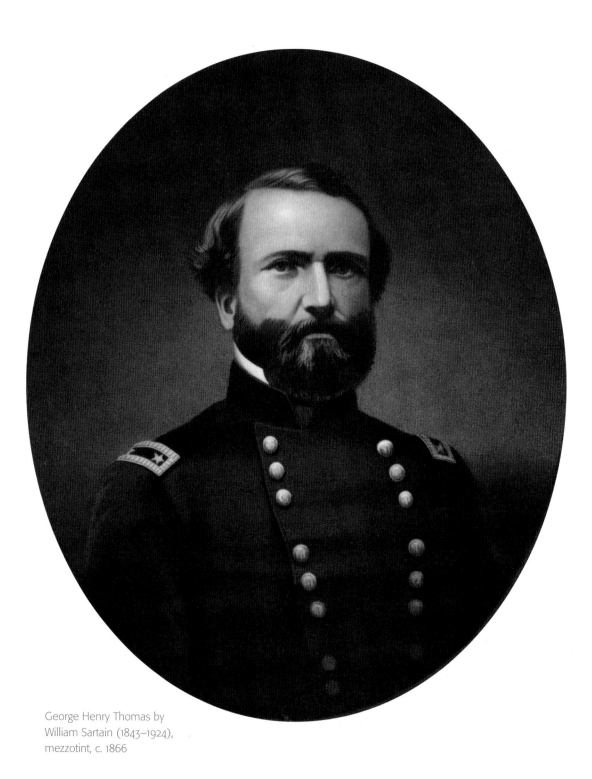

George Henry Thomas by
William Sartain (1843–1924),
mezzotint, c. 1866

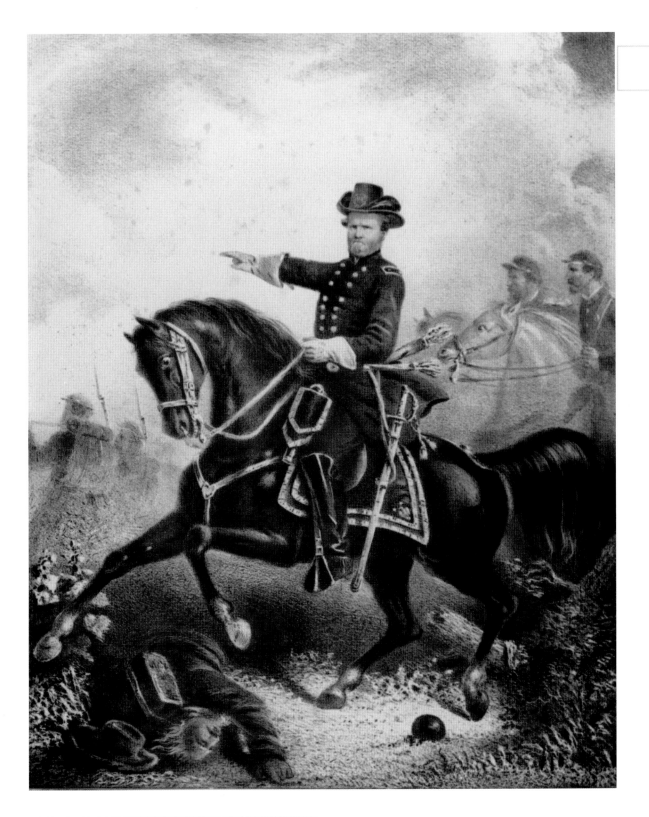

Major General George H. Thomas by Ehrgott and Forbriger
Lithography Company (active 1858–c. 1869), lithograph,
c. 1862

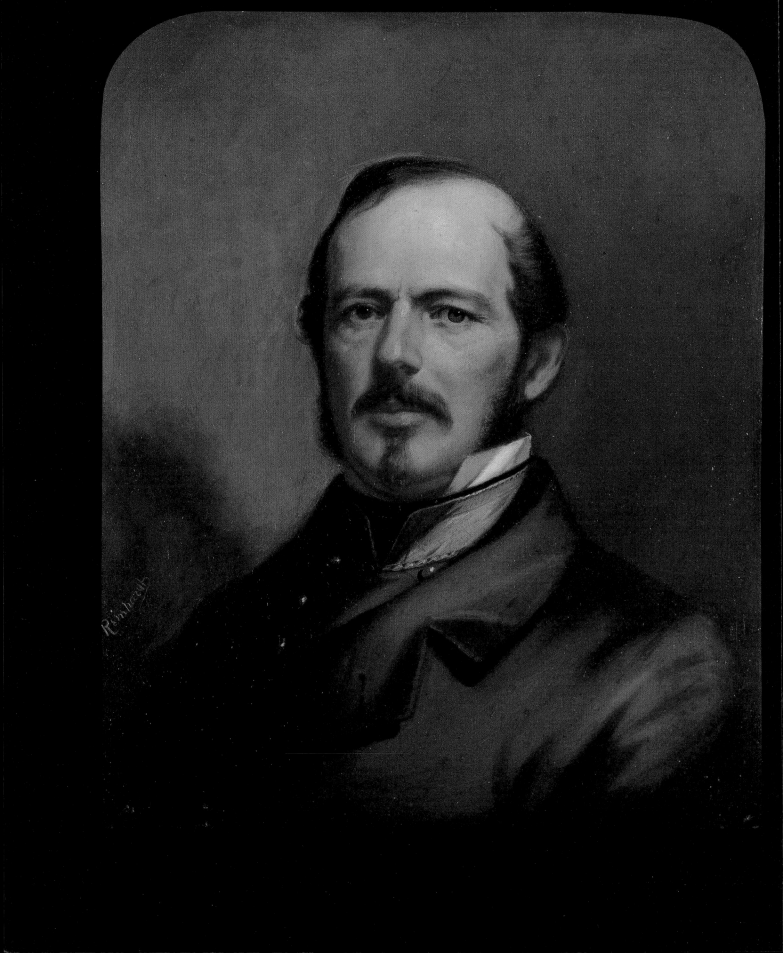

JOSEPH EGGLESTON JOHNSTON'S CIVIL WAR career was a little like the Confederate experiment itself in that it began with high hopes, was riddled with missed opportunities, and ultimately ended in disappointment. Johnston joined the rebel army as a leading contender for a high command. His brilliant performance at the First Battle of Manassas earned him a full general's commission and seemed to foretell further military laurels. Yet his promotion was the beginning of a tempestuous working relationship with Confederate president Jefferson Davis.

Johnston thought that he should have been the ranking Southern general from the beginning. Yet because he had misread the Confederate military formula for designating rank, he was miffed to learn that he was really only fourth in line, behind Generals Samuel Cooper, Albert Sidney Johnston, and Robert E. Lee. Johnston blamed Davis for what he perceived to be a slight and held a grudge throughout the war. From the start, the two men never established a mutual trust. When assigned to command in Tennessee and Mississippi, Johnston erroneously complained that his orders were nominal and that he lacked the authority he needed to implement them. In turn, when the strategic river town of Vicksburg fell, Davis blamed Johnston for circumstances beyond his immediate control. What hurt Johnston most, however, was his overcautiousness, which was interpreted by his superiors as passivity. He liked ideal situations in which his army had a numerical edge and could take the defensive, but at no time was the Confederacy ever blessed with superior numbers. Still, Johnston ended the war with his reputation for command solidly intact. He was respected by his own troops, as well as by the Union high command, namely Ulysses S. Grant. In the opinion of Henry Kyd Douglas, a former member of Stonewall Jackson's staff, "for clear military judgement and capacity to comprehend and take advantage of what is loosely termed 'the situation,' General Johnston was not surpassed by any general in either army."[116]

This cabinet-size portrait of Johnston by Benjamin Franklin Reinhart may have been painted in England, where the artist lived during the Civil War. Reinhart also painted similar small oil portraits of Stonewall Jackson and Jefferson Davis. Like the Jackson portrait, the visage of Johnston is based on an earlier, prewar image.

JB

JOSEPH E. JOHNSTON
By Benjamin Franklin
Reinhart (1829–1885),
oil on artist board,
c. 1860–61

General Joseph E. Johnston by A. G. Campbell (active 1860–1869?), mezzotint, c. 1865

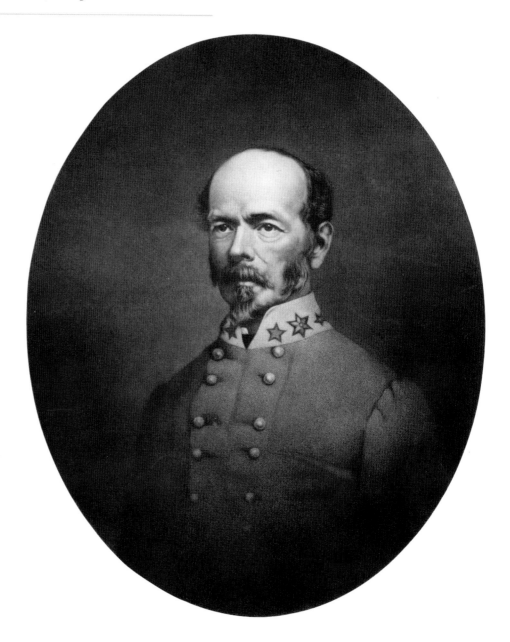

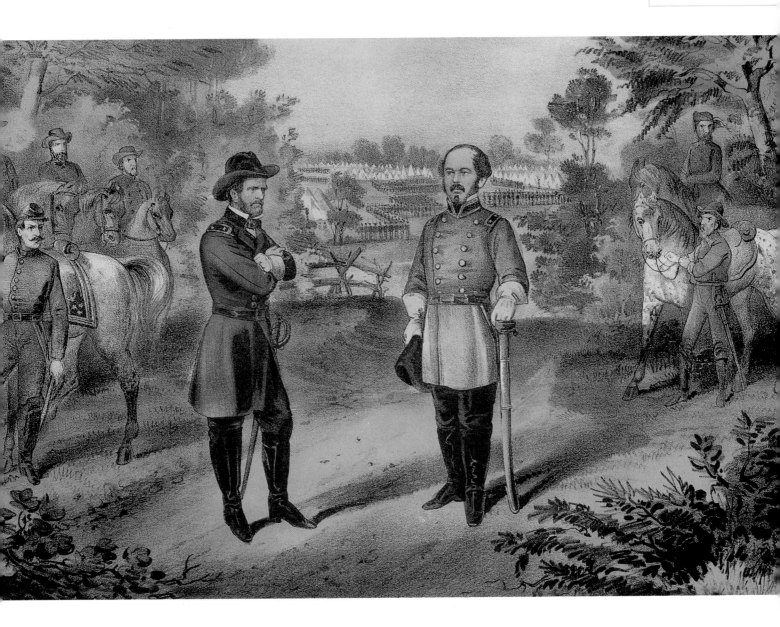

The Surrender of Genl. Joe Johnston near Greensboro,
N. C. April 26th, 1865 by Currier and Ives Lithography Com-
pany (active 1857–1907), hand-colored lithograph, 1865

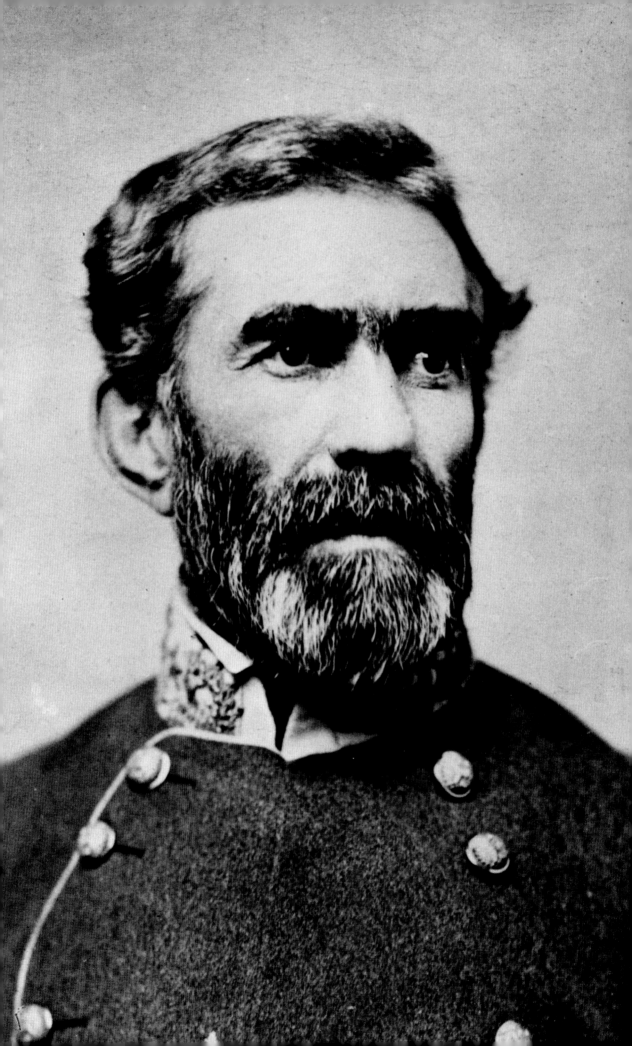

BRAXTON BRAGG WAS ONE of many West Point graduates who had served honorably in the U.S. Army only to side with his native South at the start of the Civil War. As a major general, Bragg first distinguished himself at the Battle of Shiloh in Tennessee, where he commanded the Confederate right flank, capturing thousands of prisoners and many guns. In June 1862, he replaced P. G. T. Beauregard as commander of the Army of Tennessee. In spite of his energy and organizational talents, Bragg's want of persistence in following up victories in the West eventually contributed to the fall of that vital region.

The photograph of Bragg in uniform, published here as a carte de visite, was taken early in the war, while Bragg was organizing Southern forces near Pensacola. Just as his Louisiana peer, General Beauregard, was sent to Charleston to monitor Fort Sumter, Bragg was sent to Florida in March 1861 to maintain a Confederate presence opposite the only other significant coastal garrison held by the North, Fort Pickens, which guarded the entrance to Pensacola Bay. Bragg's photograph was the work of J. D. Edwards, a little-known photographer from New England who was working in New Orleans in 1861. His photographs of Southern military installations form an insightful early record of the Confederacy. Edwards's photograph of Bragg, one of several views taken in the spring of 1861, shows him dressed in a new brigadier general's uniform. Bragg's stern, bristly appearance reflected his temperament, which made him one of the most disliked generals in the Confederacy. His "most remarkable feature is the eye," noted one soldier, after seeing Bragg for the first time. It was "dark-gray and as strong and unflinching as a hawk's."[117]

JB

BRAXTON BRAGG
By J. D. Edwards
(1831–?), albumen
silver print, c. 1861

In the Mexican War, Braxton Bragg was a captain in the Third Artillery and served under General Zachary Taylor. For his gallantry during the Battle of Buena Vista in February 1847, Bragg was breveted a lieutenant colonel. After the battle, Taylor returned with his troops to their encampment at Walnut Springs near Monterrey, Mexico.

This painting was commissioned in 1847 by Robert H. Gallaher, proprietor of the Richmond (Virginia) *Daily Republican*. Gallaher observed that military victories had often led to the White House, and he was convinced that Taylor's success in the Mexican War could turn him into a promising presidential candidate for the Whigs, the predecessors of today's Republican Party. Gallaher sent William Garl Browne Jr. to Mexico to paint a portrait of Taylor so that the hero's face would become as familiar to the American public as was his name. Upon completion, *Zachary Taylor at Walnut Springs* was exhibited in principal cities across the nation.

Taylor appears in the center of the painting, wearing a checked shirt and holding his hat. Braxton Bragg appears hatless and is the third man standing to Taylor's left in the back.

Zachary Taylor at Walnut Springs by William Garl Browne Jr. (1823–1894), oil on canvas mounted on wood, 1847

Braxton Bragg by an unidentified photographer,
ambrotype, c. 1857

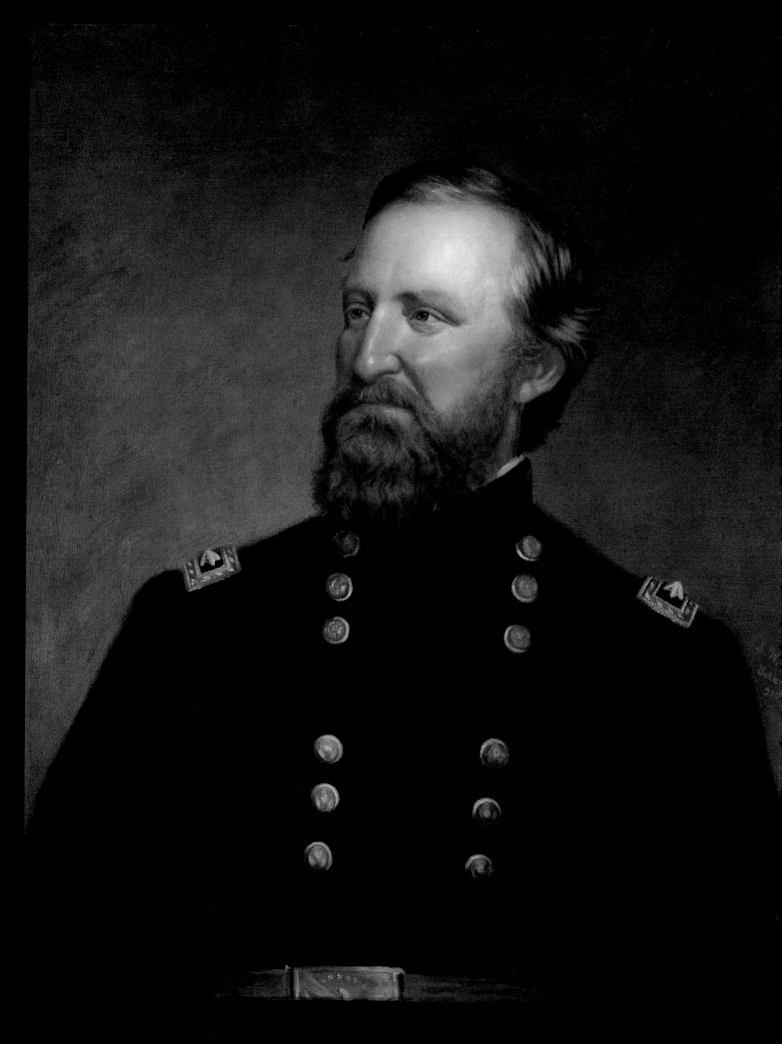

AFFECTIONATELY CALLED OLD ROSY BY HIS TROOPS, William S. Rosecrans proved to be one of the North's best strategists early in the war. His successes were promising, and he achieved them right from the start. In July 1861, Rosecrans's brigade won the Battle of Rich Mountain, Virginia, thus securing a Union foothold in territory that would ultimately become the state of West Virginia. His ability to maneuver the enemy was especially evident in the western theater, where he commanded the Army of the Cumberland in the Battle of Stones River at Murfreesboro, Tennessee. At Chickamauga, Georgia, in September 1863, however, his army suffered disaster when one of his orders was misconstrued. This allowed the enemy to attack through a wide gap in the Federal line. The mistake cost Rosecrans his command and virtually ended his active service in the war.

This likeness of Rosecrans was painted in 1868 by Samuel Woodson Price, who, as colonel of the Twenty-first Kentucky Volunteers in Rosecrans's Army of the Cumberland, performed admirably in holding a portion of the Union line in the Battle of Stones River, in early January 1863. After the war, Price resumed his career as a painter in Lexington, Kentucky. It is believed that he painted this portrait in Washington, D.C., which Rosecrans visited in August 1868, upon his appointment by President Andrew Johnson as minister to Mexico. For a time, the portrait was in the possession of the Veterans' Society of the Army of the Cumberland. Rosecrans and Price, each respected veterans themselves, were both buried in Arlington National Cemetery.

JB

WILLIAM S. ROSECRANS
By Samuel Woodson
Price (1828–1918),
oil on canvas, 1868

William S. Rosecrans by the Mathew Brady Studio (active
1844–1894), albumen silver print, c. 1861

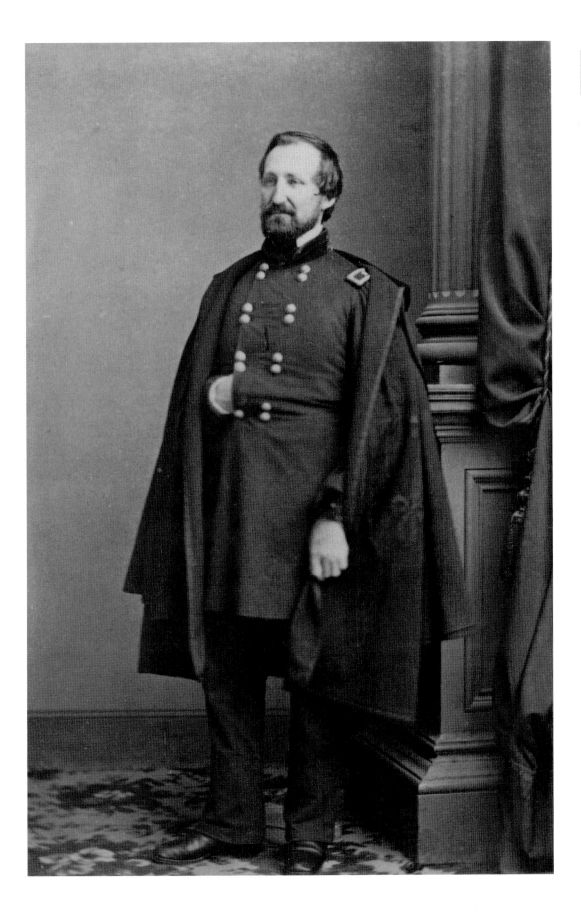

WILLIAM S. ROSECRANS

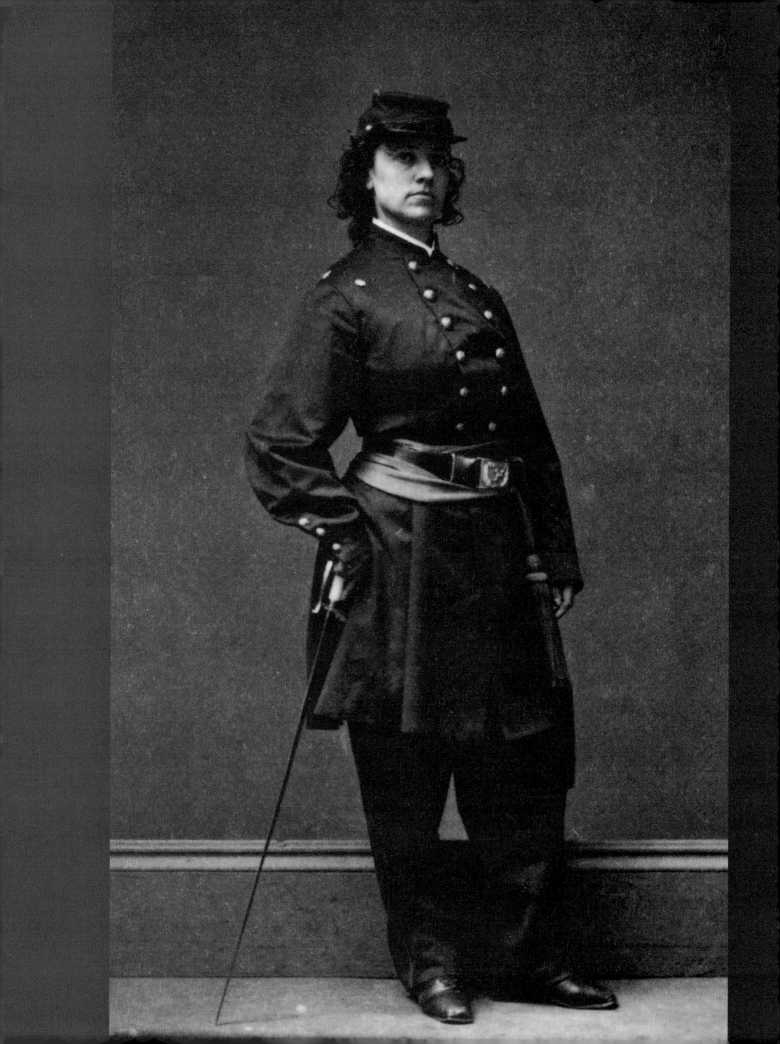

HER HAND RESTS ON A SWORD, and a brightly colored sash is wrapped around her middle, giving her figure the suggestion of a waistline. She wears pants and is dressed like scores of other Union officers who enlisted in the war, reached the rank of major, and wore gold oak leaves on their shoulders. Yet Pauline Cushman's war story was different from that of most Yankee veterans, as might be expected in an all-male army.

In 1863, Cushman was a struggling actress in a Louisville playhouse. In a play that required her to give a toast in her character, she was bribed by two Confederate parolees to toast Jefferson Davis. She agreed, but first sought the permission of the Federal provost marshal. The audience of Union sympathizers was offended by Cushman's bravado, and she was expelled from the theater. Because the public now perceived her as a self-proclaimed secessionist, a new opportunity presented itself—a chance to spy for the Union. In lace and petticoats, she became a camp follower of the Confederate army in Kentucky and Tennessee. Her allure and beauty aided her in obtaining information that would be of value to the Federal army. Yet the frustrated actress soon proved wanting in spying as well. She aroused suspicions and was finally caught with secret papers. General Braxton Bragg had her tried, and a military court sentenced her to hang, whereupon her health broke and her sentence was delayed. Then military operations intervened: Bragg moved his army and left Cushman behind. Rescued by Yankees in Shelbyville, Tennessee, she traveled north to acclaim. President Lincoln made her an honorary major, and wearing her new uniform, she lectured about her clandestine adventures behind rebel lines.

After the war, Cushman's fame mostly ebbed. She tried acting again and married for the second and third times. Her last marriage ended in separation. She began taking opium for an illness and died at sixty. Veterans of the Grand Army of the Republic paid tribute by burying her with military honors in their cemetery in San Francisco.

JB

PAULINE CUSHMAN
By the Mathew Brady
Studio (active 1844–1894),
collodion glass-plate
negative, c. 1864

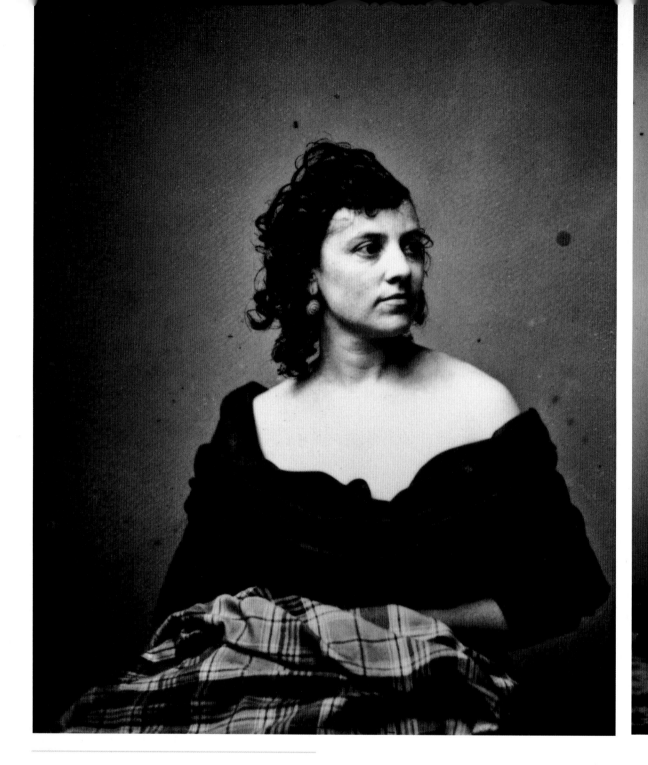

Pauline Cushman Gallery

In what today would be called publicity stills, these pictures of actress Pauline Cushman, for the most part dressed in theatrical costumes, illustrate the natural allure of the camera for future "Hollywood" types during the early years of photography. They also hint at the potential of the camera to someday be a pioneering medium with the power to transform the acting industry.

Pauline Cushman by the Mathew Brady Studio (active 1844–1894), collodion glass-plate negative, c. 1864

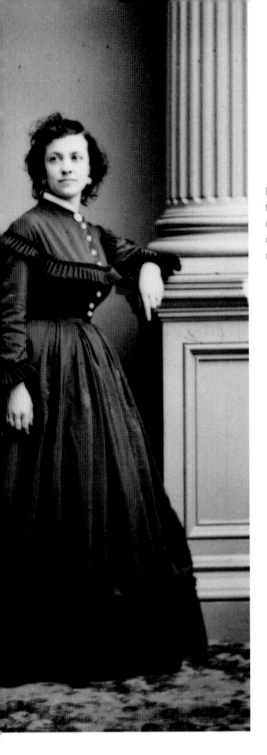

Pauline Cushman by
the Mathew Brady Studio
(active 1844–1894),
collodion glass-plate
negative, c. 1864

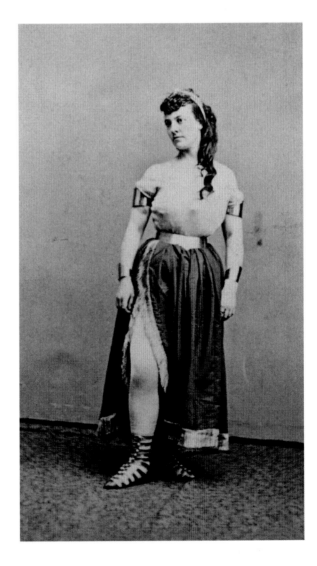

Pauline Cushman by
Charles DeForest Fredricks
(1823–1894), albumen
silver print, c. 1866

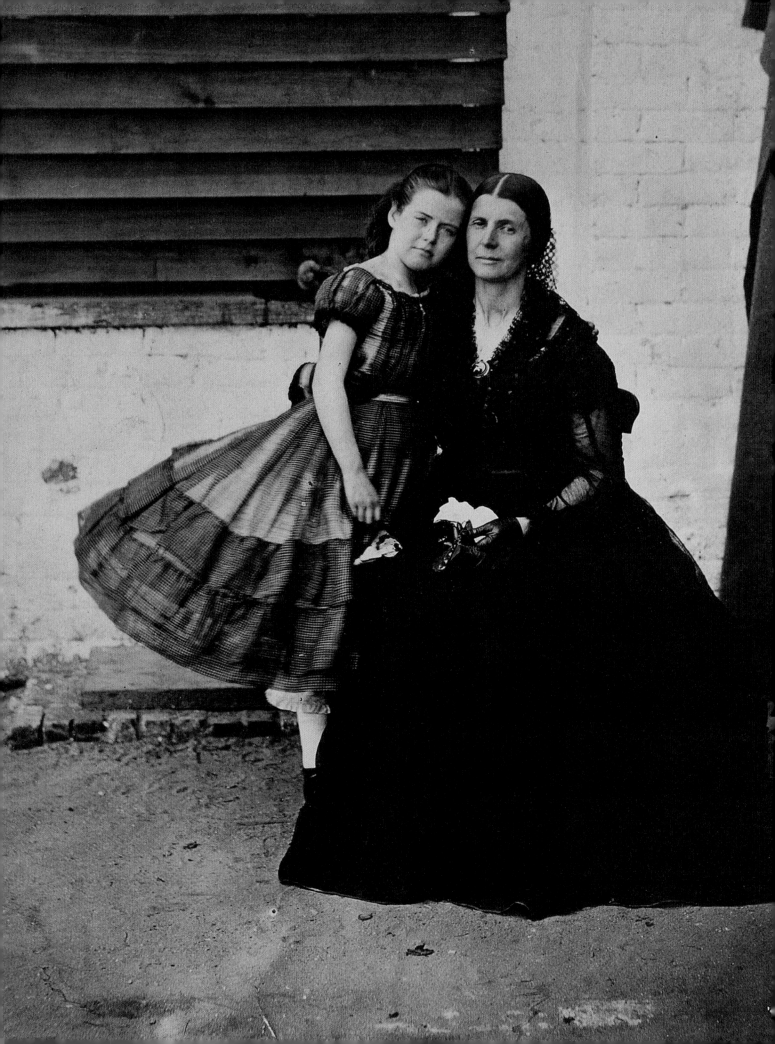

Rose O'Neal Greenhow and Her Daughter Rose

1817–1864

ROSE O'NEAL GREENHOW was the Confederacy's most celebrated female spy at the start of the Civil War. A popular Washington widow and hostess, Greenhow moved easily in the social circles of the nation's capital, and few were better connected than she when hostilities commenced in the spring of 1861. An ardent Southern sympathizer, she used her ample charms and guile to pass along to Confederate officials information on the defenses of Washington and Union troop movements. She is credited with alerting the rebels of enemy military operations just prior to the First Battle of Manassas. The success of her clandestine activities can be gauged by the level of surveillance she received from the noted detective Allan Pinkerton. Although he put her under house arrest and ultimately had her confined in the Old Capitol Prison, Greenhow was always considered a security risk, given her extensive social connections. Finally deported to the South in 1862, she acted as an unofficial Confederate emissary to England, where she wrote her memoirs, *My Imprisonment and the First Year of Abolition Rule* at Washington. Her book cemented her exploits in the annals of Civil War lore. On her return to America in 1864, her ship ran aground on the North Carolina coast. Greenhow insisted upon going ashore in a small boat, which took on water and sank. "Wild Rose" drowned, allegedly weighted down by a leather purse filled with gold sovereigns, representing the royalties from her book. Her body washed ashore, and she was buried with military honors in Oakdale Cemetery in Wilmington.

This photograph of Greenhow with her daughter Rose was taken at the Old Capitol Prison by Alexander Gardner for Mathew Brady's studio.

JB

ROSE O'NEAL
GREENHOW AND HER
DAUGHTER ROSE
By Alexander Gardner
(1821–1882) for the
Mathew Brady Studio
(active 1844–1894),
albumen silver print,
1862

In the late summer of 1861, private detective Allan Pinkerton (1819–1884) was recruited by General George B. McClellan to organize a secret service for his new Army of the Potomac. Pinkerton had no sooner arrived in Washington when he began to monitor the comings and goings of Rose Greenhow. Pinkerton and his operatives staked out Greenhow's house on Sixteenth Street. In the course of one rainy night, Pinkerton was known to have peeked into an upper parlor window of her house while standing barefoot on the shoulders of two companions. This image of Pinkerton on horseback and with a cigar in his mouth was taken later, near Antietam shortly after the battle in 1862.

By Alexander Gardner
(1821–1882), albumen silver
print, 1862

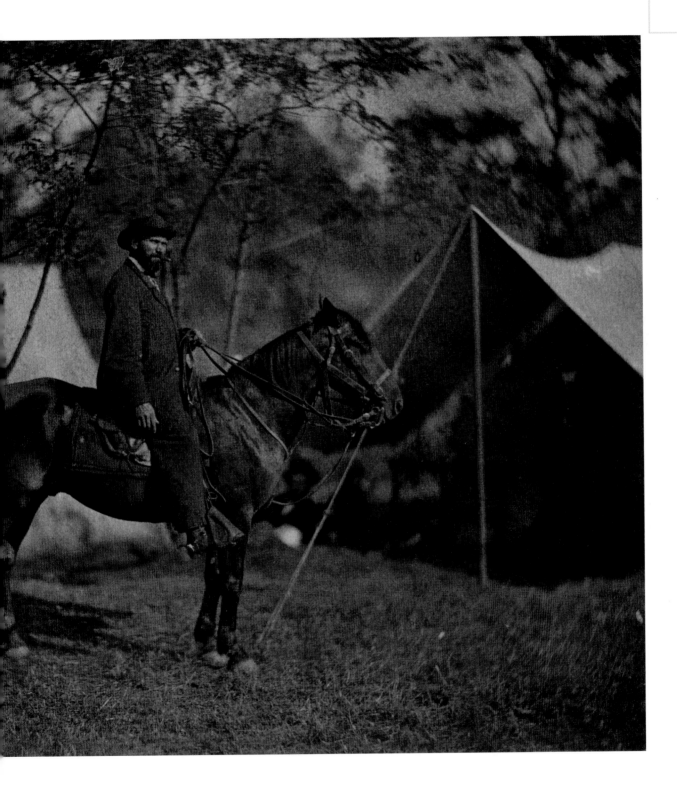

ROSE O'NEAL GREENHOW AND HER DAUGHTER ROSE

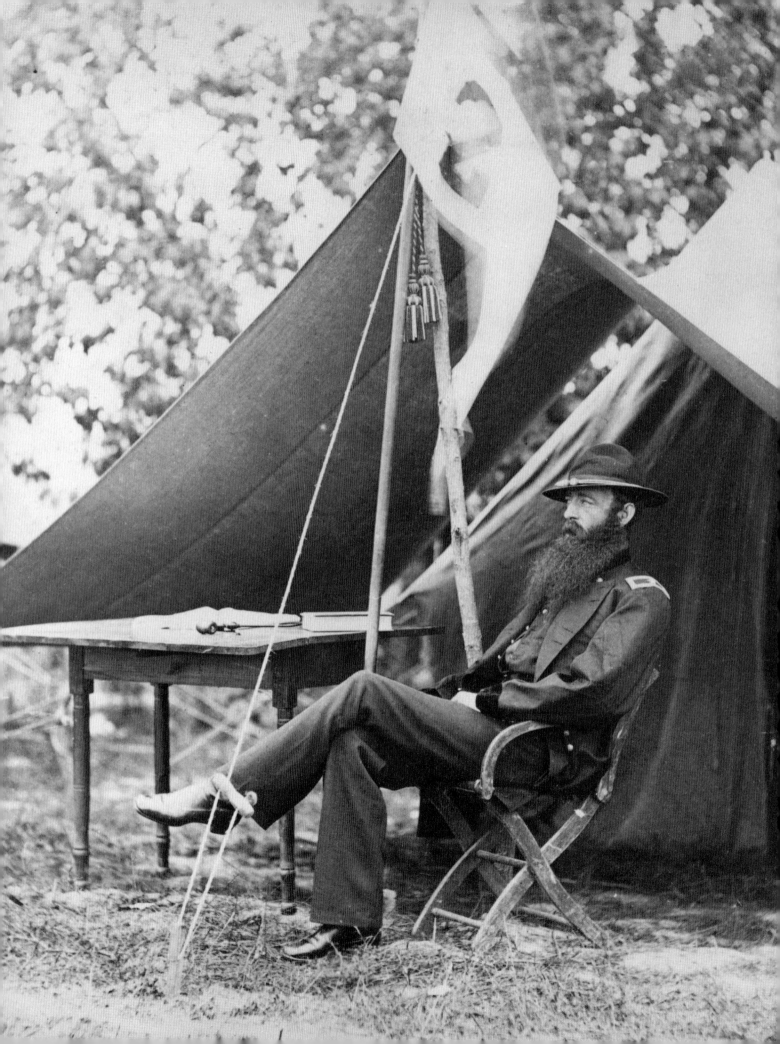

UNION CAVALRY COMMANDER DAVID M. GREGG was said to be as modest and unassuming as this photograph of him suggests. Taken probably in the spring of 1864, during Grant's drive for Richmond, this image shows Gregg as he was commanding the Second Cavalry Division of the Army of the Potomac. In a quiet moment in camp, an unidentified photographer caught Gregg in what appears to be an unposed image. Gregg is seated in a folding chair in front of his tent and next to his division flag, which hovers above. A dropleaf table rests an arm's reach away, holding a book and a pipe. Although in the midst of an active campaign, Gregg appears relaxed; his uniform is tidy and his boots shine. Unlike many photographs of soldiers bearing guns, knives, and swords, not a weapon is visible. Although the picture is quintessentially martial in character, there is a civility to it that reflects Gregg's temperament. One of the ablest of cavalry officers to serve the Union, Gregg could still see fit during the war to take a leave of absence to get married.

A native of Pennsylvania, Gregg graduated from West Point in 1855 and served on the western frontier with the dragoons before the Civil War. In 1861, he came east and became attached to McClellan's Army of the Potomac, then manning the defenses of Washington. Only a first lieutenant at the start of the war, Gregg rose to brigadier general of volunteers by the end of 1862. He participated in the major Virginia campaigns between 1862 and 1864, as well as at Antietam and Gettysburg. His repulse of Jeb Stuart's cavalry on the last day at Gettysburg kept the Confederates from attacking behind the Union line that would be defending against Pickett's charge.

The genially disposed Gregg was well liked in the army. His ability in the saddle made him a favorite with his superiors, especially Grant and Sheridan. In August 1864, he was breveted a major general of volunteers for his distinguished reconnaissance near Charles City Court House, Virginia. Gregg's sudden resignation from the army two months before the surrender at Appomattox has remained one of the war's minor mysteries.

JB

DAVID M. GREGG
By an unidentified
photographer, albumen
silver print, c. 1864

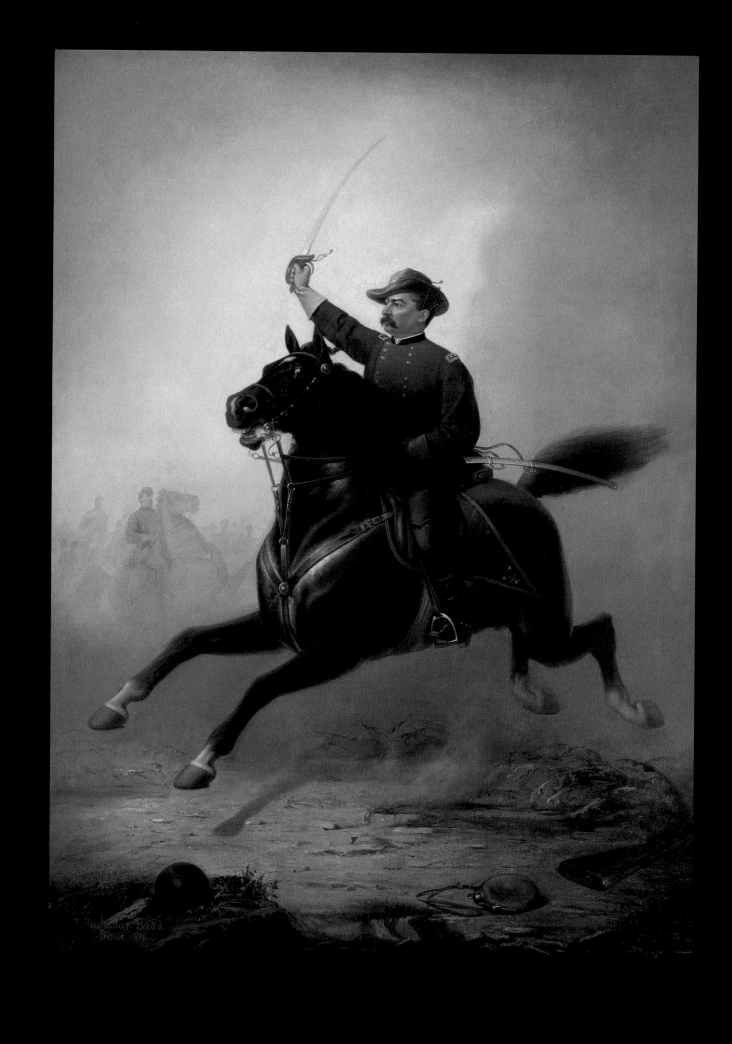

SPEAKING ABOUT PHILIP HENRY SHERIDAN AFTER THE WAR, Ulysses S. Grant said that "as a soldier, as a commander of troops, as a man capable of doing all that is possible with any number of men, there is no man living greater than Sheridan."[118] Given the task of reorganizing and leading Grant's cavalry in 1864, Sheridan gave the ultimate demonstration of these qualities on October 19 of that year, during his campaign against Jubal Early in the Shenandoah Valley. Informed that his troops had come under attack and were being flanked and overrun at the unfolding Battle of Cedar Creek, he mounted his favorite black steed, Rienzi, and galloped twenty miles from his headquarters in Winchester, Virginia, at breakneck speed to the scene of the Union rout. Waving his hat to stop the retreat, and to the cheers of his men, Sheridan regrouped the Federal lines and gave fight. By the time the smoke had cleared, "Little Phil" had snatched a victory from certain defeat.

News of this stirring event gripped the Northern imagination as few other triumphs of the war had. President Lincoln was especially gratified, because he could not afford setbacks on the battlefield with the presidential election only weeks away. Meanwhile, Thomas Buchanan Read of Philadelphia was about to give Sheridan's feat a measure of immortality in a poem called "Sheridan's Ride." With the return of peace in 1865, the versatile poet and artist proposed transcribing his verse upon canvas. Working from sketches he had made of Sheridan in New Orleans, where the general was administering the military division of the Gulf of Mexico, Read journeyed to Rome in 1868. There he began a portrait of Sheridan, astride his black charger, arriving at the Battle of Cedar Creek. "The eye of the horse is bloodshot," reported one newspaper, "the nostrils dilated, and from the mouth falls a fleck of foam. The rapid motion of the animal is finely expressed: the whole painting is full of spirit and life. It is the poem and the warlike act in one."[119]

Commissioned by the Union League of Philadelphia, the painting went on view at the Academy of the Fine Arts in March 1870. By the end of the fourth week, it had attracted more than thirty thousand visitors, each paying twenty-five cents' admission. Before his death in 1872, Read painted several versions of this portrait, for which he is best known. The copy in the collection of the National Portrait Gallery had formerly been owned by a descendant of Ulysses S. Grant.

JB

PHILIP H. SHERIDAN
By Thomas Buchanan
Read (1822–1872),
oil on canvas, 1871

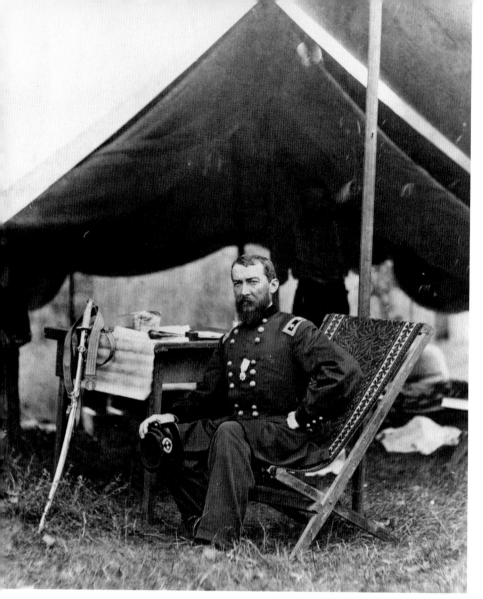

Philip H. Sheridan by an unidentified photographer, albumen silver print, 1864

In this posed photograph, General Sheridan, second from left, meets with members of his highly competent staff. They are, left to right, Wesley Merritt, George Crook, James Forsyth, and George Custer.

By Alexander Gardner (1821–1882), albumen silver print, c. 1865

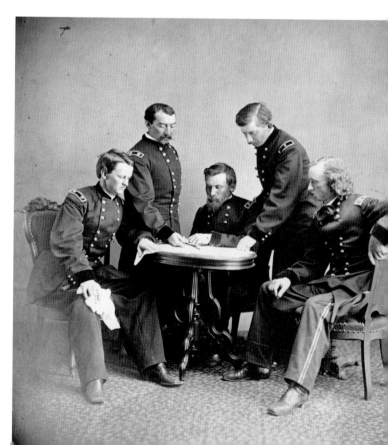

Thomas Buchanan Read took an active interest in developing his skills as a painter, sculptor, and poet. Yet for all of his versatility and raw talent, Read never achieved lasting recognition in any of these endeavors. His artistic and poetic works to preserve the memory of Philip H. Sheridan may in turn be Read's own greatest claim to fame. Read sculpted this marble bust of Sheridan in 1871, the year before Read died.

By Thomas Buchanan Read
(1822–1872), marble, 1871

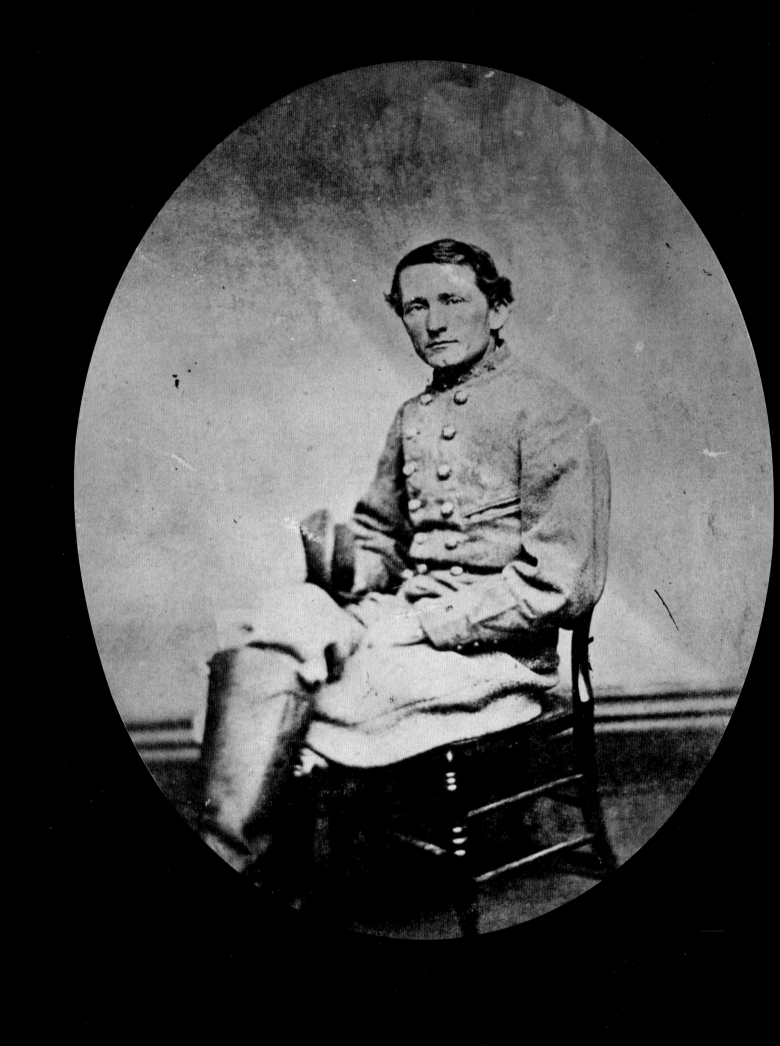

DEPENDING ON ONE'S SYMPATHIES, John S. Mosby was either a guerrilla or a cavalry hero. This native Virginian was by profession a lawyer. When the Civil War began, he joined the Confederate cavalry in time to participate at the First Battle of Manassas. Placed under the command of General Jeb Stuart, Mosby fought with such distinction in the Peninsular Campaign and at Antietam that in 1863 he was authorized to organize a group of partisan rangers. This small band of men became the nucleus of the Forty-third Battalion Partisan Rangers and grew in time to number eight hundred. The rangers operated behind enemy lines with usually fewer than a hundred men during any one assignment. They struck without warning, often at night, only to disperse and regroup later at a prearranged spot. Free from the drudgeries of drilling and camp life, they could live at will, providing their own food, horses, and uniforms. Because Mosby personally saw little use for the cavalry saber, the revolver became their weapon of choice.

Mosby operated primarily in the counties of Northern Virginia; the towns of Upperville and Middleburg lay in the heart of what became known as Mosby's Confederacy. His first notable success occurred at Fairfax Court House in March 1863, when he captured, in the middle of the night, General Edwin H. Stoughton and his cavalry garrison of some thirty men and their horses. By June, Mosby's reputation for daring raids was feared enough in the Union-occupied city of Alexandria that authorities began erecting stockades throughout the town. The next year, as Union cavalry under General Philip H. Sheridan tried to contain Mosby, Alexandrians who refused to take the oath of allegiance to the United States were forced to ride the Union supply trains in a desperate measure to keep his rangers from pillaging them. His men routinely divided the spoils, provoking Northerners to call them marauders. Finally, in an attempt to destroy the rangers' means of subsistence, General Grant gave orders to Sheridan to set fire to Mosby's Confederacy. All forage was to be destroyed, including barns and grist mills, and all livestock was to be driven off, regardless of an owner's loyalty to the Union. Yet at war's end, Grant proved to be as generous with Mosby as he had been stern by convincing the War Department to offer the rangers the same terms of surrender given to Lee's regular army. Mosby, however, elected to disband his command rather than surrender it, and to allow each member to seek his own parole. Mosby himself was not paroled until June 17, 1865, a full two months after Lee.

JB

JOHN S. MOSBY
By Daniel (1835–1914)
and David Bendann
(1841–1915), albumen
silver print, 1865

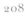

Based on certain similarities—Mosby's uniform and hair length, and the furniture and the room's baseboard molding—this image of Mosby with his rangers was no doubt taken at the same time as the one of him seated in a chair.

By Daniel (1835–1914) and David Bendann (1841–1915), albumen silver print, 1865

This jacket and slouch hat were worn by John Mosby. According to Virgil Carrington Jones, author of *Grey Ghosts and Rebel Raiders*, the hat was left behind in a house in Rector's Cross Roads, Virginia, where Mosby was seriously wounded by a detachment of Federal cavalry in December, 1864. Forty years later, it was returned to him by the daughter of an officer of the Thirteenth New York Cavalry.

National Museum of American History, Smithsonian Institution, Behring Center

Richmond sculptor Edward V. Valentine took Mosby's measurements for this bust on December 5, 1865. It would be another eleven months, however, before Valentine completed his work.

By Edward Virginius Valentine (1838–1930), bronze, 1972 cast after 1866 plaster

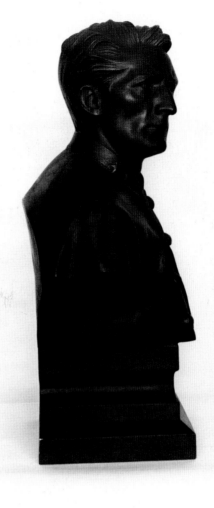

These crutches were made for Mosby during the Civil War by a slave named Isaac who belonged to Mosby's father. Mosby first used them in August 1863 when he went home wounded. His mother kept them for him and he used them again in September and December of 1864. General Robert E. Lee, after seeing Mosby on crutches at his headquarters, told the partisan ranger that he could find no fault with him other than his propensity for getting wounded.

National Museum of
American History,
Smithsonian Institution,
Behring Center

JOHN S. MOSBY

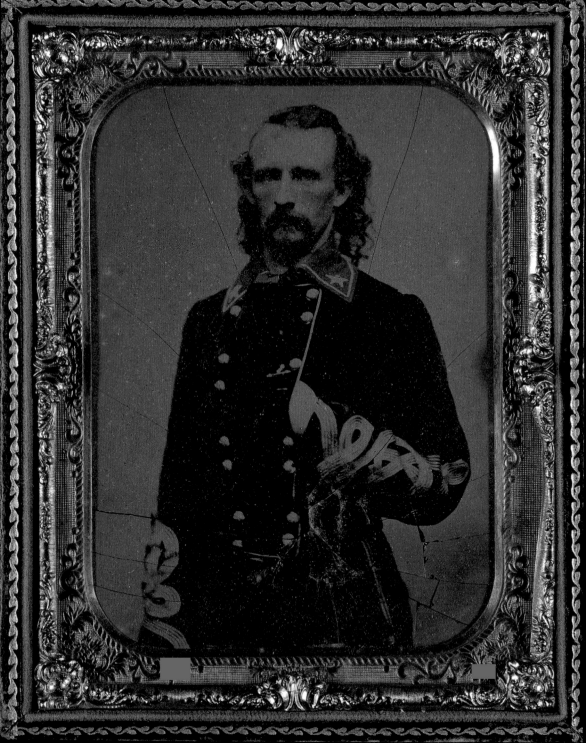

IN APRIL 1861, when Fort Sumter was fired upon, George Armstrong Custer had still to take his final examinations at the U.S. Military Academy. He graduated that June, last in a class of thirty-four. Custer's ambition to fight in the war was realized immediately, and he participated in the conflict from beginning to end, from Manassas to Appomattox. Fearless and fortunate, Custer made the most of every opportunity of engaging the enemy. Promotions followed. Having entered the war a second lieutenant in the Second Cavalry, Custer became a brigadier general of volunteers two years later. At twenty-three, he was the youngest officer ever to wear a star. Before the war was over, he was donning a pair and was commanding the Third Division of Sheridan's cavalry corps. In the days just before Lee's surrender, it was Custer's men who played a supporting role in blocking the enemy's retreat near Appomattox. One of the white surrender flags was presented to Custer himself.

Always in the front of a saber charge, Custer was an inspirational leader. One of his former privates wrote, "Custer commanded in person and I saw him plunge his saber into the belly of a rebel who was trying to kill him. You can guess how bravely soldiers fight for such a general."[120] Critics, however, viewed the flamboyant blond general as reckless with his command. His losses were higher than any similar unit in the war. Ultimately, in 1876, Custer would become a legend at Little Big Horn, Montana, where his entire command was killed in an Indian attack. What had been known during the war as Custer's luck had finally run its course.

Custer appears in this photograph as a brigadier general, in command of a brigade of Michigan volunteer cavalry. He was conspicuous in his choice of uniform, and made a vivid impression on one of his captains, who was seeing him for the first time:

> My eyes were instantly riveted upon a figure only a few feet distant, whose
> appearance amazed if it did not for the moment amuse me. He was clad in a suit
> of black velvet, elaborately trimmed with gold lace, which ran down the outer
> seams of his trousers, and almost covered the sleeves of his cavalry jacket. The
> wide collar of a blue navy shirt was turned down over the collar of his velvet
> jacket, and a necktie of brilliant crimson was tied in a graceful knot at the
> throat. . . . His golden hair fell in graceful luxuriance nearly to his shoulders,
> and his upper lip was garnished with a blond mustache. . . . A keen eye would
> have been slow to detect in that rider with the flowing locks and gaudy tie, in his
> dress of velvet and of gold, the master spirit that he proved to be.[121]

JB

GEORGE
ARMSTRONG
CUSTER
By an unidentified
photographer,
ambrotype, c. 1863

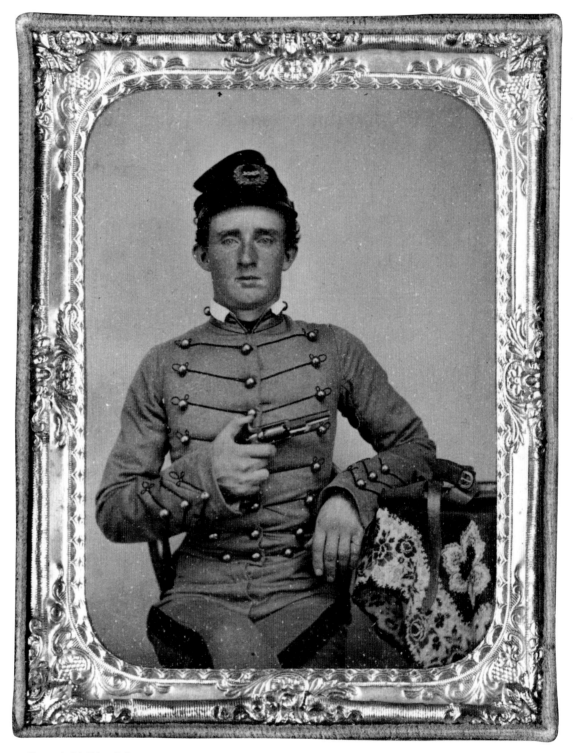

Custer in his West Point
uniform by an unidentified
photographer, ambrotype,
c. 1860

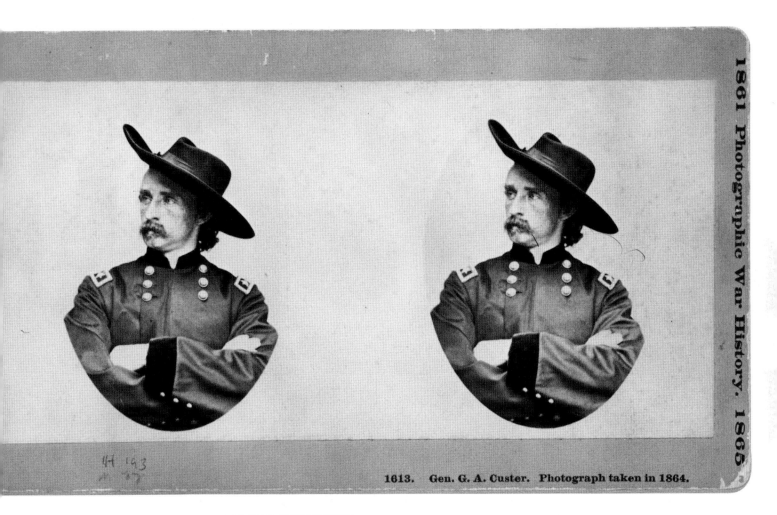

1613. Gen. G. A. Custer. Photograph taken in 1864.

Custer appears in this 1864 stereo view wearing the uniform of a brevet major general of volunteers. As his demeanor suggests, Custer's panache as a cavalry officer was legendary.

By the Mathew Brady Studio (active 1844–1893), albumen silver print, c. 1864 (printed c. 1890)

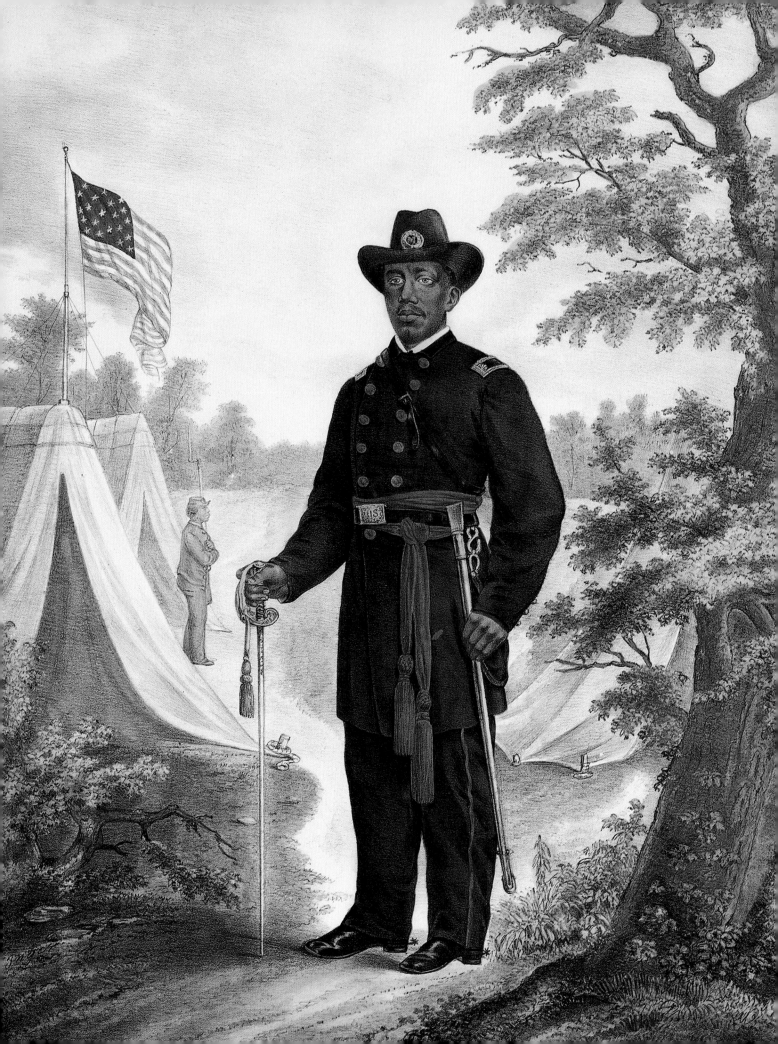

MARTIN R. DELANY was the only African American officer to receive the rank of major during the Civil War. Although this distinction proved to be mostly symbolic, it recognized Delany's stature as a black leader in the 1860s. Born into a family of free blacks in Charles Town, Virginia (now West Virginia), Delany was educated at home with the aid of a Yankee peddler who taught him and his four siblings how to read. When their community discovered this, the threat of imprisonment pressured the family to seek a new home in Chambersburg, Pennsylvania, where they could educate themselves freely.

At the age of nineteen, Delany struck out on his own, walking across half of the state and through the Allegheny Mountains to Pittsburgh. There he began to study medicine and became involved in the abolition movement. He founded a weekly newspaper for blacks, *The Mystery*, until financial difficulties forced him to abandon the effort. Delany next became a co-editor of Frederick Douglass's *North Star* before resuming his medical studies. Admitted to Harvard in 1850, Delany was asked to leave after only one term, because of the prejudice of his white classmates, who proved to be as intolerant as his former Charles Town neighbors. Delany, frustrated by his treatment as a free black, soon began to see emigration— perhaps to Central or South America—as a viable solution for the future of his race, and he published a treatise promoting the idea.

Yet the start of the Civil War offered blacks hope and opportunity. In 1863, following President Lincoln's Emancipation Proclamation and the call for the enlistment of black militia regiments, Delany began actively recruiting in New England. The chance to organize his own unit came in February 1865, when Lincoln commissioned him a major in the army. Delany hastened to Charleston, South Carolina, and began recruiting two regiments of former slaves. The war ended, however, two months later, before Delany or any of his men had a chance to participate.

This hand-colored lithograph recognized Delany's unique status as a commander of "Colored Troops." Black units were normally led by white commanders. It erroneously states, perhaps prematurely, that he was "promoted on the battle field for bravery."

JB

MARTIN R. DELANY
By an unidentified
artist, hand-colored
lithograph, c. 1865

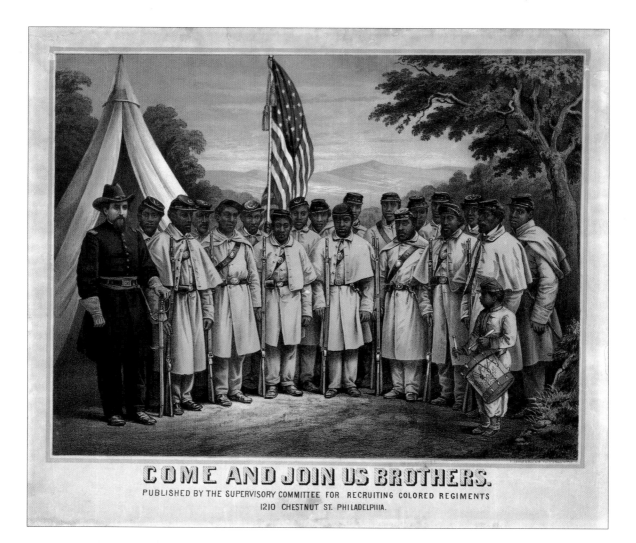

COME AND JOIN US BROTHERS.
PUBLISHED BY THE SUPERVISORY COMMITTEE FOR RECRUITING COLORED REGIMENTS
1210 CHESTNUT ST. PHILADELPHIA.

This rare color lithograph, *Come and Join Us Brothers,* underscored the Union's efforts in 1863 to recruit "colored troops" to bolster its depleted ranks. As suggested in the picture, black regiments were almost always commanded by white officers.

By P. S. Duval Lithography Company (active 1837–1869), chromolithograph, c. 1864. National Museum of American History, Smithsonian Institution, Behring Center

This silk thirty-five-star U.S. flag belonged to the Eighty-fourth Regiment of Infantry, United States Colored Troops. The unit was organized on April 4, 1864, and mustered out of Federal service on March 14, 1866. During its history, the Eighty-fourth fought in a number of battles in Louisiana together with a larger force of Union army volunteers and three other regiments of black troops. Some of the battles in which they participated are written on the front of the flag: Port Hudson, July 1863; Pleasant Hill, April 1864; Mansura, May 1864; Bayou De Glaise, May 1864; White Ranche, Texas, May 1865.

National Museum of American History, Smithsonian Institution, Behring Center

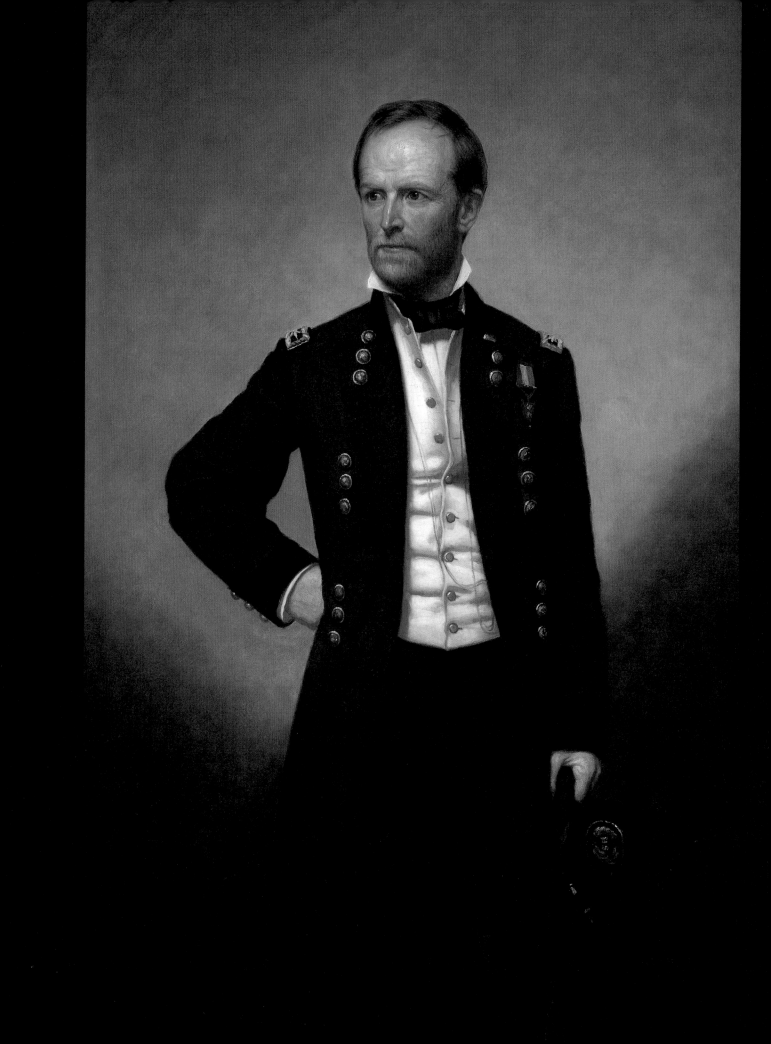

"A WAR IS CRUELTY. There is no use trying to reform it, the crueler it is, the sooner it will be over."[122] So spoke Union General William T. Sherman in late 1863. It was a sentiment that many a war-weary veteran might have agreed with, but as implemented by Sherman himself, it took on a meaning that would earn him an undying enmity in the South.

Graduating from West Point in 1840, Sherman did not distinguish himself in the first phase of his military career, and he resigned his army commission in 1853. Civilian life brought only a succession of failures, however, and after he reentered the military at the outbreak of the Civil War, his erratic temperament initially raised doubts about his fitness for major field responsibilities. But when he came under the command of yet another civilian failure, General Ulysses S. Grant, Sherman found the kind of solid superior he needed to make him effective. Under Grant, he played a vital part in the Northern victory at Vicksburg in July 1863, thus securing the Mississippi River for the Union. Later that year, he again performed ably at the Battle of Chattanooga, where a Northern victory opened the way for advancement into the heart of the Confederacy. With his orchestration of the successful campaign to take Atlanta in the summer of 1864, his reputation as one of the Union's finer generals became secure.

At this point, however, Sherman's fame took on a dimension that soon eclipsed these previous achievements. Concluding that the quickest way to subdue the Confederacy was to kill its spirit, he undertook to bring the "hard hand of war" to bear on its civilian population, which until now had been left relatively unscathed.[123] In short, he introduced the Civil War to the modern concept of total warfare. After burning the industrial and business districts of Atlanta to the ground in late 1864, his army began a march through Georgia that cut a swath of destruction sixty miles wide all the way to Savannah and then north through South Carolina. The damage to property and resources was incalculable, and the South would never forgive him for it. Sherman had achieved his objective—a demoralization that hastened Southern surrender.

Artist George P. A. Healy derived three portraits from his sittings with Sherman late in 1865. The version here went to Sherman himself, while another was raffled off to raise funds for the care of disabled soldiers. Healy and Sherman got along well, and when the artist began to conceive his large painting, *The Peacemakers*, depicting Lincoln's end-of-the-war conference with Grant, Sherman, and Admiral David D. Porter, Sherman proved enormously helpful, giving Healy details about the setting.

FV

WILLIAM T. SHERMAN
By George P. A. Healy
(1813–1894), oil on
canvas, 1866

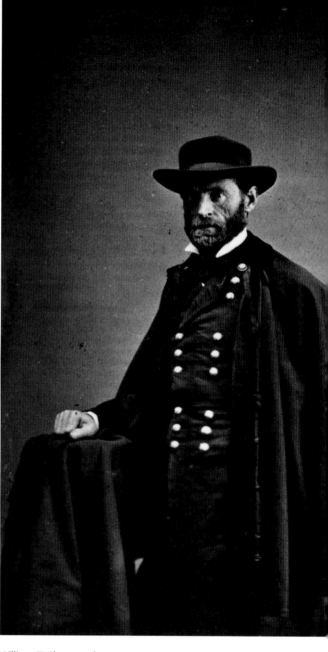

William T. Sherman by
the Mathew Brady Studio
(active 1844–1894), collodion
glass-plate negative, c. 1865

Sherman's campaign hat

National Museum of
American History,
Smithsonian Institution,
Behring Center

THE COUNCIL OF WAR.

" I PROPOSE TO FIGHT IT OUT ON THIS LINE IF IT TAKES ALL SUMMER."

In this print titled *The Council of War,* General William T. Sherman is the center figure among key members of the Union high command. The others are, left to right, Admirals David Dixon Porter and David G. Farragut; President Lincoln; and Generals George H. Thomas, U. S. Grant, and Philip H. Sheridan. Such a council of war involving all of these men never transpired. Yet it is reminiscent of a related war council that occurred aboard the *River Queen* at City Point, Virginia, in March 1865. On that occasion, President Lincoln met with Grant, Sherman, and Porter to discuss the last phases of the war. This meeting was commemorated in a painting called *The Peacemakers* by George P. A. Healy.

By Peter Kramer (1823–1907), lithograph, 1865

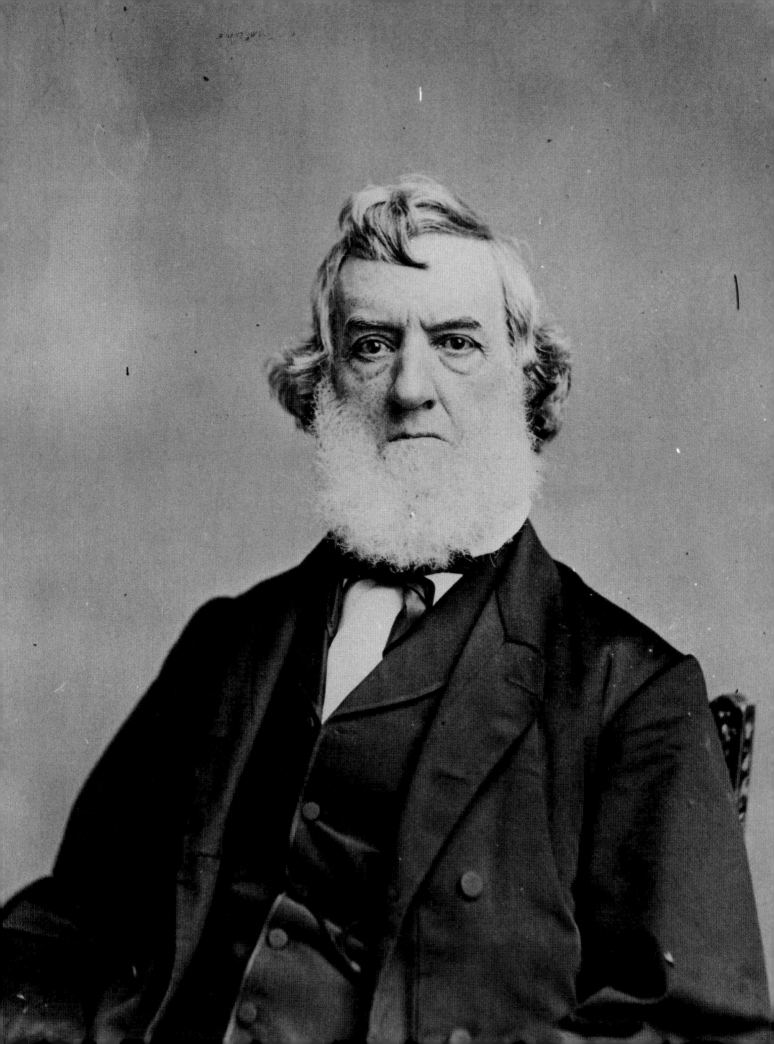

ON HIS SIXTY-THIRD BIRTHDAY, Gideon Welles, President Lincoln's introspective secretary of the navy, noted soberly in his diary: "I have attained my grand climacteric, a critical period in a man's career. Some admonitions remind me of the frailness of human existence and of the feeble tenure I have on life. I cannot expect, at best, many returns of this anniversary and perhaps shall never witness another."[124]

Welles would live to be seventy-five. Although he was astute about his career and the tenuousness of life, Welles was himself a model of endurance and perseverance. The diary he kept during his tenure as secretary of the navy, from 1861 to 1869 (longer than any of his predecessors), is itself an insightful record of the people and events of official Washington during the Lincoln and Johnson administrations. Welles's predilection for daily journal writing about national affairs harked back to his former career as a journalist in Hartford, Connecticut. In 1855, poet William Cullen Bryant spoke of him as almost without an equal in the field of journalism. For Welles's early and active support of the Republican Party, Abraham Lincoln promised him a cabinet position after the 1860 election. Welles had been a bureau chief in the Navy Department between 1846 and 1849, but this brief appointment was the extent of his practical experience as he assumed his new duties as navy secretary. The job was daunting from the start because there was almost no effective navy in existence, and what vessels were in commission were mostly old and scattered around the globe. Moreover, many senior officers resigned during the secession crisis. In spite of these difficulties, Welles succeeded in building a navy that played a vital role in winning the war. Attempting to blockade the Confederate coast with a makeshift fleet was a primary goal, yet in time, this grand strategy proved effective. Welles's endorsement of ironclad vessels was also ambitious for its day—and had many influential detractors—but it anticipated the modern navy.

This photograph of Welles by Mathew Brady's studio was taken in 1865, probably in the spring or early summer. At the time, Brady was taking photographs of those who had been at Lincoln's bedside just before he died, and Welles had been one of the many. The photographs were then used to compose a picture entitled *The Last Hours of Lincoln*, painted by Alonzo Chappel and published as a memorial print by John Bachelder. This head-on likeness, although not the one included in the composite picture, was taken at the same time, and is perhaps the best view extant of Welles's ill-fitting wig, which received discreet notice in his day.

JB

GIDEON WELLES
By the Mathew Brady
Studio (active 1844–
1894), albumen silver
print, 1865

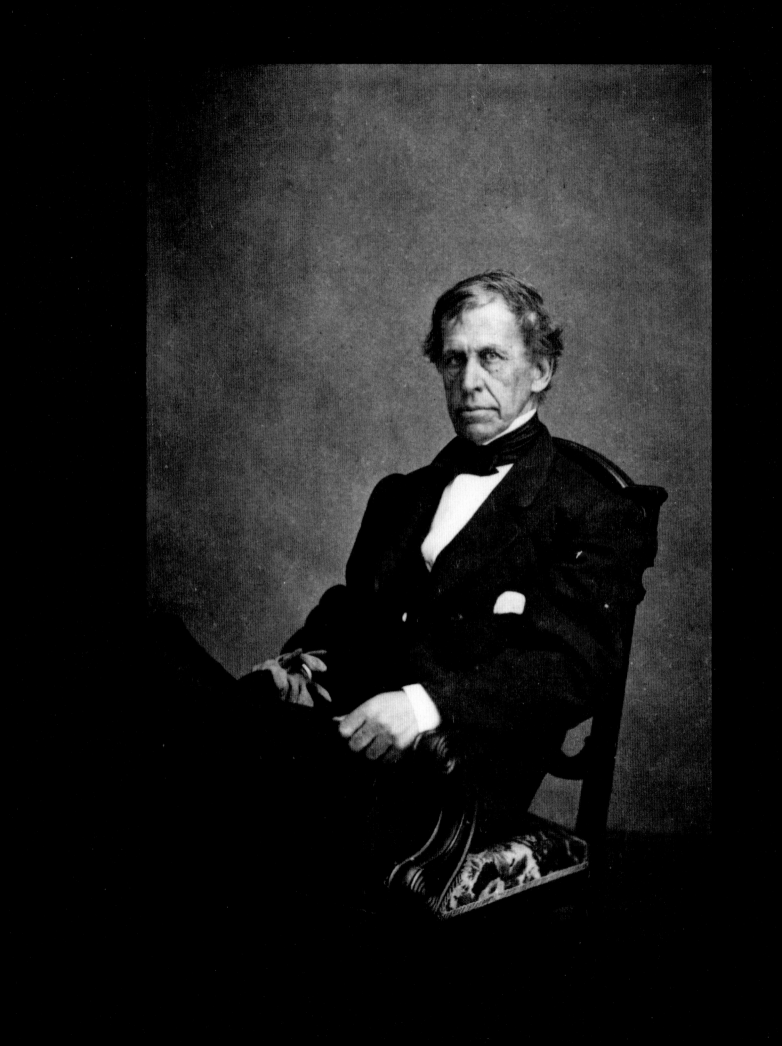

TYPICAL OF THE TRIALS AND TRIBULATIONS President Lincoln endured during his first months as president was the case of Captain Charles Wilkes of the U.S. Navy. On November 8, 1861, Wilkes, acting without orders and wholly on his own initiative, was about to stir up an international crisis that would threaten a war with Great Britain and cause the president many a sleepless night before its peaceful resolution two months later.

Wilkes was commanding the USS *San Jacinto*, a warship returning from the African coast, with orders to join the U.S. fleet preparing for an attack on Port Royal, South Carolina. While in the Caribbean, Wilkes learned that the Confederate raider *Sumter* had captured three merchant ships near Cienfuegos, Cuba, in July. Although it was now several months later, the opportunistic Wilkes set sail for Cienfuegos in hopes that the *Sumter* might still be found and captured. Yet his focus changed abruptly when he read in a newspaper that two Confederate envoys, James Mason of Virginia and John Slidell of Louisiana, were in Havana and soon to leave port aboard the British mail steamer *Trent*; Mason was bound for England and Slidell for France. Their mission was to try to secure from these two European powers recognition of the Confederate states as an independent nation. Wilkes now had a mission of his own, an unauthorized one that, if successful, would make headlines on two continents.

Wilkes had long held a reputation of being overzealous, impulsive, and independent-minded. These traits better suited his keen enthusiasm for scientific exploration than they did for the strategic and tactical disciplines of war. Between 1838 and 1842, Wilkes had commanded the South Seas Surveying and Exploring Expedition. In 1845, he published a five-volume narrative of this successful expedition and survey of the Antarctic coast, the islands of the Pacific, and the American northwest coast around Puget Sound. A 1,600-mile stretch of Antarctica along the Indian Ocean is called Wilkes Land in his tribute.

In the fall of 1861, Wilkes, age sixty-four, was a forty-four-year veteran of the navy. In those four decades he had never seen combat duty; his best chance had been in 1846 during the Mexican War, but his request for active service had been refused until he had accomplished his scientific work and writings relative to his South Seas expedition. Now on November 8, Wilkes, still eager for action, positioned the *San Jacinto* in the narrow Bahama Channel near Havana, through which the *Trent* would have to pass. Early that afternoon, Wilkes and his crew spotted the *Trent*, and fired a shot over her bow. Wilkes then ordered a boarding party to arrest Mason and Slidell and their secretaries, against the protests of the British captain. Because the official papers of these two envoys had been locked in the

CHARLES WILKES
By the Mathew Brady Studio (active 1844–1894), collodion glass-plate negative, c. 1861

This jeweled sword was presented to Captain Charles Wilkes by the city of Boston in 1862 in recognition of his service as commanding officer of the USS *San Jacinto* during the arrest of Confederate commissioners James Mason and John Slidell while they were en route to Europe.

National Museum of
American History,
Smithsonian Institution,
Behring Center

mailroom and were not recovered by the Americans, who honored a request not to search the ship, the *Trent* was allowed to resume her voyage as a neutral vessel.

For several weeks after Wilkes's return to the United States with his prize dignitaries, he was lauded as a hero by the Northern press, the U.S. Congress, and the public in general. Officially, President Lincoln maintained a judicious reticence about the *Trent* affair. "I fear the traitors will prove to be white elephants," he confessed in private.[125] The British outrage over the seizures, their demand for the envoys' immediate release coupled with an apology, and their diplomatic overtures that war could be the outcome if the United States failed to give satisfaction all combined to validate Lincoln's fears.

Wilkes's chance foray had put the administration in an embarrassing diplomatic bind. "We must stick to American principles concerning the rights of neutrals," reasoned Lincoln. "We fought Great Britain for insisting . . . on the right to do precisely what Captain Wilkes has done."[126] Since Wilkes had acted independently, Lincoln saw clearly that the British demands must be met. To have risked a war with a European nation would have seriously jeopardized the administration's efforts to reunite the nation. The Federal blockade, for instance, would have surely floundered against the superior British navy.

Wilkes emerged from the *Trent* affair relatively unscathed by public opinion and his hero's mantel still intact. Although he would receive two promotions—to commodore and acting rear admiral—within the next year, he never fully regained the confidence of Secretary of the Navy Gideon Welles. An insubordinate streak in Wilkes ultimately forced his retirement in 1863.

JB

THE ILLUSTRATED LONDON NEWS.

No. 1121.—VOL. XXXIX.] SATURDAY, DECEMBER 14, 1861. [WITH A SUPPLEMENT, FIVEPENCE

OUR CONTROVERSY WITH AMERICA.

CAPTAIN WILKS, OF THE SAN JACINTO.

MR. MASON. MR. SLIDELL.

THE CONFEDERATE COMMISSIONERS TO ENGLAND AND FRANCE SEIZED ON BOARD THE TRENT.—SEE NEXT PAGE.

Captured Confederate envoys James Mason (left) and John Slidell appeared under a picture of Charles Wilkes in this cover story of the *Trent* affair in the *Illustrated London News* of December 14, 1861.

By an unidentified artist,
wood engraving, 1861

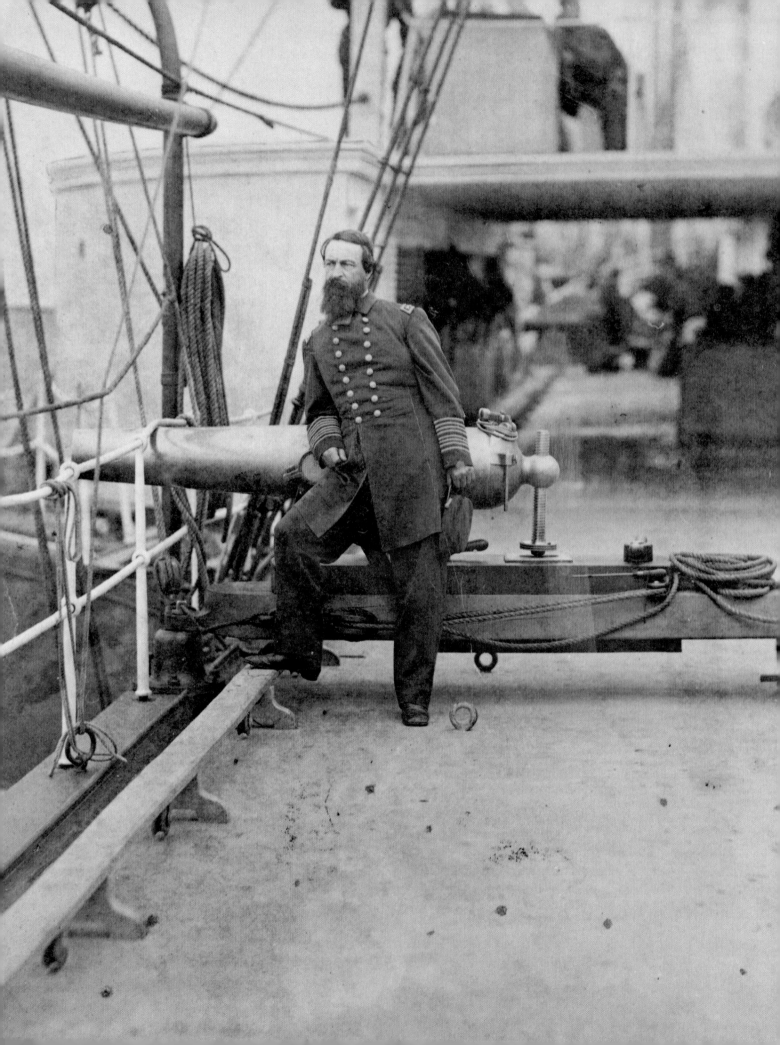

AMONG UNION NAVAL OFFICERS, David D. Porter earned a reputation for valor second only to that of David G. Farragut, his foster brother. Porter's love of the sea went back to his youth. His grandfather and father were both naval veterans, of the Revolutionary War and the War of 1812, respectively. By the start of the Civil War, Porter himself had spent most of his forty-seven years with the navy, often in what he considered to be menial assignments. The commencement of hostilities would quickly create opportunities for such ambitious men as he. In less than four years Porter would rise from the rank of lieutenant to rear admiral. He would also receive the thanks of Congress on three occasions, the only naval officer to do so.

Porter's first war assignments were off of Florida's panhandle, where he monitored the coast around Fort Pickens, Mobile, and the western mouth of the Mississippi River. Given permission to seek out the Confederate raider *Sumter*, commanded by the cagey seaman Raphael Semmes, Porter gave pursuit as far away as South America without ever seeing his elusive quarry. In the spring of 1862, Porter played an instrumental role in the capture of New Orleans. His mortar boats bombarded the city's outer defenses and covered Farragut's fleet as it moved upon the city. In October, Porter was made commander of the Mississippi Squadron, although on the grounds of seniority, some eighty officers outranked him for this important command. The nod to Porter gave Secretary of Navy Gideon Welles reason to pause and reflect: "Porter . . . has stirring and positive qualities, is fertile in resources, has great energy, excessive and sometimes not over-scrupulous ambition, is impressed with and boastful of his own powers. . . . It is a question, with his mixture of good and bad traits, how he will succeed."[127]

Years later, Ulysses S. Grant addressed this question in his memoirs. Of Porter's actions on the Mississippi River during the Vicksburg campaign of 1863, Grant wrote, "The navy under Porter was all it could be, during the entire campaign. Without its assistance the campaign could not have been successfully made with twice the number of men engaged."[128]

In January 1865, with an armada of more than sixty vessels, Porter, now commanding the North Atlantic Blockading Squadron, launched a second attack, this one successful, against Fort Fisher, the principal defense of Wilmington, North Carolina. Its fall to the army sealed the Confederacy's last major port of entry. This photograph of Porter aboard his flagship, *Malvern*, was taken by Alexander Gardner shortly after the Union victory.

JB

DAVID D. PORTER
By Alexander Gardner
(1821–1882), albumen
silver print, 1865

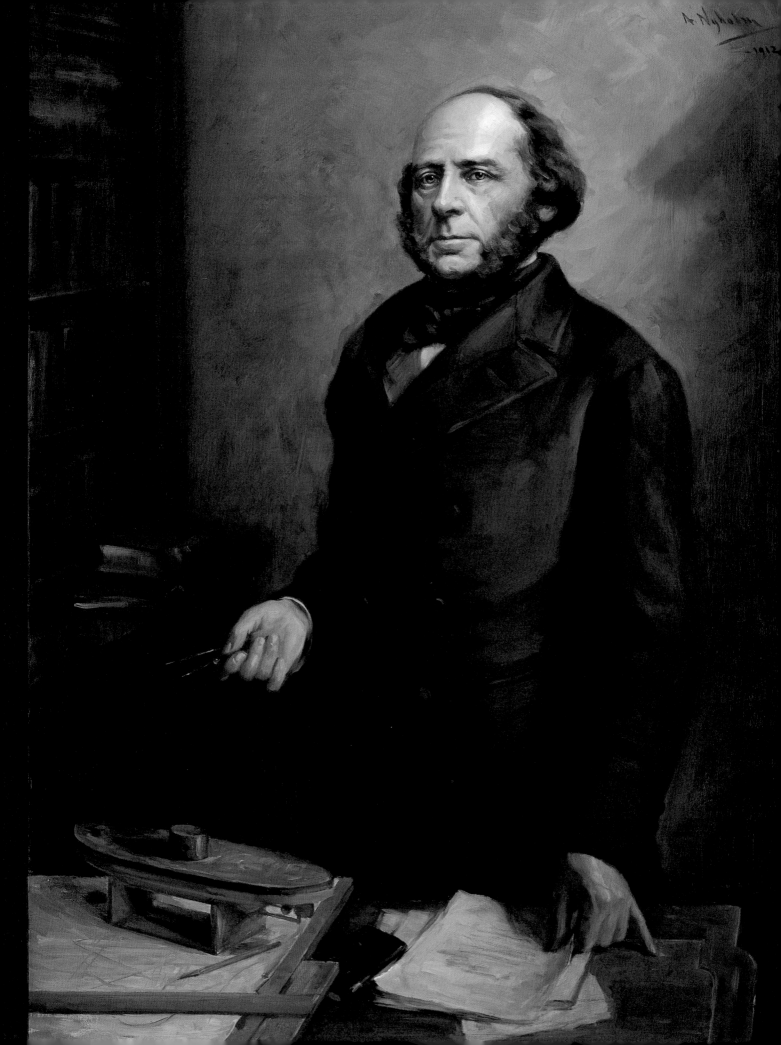

JOHN ERICSSON'S PRACTICAL APPLICATION of the principles of all-iron nautical vessels, steam-driven with screw propellers, radically altered the strategies of the U.S. Navy during the Civil War, and hastened the demise of wooden armadas, which had been in use worldwide since ancient times. Ericsson, a Swedish-born engineer and inventor, fashioned his career largely around his drawing board, at which he first practiced the rudiments of mechanical design as a boy. His interest in nautical engineering grew later in England, where he moved after taking a leave of absence from the Swedish army. In 1839 he journeyed to the United States to apply several of his ideas to American shipping, particularly the screw propeller for use on canal boats. His wife of three years subsequently joined him. But when their stay became prolonged, she grew tired of New York and returned to her family in England, where she waited amid familiar surroundings for her husband.

Meanwhile, Ericsson designed a large, screw-propelled steam frigate for the navy, the USS *Princeton*. At a trial of the ship in 1844, a gun not designed by Ericsson exploded, killing the secretaries of state and the navy, among others. Although Ericsson was not at fault, the navy shunned him for years after, until 1861, when it again required his expertise. When, early in the Civil War, it became known that the Confederates were raising the USS *Merrimack*, lying scuttled in the Norfolk Navy Yard, with the intention of turning it into an ironclad vessel, the navy accepted Ericsson's offer to design a floating battery of its own, built entirely of iron. Working from plans he had begun as far back as 1854, Ericsson designed a flat-decked vessel with a freeboard that barely rose above the water. It was propelled by a steam-powered propeller, the machinery of which was housed below the waterline. The boat's distinctive feature was a circular revolving turret, which looked from a distance like a floating box of cheese. Three weeks after the navy took possession, the *Monitor* proved itself against the *Merrimack* (renamed the CSS *Virginia*), at Hampton Roads, Virginia, on March 9, 1862. Although both sides claimed victory, Ericsson won the thanks of Congress, as well as new contracts for larger and improved *Monitor*-type vessels.

In this oil painting of Ericsson, based on an 1862 photograph by Mathew Brady, Swedish painter Arvid Frederick Nyholm placed his subject in an appropriate setting, his home office, amid drawings and a model of the *Monitor*. Ericsson always worked alone and lived his life much the same way—alone. Although he corresponded through the years with his wife until her death, he never returned to England or saw her again.

JB

JOHN ERICSSON
By Arvid Frederick
Nyholm (1866–1927),
oil on canvas, 1912

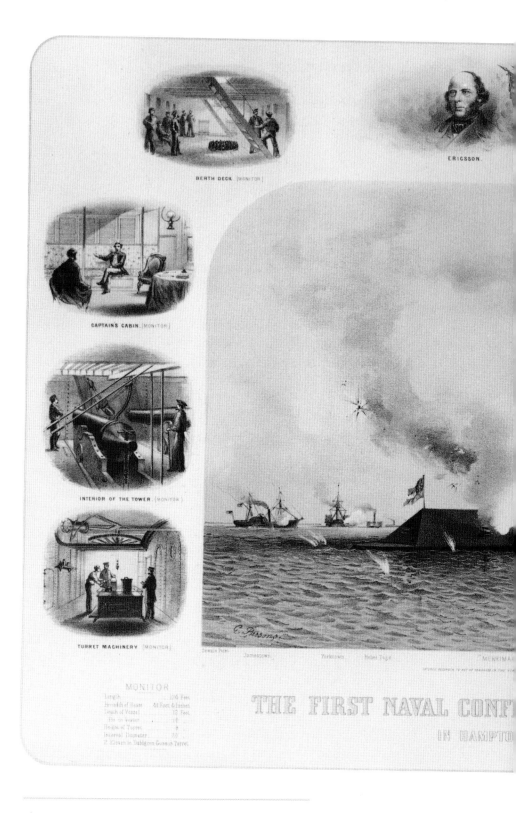

The First Naval Conflict Between Iron Clad Vessels by
Charles Parsons (1821–1910) for the Endicott Lithography
Company, lithograph with tintstones, 1862

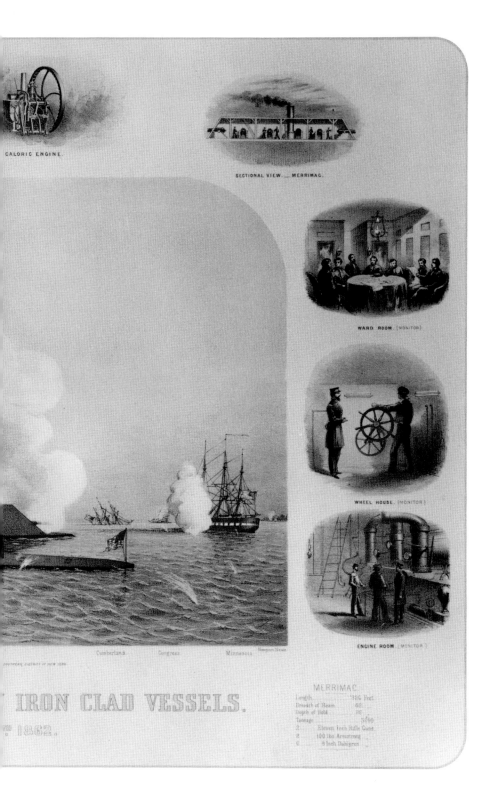

CALORIC ENGINE.

SECTIONAL VIEW. — MERRIMAC.

WARD ROOM. (MONITOR)

WHEEL HOUSE. (MONITOR)

ENGINE ROOM. (MONITOR)

Cumberland Congress Minnesota Newport News

IRON CLAD VESSELS.

1862.

MERRIMAC.

Length	316 Feet
Breadth of Beam	48.
Depth of Hold	30
Tonnage	3600
2	Eleven Inch Rifle Guns
2	100 lbs Armstrong
6	9 Inch Dahlgren

IN FEBRUARY 1861, Stephen R. Mallory of Florida was appointed secretary of the navy in the newly formed Confederate government. Mallory, not brilliant but amply intelligent, was a good choice for his qualities of practicality and resourcefulness alone. He would prove to be one of the two cabinet members who remained in their posts throughout the war. A former member of the U.S. Senate, Mallory had been chairman of the Committee on Naval Affairs, which accounted for most of his knowledge of naval matters. After the war, a Northern newspaper mocked his credentials, stating that "Mr. Mallory . . . had been in the habit of seeing some ships (especially those of war) at the navy yard, near his residence."[129] In the circumstances of the hastily concocted Confederacy, an in-depth knowledge of naval affairs seemed almost superfluous in the beginning, because the South had no navy. Mallory's best qualification for the daunting task at hand was applying his insatiable interest for learning to practical ends. His challenge now was how best to counter the formidable U.S. Navy, outdated but still vastly superior. Trying to match the enemy ship for ship would be impossible. Instead, Mallory seized on a broader strategy, one that he envisioned would damage Yankee commerce and weaken the will of Northern merchants, who were already ambivalent about the war, to support the Lincoln administration. Mallory's efforts to assemble a fleet of commerce raiders was gambling with scarce resources, but under the circumstances it was an alternative made viable and effective by such raiders as Raphael Semmes piloting the yare *Alabama*. Mallory realized, too, that iron would be his other major weapon against the North's wooden navy. From the first months of the war he was committed to building ironclad vessels, and the refitting of the *Merrimack* was the most promising example. Mallory, however, found himself short on everything but energy and ideas. Only three vessels ever became operational, and two more had to be destroyed during construction to keep them from falling into enemy hands. The endeavor was a failure. In the end, the Confederate navy was just another victim of the Union army marching on Richmond in early April 1865. Mallory fled the city with President Jefferson Davis and was captured in Georgia in May. Imprisoned for almost a year, he was paroled and lived the last few years of his life with his family in Pensacola.

This image by an unidentified photographer is believed to have been taken in the early 1850s, when Mallory was beginning his career in the U.S. Senate. On close inspection, the camera has seemingly caught the look of his eyes, described by one contemporary as "large and blue, with an attractive air of semi-puzzlement about them."[130]

JB

STEPHEN R. MALLORY
By an unidentified
photographer,
daguerreotype, c. 1852

MAURY

MATTHEW FONTAINE MAURY WAS A PROFESSIONAL naval officer who, unlike many of his predecessors, viewed the sea as a distinct branch of science rather than as the subject of romance and adventure. In 1836, he wrote the first work of nautical science by an American naval officer, and in 1855 he published the first textbook on modern oceanography in English. As superintendent of the U.S. Navy's Depot of Charts and Instruments from 1842 to 1861, Maury conducted extensive research on wind and currents. His oceanographic charts for the Atlantic, Pacific, and Indian Oceans shortened the sailing time of ships around the world, and his topographical map of the North Atlantic ocean floor illustrated the most practical route for a transoceanic cable. His work led to an international congress in 1853 in Brussels, where his system of recording oceanographic data was adopted for all naval and merchant marine vessels.

With the secession of his native state of Virginia, Maury resigned his navy commission and entered the service of the Confederate navy as a commander. In that capacity, Maury applied his scientific mind to such new technologies as devising submersible electric torpedoes, or mines, for use against the enemy. From 1862 to 1865, he was in England as an agent of his government to procure ships and supplies. After the war he went to Mexico, but he returned to the United States in 1868 to accept a professorship in meteorology at the Virginia Military Institute, where he spent his remaining years.

Maury sat for the original plaster version of his portrait by the Richmond sculptor Edward Valentine over a period of four days. After its completion in February 1869, the artist declared it the best likeness he had ever modeled.

JB

MATTHEW
FONTAINE MAURY
By Edward
Virginius Valentine
(1838–1930), bronze,
1978 cast after
1869 plaster

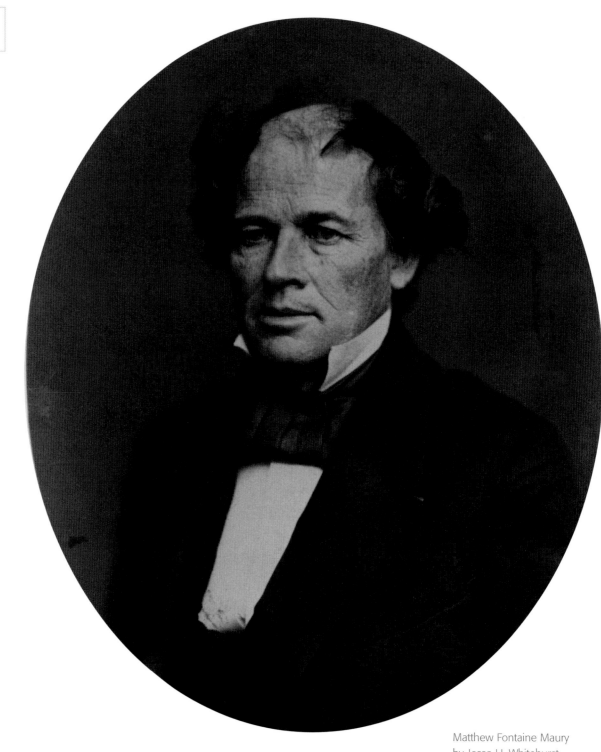

Matthew Fontaine Maury
by Jesse H. Whitehurst
(1819–1875), salted-paper
print, c. 1857

In this print by Charles Magnus, Maury appears second from the right in the second row.

Confederate Leaders and Generals by Charles Magnus (active c. 1854–1879) after the Mathew Brady Studio, lithograph, c. 1861–1865

CAPT SEMMES,
of the Pirate "Alabama".
Published by L. Prang & Co. Boston.

HIS CREW CALLED HIM Old Beeswax for his amply waxed mustache; Northerners called him a pirate; and Southern sympathizers hailed him as the legendary privateer of the Confederacy. Similar in certain respects to John Mosby, the partisan ranger of Northern Virginia, Semmes, in his search for spoils on the high seas, had an independent command and was a fully commissioned officer in the Confederate navy. At the helm of the *Sumter*, which had been converted into a man-of-war in June 1861, and later as captain of the *Alabama*, Semmes excelled at implementing the South's naval strategy of destroying Yankee commerce. In the first three years of the conflict, Semmes captured or sank more than eighty merchant vessels, representing $6 million of trade. The *Alabama* accounted for the vast majority of these prizes, for a total of about sixty-nine strikes. Built in Liverpool, England, in 1862, and armed in the Azores so as not to violate England's neutrality, the *Alabama* quickly became legendary. In January 1863, only four months after Semmes acquired the ship, it was already a serious vexation for the Lincoln administration. Secretary of the Navy Gideon Welles vented his chagrin in his diary: "Thus far the British pirate Alabama, sailing under Rebel colors, has escaped capture. As a consequence there are marvelous accounts of her wonderful speed, and equally marvelous ones of the want of speed of our cruisers. . . . She will be a myth, a 'skimmer of the seas,' till taken."[31]

On June 19, 1864, one of the war's most celebrated sea battles occurred off the coast of Cherbourg, France. The *Alabama* had just put into port for repairs when the USS *Kearsarge* discovered her. Semmes, buoyed by his string of naval victories, challenged Captain John A. Winslow to a duel. After the opening salvos, it soon became apparent that the larger *Kearsarge* was the fitter and superior ship. It sank the infamous *Alabama* in little more than an hour. Semmes and most of his crew were rescued by an English yacht, the *Deerhound*. Semmes's raiding days were over, but not his service in the Confederacy. Made a rear admiral in January 1865, and given command of the James River Squadron protecting Richmond, Semmes was soon forced to burn his ships with the Union advance upon the Confederate capital. He then organized his sailors into a brigade of militia and hastened south to North Carolina, where he surrendered with General Joseph E. Johnston's army that spring.

JB

RAPHAEL SEMMES
By Louis Prang
Lithography Company
(active 1856–1899),
lithograph with
tintstone, c. 1864

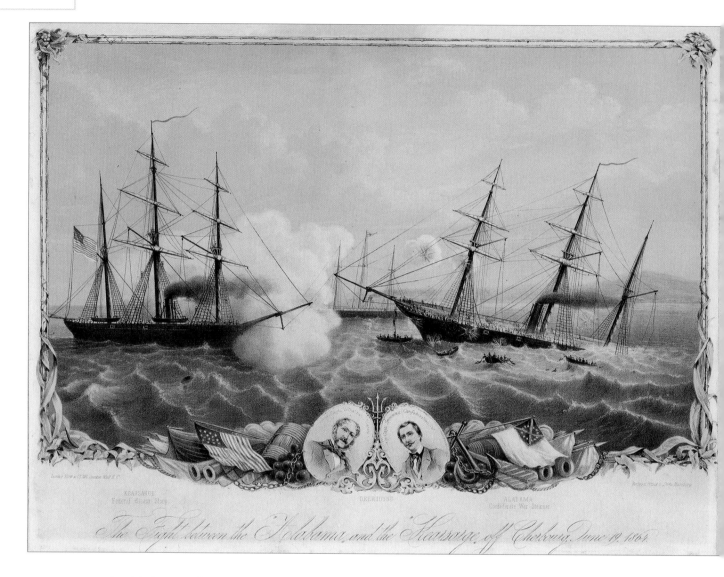

The Fight between the "Alabama" and the "Kearsarge" off Cherbourg, June 19, 1864, by Gustav W. Seitz (1826–1900?), color lithograph, c. 1864.

This ironstone china vegetable dish, made by E. F. Bodley and Company, of Burslem, Staffordshire, England, bears the motto of the CSS *Alabama*, "AIDE TOI ET DIEU T'AIDERA" (loosely translated: "God helps those who help themselves").

National Museum of
American History,
Smithsonian Institution,
Behring Center

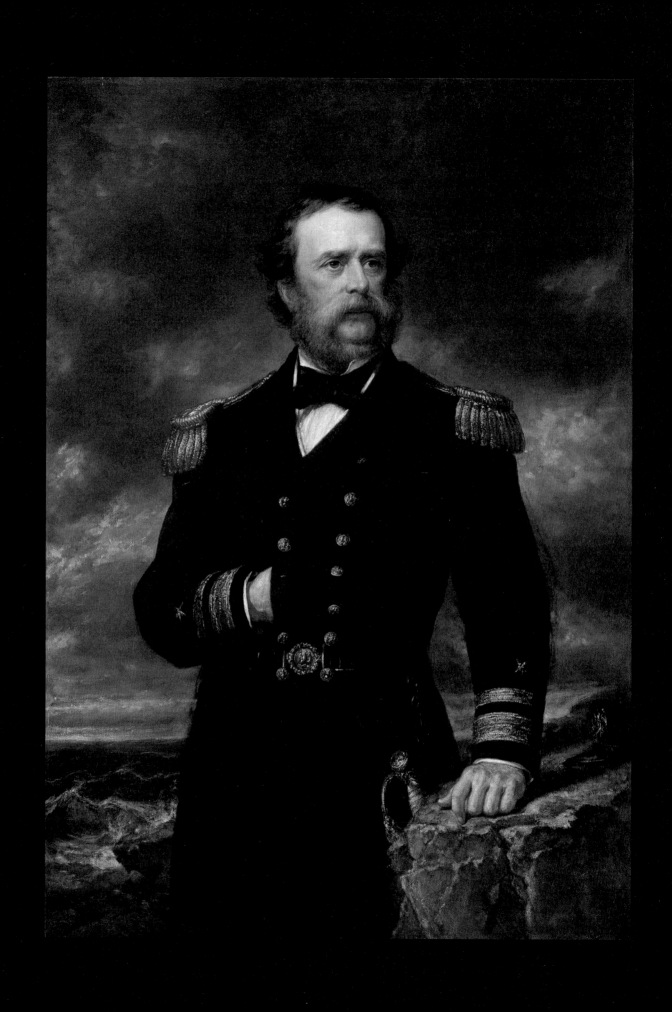

THE U.S. NAVY'S plan to capture Charleston, South Carolina, in 1863 by a frontal assault of ironclad warships and without the direct assistance of the army was a bold initiative, never before attempted in warfare. From the plan's conception, Rear Admiral Samuel F. Du Pont, commander of the attacking floating fortress of nine vessels, had serious doubts about the ability of his guns to pound into submission the cul-de-sac of Confederate defenses that guarded Charleston harbor. This grand offensive was founded on the yet-to-be-proven theory that the new ironclads, with their sides of armor and heavy caliber guns, could withstand any bombardment thrown at them, while hurling back equal or better punishment. Du Pont's capture of Port Royal, South Carolina, in November 1861, the first major Union naval victory of the war, had demonstrated the effectiveness of the navy's improved ordnance against shore defenses. Moreover, the Navy Department, buoyed by the success of John Ericsson's original ironclad, the *Monitor*, had invested heavily in money and prestige on a small armada of improved *Monitor*-type designs. Keen to display their potential, the department saw no better showplace than Charleston, the seedbed of secession. A victory there would be a political one for the Lincoln administration, as well as a feat for the technologically minded navy bureau. As commander of the important South Atlantic Blockading Squadron, Du Pont was given this vital task. "The fall of Charleston is the fall of Satan's kingdom," wrote Gustavus Fox, the ebullient assistant secretary of the navy.[132]

As Du Pont made final preparations for his assault in early April 1863, he fully understood the experimental nature of his assignment and requested that his superiors share the consequences. Personally, he had a lot to lose. He was a forty-five-year veteran who had won distinction for valor in the Mexican War. The taking of Charleston would make him a national hero. A defeat, however, might just end his career, and that is exactly what happened. In a battle lasting less than two hours, Du Pont and his nine-vessel flotilla were stymied by the relentless guns of Fort Sumter and its sister forts. Although Du Pont salvaged eight of his ironclads, preventing any of them from falling into enemy hands and thus avoiding a disaster, his defeat was a blow to Union morale, especially to the navy. Subsequently relieved of command, Du Pont never again saw active duty. His last campaign before his death at war's end was to redeem his reputation with an accurate accounting of the facts. Time and history have largely weighed in his favor by putting his whole career into perspective.

In this posthumous portrait, Daniel Huntington has done justice to Du Pont's commanding presence. Born into a prominent family of New York merchants, Du Pont stood six feet, one inch and was a model of an officer and gentleman. He impressed one journalist as "one of the stateliest, handsomest, and most polished gentlemen I have ever seen."[133]

JB

SAMUEL F. DU PONT
By Daniel Huntington
(1816–1906), oil on
canvas, 1867–1868

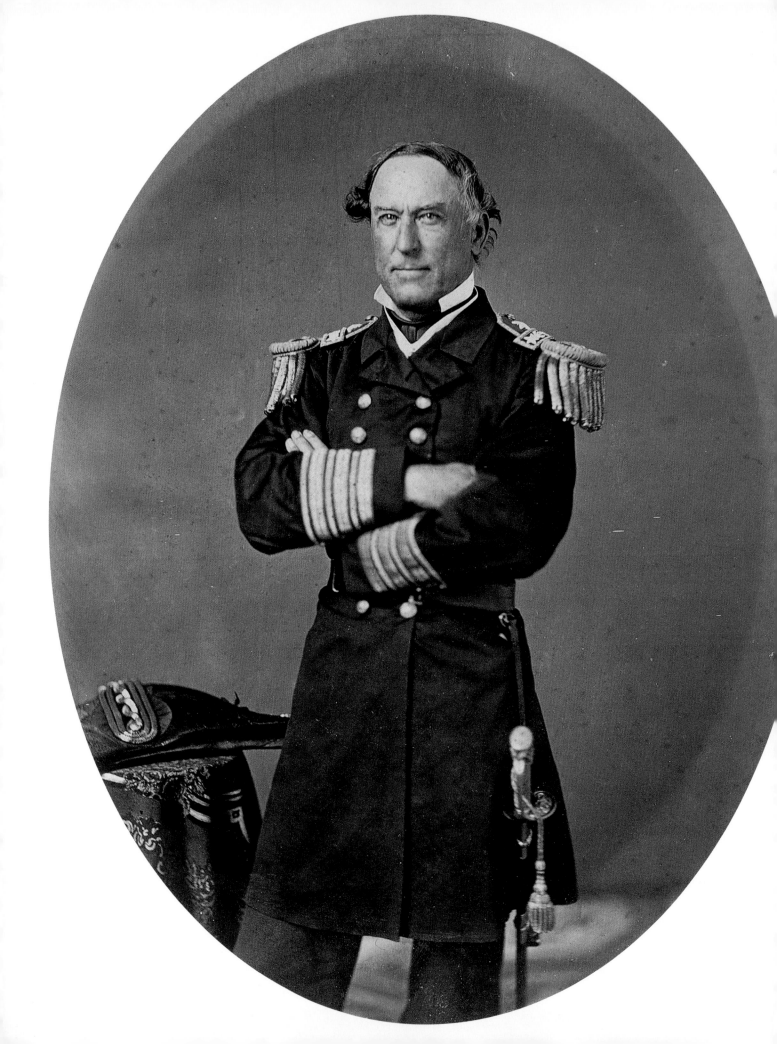

ENERGY AND DECISIVENESS were two of the qualities that made David G. Farragut the Civil War's outstanding naval hero of either side. A Tennessean by birth, Farragut was living in Norfolk, Virginia, his wife's hometown, at the start of the war. On April 18, 1861, the day after the Virginia Convention adopted an ordinance of secession, Farragut packed up his family and departed that evening for New York State. Settling into a cottage in the village of Hastings-on-Hudson, Farragut, a navy captain with years of service dating back to his teens, awaited orders, which were slow in arriving. As an officer from the South, Farragut at first was apparently a victim of Yankee prejudices. In September 1861, he was placed on a retirement board and given a desk assignment at the New York Navy Yard. Yet as the Union began a deeper search for qualified officers, Farragut's steadfast loyalty to his country, coupled with his long service record, made him acceptable for the important command of the West Gulf Blockading Squadron. Ordered to engage the defenses of New Orleans and capture the city, Farragut, aboard the new steam flagship *Hartford*, with a fleet of seventeen vessels and a mortar flotilla, sailed up the Mississippi River in April 1862. After giving battle for several days, Farragut ran his fleet successfully past the enemy forts and took the defenseless city with the loss of 184 men. Voted the thanks of Congress, Farragut was promoted to rear admiral in July, along with Samuel F. Du Pont, and they became the first admirals in the history of the American navy.

Farragut next hoped to capture Mobile but was ordered instead to take control of the lower Mississippi. He got as far as Vicksburg, which was impregnable, before descending the river and focusing his efforts on enforcing the blockade along the Gulf Coast. In the summer of 1864, however, he was free to move on Mobile Bay, which he did early in August with a wooden fleet of fourteen ships and four ironclads. When a torpedo sank one of his vessels, causing the fleet to hesitate in confusion, Farragut bellowed his famous command from the main rigging of his ship, "Damn the torpedoes! Full speed ahead!" The Union fleet successfully advanced on Mobile, and the capture of it and surrounding forts closed the Confederacy's last major port on the Gulf. With this victory, Farragut was promoted to vice admiral and became the navy's most esteemed officer.

In this photograph by Edward Jacobs of New Orleans, Farragut is shown in the uniform of a rear admiral. Farragut held that rank from July 1862 to December 1864. Minor additions and changes in uniform designs in 1863 and 1864 suggest that this image may have been taken in 1862.

JB

DAVID G. FARRAGUT
By Edward Jacobs
(1813–1892), albumen
silver print, c. 1862

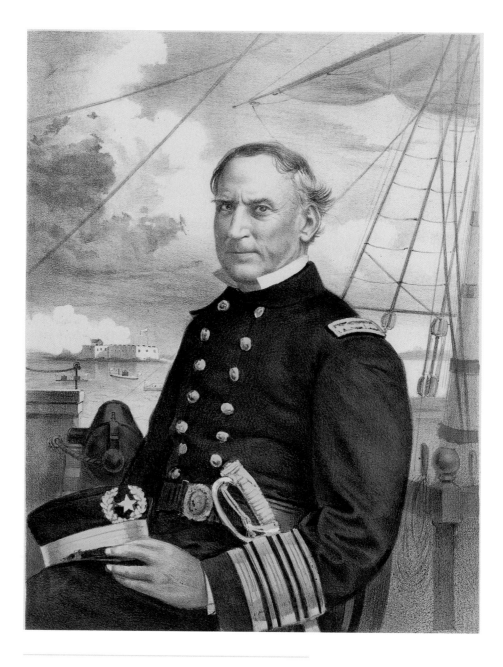

Rear Admiral D. G. Farragut by J. H. Bufford Lithography
Company (active 1835–1890), hand-colored lithograph,
c. 1864

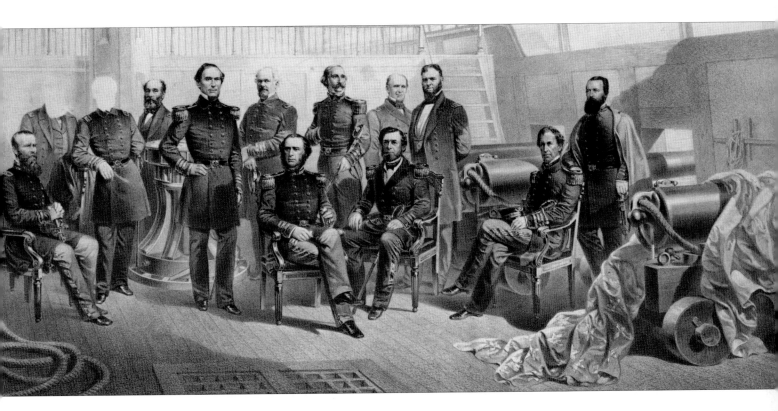

Civil War Naval Officers
by an unidentified artist,
lithograph, c. 1862

Since single portraits of national heroes sold well during the Civil War, publishers assumed that composite group portraits filled with many generals, cabinet members, or naval officers would be even more appealing. Yet as military leadership shifted and reputations rose and fell, the prints quickly became outdated. In this lithograph of Union naval officers, two of the heads are missing; either they had not yet been drawn or, more likely, they had been burnished out in preparation for adding new heroes. The figures in this print are, left to right, John L. Worden, Andrew A. Harwood, David G. Farragut, Theodorus Bailey, Samuel F. Du Pont, Charles Henry Davis, Andrew Hull Foote, Silas H. Stringham, Louis M. Goldsborough, Charles Wilkes, and David Dixon Porter.

One Nation Again

AS PRESIDENT LINCOLN had proclaimed with earnest hope in his Gettysburg Address of November 1863, the nation would indeed experience "a new birth of freedom" at the close of the Civil War. The march toward equality for all Americans, especially African Americans, would finally begin with the end of slavery. Yet attaining the rights and freedoms that promised to transform the nation forever would take generations to be fully realized: a hundred years after the war, the civil rights movement of the 1960s would, in a sense, be the culmination of Lincoln's idealism.

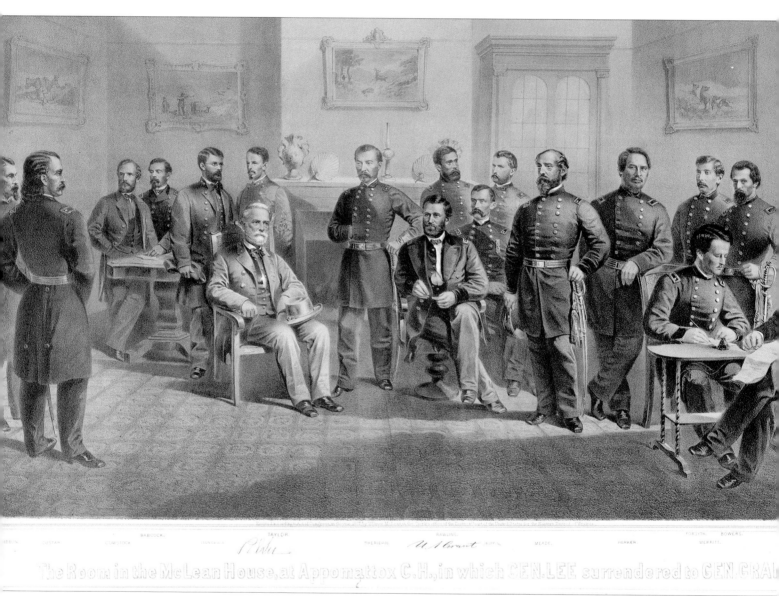

TAYLOR

BABCOCK.

RAWLINS.

BOWERS.

CUSTER

COMSTOCK

SHERIDAN

U. S. Grant

MEADE.

PARKER

FORSYTH

MERRITT.

The Room in the McLean House, at Appomattox C.H., in which GEN. LEE surrendered to GEN. GRANT

The Room in the McLean House, at Appomattox C.H., in Which Gen. Lee Surrendered to Gen. Grant

AS A SPECTATOR of the Civil War, and an unwilling one at that, no one had a better vantage point of its start and finish in Virginia than Wilmer McLean. On two separate occasions the war enveloped two of McLean's houses, approximately 130 miles apart. In July 1861, Confederate commander General P. G. T. Beauregard was using McLean's farmhouse in Prince William County as his headquarters at the start of the First Battle of Manassas. One story alleged that McLean was preparing breakfast for the general when a cannon shot crashed through a window. After the battle, McLean had second thoughts about living in an area of strategic importance to both armies. He decided to relocate his family to what he thought would be a safer part of Virginia, the village of Appomattox Court House.

On Palm Sunday, April 9, 1865, by a coincidence that would have been considered too contrived for most writers of fiction, McLean's parlor became the scene of the surrender of General Robert E. Lee's army to General Ulysses S. Grant. The participants at that ceremony, if not fully aware of its vast future implications for the nation at large, were ever mindful that they were making history. Once Lee and Grant had signed the surrender papers and had left McLean's premises, "relic-hunters charged down upon the manor house," recalled a staff officer, "and began to bargain for the numerous pieces of furniture."[134] McLean was asked to sell the tables and chairs used by Grant and Lee. When he refused, money was strewn at him, and it lay on the floor of the parlor, which was becoming more and more despoiled as troops began cutting the caning out of his chairs and stripping the haircloth from his upholstered furniture. In an effort to help compensate his loss, McLean in 1867 commissioned this print of the famous surrender ceremony. The images were based on photographs. The one of Lee was taken by Mathew Brady at Lee's residence in Richmond on Easter Sunday, a week after the surrender.

JB

THE ROOM IN THE
MCLEAN HOUSE, AT
APPOMATTOX C.H.,
IN WHICH GEN. LEE
SURRENDERED TO GEN.
GRANT by Major and
Knapp Lithography
Company (active 1864–
c. 1881), lithograph with
tintstone, 1867

These chairs and this table were just some of the furnishings that Union officers acquired as souvenirs from the McLean house in Appomattox after Lee and Grant vacated the premises after signing the terms of surrender.

General E. W. Whitaker acquired the caned armchair in which Lee sat when he signed the surrender. The small oval-topped table and black-backed leather swivel chair were used by Grant. General Philip Sheridan acquired the table and presented it to Mrs. George A. Custer, who left it to the Smithsonian in her will. Grant's chair was acquired by General Henry Capehart. As in the case of Lee's chair, it too was willed to the Smithsonian by a secondary owner.

National Museum of American History, Smithsonian Institution, Behring Center

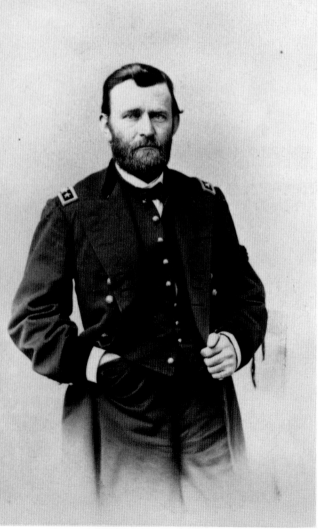

U. S. Grant by Frederick Gutekunst (1831–1917), albumen silver print, 1865

This is one of six images that Mathew Brady took of Robert E. Lee upon his arrival home in Richmond. The date was April 16, 1865, Easter Sunday, a week after Lee had surrendered to Grant at Appomattox.

By Mathew Brady
(c. 1823–1896), albumen
silver print, 1865

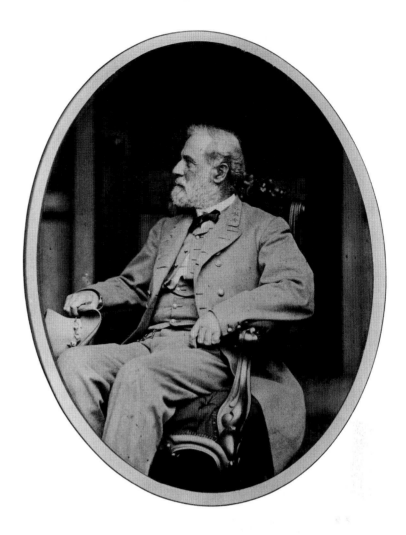

1866 Baltimore lithographer Ernest Crehan commemorated the occasion of Robert E. Lee's farewell address to the soldiers of the Army of Northern Virginia, following its formal surrender on April 9, 1865, at Appomattox Court House.

After four years of arduous service marked by unsurpassed courage and fortitude, the Army of Northern Virginia has been compelled to yield to overwhelming numbers and resources. I need not tell the brave survivors of so many hard fought battles, who have remained steadfast to the last, that I have consented to this result from no distrust of them; but feeling that valor and devotion could accomplish nothing that could compensate for the loss that must have attended the continuance of the contest, I determined to avoid the useless sacrifice of those whose past services have endeared them to their countrymen.

By the terms of the agreement, officers and men can return to their homes and remain until exchanged. You will take with you the satisfaction that proceeds from a consciousness of duty faithfully performed; and I earnestly pray that a Merciful God will extend to you His blessings and protection.

With an unceasing admiration of your constancy and devotion to your Country, and a grateful remembrance of your kind and generous consideration for myself, I bid you all an affectionate farewell.

Ernest Crehen (active
1860–c. 1874), after
photograph by Minnis and
Powell, lithograph, 1866

Used as a Confederate flag of truce at Appomattox, this half of what had once been a white linen dish towel was carried by a staff officer of General James Longstreet into the lines of General George Custer, a cavalry commander under General Philip Sheridan. General Robert E. Lee was requesting a suspension of fighting while he sought to learn the terms of surrender General Grant was proposing to offer. After the war, Sheridan presented the flag to Mrs. Custer in appreciation of the loyal service performed by her husband.

National Museum of
American History,
Smithsonian Institution,
Behring Center

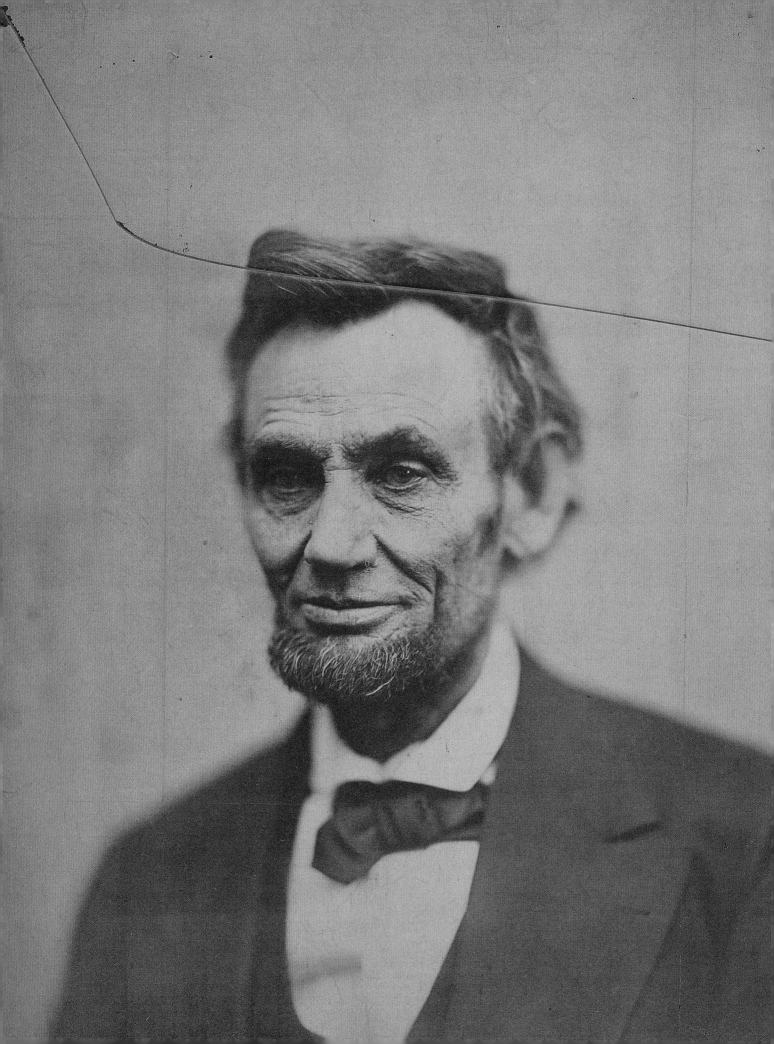

ON SUNDAY AFTERNOON, February 5, 1865, President Lincoln was in Alexander Gardner's photographic studio at Seventh and D Streets, N.W., in Washington, D.C. The occasion no doubt offered him a brief respite from his all-consuming duties as president and commander in chief. Only two days before, he had sailed down to Hampton Roads, Virginia, to meet with three commissioners of the Confederate government to explore a possible peace agreement. The four-hour peace conference proved a failure. Lincoln, however, as a personal favor to Vice President Alexander Stephens, one of the commissioners, promised to see what he could do about securing the exchange of Stephens's nephew from a Yankee prison. That Sunday evening at seven o'clock, Lincoln was scheduled to meet with his cabinet and propose by a joint resolution of Congress that $400 million be paid to the states to compensate slave owners if a cessation of all resistance to Federal authority could be achieved by April 1, 1865. The cabinet, to a man, disapproved the proposal. Meanwhile, Lincoln sent word to General Grant that he should continue to pursue every military option for ending the war. Under the circumstances, that Lincoln could give a hint of a smile for Alexander Gardner's camera was a measure of his natural goodwill, and also of the hope and trust he had "in the providence of God" to heal the nation. That would be the theme of his second inaugural address, which he would deliver in a month.

Alexander Gardner was intent foremost on preserving the craggy face before him. Born in Paisley, Scotland, Gardner had immigrated to New York City in 1856 and soon became employed in Mathew Brady's studio. Two years later, he moved to the nation's capital to manage Brady's Washington branch. By 1863, Gardner was responsible for taking some of the most graphic battlefield scenes of the war, especially at Antietam. Tired of not receiving recognition for his work, he left Brady and started his own business.

Lincoln had sat to Gardner's camera earlier, in both the spring and fall of 1863. He was now posing for a series of photographs, and in at least one of these he posed with his young son Tad. The session produced this close-up view of the president, which for many years was misattributed as being the last photograph of Lincoln. At the time of this sitting, Lincoln was one week shy of his fifty-sixth birthday. Because the glass plate somehow became cracked, Gardner made only this one large print before destroying the damaged plate. The print was purchased by sculptor Truman H. Bartlett from Gardner's Washington studio in 1874, and acquired in 1913 by Frederick Hill Meserve, the great collector of Civil War photographs.

JB

ABRAHAM LINCOLN
By Alexander Gardner
(1821–1882), albumen
silver print, 1865

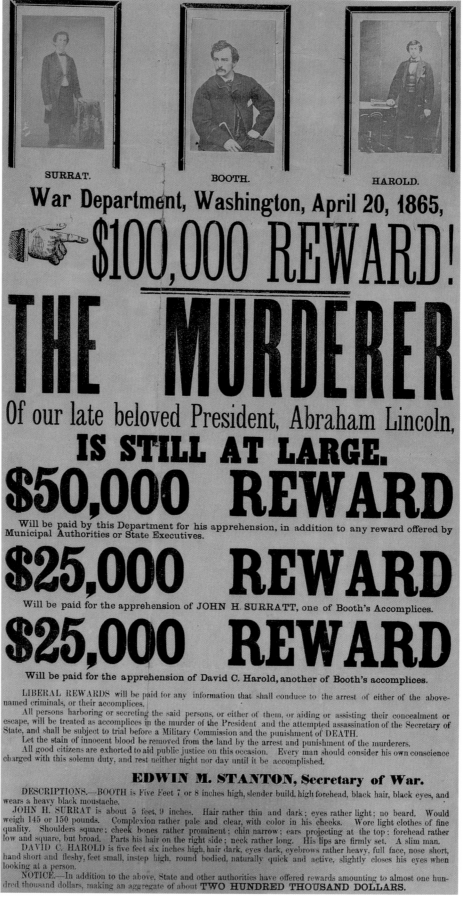

SURRAT. BOOTH. HAROLD.

War Department, Washington, April 20, 1865,

$100,000 REWARD!

THE MURDERER

Of our late beloved President, Abraham Lincoln,

IS STILL AT LARGE.

$50,000 REWARD

Will be paid by this Department for his apprehension, in addition to any reward offered by Municipal Authorities or State Executives.

$25,000 REWARD

Will be paid for the apprehension of JOHN H. SURRATT, one of Booth's Accomplices.

$25,000 REWARD

Will be paid for the apprehension of David C. Harold, another of Booth's accomplices.

LIBERAL REWARDS will be paid for any information that shall conduce to the arrest of either of the above-named criminals, or their accomplices.

All persons harboring or secreting the said persons, or either of them, or aiding or assisting their concealment or escape, will be treated as accomplices in the murder of the President and the attempted assassination of the Secretary of State, and shall be subject to trial before a Military Commission and the punishment of DEATH.

Let the stain of innocent blood be removed from the land by the arrest and punishment of the murderers.

All good citizens are exhorted to aid public justice on this occasion. Every man should consider his own conscience charged with this solemn duty, and rest neither night nor day until it be accomplished.

EDWIN M. STANTON, Secretary of War.

DESCRIPTIONS.—BOOTH is Five Feet 7 or 8 inches high, slender build, high forehead, black hair, black eyes, and wears a heavy black moustache.

JOHN H. SURRAT is about 5 feet, 9 inches. Hair rather thin and dark; eyes rather light; no beard. Would weigh 145 or 150 pounds. Complexion rather pale and clear, with color in his cheeks. Wore light clothes of fine quality. Shoulders square; cheek bones rather prominent; chin narrow; ears projecting at the top; forehead rather low and square, but broad. Parts his hair on the right side; neck rather long. His lips are firmly set. A slim man.

DAVID C. HAROLD is five feet six inches high, hair dark, eyes dark, eyebrows rather heavy, full face, nose short, hand short and fleshy, feet small, instep high, round bodied, naturally quick and active, slightly closes his eyes when looking at a person.

NOTICE.—In addition to the above, State and other authorities have offered rewards amounting to almost one hundred thousand dollars, making an aggregate of about TWO HUNDRED THOUSAND DOLLARS.

THE CIVIL WAR was prefaced by John Brown's defiant raid at Harpers Ferry, Virginia, and it would end with an epilogue of an even greater tragedy—the assassination of President Abraham Lincoln by John Wilkes Booth. Although one fanatic was a Northerner and the other was a Southerner, both Brown and Booth were moved by the notion that acts of anarchy by individuals could somehow supplant the processes of democratic institutions. As head of state, President Lincoln from time to time pondered his own vulnerability to violent attack and was warned by those around him to take greater precautions. It cannot be said how seriously he took the death threats he received by mail, but he carefully saved them in a special envelope inside his office desk drawer. Although he allowed himself the protection of a few plainclothes policemen toward the end of the war, he never doubted that an assassin such as Booth could succeed if he were determined.

This printed broadside, issued five days after Lincoln's death, announced a $100,000 reward for the apprehension of Booth and two of his known accomplices, "John H. Surrat" and "David C. Harold," in connection with the assassination of President Lincoln at Ford's Theatre on April 14, 1865. In the days and weeks that followed, the conspirators would become better known (the names of John *Surratt* and David *E. Herold* would be correctly spelled), and other conspirators would be identified; Booth would be tracked into Caroline County, Virginia, and mortally wounded in a tobacco barn set afire by Federal soldiers. Afterward, there would be a clamor for the reward money, a portion of which would be divided among the officers and the twenty-six soldiers who had captured Booth and taken Herold into custody. John Surratt would save himself by fleeing to Canada, while his mother, Mary Surratt, would be found guilty, largely by association, and hanged.

JB

$100,000 REWARD!
Albumen silver prints
mounted on printed
broadside, 1865

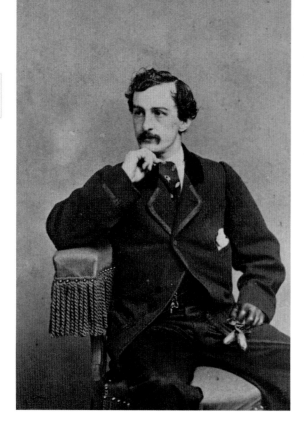

Cartes de visite, such as this one of actor John Wilkes Booth, were popular and inexpensive souvenirs distributed by the actors themselves and collected by admirers at the time of the Civil War.

By Charles DeForest Fredricks (1823–1894), albumen silver print, c. 1862

One of the Smithsonian's most treasured icons is this top hat that Abraham Lincoln wore to Ford's Theatre on the night of his assassination.

National Museum of American History, Smithsonian Institution, Behring Center

This playbill is from the Ford's Theatre production of *Our American Cousin*, starring Laura Keene, for April 14, 1865, the night Abraham Lincoln was assassinated.

National Museum of American History, Smithsonian Institution, Behring Center

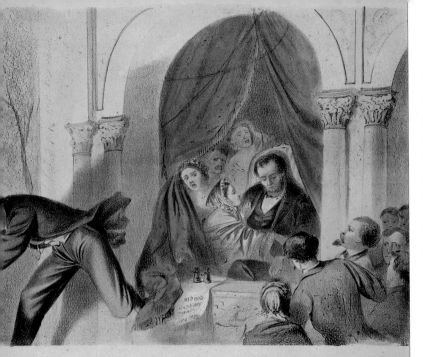

ASSASSINATION OF PRESIDENT LINCOLN.
AT FORD'S THEATRE WASHINGTON. D.C APRIL 14ᵗʰ 1865.

Today it is hard to imagine that anyone living during the time of Lincoln's assassination would have purchased this print for decorative purposes. Still, printmakers were not dissuaded from producing several different versions of the assassination for posterity. Most tended to show Booth, derringer in hand, in the act of shooting the president. This print by Joseph E. Baker is especially action-oriented in that it depicts Booth leaping out of the president's box. The knife he holds was used to severely wound Lincoln's guest, Major Henry R. Rathbone.

Assassination of President Lincoln by Joseph E. Baker (1835–1914), color lithograph, c. 1865

British-born actress Laura Keene (c. 1826–1873) was playing in the lead role of *Our American Cousin* at Ford's Theatre on the night President Lincoln was assassinated. Keene had become a major theatrical attraction in New York City since her arrival in the United States in 1852. By the start of the Civil War, she had also demonstrated a remarkable aptitude for business in becoming the first female theater manager in the country. *Our American Cousin* was one of her long-running successes, and she brought it to the nation's capital in the spring of 1865.

By Charles DeForest Fredricks (1823–1894), albumen silver print, c. 1863

A MONTH AFTER the Confederate surrender at Appomattox and the subsequent assassination of President Abraham Lincoln, Southern diarist Mary Boykin Chesnut wrote on May 16, 1865: "We are scattered—stunned—the remnant of heart left alive with us, filled with brotherly hate. We sit and wait until the drunken tailor who rules the U.S.A. issues a proclamation and defines our anomalous position."[135] Americans, like Chesnut, harbored sectional bitternesses of their own and watched to see how the new president, Andrew Johnson, would implement the peace and reconcile the nation. The task would have been difficult for even Abraham Lincoln, a skilled compromiser yet a principled statesman. Johnson, never a natural leader, had too many self-doubts to inspire much confidence in others. He had grown up largely in poverty; all of his adult life, he was driven to rise above the lot of a tailor, the occupation to which he had been apprenticed at the age of fourteen. A North Carolinian by birth, Johnson moved to Greeneville in eastern Tennessee in 1826, where he made his permanent home. An early admirer of Jacksonian Democracy, Johnson climbed the rungs of Tennessee politics, rising from town alderman to governor and eventually to U.S. senator. At the start of the Civil War, Johnson was the only senator from the South to remain loyal to the Union, and in 1862 President Lincoln appointed him military governor of Tennessee. Two years later, in an effort to win the votes of Southern unionists, Johnson was picked to run on Lincoln's reelection ticket as vice president. At the inaugural ceremonies, Johnson, recovering from an illness, braced himself with whiskey, and unfortunately his incoherent performance gave rise to the rumor that he was a drunkard. Upon taking the presidential oath after Lincoln's death on April 15, 1865, Johnson suddenly found himself in a critical position of power under circumstances for which there were no precedents. Intent on bringing the seceded states back into the Union as quickly as possible, Johnson adopted a modified version of Lincoln's plan for leniency, one that did not punish Southerners for the war. Yet Radicals in the Republican-dominated Congress resented seating former Confederates and were determined to secure rights for freed slaves, especially suffrage for black men. What they enacted was a policy of radical reconstruction for the South that was implemented by Federal troops over the next decade. Moreover, after a tumultuous four years of war in which Lincoln had historically expanded the powers of the presidency, Johnson became the victim of a Congress naturally inclined to curtail his executive authority. His violation of the Tenure of Office Act (later declared unconstitutional by the Supreme Court) in the removal of Secretary of War Edwin Stanton led to his impeachment in 1868. His acquittal by a single vote, more than just a personal victory, was a national vindication of the office of the presidency.

JB

ANDREW JOHNSON
By Washington Bogart
Cooper (1802–1889),
oil on canvas, after 1866

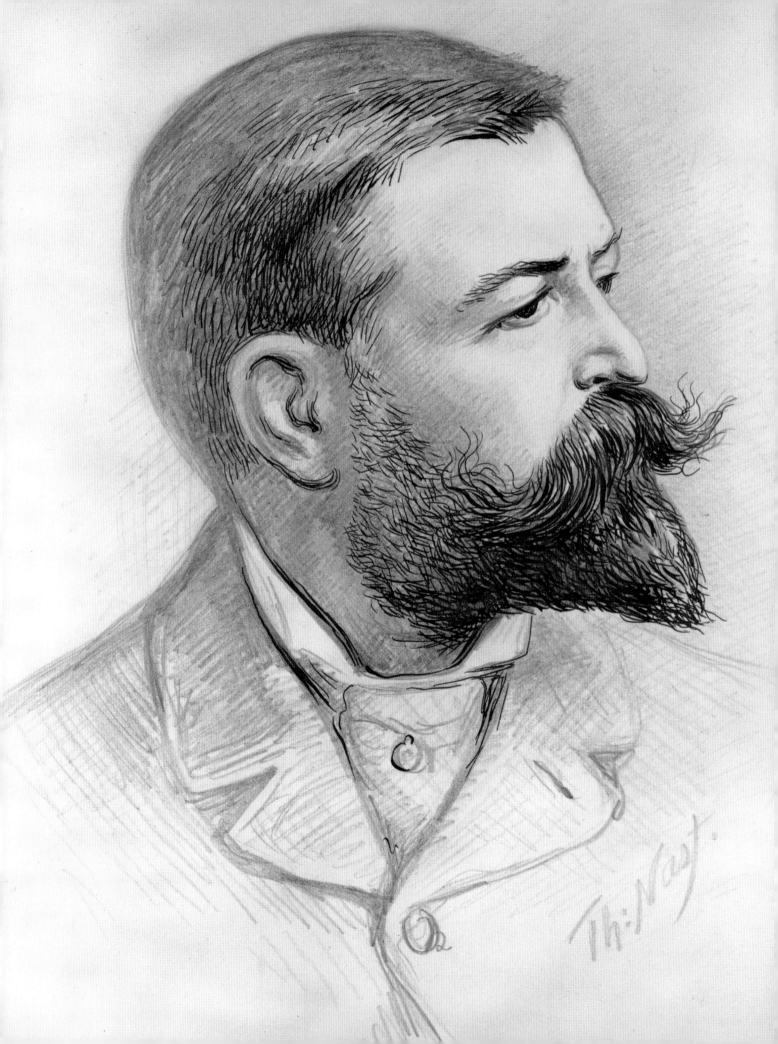

IN SPITE OF his strong Union bias, the German-born journalist-illustrator Thomas Nast had initially undertaken to chronicle the Civil War in a reasonably objective manner. Gradually, however, his drawings for *Harper's Weekly* became more blatantly partisan, and by mid-war he had developed a style of emotion-charged illustration that made him one of the most influential editorialists of the North. "Thomas Nast," declared President Lincoln near the conflict's end, "has been our best recruiting sergeant. His emblematic cartoons have never failed to arouse enthusiasm and patriotism, and have always seemed to come just when these articles were getting scarce."[136]

In 1865, Nast heartily endorsed the Radical Republicans' postwar call for stringent Federal control of Reconstruction in the South. When Lincoln's successor, President Andrew Johnson, stubbornly opposed this policy, Nast launched a cartoon attack that would rank among his most merciless. Nast had never before resorted to caricaturing public figures, but Johnson prompted the famed artist's venture into this editorial art form. He hounded his subject with vicious abandon, transforming Johnson by turns into a conniving Iago, a blood-lusting Roman emperor, and the scowling "King Andy I." In 1873, Nast took to the lecture circuit, delighting his audiences with demonstrations of his work. It is thought that this pastel rendering of the dictatorial King Andy (below) was done for one of Nast's platform appearances. The donkey—his ears wreathed in an emperor's garland—was meant to belittle the Democratic Party's charge of "Caesarism," which had been inspired by the current Republican talk of a third term for President Ulysses S. Grant.

FV

Andrew Johnson by Thomas Nast (1840–1902), pastel on paper, 1873

THOMAS NAST
Self-portrait, pencil and india ink on paper, c. 1882

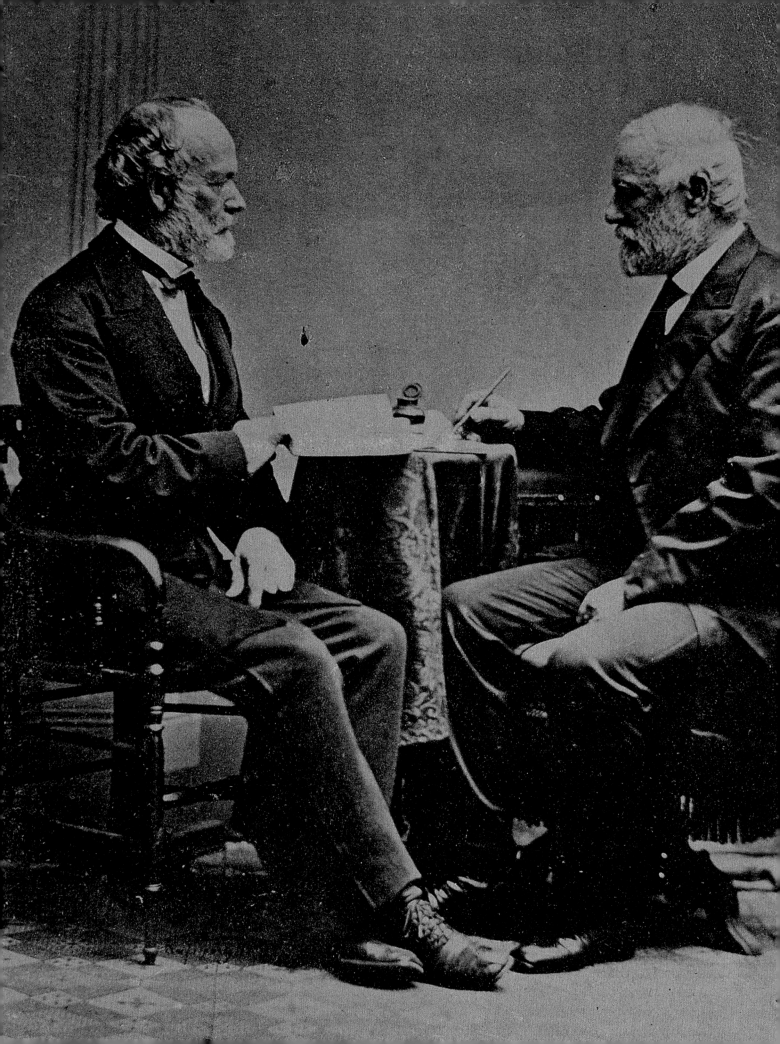

THE OCCASION FOR the posed photograph of General Robert E. Lee seated at a small table opposite General Joseph E. Johnston was natural enough. Just five years to the month before, both generals had surrendered the Confederacy's two largest armies. The date now was April 1870. Lee, joined by his daughter Agnes, was visiting Savannah, Georgia, as part of a two-month sojourn in the South, in the hope of improving his health, aggravated by the "rheumatism" that historians now believe was really heart disease. Lee also viewed the trip as a last opportunity to see old friends and visit sites dear to him. He planned to spend a few days in Savannah before visiting Cumberland Island, the gravesite of his famous father, "Light-Horse Harry" Lee. Savannah, with its old, tree-lined streets and yellow jasmine blooming in abundance, had special meaning for Lee. It was to nearby Cockspur Island that he had been first assigned to duty as an engineer fresh out of West Point. Joe Johnston had been a classmate, the only other Virginian to graduate in 1829. Johnston's father had served under Light-Horse Harry Lee in the Revolutionary War. Both Lee and Johnston had had long military careers before the Civil War, and both resigned within days of each other after Virginia had passed an ordinance of secession. In early June 1862, following the Battle of Seven Pines near Richmond, Lee took over command of the Army of Northern Virginia from the wounded Johnston.

On April 2, the day after Lee arrived in Savannah, he attended a private dinner at which Johnston was also in attendance. The two gray-bearded generals, both sixty-three, had not seen each other since the war. Johnston was then living in Savannah, trying to earn a livelihood in the insurance business. Over the past four-and-a-half years, Lee had been serving as president of Washington College in Lexington, Virginia. It is not known if the dinner they both attended was the occasion for their photograph, or whether they met again. Whatever, the idea for them to sit together for a photographer was surely someone else's. At least two images, similar in composition, are known to have been taken. Lee's pose in the image illustrated here, with pen in hand, was assumed especially for the camera. The shine on his shoes, in contrast to Johnston's, was typical of this "Southern Arthur," and of this West Pointer who had graduated forty-one years before with no demerits.

Photographs of this image were later sold to raise funds for the Lee monument in Richmond.

JB

ROBERT E. LEE AND
JOSEPH E. JOHNSTON,
SAVANNAH, GEORGIA,
By D. J. Ryan (1825–
1925?), albumen
silver print, 1870

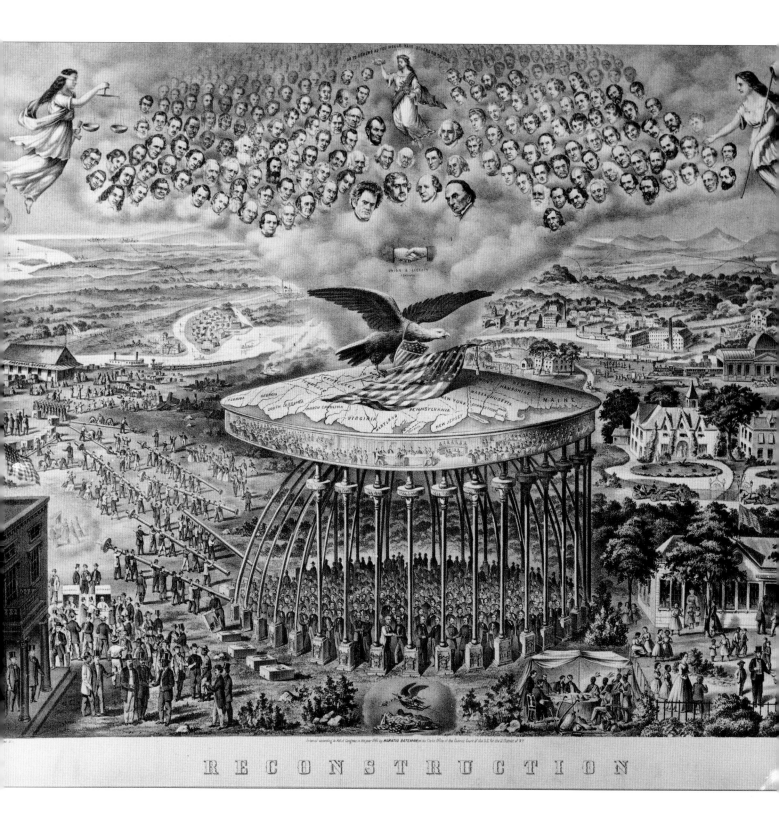

RECONSTRUCTION

PUBLISHED TWO YEARS AFTER THE END OF THE CIVIL WAR, this print titled *Reconstruction* symbolically depicts the idealism with which President Lincoln spoke in his second inaugural address:

> With malice toward none, with charity for all, with firmness in the right as God gives us
> to see the right, let us strive on to finish the work we are in, to bind up the nation's
> wounds, to care for him who shall have borne the battle and for his widow and his
> orphan, to do all which may achieve and cherish a just and lasting peace, among
> ourselves, and with all nations.

The Civil War did not necessarily guarantee the end of slavery and the freedom of any or all slaves. "Liberty for all" was an ideal in which President Abraham Lincoln believed firmly, and ultimately brought about with his extraordinary patience, perseverance, and moral vision for the future of America. Yet at the start of the war in 1861, Lincoln's primary and only cause for fighting was to preserve the union of states under the Constitution. As the nation's chief executive officer, sworn to uphold the laws of the land, this responsibility fell squarely on his shoulders. Such was his belief in the principles of law and order that he carefully respected the rights of slave owners, especially in the border states where Union loyalties were fickle.

Nonetheless, as the Civil War became prolonged, first by months and then by years, slaves began winning their freedom in several ways. Some slaves resorted to the age-old practice of running away; some became the contraband and paid laborers of the Union army; still others were freed by Union soldiers, in compliance with Lincoln's Emancipation Proclamation in 1863; and the rest were freed by passage of the Thirteenth Amendment in 1865, which outlawed slavery in the United States. Henceforth, the divisive issue of slavery mutated into that of race, and a long and bitter fight for equal rights followed. Yet progress proved to be abysmally slow. Fully one hundred years afterward, as the nation observed the Civil War Centennial, President Lyndon Johnson signed the landmark Civil Rights Act of 1964, making discrimination in public facilities illegal, including housing, education, and voting rights.

JB

RECONSTRUCTION
By J. L. Giles (active
c. 1861–1881),
lithograph, 1867

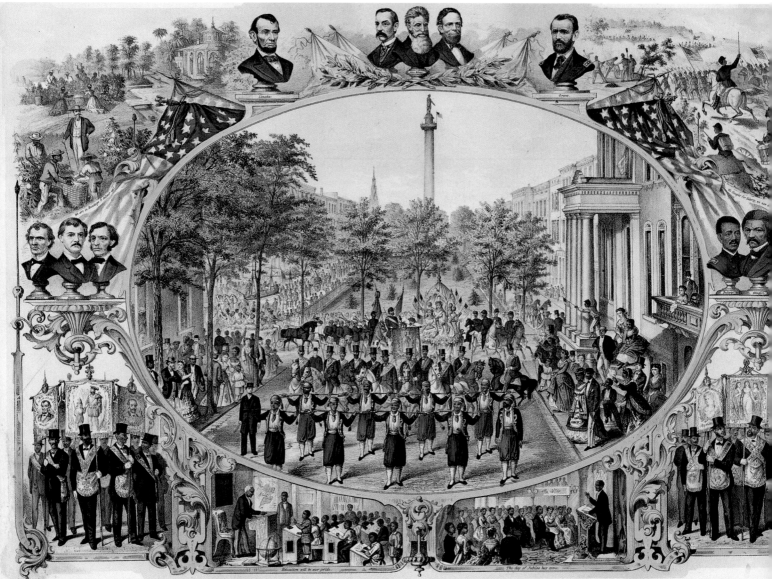

THE RESULT OF THE FIFTEENTH AMENDMENT,

And the Rise and Progress of the African Race in America and its final Accomplishment, and Celebration on May 19th A.D. 1870.

BALTIMORE, PUBLISHED BY METCALF & CLARK, 687 W. BALTIMORE ST.

Entered according to act of Congress, in the year 1870 by Metcalf & Clark, in the office of the Librarian of Congress at Washington.

THE FRUITS OF the Civil War were the Thirteenth, Fourteenth, and Fifteenth Amendments to the Constitution, and these respectively abolished slavery, guaranteed citizenship to all persons born in the United States, and granted the right to vote (to male citizens), regardless of "race, color, or previous condition of servitude." Free blacks and former slaves were the immediate beneficiaries of these new freedoms, which laid the foundations for greater social justice and instilled hope to the oppressed and disenfranchised. The Fifteenth Amendment was especially significant because for the first time in the nation's history, a minority class was empowered. "A man with a ballot in his hand is the master of the situation," wrote former abolitionist Wendell Phillips. "He defines all his other rights. What is not already given him, he takes."[137] Frederick Douglass, a runaway Maryland slave, voiced this same sentiment in celebration of the amendment's ratification in February 1870: "The Fifteenth Amendment means that hereafter the black man is to have no excuse for ignorance, poverty or destitution."[138] The reality of history, however, would prove such optimism to be largely premature, as the nation both ignored and grappled with enforcing voting rights—and equal rights in general—in the South for decades to follow.

This hand-colored lithograph commemorated the passage of the Fifteenth Amendment and the national celebration held in Baltimore on May 19, 1870. It was estimated that ten thousand black marchers participated in a five-hour parade, which passed through the downtown streets of the city in the vicinity of the Washington Monument, which can be seen in the lithograph, rising in the distance. The local paper reported that the crowd of spectators was heterogeneous: "From six to ten thousand persons had collected in the Square, representing every color, and shade of color, as well as every class and condition of men.[139] Frederick Douglass was one of the invited speakers. His image was included on the right side of the lithograph, which is adorned at the top with the likenesses of Abraham Lincoln (left), John Brown (center), and President Ulysses S. Grant (right).

JB

THE RESULT OF THE
FIFTEENTH AMENDMENT . . .
By Metcalf and Clark
(active c. 1870),
hand-colored lithograph,
1870

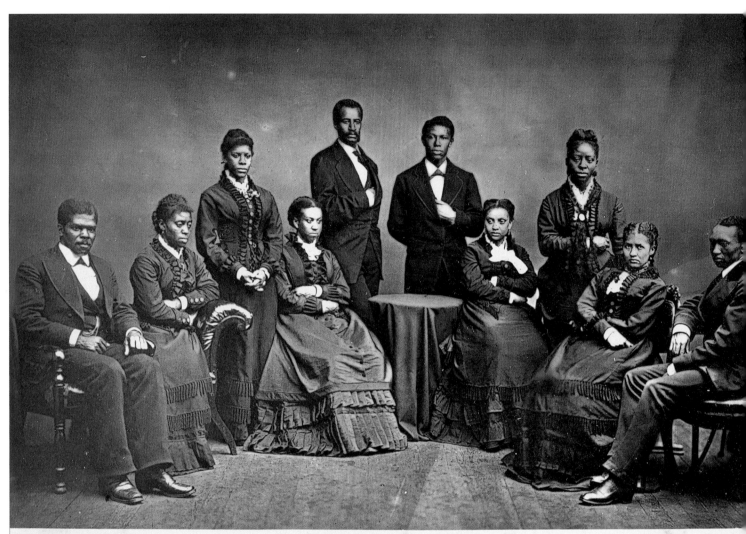

B. W. Thomas. F. J. Loudin. H. D. Alexander. Thomas Rutlin
 Maggie L. Porter. Jennie Jackson.
 Julia Jackson Ella Sheppard. Georgia Gordon. America W. Robinson.

The founding of Fisk University in 1866 in the former Confederate capital of Tennessee—Nashville—was a rare example of the educational opportunities emerging for newly freed slaves. In 1871, in an effort to raise funds for the school, a student singing group was formed, soon to be called the Fisk Jubilee Singers. The group, composed mostly of former slaves, became instantly popular, and their concert tours were soon raising substantial amounts of money. They appeared at the White House before President Ulysses S. Grant; toured the British Isles, where they performed before Queen Victoria; and raised enough money to finance Fisk's first permanent building, Jubilee Hall.

By an unidentified photographer, carbon print, 1875

Mathew Brady's War

HISTORY RECORDS THAT the most familiar byline of the Civil War was "Photograph by Brady." As the impetus for some 30,000 vintage images, Mathew Brady was easily the most prolific photographer of his era. He had portrait studios in New York City and Washington, and his roving cameramen were no less than pioneering photojournalists as they followed the armies of blue and gray onto the bloody battlefields. Visited by generals, statesmen, and a president, the Brady studios, in camp and in court, made the most complete graphic record of the war, and the one best remembered today.

Mathew Brady (c. 1823–1896)
with Juliette Handy Brady and Mrs. Haggerty

MATHEW BRADY was a successful commercial portrait photographer before the Civil War, with two studios, a main one in New York and a branch in Washington, D.C. He photographed scores of the country's most notable personalities, including statesmen like Daniel Webster and foreign celebrities like concert singer Jenny Lind, the "Swedish nightingale." The start of the war, however, changed the direction of Brady's career and business. Brady, always an innovator, saw unprecedented opportunities to record the spectacle of war in the camps and on the fields of battle. What he was embarking on was new and unexplored—the field of photojournalism. "My wife and my most conservative friends had looked unfavorably upon this departure from commercial business to pictorial war correspondence," he admitted later, "and I can only describe the destiny that overruled me by saying like Euphorion, I felt that I had to go. A spirit in my feet said 'Go,' and I went."[140]

As a result of Brady's instinct and initiative, his name ever after has been associated foremost with the pictorial record of the Civil War. Because Brady suffered from poor eyesight, a corps of operatives in his employ were actually directly responsible for making most of the thousands of images credited to him. The process of deploying cameramen in the field was expensive, and Brady, never a prudent financial manager, did not profit from the endeavor. With the return of peace, he was hard-pressed to recoup his expenses, and the public, tired of war, showed little interest in his historic pictures. In 1875, he persuaded the Federal government to purchase a large part of his collection for $25,000. Meanwhile, in an effort to earn royalties, Brady had been giving thousands of his glass negatives to the E. & H. T. Anthony Company of New York City, which produced the small and inexpensive portraits for mass consumption known as cartes de visite. In 1896, Brady died impoverished and largely unappreciated.

Six years later, a young collector, Frederick Hill Meserve (1865–1962), made an inquiry about the collection of glass carte-de-visite negatives in New York and went to inspect them at a storage facility in Jersey City. What he first saw astounded him. On the warehouse floor lay scores of broken negatives that "had sort of spilled over." Among the pieces lay a complete plate. When he held it up to the light, he saw "an extraordinary photographic negative, a profile of the face and right shoulder of Abraham Lincoln . . . in February 1864, facing the awful issues of that year of smoke, agony, and ballots."[141]

Meserve went on to become the country's first great collector of photography, and especially of Lincoln images. The thousands of glass negatives in New Jersey, which he purchased in 1902, formed the nucleus of his collection. After Meserve's death in 1962, his

MATHEW BRADY WITH
JULIETTE HANDY BRADY
AND MRS. HAGGERTY
By the Mathew Brady
Studio (active 1844–1894),
daguerreotype, c. 1851

collection came into the stewardship of his daughter, Dorothy Meserve Kunhardt. In 1981, the National Portrait Gallery purchased a selection of more than 5,400 of Brady's original negatives from the trust of the late Mrs. Kunhardt. In addition to several negatives of Abraham Lincoln made by Anthony Berger and Alexander Gardner—Brady operatives who later had distinguished careers of their own—the Portrait Gallery acquired Meserve's favorite photograph of Lincoln, the only print made from the cracked glass plate taken by Gardner in 1865. The photographs illustrated here are a sample of the Gallery's Meserve collection. They are modern albumen prints made by the Chicago Albumen Works from Brady's original collodion glass-plate negatives.

JB

Ambrose E. Burnside 1824–1881

By the Mathew Brady Studio (active 1844–1894), collodion glass-plate negative, c. 1862

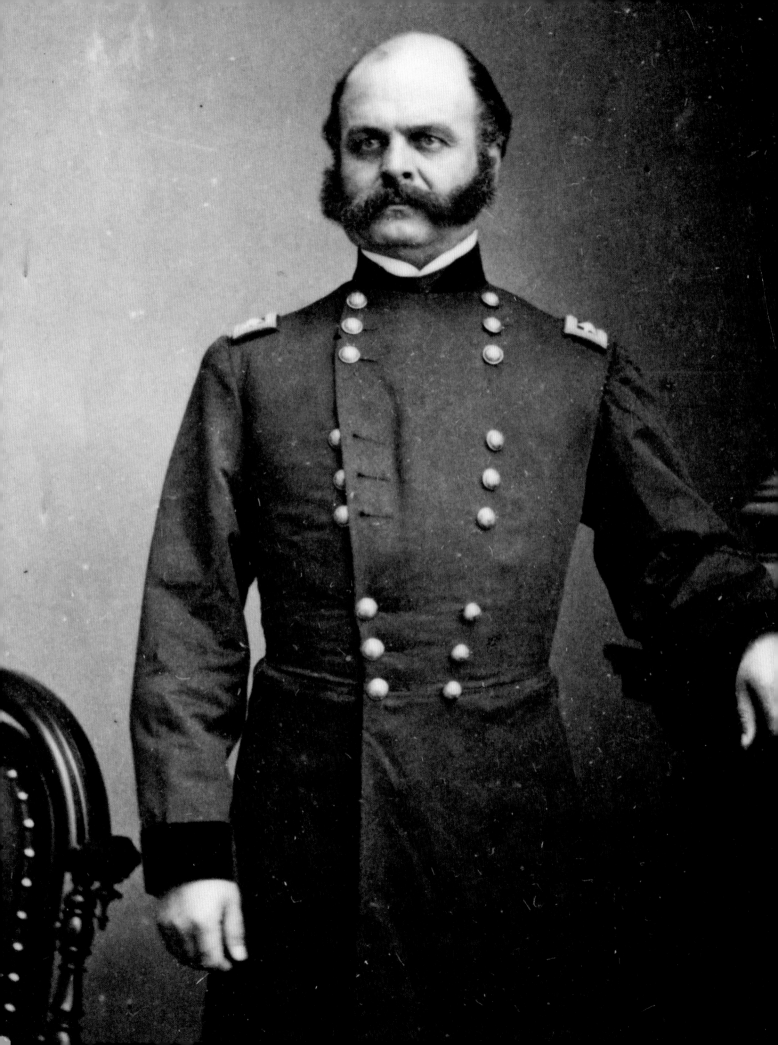

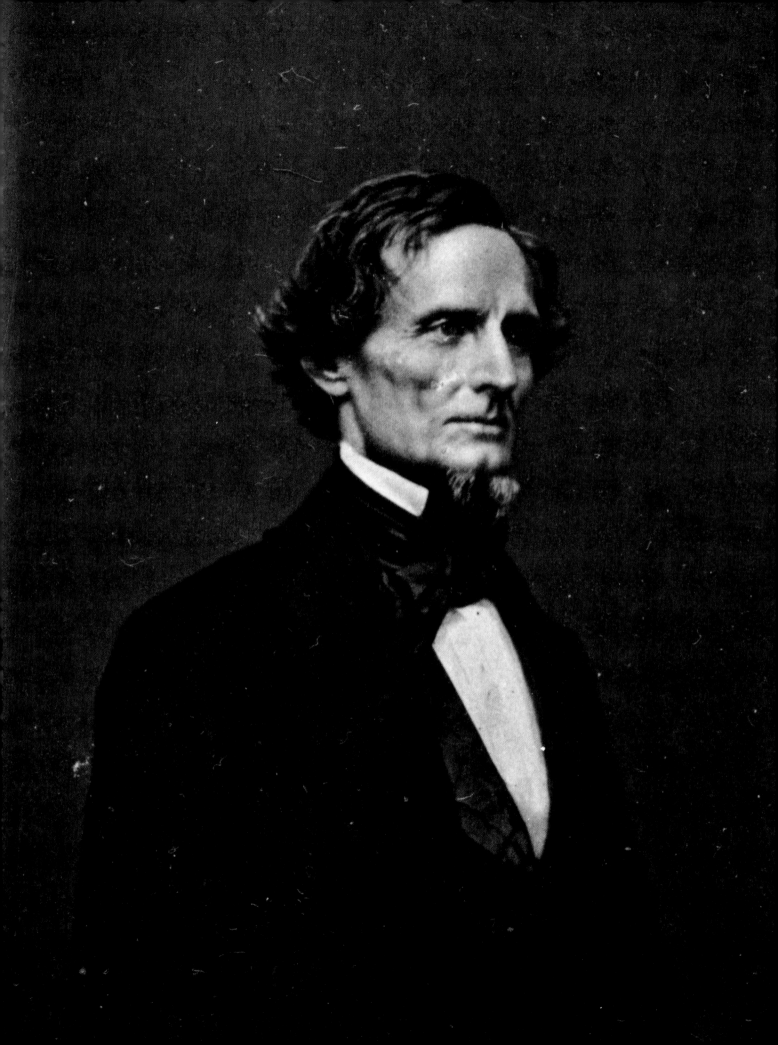

Jefferson Davis 1808–1889

By the Mathew Brady
Studio (active 1844–1894),
collodion glass-plate
negative, c. 1860

James A. Garfield 1831–1881

By the Mathew Brady
Studio (active 1844–1894),
collodion glass-plate
negative, 1862

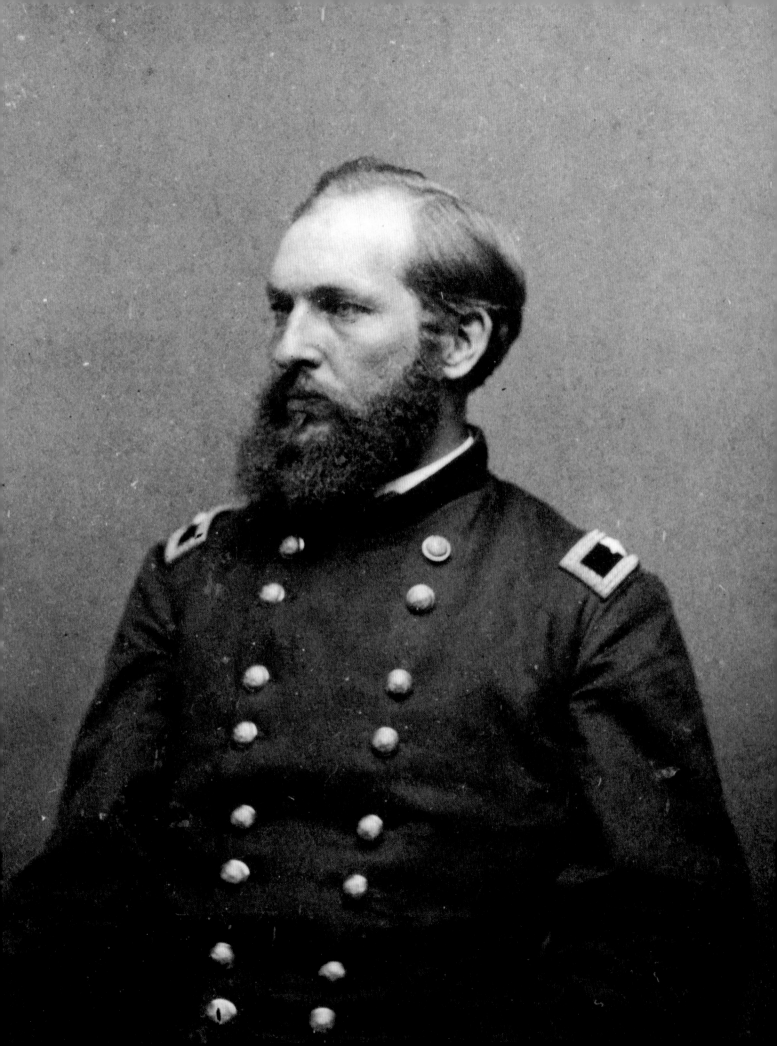

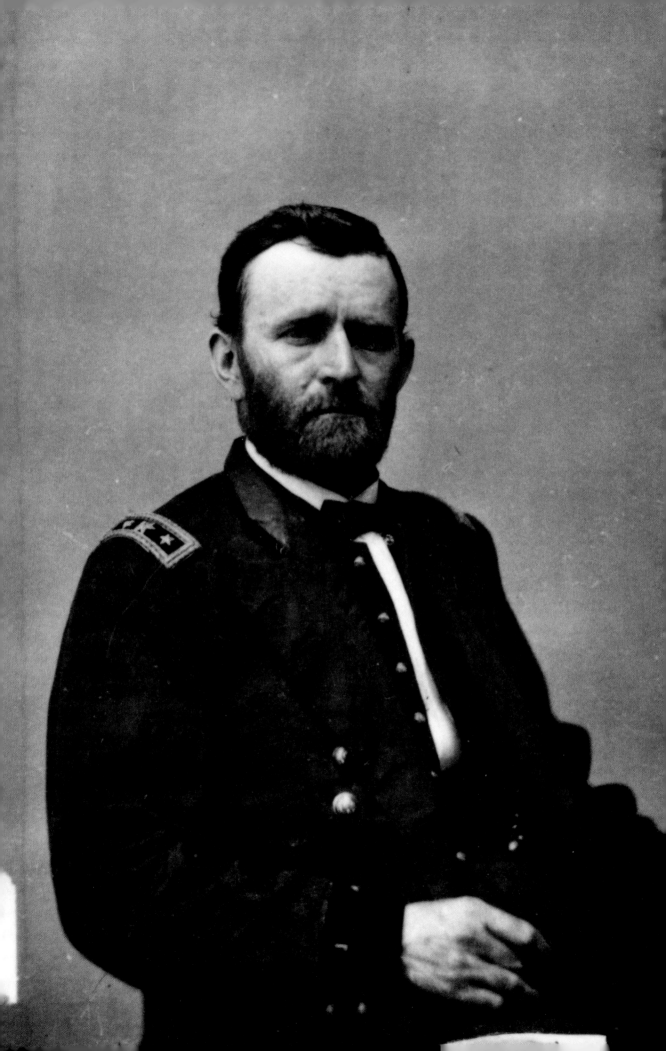

Ulysses S. Grant 1822–1885

By the Mathew Brady
Studio (active 1844–1894),
collodion glass-plate
negative, c. 1864

David G. Farragut 1801–1870

By the Mathew Brady
Studio (active 1844–1894),
collodion glass-plate
negative, 1863

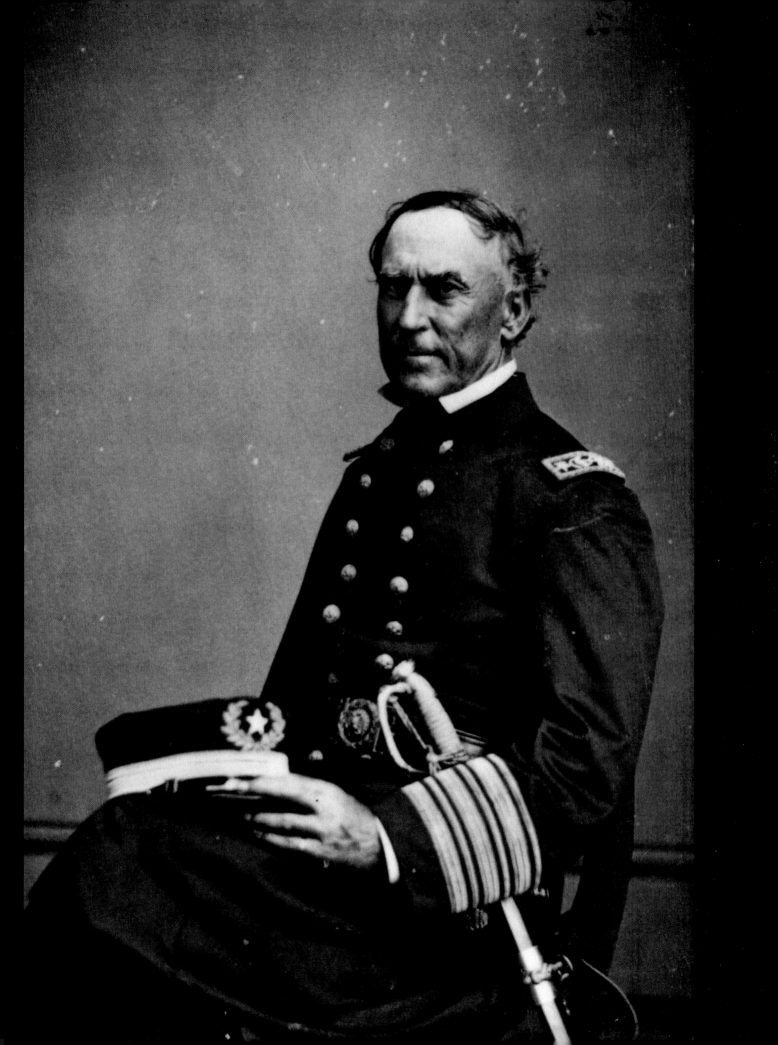

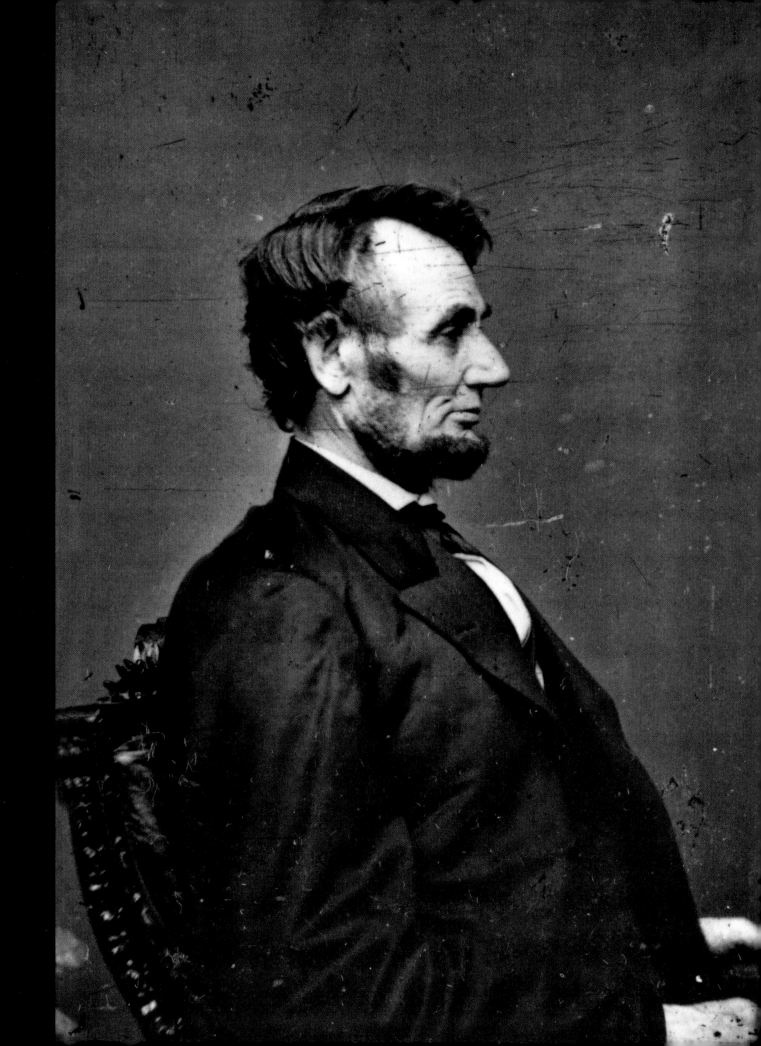

Abraham Lincoln 1809–1865

By Anthony Berger
(lifedates unknown) for
the Mathew Brady Studio
(active 1844–1894),
collodion glass-plate
negative, 1864

George B. McClellan 1826–1885

By the Mathew Brady
Studio (active 1844–1894),
collodion glass-plate
negative, 1863

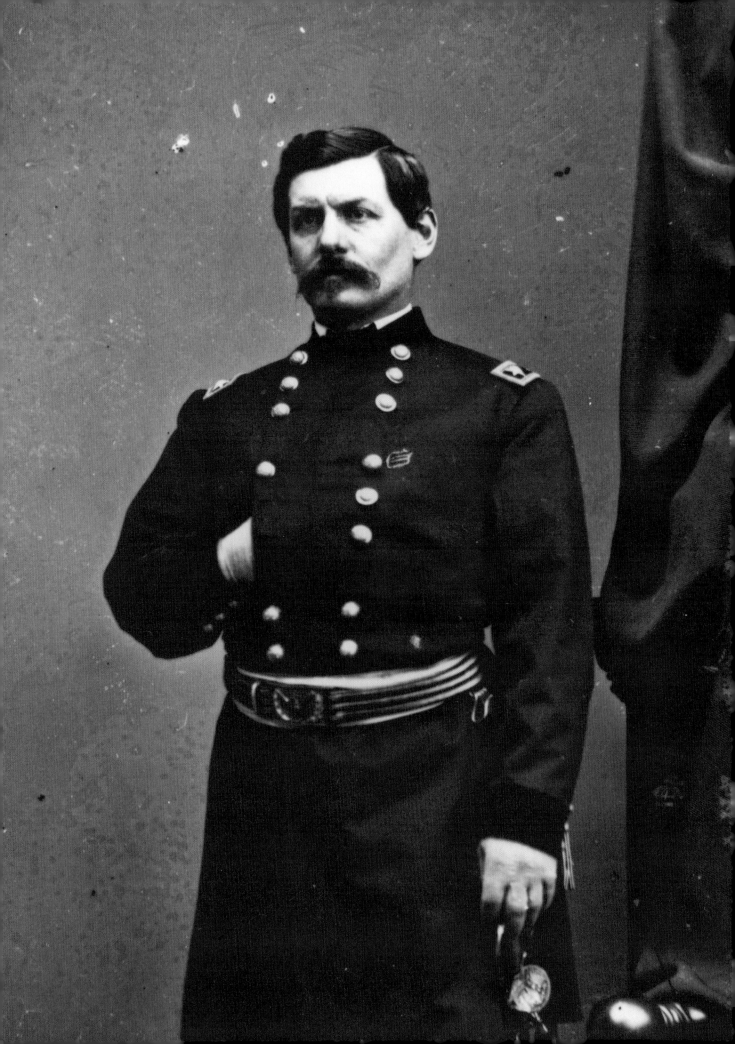

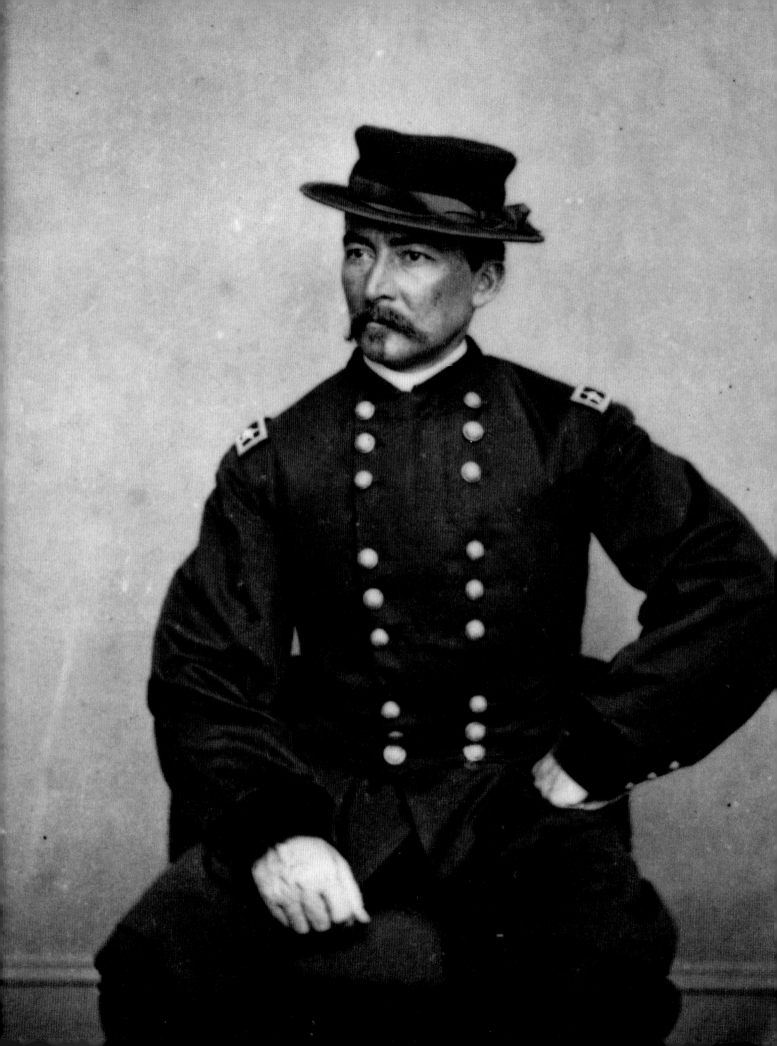

Philip H. Sheridan 1831–1888

By the Mathew Brady
Studio (active 1844–1894),
collodion glass-plate
negative, 1864

William T. Sherman 1820–1891

By the Mathew Brady
Studio (active 1844–1894),
collodion glass-plate
negative, c. 1865

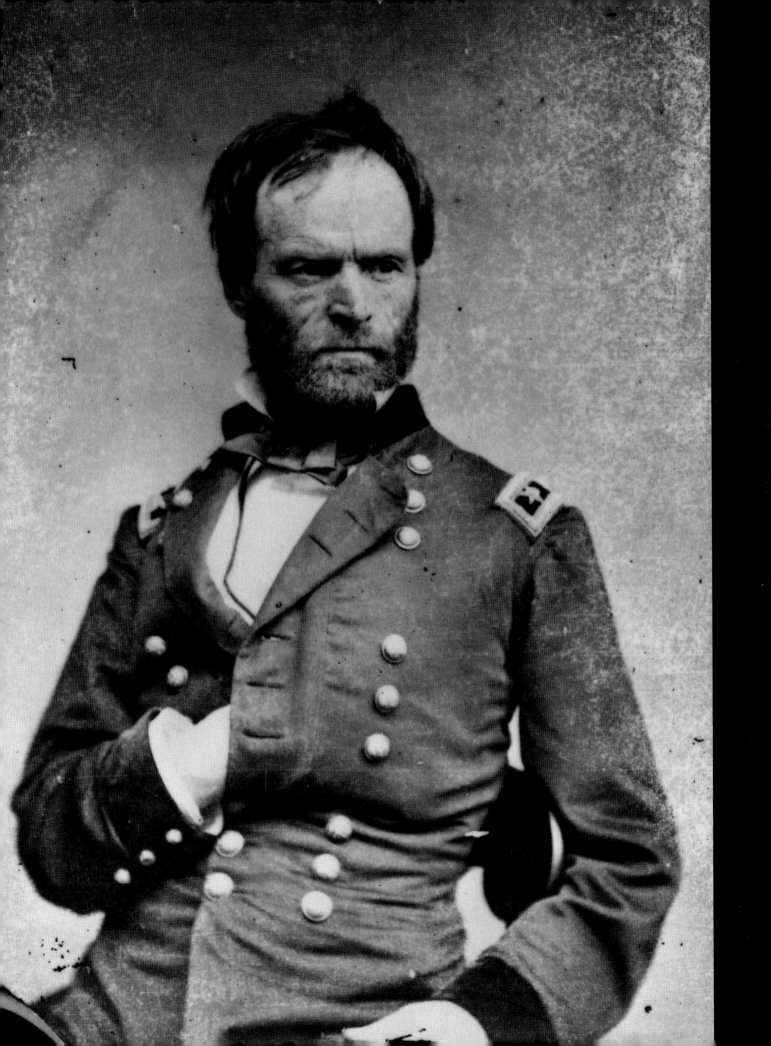

Edwin M. Stanton 1814–1869

By the Mathew Brady
Studio (active 1844–1894),
collodion glass-plate
negative, c. 1864

1. Walt Whitman, *Specimen Days* (Boston, 1971), pp. 17–18.

2. Ibid., p. 18.

3. Charles Edward Stowe, *Life of Harriet Beecher Stowe, Compiled from Her Letters and Journals* (Boston and New York, 1889), pp. 197–98.

4. Harold Holzer, Gabor S. Boritt, and Mark E. Neely Jr., *The Lincoln Image: Abraham Lincoln and the Popular Print* (New York, 1984), p. 2.

5. Ibid., p. 61.

6. Ibid., p. 54.

7. Mary Panzer, *Mathew Brady and the Image of History* (Washington, D.C., 1997), pp. 101, 102.

8. *The United States Senate A.D. 1850* (Philadelphia, 1859), p. 1.

9. Ibid., p. 3.

10. Ibid., p. 5.

11. Ibid., p. 6.

12. Ibid., p. 24.

13. Robert V. Remini, *Daniel Webster: The Man and His Time* (New York, 1997), pp. 326, 328.

14. Margaret L. Coit, *John C. Calhoun: American Portrait* (Boston, 1950), p. 453.

15. Charles M. Wiltse, *John C. Calhoun: Nullifier, 1829–1839* (1949; reprint, New York, 1968), p. 308.

16. Robert V. Remini, *Henry Clay: Statesman for the Union* (New York, 1991), p. 527.

17. Robert Seager II and Melba Porter Hay, eds., *The Papers of Henry Clay* (Lexington, Ky.: 1988), vol. 9, p. 822.

18. Charles Sheffeld, ed., *The History of Florence, Massachusetts* (Florence, Mass., 1895), p. 132.

19. Kathleen Collins, "Shadow and Substance: Sojourner Truth," *History of Photography* 7, no. 3 (July–September 1983): 190.

20. Sheffeld, *History of Florence,* p. 132.

21. Collins, "Shadow and Substance," p. 186.

22. James Brewer Stewart, *Wendell Phillips: Liberty's Hero* (Baton Rouge and London, 1986), p. 186.

23. Ibid., p. 211.

24. Ibid., p. 234.

25. Ibid., p. 295.

26. *Daily Evening Transcript* (Boston), August 19, 1870.

27. Ibid., February 21, 1890.

28. Henry Mayer, *All on Fire: William Lloyd Garrison and the Abolition of Slavery* (New York, 1998), p. 141.

29. William Phillips Garrison, *William Lloyd Garrison: The Story of His Life Told to His Children* (New York, 1885), vol. 1, p. 340.

30. Ibid., vol. 1, pp. 344, 345.

31. Elizabeth Rogers Payne, "Anne Whitney, Sculptor," *Art Quarterly* 25 (Autumn 1962): 261.

32. Frederick Douglass, *My Bondage and My Freedom*, intro. by Philip S. Foner (1855; reprint, New York, 1969), p. 358.

33. Benjamin Quarles, *Frederick Douglass* (New York, 1968), p. 105.

34. Charles Francis Adams, ed., *Memoirs of John Quincy Adams, Comprising Portions of His Diary from 1795–1848* (New York, 1969), vol. 9, p. 418.

35. Ibid., vol. 11, p. 182.

36. James A. Thome and J. Horace Kimball, *Emancipation in the West Indies: A Six Months' Tour in Antigua, Barbadoes, and Jamaica, in the Year 1837* (New York, 1838), p. vi.

37. Lawrence Thomas Lesick, *The Lane Rebels: Evangelicalism and Antislavery in Antebellum America* (Metuchen, N.J., and London, 1980), p. 184.

38. G. H. Barnes and D. L. Dumond, eds., *Letters of Theodore Dwight Weld, Angelina Grimké Weld, and Sarah Grimké, 1822–1844* (Gloucester, Mass., 1965), vol. 2, p. 817.

39. Philip B. Kunhardt Jr., Philip B. Kunhardt III, and Peter W. Kunhardt, *Lincoln: An Illustrated Biography* (New York, 1992), p. 235.

40. Stowe, *Life of Harriet Beecher Stowe*, p. 476.

41. Joan D. Hedrick, *Harriet Beecher Stowe: A Life* (New York, 1994), p. 208.

42. Stowe, *Life of Harriet Beecher Stowe*, p. 171.

43. Ibid., p. 161.

44. Ibid., p. 169.

45. *New York Evening Post*, January 6, 1864.

46. Richard O. Boyer, *The Legend of John Brown* (New York, 1973), p. 314.

47. Ibid., pp. 436–37.

48. *Frank Leslie's Illustrated Newspaper*, October 29, 1859, p. 337.

49. Boyer, *John Brown*, p. 18.

50. *New-York Daily Tribune*, March 19, 1873.

51. William Kauffman Scarborough, ed., *The Diary of Edmund Ruffin* (Baton Rouge, 1972), vol. 1, p. 348.

52. Betty L. Mitchell, *Edmund Ruffin: A Biography* (Bloomington, Ind., 1981), p. 139.

53. Allan Nevins, *Frémont: The West's Greatest Adventurer* (New York and London, 1958), vol. 2, p. 488.

54. Ibid., pp. 482–83.

55. Ibid., p. 505.

56. Ibid., p. 516.

57. Carl Schurz, *The Autobiography of Carl Schurz*, ed. Wayne Andrews (New York, 1961), p. 143.

58. Robert W. Johannsen, *Stephen A. Douglas* (New York, 1973), p. 642.

59. Ibid., p. 777.

60. Ibid., p. 780.

61. Ibid., p. 794.

62. Mark E. Neely Jr., *The Abraham Lincoln Encyclopedia* (New York, 1982), p. 280.

63. James Mellon, ed., *The Face of Lincoln* (New York, 1979), p. 63.

64. Gerald R. McMurtry, ed., "John Henry Brown's Miniature Portrait of Abraham Lincoln," *Lincoln Lore* 1470 (August 1960): 1.

65. Ibid., p. 2.

66. *Daily Illinois State Journal*, August 28, 1860.

67. Kunhardt Jr. et al., *Lincoln*, p. 119.

68. Mrs. Chapman Coleman, ed., *The Life of John J. Crittenden: With Selections from His Correspondence and Speeches* (Philadelphia, 1871), vol. 1, p. 333.

69. Albert D. Kirwan, *John J. Crittenden: The Struggle for the Union* (Lexington, Ky., 1962), p. 423.

70. Robert Penn Warren, "Jefferson Davis Gets His Citizenship Back," *New Yorker*, February 25, 1980, p. 50.

71. Cass Canfield, *The Iron Will of Jefferson Davis* (New York, 1978), p. 31.

72. Hudson Strode, *Jefferson Davis: Tragic Hero* (New York, 1964), p. 81.

73. Hudson Strode, *Jefferson Davis: American Patriot, 1808–1861* (New York, 1955), p. 252.

74. Thomas E. Schott, *Alexander H. Stephens of Georgia: A Biography* (Baton Rouge, 1988), pp. 20, 254.

75. Kathleen W. Dorman, " 'Interpretations and Embarrassments': The Smithsonian

Institution during the Civil War," a revised version of a talk given on September 25, 1996, as part of the Smithsonian Institution History Lecture Series, Joseph Henry Papers Project, Smithsonian Institution, History Division, www.si.edu/archives/ihd/jhp/Civilwar.htm.

76. Ibid.

77. Diary of Mary Henry, January 25 and 26, 1865, Smithsonian Institution Archives, Institutional History Division.

78. John M. Taylor, *William Henry Seward: Lincoln's Right Hand* (New York, 1991), pp. 3, 118.

79. Dorothy Meserve Kunhardt and Philip B. Kunhardt Jr., *Twenty Days: A Narrative in Text and Pictures of the Assassination of Abraham Lincoln . . .* (New York, 1965), p. 50.

80. For mention of Seward's visit to Benzoni, see Olive Risley Seward, ed., *William H. Seward's Travels around the World* (New York, 1873), p. 680.

81. Georges J. Joyaux, ed., "The Tour of Prince Napoleon," *American Heritage* 8 (August 1957): 76.

82. T. Harry Williams, *P. G. T. Beauregard: Napoleon in Gray* (Baton Rouge, 1955), p. 52.

83. Douglas Southall Freeman, *Lee's Lieutenants: A Study in Command* (New York, 1944), vol. 3, p. xxiv.

84. Robert J. Titterton, *Julian Scott: Artist of the Civil War and Native America* (Jefferson, N.C., 1997), p. 7.

85. "Julia Ward Howe, President of the New England Women's Club: A Birthday Anniversary," May 27, 1919–39, NPG curatorial files.

86. Deborah Pickman Clifford, *Mine Eyes Have Seen the Glory: A Biography of Julia Ward Howe* (Boston and Toronto, 1979), p. 144.

87. Ibid.

88. "Julia Ward Howe, President of the New England Women's Women's Club."

89. Julia Ward Howe, *Reminiscences 1819–1899* (Boston and New York, 1899), p. 279.

90. Maud Elliott Howe to R. P. Tolman, December 9, 1933, NPG curatorial files.

91. Douglas Southall Freeman, *R. E. Lee: A Biography* (New York, 1942), vol. 1, p. 439.

92. Emory M. Thomas, *Robert E. Lee* (New York, 1995), p. 188.

93. Freeman, *R. E. Lee*, vol. 1, p. 447.

94. Ulysses S. Grant, *Personal Memoirs of U. S. Grant* (1885–86; reprint, New York, 1982), p. 581.

95. *Private and Official Correspondence of Gen. Benjamin F. Butler, During the Period of the Civil War* (Norwood, Mass., 1917), vol. 5, p. 88. In November 1864, a Boston newspaper gave notice that Brackett's bust of General Butler could be seen at a local gallery. "For embody-

ing character as well as delineating features," reported the source, Brackett in his present bust of Butler "has fairly exceeded all his previous efforts." A notice of January 1866 reported that Brackett had "just completed another bust of General Butler, it being the third which he has executed in marble. The present work is a decided improvement on the first, which attracted so much attention" (see *Boston Transcript*, November 28, 1864, and January 13, 1866). Although it is not known for certain, the National Portrait Gallery's bust may well be the first one. Butler acknowledged purchasing the bust in his letter to his wife of August 21, 1864. Moreover, the Gallery's bust had been owned by Butler's descendants and was given to the museum by his great-grandchildren in 1973.

96. University of the State of New York, Division of Archives and History, *Proceedings at the Unveiling of a Memorial to Horace Greeley at Chappaqua, N.Y. February 3, 1914* (Albany, 1915), p. 113.

97. William Harlan Hale, *Horace Greeley: Voice of the People* (New York, 1950), p. 73.

98. Henry Luther Stoddard, *Horace Greeley: Printer, Editor, Crusader* (New York, 1946), p. 162.

99. University of the State of New York, *Proceedings at the Unveiling of a Memorial*, pp. 189–90.

100. Ibid., p. 190.

101. Stoddard, *Horace Greeley*, p. 223.

102. James M. McPherson, *Battle Cry of Freedom: The Civil War Era* (New York, 1988), p. 841.

103. For an in-depth discussion of Carpenter's picture, see Harold Holzer, Gabor S. Boritt, and Mark E. Neely Jr., "Francis Bicknell Carpenter (1830–1900): Painter of Abraham Lincoln and His Circle," *American Art Journal* 16 (Spring 1984): 66–89.

104. Justin G. Turner and Linda Levitt Turner, *Mary Todd Lincoln: Her Life and Letters* (New York, 1972), p. 83.

105. See Lloyd Ostendorf, *The Photographs of Mary Todd Lincoln* (Springfield, Ill., 1969), p. 52.

106. See *Washington Evening Star*, March 14, November 4 and 27, December 16, 1872; February 1, 1873.

107. "Fifth New York Volunteer Infantry: History of Duryee's Zouaves," pt. 1, www.zouave.org/durypt1.html.

108. William H. Russell, *The Civil War in America* (Boston, 1861), p. 44.

109. Mary Anna Jackson, *Memoirs of Stonewall Jackson* (Louisville, Ky., 1895), pp. 409–10.

110. Ibid., pp. 413–14.

111. Jackson was a lieutenant general and was entitled to wear rows of three buttons down the front of his coat, as shown in King's portrait. Yet the photograph from which this painting is derived clearly shows him in a coat with rows of two buttons, the designation of a brigadier general. Mrs. Jackson's chance mention that this coat was from Jeb Stuart may help to explain the discrepancy. Jackson, however, liked simplicity in his uniforms and no doubt never gave the buttons a second thought. For mention of J. W. King, see Virginius Cornick Hall Jr., comp., *Portraits in the Collection of the Virginia Historical Society: A Catalogue* (Charlottesville, Va., 1981), pp. 230–31, and Mark E. Neely et al., *The Confederate Image: Prints of the Lost Cause* (Chapel Hill, N.C., 1987), pp. 24, 112.

112. David Gollaher, *Voice for the Mad: The Life of Dorothea Dix* (New York, 1995), p. 410.

113. Ibid., p. 409.

114. C. Vann Woodward, ed., *Mary Chesnut's Civil War* (New Haven, Conn., 1981), p. 495.

115. Freeman, *R. E. Lee*, vol. 4, pp. 445–46.

116. Steven H. Newton, *Joseph E. Johnston and the Defense of Richmond* (Lawrence, Kans., 1998), p. 4.

117. Grady McWhiney, *Braxton Bragg and Confederate Defeat* (New York, 1969), vol. 1, p. 389n.

118. John Russell Young, *Around the World with General Grant* (New York, 1879), vol. 2, p. 297.

119. *Daily Evening Transcript* (Boston), January 22, 1869.

120. Stephen E. Ambrose, "Custer's Civil War," *Timeline* 7 (August–September 1990): 31.

121. Louise Barnett, *Touched by Fire: The Life, Death, and Mythic Afterlife of George Armstrong Custer* (New York, 1996), p. 54.

122. Lloyd Lewis, *Sherman: Fighting Prophet* (New York, 1932), p. 330.

123. Stephen E. Ambrose, "William T. Sherman: A Re-appraisal," *American History Illustrated* 1 (January 1967): 54.

124. Howard K. Beale, ed., *Diary of Gideon Welles* (New York, 1960), vol. 2, p. 327.

125. Dean B. Mahin, *One War at a Time* (Washington, D.C., 1999), p. 62.

126. Ibid.

127. Beale, ed., *Diary of Gideon Welles*, vol. 2. p. 157.

128. Grant, *Personal Memoirs*, p. 300.

129. Joseph T. Durkin, *Confederate Navy Chief: Stephen R. Mallory* (Columbia, S.C., 1954), p. 135.

130. Ibid., p. 43.

131. Beale, *Diary of Gideon Welles*, vol. 1, p. 216.

132. John D. Hayes, ed., *Samuel Francis Du Pont: A Selection from His Civil War Letters* (Ithaca, N.Y., 1969), vol. 1, p. lxxvii.

133. Shelby Foote, "Du Pont Storms Charleston," *American Heritage* 14 (June 1963): 33.

134. Shelby Foote, *The Civil War: A Narrative* (New York, 1974), vol. 3, p. 950.

135. Woodward, *Mary Chesnut's Civil War*, p. 814.

136. Albert Bigelow Paine, *Thomas Nast: His Period and His Pictures* (New York, 1904), p. 69.

137. William Gillette, *The Right to Vote: Politics and the Passage of the Fifteenth Amendment* (Baltimore, 1965), p. 87.

138. *The American and Commercial Advertiser* (Baltimore), May 20, 1870.

139. Ibid.

140. Panzer, *Mathew Brady*, p. 18.

141. Kunhardt Jr. et al., *Lincoln* , p. ix.

Unless otherwise indicated, all objects are from the collection of the National Portrait Gallery, Smithsonian Institution.

The United States Senate, A.D. 1850 by Robert Whitechurch (1814–c. 1880), after Victor Piard, after Peter Frederick Rothermel, after daguerreotypes, engraving, 65.8 × 86.8 cm (25⅞ × 34³⁄₁₆ in.), 1855. Gift of Mrs. Richard K. Doud (NPG.77.11)

Daniel Webster by George P. A. Healy (1813–1894), oil on canvas, 129 × 102 cm (50¹³⁄₁₆ × 40³⁄₁₆ in.), 1846. Gift of the A. W. Mellon Educational and Charitable Trust (NPG.65.51)

Daniel Webster by Albert Sands Southworth (1811–1894) and Josiah Johnson Hawes (1808–1901), studio active 1844–1861, daguerreotype, 21.5 × 16.5 cm (8⁷⁄₁₆ × 6½ in.), c. 1846 (NPG.76.93)

John C. Calhoun by George P. A. Healy (1813–1894), oil on canvas, 91.9 × 74.1 cm (36³⁄₁₆ × 29³⁄₁₆ in.), c. 1845 (NPG.90.52)

Henry Clay by John Neagle (1796–1865), oil on canvas, 70.5 × 55.2 cm (27¾ × 21¾ in.), 1842 (NPG.93.476)

Henry Clay by Frederick De Bourg Richards (1822–1903), daguerreotype, 14.1 × 10.6 cm (5⁹⁄₁₆ × 4³⁄₁₆ in.), c. 1850 (NPG.90.24)

Henry Clay by John Sartain (1808–1897), mezzotint, 58.1 x 38 cm (22⁷⁄₈ × 14¹⁵⁄₁₆ in.), 1843 (NPG.91.18)

Sojourner Truth by an unidentified photographer, albumen silver print, 8.7 × 5.6 cm (3⁷⁄₁₆ × 2³⁄₁₆ in.), 1864 (NPG.79.209)

Wendell Phillips by Martin Milmore (1844–1883), bronze, 72.4 cm (28½ in.), 1869 (NPG.68.27)

William Lloyd Garrison by Nathaniel Jocelyn (1796–1881), oil on panel, 81.3 × 69.2 cm (32 × 27¼ in.), 1833. Bequest of Garrison Norton (NPG.96.102)

William Lloyd Garrison by Albert Sands Southworth (1811–1894) and Josiah Johnson Hawes (1808–1901), studio active 1844–1861, daguerreotype, 14 x 10.8 cm (5½ x 4¼ in.), c. 1846 (NPG.99.47)

William Lloyd Garrison by Anne Whitney (1821–1915), plaster, 61 cm (24 in.), 1878. Gift of Lloyd Kirkham Garrison (NPG.74.52)

Frederick Douglass by an unidentified artist, oil on canvas, 70.2 × 57.5 cm (27⅝ × 22⅝ in.), c. 1844 (NPG.74.45)

Frederick Douglass by an unidentified artist, daguerreotype, 8 x 6.9 cm (3⅛ × 2¹¹⁄₁₆ in), c. 1850 after a c. 1847 daguerreotype (NPG.80.21)

Frederick Douglass by an unidentified photographer, ambrotype, 10.6 × 8.6 cm (4³⁄₁₆ × 3⅜ in.), 1856. Gift of an anonymous donor (NPG.74.75)

John Quincy Adams by George Caleb Bingham (1811–1879), oil on canvas, 75.9 × 63.8 cm (29⅞ × 25⅛ in.), c. 1850 from an 1844 original (NPG.69.20)

John Quincy Adams's cane. National Museum of American History, Smithsonian Institution, Behring Center

James A. Thome attributed to Nathaniel Jocelyn (1796–1881), oil on canvas, 86.3 × 68.6 cm (34 × 27 in.), c. 1840 (NPG.91.204)

Slave collar. National Museum of American History, Smithsonian Institution, Behring Center

Private Gordon by the Mathew Brady Studio (active 1844–1894), after William D. McPherson and Mr. Oliver, albumen silver print, 8.6 × 5.5 cm (3⅜ × 2³⁄₁₆ in.), 1863 (NPG.2002.89)

Harriet Beecher Stowe by Alanson Fisher (1807–1884), oil on canvas, 86.4 × 68.6 cm (34 × 27 in.), 1853 (NPG.68.1)

Uncle Tom and Little Eva by an unidentified Staffordshire potter, porcelain, 25.5 cm (10¹⁄₁₆ in.), c. 1852. Gift of Richard E. Guggenheim (AD/NPG.78.6)

Theatrical poster for *Uncle Tom's Cabin* by Erie Lithography Company (active 1890s), color lithographic poster, 100.6 × 66.9 cm (39⅝ × 26⁵⁄₁₆ in.), c. 1890. Gift of Mr. and Mrs. Leslie J. Schreyer (NPG.84.227)

Harriet Beecher Stowe, Lyman Beecher, and Henry Ward Beecher by the Mathew Brady Studio (active 1844–1894), albumen silver print, 6.9 × 5.5 cm (2¹¹⁄₁₆ × 2³⁄₁₆ in.), c. 1861 (NPG.96.79)

.52 caliber Sharps carbine. National Museum of American History, Smithsonian Institution, Behring Center

John Brown by Ole Peter Hansen Balling (1823–1906), oil on canvas, 76.5 × 64.5 cm (30⅛ × 25⅜ in.), c. 1873 (NPG.74.2)

Pike from John Brown's raid. National Museum of American History, Smithsonian Institution, Behring Center

John Brown by Augustus Washington (1820/21–1875), daguerreotype, 11.4 × 19.7 cm (4½ × 7¾ in.) case open, c. 1846–1847. Purchased with major acquisition funds and with funds donated by Betty Adler Schermer in honor of her great-grandfather, August M. Bondi (NPG.96.123)

John Brown Brought Out for Execution by Albert Berghaus (lifedates unknown), pencil on paper, 24.1 × 35.2 cm (9½ × 13⅞ in.), 1859 (NPG.73.2)

Edmund Ruffin by an unidentified photographer, salted-paper print with watercolor wash, 22.3 × 15.6 cm (8¾ × 6⅛ in.), c. 1861 (NPG.99.157)

John C. Frémont by Samuel Worcester Rowse (1822–1901), after a photograph by Samuel Root, lithograph, 63.5 × 50.7 cm (25 × 19¹⁵⁄₁₆ in.), c. 1856 (NPG.96.117)

Stephen A. Douglas by Duncan Styles (lifedates unknown), oil on canvas, 128.3 × 97.2 cm (50½ × 38¼ in.), 1860 (NPG.70.42)

Stephen A. Douglas by James Earl McClees (1821–1887) and Julian Vannerson (c. 1827–?), studio active 1857–1860, salted-paper print, 18.4 × 13.3 cm (7¼ × 5¼ in.), c. 1858. Gift of Roger F. Shultis (NPG.77.262)

Stephen A. Douglas by an unidentified artist, polychromed wood, 46.4 cm (18¼ in.), c. 1858. Gift of Richard E. Guggenheim (NPG.71.59)

Abraham Lincoln by John Henry Brown (1818–1891), watercolor on ivory, 11.7 × 8.9 cm (4⅝ × 3½ in.), 1860 (NPG.75.11)

Abraham Lincoln by Samuel M. Fassett (active 1855–1875?), salted-paper print, 18.4 × 13.3 cm (7¼ × 5¼ in.), 1859 (NPG.77.265)

The Rail Candidate by Louis Maurer (1832–1932) for Currier and Ives Lithography Company, lithograph, 25 × 37.8 cm (9¹³⁄₁₆ × 14⅞ in.), 1860 (NPG.85.148)

Lincoln campaign parade torch. National Museum of American History, Smithsonian Institution, Behring Center; gift of Carl Haverlin

Life mask of Abraham Lincoln by Leonard Wells Volk (1828–1895), plaster, 14.6 cm (5¾ in.), cast after 1860 bronze original (NPG.71.24)

Abraham Lincoln by the Mathew Brady Studio (active 1844–1894), collodion glass-plate negative, 8.8 × 5.8 cm (3½ × 2⁵⁄₁₆ in.), 1861 (NPG.81.M7)

Abraham Lincoln as Don Quixote by Adalbert J. Volck (1828–1912), etching, 17 × 11.8 cm (6¹¹⁄₁₆ × 4⅝ in.), 1861 (NPG.78.31)

John Crittenden by George P. A. Healy (1813–1894), oil on canvas, 75 × 63 cm (29½ × 24¹³⁄₁₆ in.), 1857. Gift of Mr. and Mrs. Silas B. McKinley (NPG.64.1)

"The Union Is Dissolved!" broadside from the *Charleston Mercury*, 60.2 × 30.5 cm (23¹¹⁄₁₆ × 12 in.), 1860 (AD/NPG.84.2)

Jefferson Davis by an unidentified photographer, daguerreotype, 13.4 × 10.2 cm (5¼ × 4 in.), c. 1858 (NPG.77.260)

Jefferson Davis by George Lethbridge Saunders (1807–1863), watercolor on ivory, 17 × 14 cm (6¹¹⁄₁₆ × 5½ in.), feigned oval, 1849. Gift of Joel A. H. Webb and Varina Webb Stewart (NPG.79.228)

Jeff Davis, on His Own Platform, or the Last Act of Secession by Currier and Ives Lithography Company (active 1857–1907), lithograph, 30.5 × 28.1 cm (12 × 11¹⁄₁₆ in.), c. 1861 (NPG.84.200)

Varina Howell Davis by John Wood Dodge (1807–1893), watercolor on ivory, 6.5 × 5.3 cm (2⁹⁄₁₆ × 2¹⁄₁₆ in.), 1849. Gift of Varina Webb Stewart (NPG.80.113)

Varina Howell Davis's ring. National Museum of American History, Smithsonian Institution, Behring Center; gift of Mrs. John Stewart

Jeff Davis, before and after the fall of Fort Sumter, 1861 and 1863 by David Claypoole Johnston (1799–1865), lithograph, 8.9 × 6.4 cm (3½ × 2½ in.), c. 1863 (NPG.98.32)

Alexander H. Stephens attributed to James Earl McClees (1821–1887) and Julian Vannerson

(c. 1827–?), salted-paper print, 18.7 × 13.3 cm (7⅜ × 5¼ in.), c. 1858. Gift of Roger F. Shultis (NPG.87.42.47)

Alexander H. Stephens by Frederick Graetz (c. 1840–c. 1913), chromolithograph, 27.8 × 21.9 cm (10¹⁵⁄₁₆ × 8⅝ in.), 1882 (NPG.84.105)

Joseph Henry by Henry Ulke (1821–1910), oil on canvas, 139.7 × 106.6 cm (55 × 42 in.), 1875 (NPG.79.245)

Smithsonian Castle with the Capitol in the distance, 1863. Neg. 91-1038, Smithsonian Institution Archives

Memorandum of Secretary of War Simon Cameron to Joseph Henry, April 20, 1861, Box 39, Henry Collection, RU 7001, Smithsonian Institution Archives

Mary Henry, undated photograph. Neg. 82-3258, Smithsonian Institution Archives

Winfield Scott by the Mathew Brady Studio (active 1844–1894), salted-paper print, 47 × 39.9 cm (18½ × 15¹¹⁄₁₆ in.), c. 1861 (NPG.78.245)

General Scott, the Hercules of the Union, Slaying the Great Dragon of Secession by an unidentified artist, lithograph, 30.6 × 22.1 cm (12¹⁄₁₆ × 8¹¹⁄₁₆ in.), 1861 (NPG.84.102)

Winfield Scott by Auguste Edouart (1788–1861), positive cut and lithograph, 28.1 × 21.2 cm (11¹⁄₁₆ × 8⅜ in.), 1840. Gift of Robert L. McNeil Jr. (NPG.91.126.48.A)

Winfield Scott by Otto Starck (lifedates unknown), lithograph with tintstone, 33.6 × 23.3 cm (13¼ × 9³⁄₁₆ in.), 1861 (NPG.82.8)

William H. Seward by Giovanni Maria Benzoni (1809–1873), marble, 72.1 cm (28⅜ in. with socle), 1872. Bequest of Sara Carr Upton in memory of Olive Risley Seward (NPG.65.39)

William H. Seward by the Mathew Brady Studio (active 1844–1894), albumen silver print, 8.6 × 5.4 cm (3⅜ × 2⅛ in.), c. 1860 (NPG.79.246.146)

Elmer E. Ellsworth by the Mathew Brady Studio (active 1844–1894), albumen silver print, 8.6 × 5.6 cm (3⅜ × 2³⁄₁₆ in.), c. 1861 (NPG.77.355)

A Requiem. Sam De Vincent Collection of Illustrated American Sheet Music, Archives Center, National Museum of American History, Smithsonian Institution, Behring Center

James W. Jackson's shotgun. National Museum of American History, Smithsonian Institution, Behring Center; bequest of Francis Brownell

Ellsworth commemorative envelopes. National Postal Museum, Smithsonian Institution

Francis Brownell's Medal of Honor. National Museum of American History, Smithsonian Institution, Behring Center; bequest of Francis Brownell

P. G. T. Beauregard by Edward Virginius Valentine (1838–1930), bronze, 74.2 cm (29³⁄₁₆ in.), 1978 cast after 1867 plaster (NPG.78.36)

P. G. T. Beauregard by Charles DeForest Fredricks (1823–1894), albumen silver print, 9 × 5.3 cm (3⁹⁄₁₆ × 2¹⁄₁₆ in.), 1861 (NPG.80.301)

George B. McClellan by Julian Scott (1846–1901), oil on canvas, 101.6 × 76.5 cm (40 × 30¹⁄₈ in.), not dated. Bequest of Georgiana L. McClellan (NPG.65.35)

George B. McClellan and his wife, Ellen Marcy, by the Mathew Brady Studio (active 1844–1894), collodian glass-plate negative, 8.9 × 5.9 cm (3¹⁄₂ × 2³⁄₈ in.), not dated (Meserve.1025:36)

George B. McClellan by an unidentified artist, wood, 59.7 cm (23¹⁄₂ in.), c. 1862 (NPG.78.216)

President Lincoln with General McClellan and his generals by Alexander Gardner (1821–1882), albumen silver print, 17.6 × 22.5 cm (6¹⁵⁄₁₆ × 8⁷⁄₈ in.), 1862 (NPG.80.106)

McClellan's Farewell by Charles Magnus (active c. 1854–1879), chromolithograph, 18.9 × 9.9 cm (7⁷⁄₁₆ × 3⁷⁄₈ in.), c. 1862 (NPG.91.118)

Julia Ward Howe begun by John Elliott (1858–1925) and finished by William H. Cotton (1880–1958), oil on canvas, 108 × 72.1 cm (42¹⁄₂ × 34³⁄₈ in.), c. 1925. Gift of Maud Howe Elliott (NPG.65.31)

Robert E. Lee by Edward Caledon Bruce (1825–1901), oil on canvas, 52.1 × 39.4 cm (20¹⁄₂ × 15¹⁄₂ in.), c. 1864–1865 (NPG.76.4)

Robert E. Lee by John W. Davies (lifedates unknown), albumen silver print, 6.1 × 4.2 cm (2³⁄₈ × 1⁵⁄₈ in.), 1864 (NPG.78.244)

Robert E. Lee by Edward Virginius Valentine (1838–1930), bronze, 58.4 cm (23 in.), cast after 1870 plaster (NPG.78.35)

Ambrose E. Burnside by Manchester and Brother Studio (active c. 1848–1880), ambrotype, 6.2 × 4.9 cm ($2^7\!/_{16}$ × $1^{15}\!/_{16}$ in.), c. 1861 (NPG.78.278)

Colonel Burnside and the First Rhode Island Volunteers by an unidentified photographer, albumen silver print, 27.8 × 37 cm ($10^{15}\!/_{16}$ × $14^9\!/_{16}$ in.), 1861 (NPG.78.63)

Ambrose Burnside by an unidentified artist, hand-colored steel engraving (proof), 30.8 × 27.6 cm ($12^1\!/_8$ × $10^7\!/_8$ in.), not dated (S/NPG.72.3)

Benjamin F. Butler by Edward Augustus Brackett (1818–1908), marble, 62.2 cm ($24^1\!/_2$ in.), 1863. Gift of the children of Oakes and Blanche Ames (NPG.73.1)

Benjamin Franklin Butler by Bobbett and Hooper Wood Engraving Company (active 1855–1870?), after Henry Louis Stephens, wood engraving, 16 × 14.5 cm ($6^5\!/_{16}$ × $5^{11}\!/_{16}$ in.), published in *Vanity Fair*, New York, June 28, 1862 (NPG.78.254)

Benjamin F. Butler by an unidentified photographer, albumen silver print, 11.6 × 14.8 cm ($4^9\!/_{16}$ × $5^{13}\!/_{16}$ in.), c. 1864 (NPG.84.151)

Grand Federal Menagerie!! Now on Exhibition!! by Currier and Ives Lithography Company (active 1857–1907), lithograph, 20.8 × 33.9 cm ($8^3\!/_{16}$ × $13^3\!/_8$ in.), c. 1862 (NPG.84.362)

Horace Greeley by an unidentified photographer, daguerreotype, 10.7 × 8.2 cm ($4^3\!/_{16}$ × $3^1\!/_4$ in.), c. 1850 (NPG.77.9)

Horace Greeley by Bobbett and Hooper Wood Engraving Company (active 1855–1870?), after Henry Louis Stephens, wood engraving, 27 × 20 cm ($10^5\!/_8$ × $7^7\!/_8$ in.), published in *Vanity Fair*, New York, March 29, 1862 (NPG.85.59)

The Political Gymnasium by Louis Maurer (1832–1932) for Currier and Ives Lithography Company, lithograph, 26.3 × 42.7 cm ($10^3\!/_8$ × $16^3\!/_{16}$), 1860 (NPG.83.239)

Salmon P. Chase by Francis B. Carpenter (1830–1900), oil on canvas, 30.5 × 25.7 cm (12 × $10^1\!/_8$ in.), 1861. Gift of David Rockefeller (NPG.69.47)

Abraham Lincoln by George P. A. Healy (1813–1894), oil on canvas, 188.6 × 137.2 cm ($74^1\!/_4$ × 54 in.) sight, 1887. Gift of the A. W. Mellon Educational and Charitable Trust (NPG.65.50)

The First Reading of the Emancipation Proclamation before the Cabinet by Alexander Hay Ritchie (1822–1895), after Francis B. Carpenter, stipple engraving, 53 × 82.2 cm (20⅞ × 32⅜ in.), 1866. Gift of Mrs. Chester E. King (NPG.78.109)

Subscription list for Francis B. Carpenter's *First Reading of the Emancipation Proclamation before the Cabinet.* Gift of Mrs. Chester E. King (NPG.78.109)

Portrait in script of Abraham Lincoln by William H. Pratt (1858–c. 1888), lithograph, 31.3 × 22.9 cm (12⁵⁄₁₆ × 9 in.), 1865 (NPG.84.203)

Proclamation of Emancipation by William Roberts (1846–c. 1876), after Mathew Brady, wood engraving with one tint, 50.1 × 38.2 cm (19¾ × 15¹⁄₁₆ in.), 1864 (NPG.83.229)

The Emancipation Proclamation by Adalbert J. Volck (1828–1912), transfer lithograph, 13.4 × 18 cm (5¼ × 7¹⁄₁₆ in.), 1864 (NPG.79.95.v)

Freedom to the Slaves by Currier & Ives Lithography Company (active 1857–1907), after Anthony Berger, lithograph, 30.1 × 22.3 cm (11⅞ × 8¾ in.), c. 1864–1865 (NPG.83.224)

Mary Todd Lincoln by the Mathew Brady Studio (active 1844–1894), collodion glass-plate negative, 8.8 × 6.8 cm (3½ × 2¾ in.), c. 1863 (NPG.81.M144)

Abraham and Mary Todd Lincoln by Pierre Morand (active 1839–1891), ink and opaque white gouache on paper, 20.4 × 12.8 cm (8¹⁄₁₆ × 5¹⁄₁₆ in.), c. 1864 (NPG.75.28)

Mary Todd Lincoln dress. National Museum of American History, Smithsonian Institution, Behring Center; bequest of Mrs. Julian James

Grand Reception of the Notabilities of the Nation by Major and Knapp Lithography Company (active 1864–c. 1881), lithograph, 38.4 × 51.9 cm (15¹⁄₁₆ × 20⁷⁄₁₆ in.), 1865 (NPG.82.30)

Mary Todd Lincoln's silver service. National Museum of American History, Smithsonian Institution, Behring Center; gift of Lincoln Isham

Edwin M. Stanton by Henry Ulke (1821–1910), oil on canvas, 73.3 × 58.1 cm (28⅞ × 22⅞ in.), 1872. Gift of Miss Sophy Stanton (NPG.66.69)

Edwin M. Stanton by Bobbett and Hooper Wood Engraving Company (active 1855–1870?), after Henry Louis Stephens, wood engraving, 16.5 × 15 cm (6½ × 5⅞ in.), 1862 (NPG.78.232)

Winslow Homer by Thomas A. Gray (active 1863) and Thomas Faris (1814–?), albumen silver print, 9.4 × 5.6 cm (3¹⁄₁₆ × 2³⁄₁₆ in.), 1863 (NPG.2001.50)

General McClellan's Sixth Pennsylvania Cavalry Regiment Ready to Embark at Alexandria for Old Point Comfort by Winslow Homer, graphite, brush, and gray wash on cream-colored paper, 21.9 × 40.3 cm (8⅝ × 15⅞ in.), 1862. Cooper-Hewitt, National Design Museum, Smithsonian Institution; gift of Charles Savage Homer Jr. (1912-12-137)

Zouave by Winslow Homer, black-and-white chalk on blue-green paper, 42.8 × 19 cm (16⅞ × 7½ in.), 1864. Cooper-Hewitt, National Design Museum, Smithsonian Institution; gift of Charles Savage Homer Jr. (1912-12-109)

Adalbert J. Volck self-portrait, tin relief, 21.5 cm (8⁷⁄₁₆ in.) diameter, c. 1900. Gift of Bryden B. Hyde (NPG.72.100)

Worship of the North by Adalbert J. Volck (1828–1912), etching from *Sketches from the Civil War in North America*, 17.9 × 24.8 cm (7¹⁄₁₆ × 9¾ in.), 1863 (NPG.79.95.a)

Thomas J. "Stonewall" Jackson by J. W. King (lifedates unknown), oil on canvas, 91.8 × 74 cm (36⅛ × 29⅛ in.), 1864. Given in memory of Lieselotte Richardson (NPG.96.133)

Thomas J. "Stonewall" Jackson attributed to H. B. Hull (lifedates unknown), daguerreotype, 8.4 × 7.2 cm (3⁵⁄₁₆ × 2¹³⁄₁₆ in.), 1855 (NPG.77.57)

Scene in Stonewall Jackson's Camp by Adalbert J. Volck (1828–1912), etching, 14.3 × 21 cm (5⅝ × 8¼ in.), 1863 (NPG.79.95.j)

Lieut. Gen Thomas J. Jackson and His Family by William Sartain (1843–1924), engraving, 35.4 × 49 cm (13¹⁵⁄₁₆ × 19⁵⁄₁₆ in.), 1866 (NPG.84.350)

Gen. Stonewall Jackson by Endicott Lithography Company (active 1828–1886), lithograph, 22.5 × 20.8 cm (8⅞ × 8³⁄₁₆ in.), 1865 (NPG.84.345)

Death mask of Stonewall Jackson by Adalbert J. Volck (1828–1912), etching, 11 × 4.9 cm (4⁵⁄₁₆ × 1⁵⁄₁₆ in.), c. 1863 (NPG.78.20)

Barbara Fritchie by Jacob Byerly and Son (active 1807–1883), albumen silver print, 6.1 × 5 cm (2⅜ × 1¹⁵⁄₁₆ in.), c. 1862 (printed c. 1863–1864) (NPG.2001.36)

Dorothea Dix by Samuel Bell Waugh (1814–1885), oil on canvas, 68.6 × 55.6 cm (27 × 21⅞ in.), 1868 (NPG.97.38)

A. P. Hill by George S. Cook (1819–1902), after Julian Vannerson, glossy collodion print, 14 × 9.8 cm (5½ × 3⅞ in.), copied c. 1867 (NPG.2001.39)

In Memory of the Confederate Dead by Bennett, Donaldson & Elmes Lithography Company (active c. 1866), lithograph with tintstone, 33.8 × 24.8 cm (13⁵⁄₁₆ × 9¾ in.), c. 1866 (NPG.84.363)

Ulysses S. Grant by Ole Peter Hansen Balling (1823–1906), oil on canvas, 120.3 × 94.6 cm (47⅜ × 37¼ in.), 1865 (NPG.67.34)

Ulysses S. Grant at Cold Harbor, Virginia, by Mathew Brady (c. 1823–1896), albumen silver print, 11.6 × 12.1 cm (4⁹⁄₁₆ × 4¾ in.), 1864 (NPG.77.56)

Grant and His Generals by Ole Peter Hansen Balling (1823–1906), oil on canvas, 304.8 × 487.7 cm (120 × 192 in.), 1865. Gift of Mrs. Harry Newton Blue in memory of her husband, Harry Newton Blue, 1893–1925, who served as an officer of the regular U.S. Army, 1917–1925 (NPG.66.37)

J. E. B. Stuart by George S. Cook (1819–1902), salted-paper print, 18.7 × 13.2 cm (7⅜ × 5³⁄₁₆ in.), 1863 (NPG.81.31)

Jeb Stuart's revolver. National Museum of American History, Smithsonian Institution, Behring Center; gift of the estate of William G. Renwick

Stuart's cavalry by Frank Vizetelly (1830–1883?), wood engraving, 23.9 × 34.8 cm (9⁷⁄₁₆ × 13¹¹⁄₁₆ in.), 1862. (NPG.84.341)

George E. Pickett by Edward Virginius Valentine (1838–1930), bronze, 67.3 cm (26½ in.), 1978 cast after 1875 plaster (NPG.78.37)

George H. Thomas by the Mathew Brady Studio (active 1844–1894), daguerreotype, 8.3 × 7.1 cm (3¼ × 2¹³⁄₁₆ in.), 1853 (NPG.77.61)

George Henry Thomas by William Sartain (1843–1924), mezzotint, 28 x 24 cm (11⅛ × 9⁷⁄₁₆ in.), c. 1866 (NPG.85.170)

Major General George H. Thomas by Ehrgott and Forbriger Lithography Company (active

1858–c. 1869), lithograph, 41.3 × 31.6 cm (16¼ × 12⁷⁄₁₆ in.), c. 1862. Gift of Milton and Ingrid Rose (NPG.97.200)

Joseph E. Johnston by Benjamin Franklin Reinhart (1829–1885), oil on artist board, 29.2 × 24.8 cm (11½ × 9¾ in.), c. 1860–1861 (NPG.72.21)

General Joseph E. Johnston by A. G. Campbell (active 1860–1869?), mezzotint, 29.7 × 23.2 cm (11⁷⁄₁₆ × 9⅛ in.), c. 1865 (NPG.84.334)

The Surrender of Genl. Joe Johnston near Greensboro, N.C., April 26th, 1865 by Currier and Ives Lithography Company (active 1857–1907), hand-colored lithograph, 20.8 × 31.9 cm (8³⁄₁₆ × 12⁹⁄₁₆ in.), 1865 (NPG.84.336)

Braxton Bragg by J. D. Edwards (1831–?), albumen silver print, 9.9 × 6.1 cm (3⅞ × 2⅜ in.), c. 1861 (NPG.77.192)

Zachary Taylor at Walnut Springs by William Garl Browne Jr. (1823–1894), oil on canvas mounted on wood, 74.3 × 91.2 cm (29¼ × 36¼ in), 1847 (NPG. 71.57)

Braxton Bragg by an unidentified photographer, ambrotype, 10.8 × 8.2 cm (4¼ × 3¼ in.), c. 1857 (NPG.88.61)

William S. Rosecrans by Samuel Woodson Price (1828–1918), oil on canvas, 76 × 64 cm (29¹⁵⁄₁₆ × 25³⁄₁₆ in.), 1868 (NPG.71.22)

William S. Rosecrans by the Mathew Brady Studio (active 1844–1894), albumen silver print, 8.6 × 5.4 cm (3⅜ × 2⅛ in.), c. 1861. Gift of Mrs. F. B. Wilde (NPG.83.284.12)

Pauline Cushman by the Mathew Brady Studio (active 1844–1894), collodion glass-plate negative, 8.9 × 5.9 cm (3½ × 2⅝ in.), c. 1864 (NPG.81.M222)

Pauline Cushman by the Mathew Brady Studio (active 1844–1894), collodion glass-plate negative, c. 1864 (Meserve.417:15)

Pauline Cushman by the Mathew Brady Studio (active 1844–1894), collodion glass-plate negative, c. 1864 (Meserve.427:16)

Pauline Cushman by Charles DeForest Fredricks (1823–1894), albumen silver print, 9.2 × 5.4 cm (3⅝ × 2⅛ in.), c. 1866 (NPG.80.218)

Rose O'Neal Greenhow and Her Daughter Rose by Alexander Gardner (1821–1882) for the

Mathew Brady Studio (active 1844–1894), albumen silver print, 19.7 × 16 cm (7¾ × 6⁵⁄₁₆ in.), 1862 (NPG.96.78)

Allan Pinkerton by Alexander Gardner (1821–1882), albumen silver print, 17.1 × 23.1 cm (6¾ × 9⅛ in.), 1862 (NPG.78.276)

David M. Gregg by an unidentified photographer, albumen silver print, 14.5 × 11.8 cm (5¹¹⁄₁₆ × 4⅝ in.), c. 1864 (NPG.81.26)

Philip H. Sheridan by Thomas Buchanan Read (1822–1872), oil on canvas, 137.2 × 98.7 cm (54 × 38⅞ in.), 1871. Gift of Ulysses S. Grant III (NPG.68.51)

Philip H. Sheridan by an unidentified photographer, albumen silver print, 15.4 × 11.6 cm (6¹⁄₁₆ × 4⁹⁄₁₆ in.), 1864 (NPG.78.97)

General Sheridan and his staff by Alexander Gardner (1821–1882), albumen silver print, 32.7 × 27.8 cm (12⅞ × 10¹⁵⁄₁₆ in.), c. 1865 (NPG.78.16)

Philip H. Sheridan by Thomas Buchanan Read (1822–1872), marble, 56 cm (22¹⁄₁₆ in.), 1871. Gift of Mr. Benjamin Bell (NPG.66.73)

John S. Mosby by Daniel (1835–1914) and David Bendann (1841–1915), albumen silver print, 17.4 × 12 cm (6⅞ × 4¾ in.), 1865 (NPG.81.30)

John S. Mosby by Daniel (1835–1914) and David Bendann (1841–1915), albumen silver print, 23.2 × 31.5 cm (9⅛ × 12⅜ in.), 1865 (NPG.83.213)

Mosby's hat and jacket. National Museum of American History, Smithsonian Institution, Behring Center; lent by John Singleton Mosby (jacket); gift of C. W. Russell (hat)

John S. Mosby by Edward Virginius Valentine (1838–1930), bronze, 73.7 cm (29 in.), 1972 cast after 1866 plaster (NPG.72.117)

Mosby's crutches. National Museum of American History, Smithsonian Institution, Behring Center; gift of John Singleton Mosby

George Armstrong Custer by an unidentified photographer, ambrotype, 13.8 × 10.4 cm (5⁷⁄₁₆ × 4⅛ in.), c. 1863 (NPG.82.53)

Custer in his West Point uniform by an unidentified photographer, ambrotype, 10.8 × 8.3 cm (4¼ × 3¼ in.), c. 1860 (NPG.81.138)

George A. Custer by Mathew Brady Studio (active 1844–1894), albumen silver print, 7.9 × 16.2 cm (3⅛ × 6⅜ in.), c. 1864 (printed c. 1890) (NPG.77.200)

Martin R. Delany by an unidentified artist, hand-colored lithograph, 52.2 × 43.8 cm (20⁹⁄₁₆ × 17¼ in.), c. 1865 (NPG.76.101)

Come and Join Us Brothers by P. S. Duval Lithography Company (active 1837–1869), chromolithograph, 35 × 45.4 cm (13¾ × 17⅞ in.), c. 1864. National Museum of American History, Smithsonian Institution, Behring Center

Flag of the Eighty-fourth Regiment. National Museum of American History, Smithsonian Institution, Behring Center; gift of David K. Lander

William T. Sherman by George P. A. Healy (1813–1894), oil on canvas, 158.8 × 95.3 cm (62½ × 37½ in.), 1866. Gift of P. Tecumseh Sherman (NPG.65.40)

William T. Sherman by the Mathew Brady Studio (active 1844–1894), collodion glass-plate negative, 9.3 × 5.8 cm (3¹¹⁄₁₆ × 2⁵⁄₁₆ in.), c. 1865 (NPG.81.M176)

Sherman's campaign hat. National Museum of American History, Smithsonian Institution, Behring Center; gift of P. Tecumseh Sherman

The Council of War by Peter Kramer (1823–1907), lithograph, 36.5 × 50 cm (14⅜ × 19¹¹⁄₁₆ in.), 1865 (NPG.79.185)

Gideon Welles by the Mathew Brady Studio (active 1844–1894), albumen silver print, 22.2 × 17.5 cm (8¾ × 6⅞ in.), 1865. Gift of Robert L. Drapkin (NPG.85.111)

Charles Wilkes by the Mathew Brady Studio (active 1844–1894), collodion glass-plate negative, 8.7 × 5.7 cm (3⁷⁄₁₆ × 2¼ in.), c. 1861 (NPG.81.M204)

Sword presented to Charles Wilkes. National Museum of American History, Smithsonian Institution, Behring Center; gift of Miss Jane Wilkes

James Mason and John Slidell by an unidentified artist, wood engraving, 13.9 × 24 cm (5½ × 9⁷⁄₁₆ in.), 1861 (S/NPG.84.415)

David D. Porter by Alexander Gardner (1821–1882), albumen silver print, 22.3 × 17.5 cm (8¾ × 6⅞ in.), 1865 (NPG.78.155)

John Ericsson by Arvid Frederick Nyholm (1866–1927), oil on canvas, 123.8 × 92.7 cm (48¾ × 36½ in.), 1912. Gift of the Swedish American Republican League of Illinois (NPG.66.54)

The First Naval Conflict Between Iron Clad Vessels by Charles Parsons (1821–1910) for the Endicott Lithography Company, lithograph with tintstones, 34.4 × 53.1 cm (13⁹⁄₁₆ × 20⅞ in.), 1862 (NPG.84.365)

Stephen R. Mallory by an unidentified photographer, daguerreotype, 14 × 10.8 cm (5½ × 4¼ in.), c. 1852 (NPG.79.115)

Matthew Fontaine Maury by Edward Virginius Valentine (1838–1930), bronze, 61.6 cm (24¼ in.), 1978 cast after 1869 plaster (NPG.78.34)

Matthew Fontaine Maury by Jesse H. Whitehurst (1819–1875), salted-paper print, 18.7 × 13.2 cm (7⅜ × 5³⁄₁₆ in.), c. 1857 (NPG.80.164)

Confederate Leaders and Generals by Charles Magnus (active c. 1854–1879) after the Mathew Brady Studio, lithograph, 48.2 × 28.9 cm (19 × 11⅜ in.), c. 1861–1865 (NPG.79.25)

Raphael Semmes by Louis Prang Lithography Company (active 1856–1899), lithograph with tintstone, 23.1 × 17.3 cm (9⅛ × 6¹³⁄₁₆ in.), c. 1864 (NPG.84.368)

The Fight between the "Alabama" and the "Kearsarge" off Cherbourg, June 19, 1864, by Gustav W. Seitz (1826–1900?), color lithograph, 27.1 × 40.9 cm (10¹¹⁄₁₆ × 16⅛ in.), c. 1864 (NPG.84.369)

Confederate navy china. National Museum of American History, Smithsonian Institution, Behring Center; gift of Samuel E. Kimball

Samuel F. Du Pont by Daniel Huntington (1816–1906), oil on canvas, 148 × 101.6 cm (58¼ × 40 in.), 1867–1868. Bequest of Mrs. May Du Pont Saulsbury (NPG.65.22)

David G. Farragut by Edward Jacobs (1813–1892), albumen silver print, 32.4 × 24.4 cm (12¾ × 9⅝ in.), c. 1862 (NPG.78.65)

David Glasgow Farragut by J. H. Bufford Lithography Company (active 1835–1890), hand-colored lithograph, 29 × 21.9 cm (11⁷⁄₁₆ × 8⅝ in.), c. 1864 (NPG.79.30)

Civil War Naval Officers by an unidentified artist, lithograph, 30 × 68.5 cm (11¹³⁄₁₆ × 26¹⁵⁄₁₆ in.), c. 1862 (NPG.81.38)

The Room in the McLean House, at Appomattox C.H., in which Gen. Lee surrendered to Gen. Grant by Major and Knapp Lithography Company (active 1864–c. 1881), lithograph with tintstone, 48.7 × 73.8 cm (19³⁄₁₆ × 29¹⁄₁₆ in.), 1867 (NPG.80.114)

Furniture used by Grant and Lee at Appomattox. National Museum of American History, Smithsonian Institution, Behring Center; gift of Mrs. B. O'Farrell (Lee armchair), General Wilmon W. Blackmar (Grant chair), and Mrs. Elizabeth B. Custer (table)

U. S. Grant by Frederick Gutekunst (1831–1917), albumen silver print, 9 × 5.9 cm (3⁹⁄₁₆ × 2⁵⁄₁₆ in.), 1865. Gift of Forrest H. Kennedy (NPG.82.94)

Lee's Farewell Address to the Army of Northern Virginia by Ernest Crehen (active c. 1860–c. 1874), after photograph by Minnis and Cowell, lithograph, 6 × 14.3 cm (2³⁄₈ × 5⁵⁄₈ in.), 1866 (NPG.84.96)

Robert E. Lee by Mathew Brady (c. 1823–1896), albumen silver print, 20.8 × 15.2 cm (8³⁄₁₆ × 6 in.), 1865 (NPG.78.243)

Flag of truce. National Museum of American History, Smithsonian Institution, Behring Center; gift of Mrs. Elizabeth B. Custer

Abraham Lincoln by Alexander Gardner (1821–1882), albumen silver print, 45 × 38.6 cm (17¹¹⁄₁₆ × 15³⁄₁₆ in.), 1865 (NPG.81.M1)

$100,000 Reward! albumen silver prints mounted on printed broadside, 61.4 × 31.9 cm (24³⁄₁₆ × 12⁹⁄₁₆ in.), 1865 (NPG.85.32)

John Wilkes Booth by Charles DeForest Fredricks (1823–1894), albumen silver print, 9 × 5.4 cm (3⁹⁄₁₆ × 2¹⁄₈ in.), c. 1862 (NPG.80.214)

Lincoln's top hat. National Museum of American History, Smithsonian Institution, Behring Center

Playbill for *Our American Cousin*, April 14, 1865. National Museum of American History, Smithsonian Institution, Behring Center; gift of Grace Wright

Assassination of President Lincoln by Joseph E. Baker (1835–1914), color lithograph, 24.6 × 35.7 cm (9¹¹⁄₁₆ × 14¹⁄₁₆ in.), c. 1865 (NPG.83.232)

Laura Keene by Charles DeForest Fredricks (1823–1894), albumen silver print, 9.2 × 5.4 cm (3⅝ × 2⅛ in.), c. 1863 (NPG.80.220)

Andrew Johnson by Washington Bogart Cooper (1802–1889), oil on canvas, 91.8 × 74.3 cm (36⅛ × 29¼ in.), after 1866 (NPG.86.213)

Thomas Nast self-portrait, pencil and india ink on paper, 36.1 × 27 cm (14³⁄₁₆ × 10⅝ in.), c. 1882 (NPG.85.62)

Andrew Johnson by Thomas Nast (1840–1902), pastel on paper, 131 × 103 cm (51⁹⁄₁₆ × 40⁹⁄₁₆ in.), 1873 (NPG.69.21)

Robert E. Lee and Joseph E. Johnston, Savannah, Georgia, by D. J. Ryan (1825–1925?), albumen silver print, 13.3 × 9.9 cm (5¼ × 3⅞ in.), 1870 (NPG.78.273)

Reconstruction by J. L. Giles (active c. 1861–1881), lithograph, 50.1 × 64.3 cm (19¾ × 25⁵⁄₁₆ in.), 1867 (NPG.87.216)

The Result of the Fifteenth Amendment . . . by Metcalf and Clark (active c. 1870), hand-colored lithograph, 54.3 × 70.2 cm (21⅜ × 27⅝ in.), 1870 (NPG.2000.39)

The Fisk Jubilee Singers by an unidentified photographer, carbon print, 8.8 × 13.5 cm (3⁷⁄₁₆ × 5⁵⁄₁₆ in.), 1875 (NPG.2002.92)

Mathew Brady with Juliette Handy Brady and Mrs. Haggerty by the Mathew Brady Studio (active 1844–1894), daguerreotype, 10.7 × 8.3 cm (4³⁄₁₆ × 3¼ in.), c. 1851 (NPG.85.78)

Ambrose E. Burnside by the Mathew Brady Studio (active 1844–1894), collodion glass-plate negative, 9.1 × 6.2 cm (3⅝ × 2⁷⁄₁₆ in.), c. 1862 (NPG.81.M49)

Jefferson Davis by the Mathew Brady Studio (active 1844–1894), collodion glass-plate negative, 9.3 × 6.2 cm (3¹¹⁄₁₆ × 2⁵⁄₁₆ in.), c. 1860 (NPG.81.M81)

James A. Garfield by the Mathew Brady Studio (active 1844–1894), collodion glass-plate negative, 9.2 × 6.3 cm (3⅝ × 2½ in.), 1862 (NPG.81.M96)

Ulysses S. Grant by the Mathew Brady Studio (active 1844–1894), collodion glass-plate negative, 9.3 × 5.8 cm (3¹¹⁄₁₆ × 2⁵⁄₁₆ in.), c. 1864 (NPG.81.M108)

David G. Farragut by the Mathew Brady Studio (active 1844–1894), collodion glass-plate negative, 9 × 5.8 cm (3⁹⁄₁₆ × 2⁵⁄₁₆ in.), 1863 (NPG.81.M84)

Abraham Lincoln by Anthony Berger (lifedates unknown) for the Mathew Brady Studio (active 1844–1894), collodion glass-plate negative, 8.9 × 6 cm (3½ × 2⅜ in.), 1864 (NPG.81.M3)

George B. McClellan by the Mathew Brady Studio (active 1844–1894), collodion glass-plate negative, 8.9 × 5.9 cm (3½ × 2⅜ in.), 1863 (NPG.81.M147)

Philip H. Sheridan by the Mathew Brady Studio (active 1844–1894), collodion glass-plate negative, 9.2 × 7.4 cm (3⅝ × 2¹⁵⁄₁₆ in.), 1864 (NPG.81.M171)

William T. Sherman by the Mathew Brady Studio (active 1844–1894), collodion glass-plate negative, 9.2 × 5.7 cm (3⅝ × 2¼ in.), c. 1865 (NPG.81.M177)

Edwin M. Stanton by the Mathew Brady Studio (active 1844–1894), collodion glass-plate negative, 9.3 × 5.8 cm (3¹¹⁄₁₆ × 2⁵⁄₁₆ in.), c. 1864 (NPG.81.M192)

Bryan, Charles, Jr., et al., eds. *Images of the Storm*. New York: Free Press, 2001.

Holzer, Harold, and Mark E. Neely Jr. *Mine Eyes Have Seen the Glory: The Civil War in Art*. New York: Orion Books, 1993.

Leech, Margaret. *Reveille in Washington 1860–1865*. New York: Garden City Publishing, 1941.

McPherson, James M. *Battle Cry of Freedom: The Civil War Era*. New York: Oxford University Press, 1988.

Mellon, James, ed. *The Face of Lincoln*. New York: Viking Press, 1979.

Titterton, Robert J. *Julian Scott: Artist of the Civil War and Native America*. Jefferson, N.C.: McFarland, 1997.

Wert, Jeffry D. *The Sword of Lincoln: The Army of the Potomac*. New York: Simon and Schuster, 2005.

Woodhead, Henry, et al., eds. *Echoes of Glory: Arms and Equipment of the Confederacy and the Union*. 2 vols. Alexandria, Va.: Time-Life Books, 1991.

Page numbers in **boldface** type refer to an entire entry.